DIGITAL PHOTOGRAPHY
COMPLETE
COURSE

DIGITAL PHOTOGRAPHY
COMPLETE
COURSE

Editors Joe Fullman, Camilla Hallinan, Jon Richards
Designers Malcolm Parchment, Ed Simkins, Jonathan Vipond

DK Delhi
Project editor Antara Moitra
Assistant editor Ira Pundeer
Managing editor Pakshalika Jayaprakash
Senior DTP designers Vishal Bhatia, Harish Aggarwal
Pre-production manager Balwant Singh
Picture researcher Deepak Negi
Jacket designer Dhirendra Singh
Managing jackets editor Saloni Singh

Consultant David Taylor

Written by David Taylor, Tracy Hallett, Paul Lowe, Paul Sanders

First published in Great Britain in 2015 by Dorling Kindersley
80 Strand, London WC2R 0RL

Copyright © 2015
Dorling Kindersley

A Penguin Random House Company

2 4 6 8 10 9 7 5 3 1
001–266553–September/2015

A CIP catalogue record for this book is available from the British Library.

ISBN 978-0-2411-8609-1

Printed in China

A WORLD OF IDEAS:
SEE ALL THERE IS TO KNOW

www.dk.com

Contents

GETTING STARTED
How to use this book

Photography is more popular than ever before, with billions of photos shot and shared each year. If photography has never been so popular it is largely because it has never been so simple. Sophisticated modern cameras make it easy to shoot and upload photos, while editing software can give dramatic results. The downside is that this exciting technology makes it all too tempting to ignore the fundamentals of photography.

This book is a comprehensive guide to photographic principles. It is divided into 20 modules, each of which follows the same step-by-step pattern and can be tackled in one week. By the end you will understand what it takes to make a good photo, and you will be a confident, well-rounded photographer with a broad range of skills and knowledge.

Answers are located in the top right-hand corner

1 Test your knowledge
Introductory quizzes test what you already know about each subject.

Briefs tell you the where, what, how, and why of each assignment

Inspirational yet achievable photos showcase the range of effects you can create

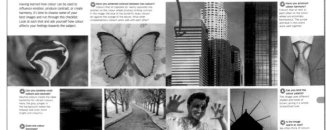

4 Practise and experiment
Themed creative assignments help you to apply your new photographic skills.

5 Assess your results
Interactive image galleries identify and troubleshoot common problems and show you how to avoid mistakes in the future.

> # Photography is still a very **new medium** and everything must be **tried** and **dared.**
> **BILL BRANDT**

Artworks show you where to find settings and tools

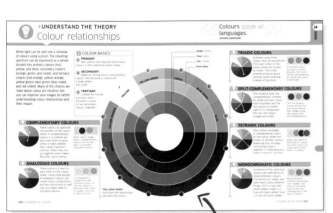

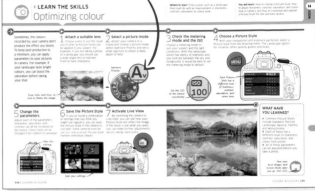

2 Understand the theory
Graphic theory spreads demystify the principles that underpin each topic.

Illustrations help explain key concepts

3 Learn the skills
Step-by-step guided shoots show you how to master the essential techniques.

Before...

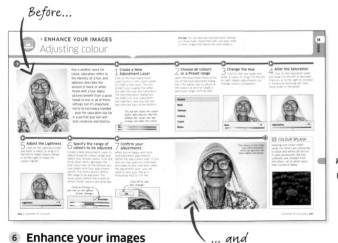

6 Enhance your images
Step-by-step tutorials explain how to use post-production techniques to give your photos extra polish.

... and after shots

Pictures from the module help refresh your memory

Multiple-choice questions

7 Review your progress
End-of-module tests assess what you've learned, and see whether you're ready to move on to the next module.

Camera types

Improving your photography means taking full control of your camera. Many smartphones and compact cameras lock you out or restrict control of certain aspects of photography, such as the ability to set exposure. To get the best out of this book, it's highly recommended that you use either a bridge camera (also known as a hybrid or prosumer) or an interchangeable lens system camera (or system camera for short). The latter type is preferable because, as the name suggests, you can swap lenses to suit a particular task. System cameras also let you expand their capabilities by adding other accessories, such as flashguns. System cameras can be neatly split into two groups: digital single lens reflex (dSLR) and mirrorless.

COMPARING CAMERAS

TYPE	PROS	CONS
Cameraphone	■ Easy to carry around ■ Apps allow you to alter images	■ Fixed focal length lens ■ Resolution and image quality can be restrictive
Compact	■ Easy to carry around ■ Inexpensive ■ Good zoom lens range	■ Limited number of physical controls on camera body ■ Restricted range of shooting modes ■ Low-light capability is lacking ■ Often can't shoot RAW
Bridge / Prosumer	■ More control over exposure than compact or cameraphones ■ Relatively inexpensive	■ Lower image quality than system cameras ■ Zoom lens is fixed, so less versatile than system cameras
System	■ Image quality ■ Expandable capability ■ Versatile	■ Bulky ■ More expensive

WHICH SYSTEM CAMERA?

DSLR

Light is reflected by mirror to pentaprism and Viewfinder

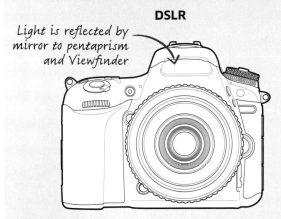

Optical Viewfinder: Image from lens is projected via mirror and pentaprism to the Viewfinder.

Advantages

- Based on older film-based systems, so wide range of lenses and accessories available
- Focusing is often quicker than in mirrorless cameras
- Excellent battery life

Disadvantages

- Camera bodies and lenses tend to be larger than mirrorless systems
- Need to switch to Live View mode to preview images on-screen

MIRRORLESS

Lack of mirror system makes the camera more compact

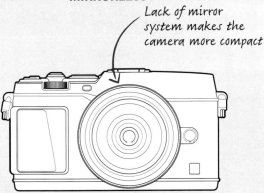

LCD or electronic Viewfinder: Image from sensor is fed directly to the LCD or Viewfinder.

Advantages

- Purely digital system, so lenses are optimized for shooting digital images
- Relatively small size and weight
- Frame rate (the number of shots a camera can shoot per second) is generally higher than dSLRs

Disadvantages

- Mediocre battery life
- Smaller range of lenses and accessories compared to dSLRs

ⓘ WHAT YOU'LL NEED

It's fun to buy accessories for your camera, though some are more useful than others. Below are the accessories you'll need for this book.

- Kit lens (see pp.121–125)
- Wide-angle zoom (see pp.124–125, 137–141)
- Telephoto zoom (see pp.124–125, 153–157)

- Tripod (see p.16)
- Remote release (see p.17)
- Filters (see p.17)
- Adobe Photoshop or similar (see pp.22–23)
- Memory card and card reader (see p.24)
- Flashgun (see pp.282–285)

How a camera sees

Inside every digital camera is a light-sensitive surface called a digital sensor. When you press the shutter button to take a photo, the sensor collects and records the exact amount of light that falls onto it. This information is then converted in-camera into the data that's needed to make a digital image.

Sensor is exposed to light when the shutter is open

Exposing an image

A digital sensor is covered in millions of microscopic cavities known as photosites. When exposed to light, particles of light (photons) fall into the photosites. When the exposure ends, the camera meticulously counts the number of photons in each photosite and uses this information to create a photo. The darkest areas of the image are those where the fewest photons were recorded by the photosites. Brighter areas are where more photons were recorded.

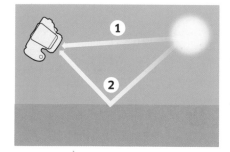

Seeing the light

Light either reaches the camera direct from the light source **(1)** – this is known as incident light – or it bounces off objects in a scene before it reaches the camera **(2)**. This is known as reflected light.

Shutter button

Converting light

In order to create a sharp photo, light must be focused precisely onto the sensor. This is achieved through the use of a glass (or plastic) optical system known as a lens. The amount of light reaching the sensor is controlled by two physical mechanisms.

The first is an iris inside the lens known as the **aperture.** The second is a mechanical curtain called the **shutter** that sits directly in front of the sensor. These two controls effectively work like a tap that enables you to turn on and off the flow of photons reaching the **sensor.**

Lens focuses the light

Object reflects light

Aperture controls the amount of light allowed through

Light passes through camera lens

When you press the **shutter button,** the shutter opens to reveal the sensor, stays open for a period known as the shutter speed, and closes. The camera analyses the light and produces an image which is written to the **memory card.**

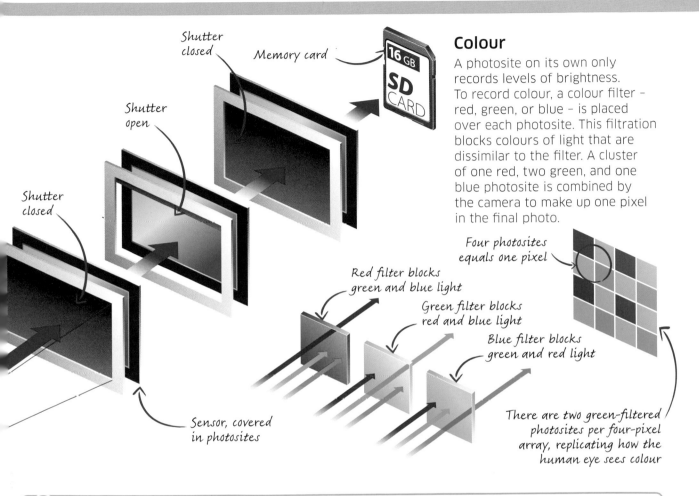

Shutter closed

Memory card

Shutter open

Shutter closed

Shutter closed

Sensor, covered in photosites

Red filter blocks green and blue light

Green filter blocks red and blue light

Blue filter blocks green and red light

Four photosites equals one pixel

There are two green-filtered photosites per four-pixel array, replicating how the human eye sees colour

Colour

A photosite on its own only records levels of brightness. To record colour, a colour filter – red, green, or blue – is placed over each photosite. This filtration blocks colours of light that are dissimilar to the filter. A cluster of one red, two green, and one blue photosite is combined by the camera to make up one pixel in the final photo.

RGB COLOUR PROFILE

Red, green, and blue are primary colours. By combining red, green, and blue in different proportions it is possible to create all the colours the human eye can see.

◼ In a digital photo, the relative proportions of red, green, and blue are represented by three numbers, one each for red, green, and blue in that order (commonly shortened to RGB).

◼ This range starts at 0, which represents an absence of colour, and ends at 255, which represents a colour at maximum intensity.

1 Red and green combined at maximum intensity produce yellow.
2 Green and blue produce cyan.
3 Red and blue produce magenta.
4 All colours combined produce white.
5 No colour produces black.

Anatomy of a camera

Modern digital cameras are far more complex devices than their film-based cousins. A digital camera is essentially a computer designed solely for creating pictures. This involves a large number of external dials and menu options to control the camera's functions, which will vary from model to model. Fortunately, once you've mastered one camera, it's generally simple to get to grips with another, particularly if you stick to the same brand.

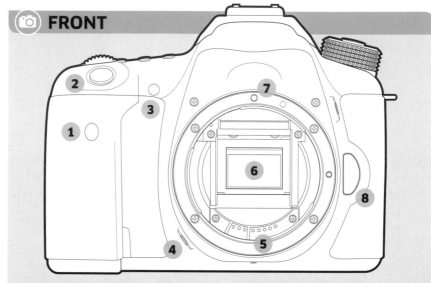

FRONT

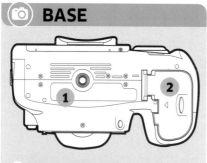

BASE

1 **Tripod socket:** Lets you mount your camera on a tripod to increase stability and avoid camera shake.

2 **Battery compartment:** The camera's rechargeable batteries are fitted here.

1 **Infrared shutter release sensor:** Lets you fire the shutter remotely.

2 **Shutter button:** Opens the camera shutter to expose the digital sensor to light and make a photo.

3 **Self-timer light:** Flashes to indicate the self-timer duration before the shutter fires.

4 **Depth-of-field preview button:** Closes the lens's aperture to let you preview the extent of sharpness in a photo before you take it.

5 **Lens electronic contacts:** Let the camera communicate with the lens to set aperture and focus.

6 **Reflex mirror:** Light from the lens is reflected up from the mirror to the optical viewfinder.

7 **Lens mount index:** Helps you align your lens correctly when fitting it to the camera.

8 **Lens release button:** Disengages the lens mount, letting you remove the lens from the camera.

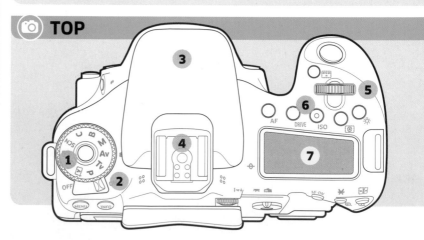

TOP

Pro tip: Many cameras let you choose and save a range of custom shooting settings. This facility is a useful way to configure a camera to your personal style of shooting.

Pro tip: Practice makes perfect. Regular use of your camera will help you find controls intuitively rather than needing to search for them.

⦿ BACK

1 Menu and info buttons: Let you change camera options and view camera status.

2 Optical viewfinder: Shows the image passed through the lens and reflected off the reflex mirror.

3 LCD monitor: Shows camera menus, Live View, and Playback.

4 Live View/Movie shooting: Switches between Live View and Movie mode.

5 Playback button: Lets you review and edit your photos or movies.

6 Control dial: Used to set camera options when shooting images or viewing menus.

7 Delete button: Erases photos stored on the memory card.

8 AF button: Activates the camera's autofocus feature.

9 Zoom button: Magnifies photos in Live View and Playback.

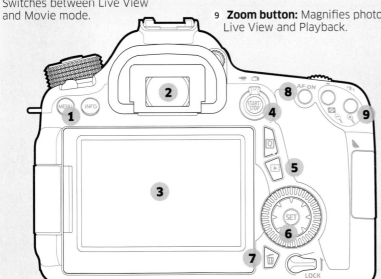

⦿ SIDES

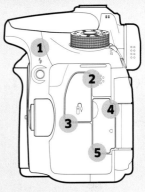

1 Flash button: Raises the built-in flash.

2 Microphone socket: Allows the fitting of an external microphone when shooting movies.

3 Remote release socket: Used to attach an optional cable-type remote release.

4 HDMI socket: Lets you connect your camera to an HDTV to review your photos or movies.

5 Digital interface: Used to connect your camera to a computer so you can download photos and movies.

6 Memory card cover: A slot that fits a memory card to store photos and movies.

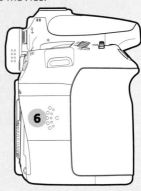

1 Mode dial: Lets you set the required shooting mode.

2 On/Off switch: Turns the camera on and off.

3 Built-in flash: A small built-in flashgun, useful as a fill-in light.

4 Hot shoe: Mount for an external flashgun.

5 Secondary control dial: Used for setting the camera's shooting and menu functions.

6 Shooting option buttons: External controls for setting a limited range of shooting functions.

7 Top-plate LCD: Small LCD showing the shooting options currently set on the camera.

Using a camera

It's easy to pick up a camera, press the shutter button, and make a photo. What isn't so easy is making a good photo, one that you'd be happy to show others. Many factors influence how good or bad a photo is – starting with how you handle your camera when shooting. A sloppy technique will lead to disappointing photos no matter how exciting your subject. A good technique will improve your chances of shooting a pleasing photo.

📷 HOLDING A CAMERA

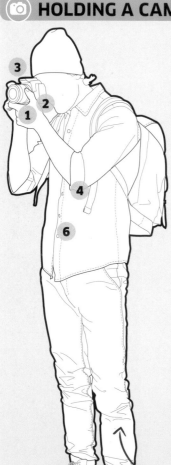

Camera shake is unsharpness in a photo caused by camera movement during shooting. Holding a camera incorrectly is the most common cause. The heavier the camera and lens combination, the more important it is to support your camera correctly.

Do

1 **Use** your left hand to support the lens from below.

2 **Grip** the camera firmly.

3 **Look** through the camera's Viewfinder if it has one.

4 **Hold** your elbows lightly against your body.

5 **Stand** upright with your feet shoulder-width apart.

6 **Breathe** in and then slowly out – gently press the shutter button fully down before breathing back in.

Don't

7 **Let** your camera bag unbalance you.

8 **Hold** your elbows out to the side of your body.

9 **Hold** the camera away from your face.

10 **Jab** sharply at the camera shutter button.

11 **Leave** the lens unsupported.

12 **Lean** at an awkward and unstable angle.

A stable, relaxed stance makes camera shake and fatigue less likely

Wear comfortable footwear and keep both feet flat on the ground

Pro tip: Not all optical Viewfinders show you 100 per cent of the scene you're shooting. Be aware of this limitation when composing your shots.

Pro tip: Leaning against a wall or supporting your camera on a fence post are easy ways to keep the camera more stable when shooting handheld.

VIEWFINDERS AND LCD SCREENS

Using a Viewfinder **(1)** has several advantages compared to using the rear LCD **(2)**. When looking through a Viewfinder, you rest the camera against your face. This makes the camera more stable when shooting handheld and lets you concentrate more on a shot without distraction. However, there are advantages to using a rear LCD as well. You can zoom into the Live View display to check your focus before shooting. It's also easier to see the effects of functions such as white balance on your image before shooting. Fit your camera to a tripod to avoid moving your camera and altering your composition.

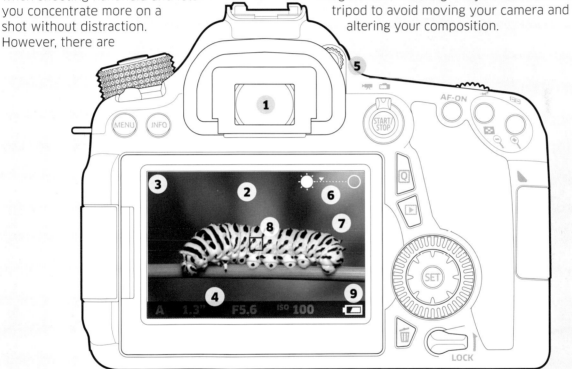

Do

When composing, look around the edge of the Viewfinder or LCD screen **(3)**, not just at the centre.

Temporarily switch off icons and information **(4)** on the LCD when composing as they may obscure key detail.

Set eyesight correction on a Viewfinder if necessary **(5)**.

Set the correct brightness **(6)** for the LCD.

Don't

Use the image on the LCD as a guide to exposure **(7)**.

Forget to check that the camera is focusing in the right place **(8)**.

Leave the LCD on for any longer than necessary – switching it off will conserve battery power **(9)**.

Helpful accessories

The appeal of using a system camera is that its capabilities can be expanded by the addition of optional accessories. Which accessories are right for you will depend on your style of shooting. With so many options available, the key to choosing a camera accessory is to be honest with yourself. Only buy an accessory that you know will either make your photographic life easier or will lead to an improvement in your photography.

ⓘ TRIPODS

A tripod supports a camera so that it doesn't move during an exposure. Height is adjusted by raising or lowering the length of the tripod legs. Often a centre column allows you raise the height of the camera still further. Tripods come either as legs only or with a head permanently attached. Buying a tripod and head separately is more costly, but means you can mix and match to suit your needs. The two basic types of head are three-way (also known as pan-and-tilt) and ball (or ball-and-socket).

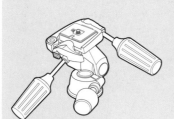

THREE-WAY HEAD
Camera orientation is adjusted by moving the head one of three ways using locking levers.

Advantages
• One axis can be adjusted at a time
• Inexpensive

Disadvantages
• Relatively bulky

BALL HEAD
Camera orientation is adjusted by loosening a ball-and-socket joint.

Advantages
• Small size and weight
• Good weight-to-strength ratio

Disadvantages
• Can be difficult to make fine adjustments

1 Tripod head

2 Centre column lock

3 Leg angle lock

4 Centre column

5 Tripod leg

6 Hand grip

7 Leg extension lock

📷 REMOTE RELEASE

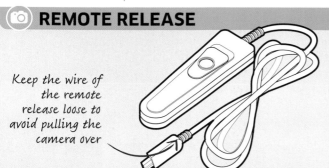

Keep the wire of the remote release loose to avoid pulling the camera over

A remote release lets you fire the shutter without pressing the camera's shutter button, so when the camera is on a tripod you can't accidentally knock it when making a photo. Infrared remote releases are wireless but have limited range. Cable remote releases attach to a dedicated socket on the camera and often have a switch to lock the shutter open.

📷 FILTERS

Filters are sheets of plastic, optical resin, or glass that, when fitted to the front of a camera lens, adjust the light passing through the lens. How the light is adjusted depends on the filter.

■ Some types of filters add colour to the light and so add colour to the final photo. Warm-up filters, for example, add yellow-orange to a shot.

■ Other types of filter can be used to reduce the amount of light entering the camera. These filters are known as Neutral Density (ND) filters.

■ Filters are bought in one of two forms: screw-in or filter holder.

Adapter ring

Filter holder

Filter

SCREW-IN
Circular filters that attach directly to the filter thread of a lens.

Advantages
• Good range of types readily available
• Inexpensive

Disadvantages
• Often need to buy multiple filters if you have more than one lens

FILTER HOLDER
Square filters slot into a filter holder that is attached via an adapter to a lens.

Advantages
• Can be used on multiple lenses by fitting adapters to the lenses

Disadvantages
• Initially expensive
• You get locked into one manufacturer's filter system

Out and about

Buying a camera can involve a considerable outlay of money. This can make for a slightly nerve-wracking experience the first time you take the camera out of the house. Ultimately however, a camera should be used as often as possible. It's difficult to get to grips with a camera unless you spend time making use of it. As long you take certain precautions, there's no reason a camera should come to any harm when you're out shooting.

ANIMALS

Pets and domestic animals are easier to photograph than wild animals, which are more suspicious of people. Studying an animal's behaviour helps you to predict what it will do. Spend time observing and waiting for the right moment and you will be rewarded.

- **Keep a low profile** when shooting wild animals. Wear drab clothing and shelter behind cover whenever possible.
- **The animal's welfare** is far more important than any photo.
- **Don't cause** any unnecessary distress to the animal. Don't disturb nests or dens.
- **Be aware** of your own safety – a frightened animal may hurt you if you're blocking its escape route or getting too close to its young.

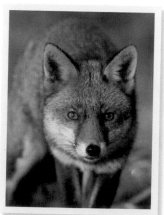

WEATHER CONDITIONS

Cameras are generally reasonably rugged devices, but they do have their limitations.
Certain weather conditions require extra care.

Heat

- **Extreme heat** can warp camera components. Keep your camera in the shade when it's not in use.
- **In dry conditions,** keep lens changes to a minimum to avoid dust coating the camera's sensor.

Cold

- **Temperatures** close to and below 0°C drain battery power. Keep a spare battery or two warm inside your jacket to swap when necessary.
- **Cold fingers** make a camera harder to operate. Use gloves or fingerless mittens.

Humidity

- **If moving** from a hot, humid location to a cooler one, check for condensation forming on the lens.
- **Use a dry cloth** to wipe away condensation as soon as it occurs. Keep the camera in a warm, well-ventilated place to dry it out still further.

Rain

- **Cameras** are often advertised as weatherproof, but in the rain the lens mount may let water in.
- **Shelter** your camera using a waterproof cover or umbrella. Check the front of the lens, too; you may not notice rain spots in your shots until you're home.

Pro tip: When you're out taking photographs, don't be afraid to shoot more than you instinctively would; you can always edit out the unsuccessful shots later when you get home.

Pro tip: If you're shooting in cold conditions and your camera has a touchscreen, use touchscreen gloves so you can use the screen without exposing your fingers.

 ## LANDSCAPES

Shooting landscapes invariably means being outdoors in the countryside. This brings its own challenges. Before you set off on a photography expedition, let someone know where you're going and what time you plan to return.

- **Check the weather** before you leave and dress appropriately.
- **Take food** and water with you, particularly if you plan to be out for a full day.
- **Don't take** unnecessary risks when shooting; it's all too easy to lose your footing.
- **If you plan** to shoot on private land, be sure to ask permission first.
- **Finally,** be conservation-minded and cause as little disruption or damage as possible to the environment.

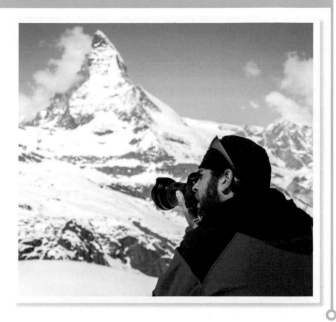

PEOPLE

It's always easier to shoot photos of people who know and trust you. Many people dislike having their photo taken: don't cajole, gently persuade. Ultimately you need to respect your intended subject's feelings; don't press the matter if they really don't want to have their photo taken.

- **Always ask** permission before you photograph children. This is a sensitive issue. Don't shoot candid shots of children you don't know, as this may look suspicious.
- **Be friendly** and engage with your subject, making the session a more personal affair. Good humour goes a long way to achieving some of the best results.
- **Do not** shoot in areas where taking photographs would be culturally insensitive.

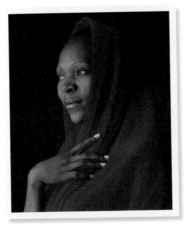

- **The use** of a few local words – such as please and thank you – will go a long way when seeking permission to shoot portraits of strangers in a foreign country. However, be aware of boundaries.

- **Review each shot** to check your subject's facial expression. Show them your shots, too, to get their opinion; portraiture is not a one-way process.

The digital workspace

An appealing aspect of digital photography is the low cost of shooting: once you've bought your camera, each shot you subsequently make is essentially free. It's all too easy to amass thousands of shots. This can lead to tears of frustration when you attempt to find one particular shot out of a multitude, so it's well worth taking a disciplined approach to storing your digital photos.

Distinctive as a photo may be, without care it may soon be lost in the crowd.

⊞ FILE TYPES

Saving in both RAW and JPEG will give you the best of both worlds

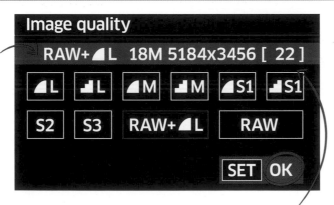

Image quality

RAW+◢L 18M 5184x3456 [22]

◢L ◢L ◢M ◢M ◢S1 ◢S1

S2 S3 RAW+◢L RAW

SET OK

Memory card space is used more quickly when shooting RAW and JPEG

For still images, system cameras let you choose between two file types: JPEG or RAW. JPEG images can be identified by the use of a .JPG suffix after the image file name. There is no standard RAW file suffix; each camera manufacturer produces its own variation on the format, with a suffix unique to the manufacturer: Nikon, for example, uses .NEF for its RAW files, whereas Canon uses .CR2.

ⓘ JPEG OR RAW?

■ JPEGs take up far less space on a memory card compared with RAW.

■ JPEGs, once they're on your computer, can be opened and used by many types of software (such as word processors); a RAW file can only be opened using special RAW conversion software.

■ However, in order to make the JPEG's file size smaller, very fine detail is thrown away when the camera saves the file.

■ JPEGs also allow for far less adjustment after shooting due to the loss of image quality. RAW, though ultimately more time-consuming to use, offers more scope for fine-tuning.

FILE NAMES

You don't have to use the camera's naming convention once the photos are on your computer

Digital cameras use a logical naming convention for images: typically, a standard four-character prefix followed by a four-digit number. The prefix varies between camera brands, but is generally standard across a brand's range of cameras.

- The four-digit number is a consecutive count of each image you shoot starting from 0001 and ending in 9999. Some cameras let you reset the count depending on certain conditions.

FOLDERS

Images are stored on a memory card in folders. Folders are named using a three-digit prefix followed by three standard characters (depending on the camera brand). The prefix is a consecutive count of the folders created on the memory card.

- A folder can hold up to 9,999 images. When that limit is reached, a new folder will be automatically created and images stored in the new folder from that point on.

Create a folder for different shooting sessions to keep photos separate

CREATING A LOGICAL FILING SYSTEM

When camera file names reach 9999, the count is reset back to 0001 – after 10,000 shots, there will be photos with the same file name. Unique file names help you locate a particular shot, so renaming your photos once they're imported to your computer is vital (see pp.30–31).

- Use a consistent file naming system that's easy to follow but will never repeat.

- Group photos in logical folders, such as animals > birds > eagles.

- Adding keywords to your images will also help you find a specific photo (see pp.342–343).

Rename only the photos you want to keep

Post-production

It takes time and skill to get the exposure right as well as the colour and contrast while taking a photo. However, sometimes the final image needs an extra polish after shooting. This can be done using image-adjustment software installed on your computer. Working on a photo after shooting is known as post-production.

> **ⓘ SOFTWARE**
>
> The most popular choice of image-adjustment software is Adobe Photoshop and its variants, Elements and Lightroom. Photoshop will be used throughout this book. Don't worry if you use other software: many of the tools described are common to most image-adjustment software.

Ⓐ Flat colour:
Photos that look pale or washed out often benefit from an increase in the vividness of the colours. This is known as increasing the colour saturation (see pp.246–247).

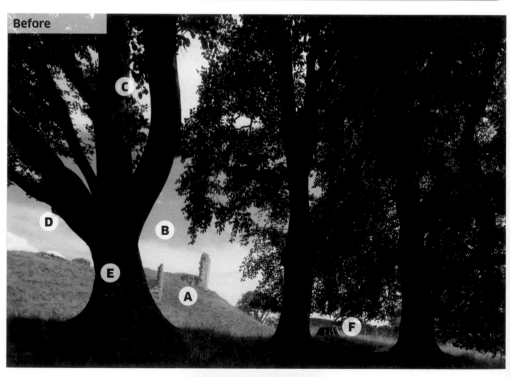

Before

Ⓑ Noise: This is seen as a random gritty pattern that obscures fine detail in a photo. It is caused by a camera's electronics corrupting the information in an image during exposure. Noise reduction in post-production can improve things (see pp.86–87).

Ⓒ Chromatic aberration: Visible light is made of different wavelengths on the spectrum of colours. A lens that can't focus all the wavelengths of light to the same point will create red/green or magenta/blue fringes around the edges of objects (see pp.134–135).

D Colour balance: Light isn't always neutral in colour. When light has a colour bias, such as red or blue, this will be seen in the final photo unless corrected. Colour bias can either be adjusted in-camera, using a function known as white balance, or later in post-production (see pp.253–263).

E Deep shadows: Uneven lighting causes high contrast between the brightness of a scene's shadows and highlights. The relative brightness can be adjusted in the final photo (see pp.310–311).

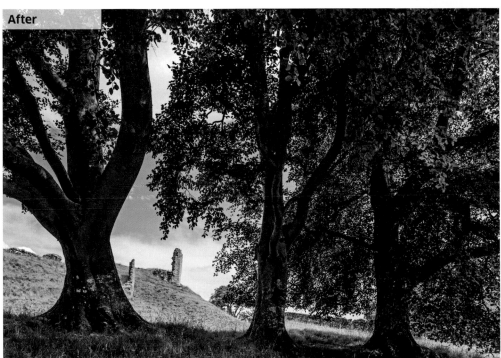

After

F Cloning: Photos are often marred by overlooked details or by dust on a camera's sensor. In post-production, the clone brush tool lets you paint out areas of a photo, using details from another part of the photo (see pp.166–167).

OTHER POST-PRODUCTION ADJUSTMENTS

- Basic fixes (see pp.38–39)
- Sharpen photos (see pp.54–55)
- Add or remove contrast (see pp.102–103)
- Adjust depth of field (see pp.118–119)

- Fix perspective (see pp.150–151)
- Create a panorama (see pp.166–167)
- Make local adjustments (see pp.182–183)

- Add blur (see pp.198–199)
- Crop a photo (see pp.214–215)
- Make targeted adjustments (see pp.230–231)
- Use the Levels tool (see pp.278–279)

▶ GETTING STARTED
Computers

Once you've shot your photos you will need to copy them from a memory card to a computer. Although cameras often feature functions such as RAW conversion, these functions are usually rudimentary. Copying your photos to a computer will give you greater scope for viewing and adjusting your photos, and for printing them, too (see pp.346–347).

COMPUTER TYPES

■ PCs can be divided into two basic types: desktops and laptops.

■ Storing and processing digital photos requires far more from a PC than other tasks such as sending emails or using a word processor. While desktop PCs offer greater performance for less money than laptops, the portability of laptops is ideal if you need to be mobile.

■ There are two dominant operating systems: Microsoft Windows and Apple Mac OS X. Both types have their devotees, but this is largely a matter of personal choice. Software such as Adobe Photoshop is available for both platforms.

MONITORS

The quality of your PC's monitor and the ambient light in the room in which you work are both important factors, as they determine how accurately you will be able to judge colour and contrast in your photos.

■ A monitor used for photo editing should have a wide viewing angle. Colour and contrast can shift unacceptably when not looking directly at a monitor that has a narrow viewing angle.

■ The room you work in should have low ambient lighting. Avoid direct light shining on your monitor screen; this makes it more difficult to judge colour and contrast in your photos.

ℹ MEMORY AND STORAGE

Whichever type of PC you use, it should have sufficient memory to allow you to run post-production software effectively; 8-16 GB is now considered the baseline requirement, though more is always better than less. The hard drive should also be large enough that you won't run out of space easily. Hundreds or thousands of high-resolution RAW files will quickly fill a small hard drive. If possible, budget for a 1 or even 2 TB hard drive as well as a similarly-sized external hard drive to make back-ups of your photos.

week 01

MAKING YOUR FIRST PHOTOS

This module will introduce you to some fundamental photographic principles and techniques, starting you on your journey towards capturing the perfect image.

In this module, you will:

▶ **assess what decisions** need to be made before you make a photo, and why a photo is "made" rather than "taken";

▶ **study different types of subject** and their possibilities;

▶ **try it yourself** by importing images after a session;

▶ **experiment and explore different photos** through guided assignments;

▶ **review your photographs** and learn how to avoid some common mistakes;

▶ **enhance your images** with simple exposure fixes in post-production;

▶ **review what you've learned** about making a photograph and see if you're ready to move on.

Let's begin... ⊙→

What makes a good photo?

The way you compose, frame, and time your photograph is critical in determining how successfully you will get your message across. See if you can spot which type, or genre, of photo is represented by each of these shots.

A **Landscape:** A broad image of a landscape can capture the beauty of nature.

B **Moment or street shot:** Crowd scenes can capture the dynamism of life on the street.

C **Sport/action:** Stopping the action at a key moment can emphasize the drama of sport.

D **Portrait:** A strong portrait can give real insights to the character of the subject.

E **Close-up or macro:** Making something larger than life can have great visual impact.

F **Nature:** The natural world is a rich source of dramatic subjects.

G **Fashion:** Shooting the glamorous world of fashion is exciting, but you need to develop a feeling for how to show clothes and accessories at their best.

H **Architecture:** The built environment can produce very dramatic images.

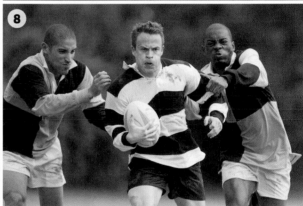

NEED TO KNOW

■ Try varying the angles and height from which you shoot, working around the subject to cover it in full. Sometimes changing your camera angle and position by just a small amount can make all the difference between an OK photograph and a perfect one.

■ Shooting from a high position lets you get above the action, while shooting from behind the subject allows you to show what they see.

■ Shoot at different times of the day to exploit the varying positions of the sun.
■ With a digital camera there are no limitations to the number of shots you can take, so make sure you shoot enough images to thoroughly explore every aspect of your subject.

Review these points and see how they relate to the photos shown here

Settings and subjects

Although cameras can give excellent results in fully automatic mode, it is important to understand how the various settings affect the final image. For real creative control you will sometimes need to override the camera's automatic settings. Depending on the type of shot you are making, you will need to concentrate on a different aspect of the camera's controls, using manual functions to set exposure and focus exactly how you want them.

APERTURE

A small aperture lets in less light and gives your images greater sharpness; a large one lets in more light, blurring the background (see pp.76–77).

For landscapes, use a small aperture to achieve a deep depth of field, keeping the foreground, mid-ground, and background all in focus (see pp.108–109).

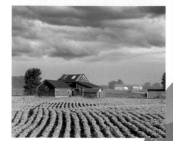

SHUTTER SPEED

A high shutter speed (opening the shutter for as little as 1/5000 sec) allows the sensor to capture only a tiny fraction of your subject's movement, allowing you to freeze the action (see pp.188–189).

A slower shutter speed, such as 1/15 sec, can be used to create blur for effect, or to allow you to use a small aperture to achieve a greater depth of field.

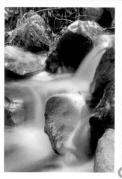

Focus ring is used to focus the lens on the subject

VIEWFINDER

When we look at a scene, we tend to see only the important elements and ignore the rest. A camera, on the other hand, sees all the details.

Elements we may not notice can become dominant when seen in print or on-screen. Look through the Viewfinder in both horizontal and vertical formats to frame your images.

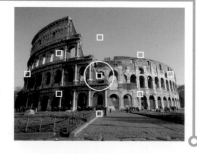

Pro tip: Try to get to the location early to give you time to find the best position to shoot from and then wait for the action and the light to come to you.

01

WEEK

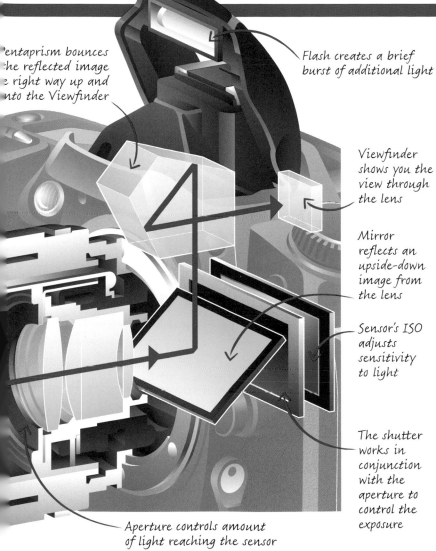

Pentaprism bounces the reflected image the right way up and into the Viewfinder

Flash creates a brief burst of additional light

Viewfinder shows you the view through the lens

Mirror reflects an upside-down image from the lens

Sensor's ISO adjusts sensitivity to light

The shutter works in conjunction with the aperture to control the exposure

Aperture controls amount of light reaching the sensor

FLASH

Your flash allows you to light the subject (see pp.284–285). It can be built-in, attached, or fired remotely.

You can use your flash to "fill in" the shadows when shooting in sunny conditions with high contrast, or as a main source of light for a portrait.

CAMERA MODE

DSLRs usually have several shooting modes from which to choose (see week 3). Program mode is good for general use or when you are shooting fast in changing light conditions. Aperture Priority is best for landscapes and static subjects, and Shutter Priority is perfect for action and sports. For ultimate control, switch to Manual to set the exact settings you want.

FOCUSING

Depending on the situation, you can use the camera's built-in autofocus (AF) mode, or switch to Manual focus and choose the focus point yourself (see pp.44–45).

In a portrait shot, you generally want to focus the lens on the subject's eyes – usually the eye closest to the lens.

SENSOR SENSITIVITY (ISO)

Setting your sensor's sensitivity (or ISO) to a high number will let you shoot in low light (see pp.300–301), a common situation with documentary photography.

Using a lower ISO will give maximum image quality, which is great for landscapes, but you may need to use a tripod to hold the camera steady.

Importing images

In order to properly view and work on your images, you will need to copy them from your camera onto a computer. There's no set way of doing this, so try and develop a system that works best for you.

 1 Decide on your image capture resolution

You should choose your preferred image size on your camera before taking any photographs. The smaller the file size you choose, the more images you can store, and the faster they will write to the card, but the image quality will not be as good.

 2 Transfer your images to your computer

Remove the memory card from your camera and use a card reader (shown below) or connect the camera directly to your computer using a USB cable to transfer your images.

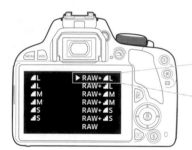

 5 Add a caption and copyright information

Using the File Info command, add a caption and your contact details so that your image can be identified in the future.

 6 Save the image

You will need to choose how you want to save the image. Saving as a RAW file will give the best quality, but a larger file. If you are saving as a JPEG, you need to select the compression level depending on what the image is going to be used for, such as print or web design.

 7 Back-up your images

You should back up your images onto some form of external storage so that there are duplicate copies in case your hard drive fails or you lose your computer. Many pros will back up onto several formats, such as a large external hard drive, a DVD, or even a cloud-based server.

File Info...

Adding information to your images allows you to organize and find them quickly (see Week 20 for more details).

JPEG image quality ranges from 1 to 12

External hard drive

Where to start: You will need your camera, a memory card, a card reader or a cable to connect your camera to a computer, a computer, and a backup system, such as an external hard drive.

You will learn: How to set up a consistent and coherent workflow so that you can quickly shoot, import, retrieve, and publish your images.

01

WEEK

3 Select the best images

Open your image-viewing program and choose the images you want to work on.

IMGP0397.JPG IMGP0524.JPG

IMGP0870.JPG IMGP0827.JPG

4 Adjust the image

Open the image you want to work on using image-editing software, such as Photoshop. If you are shooting in RAW, you will need to open the image in the Adobe Camera RAW plug-in or something similar. You can then make some simple adjustments, such as altering contrast and exposure, cropping, and retouching the image (see pp.38–39).

You can crop in tight to show just the subject

The Crop tool allows you to crop in on an image, removing any unwanted bits

KIT: **MEMORY CARDS**

The memory card is the part of the camera where your images are stored. They are usually removable and come in a variety of capacities.

Ideally, you should buy a memory card that has enough capacity to capture files in RAW format, as this will give you the best quality. If you can, use the RAW plus JPEG mode on your camera so that you can use the JPEGs for quick editing and then work on the RAW files for the final image processing.

64GB

800×

32GB

Compact Flash Card

The capacity of memory cards is getting bigger all the time, so make sure you've bought one big enough to store all the images you want to take

WHAT HAVE YOU LEARNED?

■ You need to select the most appropriate image size and type, such as RAW or JPEG, before you take a photograph.

■ Add information to your image so that you can find and identify it later on, and include copyright data should you want to sell it to other people.

Always make sure that you save and back up your images

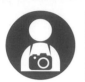

▶ PRACTISE AND EXPERIMENT
Shooting different subjects

When taking photos, try to make detailed notes about the settings of your aperture, shutter speed, and ISO. Even in automatic mode, digital cameras will embed these details in every image, and this information will help you to determine whether certain settings work or not so that you can either continue to use them or adjust them later.

ON THE STREET

- **EASY**
- **2–3 HOURS**
- **BASIC**
- **OUTDOORS**
- **A WELL-LIT SCENE**

The street is the stage for much of everyday life, and a street scene should give the viewer a sense of place and of how life is lived. It also gives you an opportunity to work at making a visually complex and challenging image.

■ **Find** an interesting backdrop and wait for something to happen. Patience is important, as you might stand on a particular spot for a long time waiting for the right combination of things to occur.

■ **Concentrate** on people's body language, how they relate (or don't) to each other and their surroundings. Pay special attention to people's eyes and hands, as they can say a lot about someone's attitude to those around them. Look out for juxtapositions and contrasts, and, if you can, make some humorous images too.

■ **Think** about the light and how it changes during the day, and how this changing light will affect your scene.

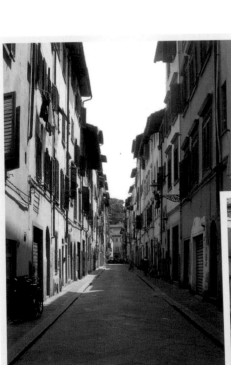

Streets can be portrayed as quiet and lonely...

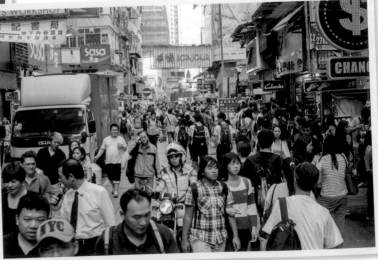

... or as chaotic spaces full of life.

Pro tip: Be aware of the impact you may be having on your environment. Is your presence changing the situation? Are people acting up for the camera, or are they behaving normally?

HARD AT WORK

- **EASY**
- **INDOORS**
- **2-3 HOURS**
- **A MODEL**
- **BASIC**

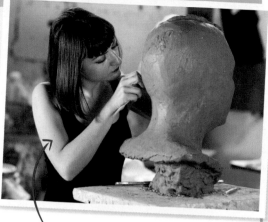

Shooting people engaged in an activity is a common theme in photography. Learning how to work your way around a subject to find the best angles and lighting will help to improve your skills.

- **Hold** your camera so that you are able to move around your subject easily and without too much fuss.

- **Take** photos from as many angles as possible, but try not to disturb the person while they are at work.

- **Think** about the nature of the job and the relationship of the person to their work. Does this affect the photograph you take?

This sculptor could be easily disturbed, so be careful when taking your photos

HEAD-AND-SHOULDERS PORTRAIT

- **EASY**
- **INDOORS**
- **1 HOUR**
- **A MODEL**
- **BASIC**

The human face and figure has always been a focus of fascination for photographers, and different poses can convey different characteristics of a person. See if you can find a pose that best suits your model's personality.

- **Ask** the model to sit so that they are directly facing the camera. Take a variety of photos from different heights and using various lighting.

- **Get** the model to turn slightly towards the camera. Repeat the sequence using different heights, angles, and lighting.

Ask your model which of your shots best captures their character.

WHAT HAVE YOU LEARNED?

- Your presence may make a subject behave in a different way and cause them to appear unnatural so try not to interfere with them, especially if they are going about their lives.

- Changes in light and weather during the day will affect your photo. Think about how the light will be in the morning and at midday. Will your image look better when it is sunny or overcast?

A BEAUTIFUL LANDSCAPE

- 📶 **EASY**
- 🕐 **2–3 HOURS**
- ◎ **BASIC +** tripod

- ⊙ **OUTDOORS**
- ⊕ **A WELL-LIT SCENE**

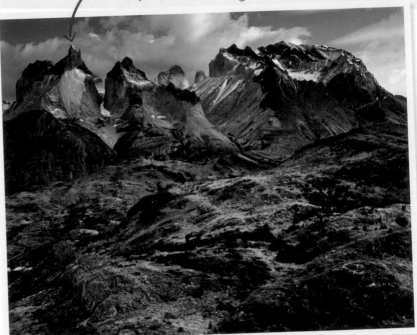

Lines, such as this mountain ridge, help to guide the viewer's eye around the image

Learning how to shoot amazing landscape images that give a dramatic sense of place is an essential skill.

■ **Be prepared** to do a lot of walking to find the perfect viewpoint. Go out in good light – at dawn or dusk. Think in advance about where the light will be coming from and choose the right time of day to be there.

■ **Set** your camera on a tripod so that it is nice and steady to reduce any blur caused by camera movement.

■ **Play** with your composition. Landscapes often work well with the horizon line positioned either in the top or bottom third of the image, rather than in the centre.

ⓘ KIT: **TRIPOD**

Using a tripod will help to avoid camera shake when your shutter speed needs to be slow due to the light, or because you want to use a small aperture to get a large depth of field (see week 6). Tripods are also useful for making very precise compositions as you can make small adjustments to the camera position. You can also use a tripod to make a time-lapse exposure, or a panoramic or 360-degree image.

Choose a tripod that is strong and sturdy as it needs to be able to give a stable support. However, there is a trade-off between weight and stability; if it is too heavy, you won't want to carry it around, but if it is too light, it won't support the camera.

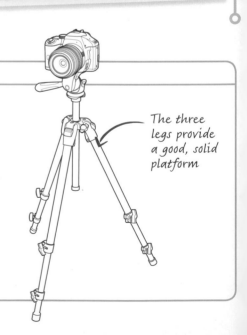

The three legs provide a good, solid platform

SHOOT A STILL LIFE

- **EASY**
- **2–3 HOURS**
- **BASIC +** tripod
- **INDOORS**
- **OBJECTS SUITABLE FOR A STILL LIFE**

The detail shot or still life makes us pay attention to something we might otherwise have overlooked, and can often be used to make an interesting picture from something that would usually be considered dull.

- **Take** a number of everyday objects and set them up on a table near a window so that they are lit from the side.

- **Shoot** a series of photos, taking them from different angles. Try to get above the objects or as low as possible. Move as close as your camera will let you and then move farther away.

- **Look** carefully at the images you have made, and see how the different positions have affected your image. You can also rearrange the objects to see what effect this may have.

Detail shots can make small objects, such as these asparagus, appear larger than life

GET IN ON THE ACTION

- **EASY**
- **2–3 HOURS**
- **BASIC**
- **OUTDOORS**
- **A MODEL**

Learning how to photograph fast-moving subjects will help improve your reaction time and your ability to focus and shoot quickly.

- **Find** a sports or action event – a football match would be a good choice, or a race on a lapped course such as mountain biking where you can find a good spot and shoot the riders as they come past each time.

- **Stand** in a good spot on the course or pitch and shoot a wide-angle shot with the subject moving through the frame.

- **Look** for peak moments in the action, and try to fill the frame for maximum impact.

Try to position yourself where an impressive piece of action is likely to occur.

WHAT HAVE YOU LEARNED?

- Action shots look best when you capture a key piece of movement.
- A tripod is essential when using slow shutter speeds to avoid camera shake and a blurred image.
- Landscapes work well when the light is good, so check the weather forecast beforehand.

After you have spent a week taking and experimenting with these early photos, edit them to select the best images from each assignment. Look carefully and think how you could have improved each of them.

Did you get close enough to the subject?
Does your subject fill the frame? This image has been composed so that there is something going on right across the frame.

Is your image well-composed?
In this shot, the horizon line is positioned less than one-third up from the bottom of the frame and the sun and boat balance the composition with the trees on the right-hand side. Read more about composition in weeks 12 and 13.

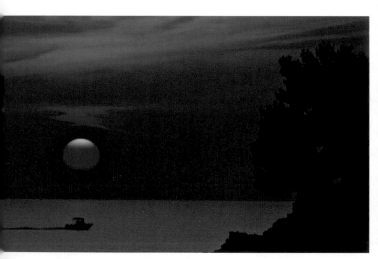

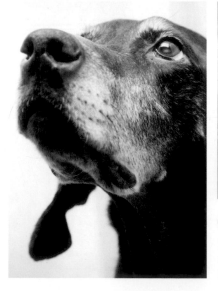

Is the image sharp where you want it to be?
The dog's eyes are sharp in this image, while the rest is out of focus. Week 6 will show you how to create this effect.

Have you got the exposure right?
This photograph has been deliberately underexposed so that the figures stand out as silhouettes against the sky. Turn to week 4 to learn how you can vary exposure.

> ## "You don't **take a photograph,** you **make it.**"
> **ANSEL ADAMS**

How is your cropping?

Is everything inside the frame there because you want it to be? This shot is tightly cropped to exclude any background that would detract from the impact of the image.

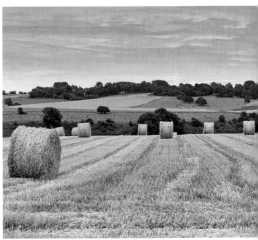

Is the image sharp from front to back?

Everything in this image is in focus. Turn to week 2 to see how setting the right aperture size can create this effect.

Did you catch all of the action?

Is your image blurred or have you been able to freeze fast-moving action, such as the stones flying off the wheel of this bike? Turn to week 11 to see the effects different shutter speeds have on movement.

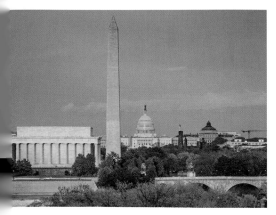

Have you used the light well?

Waiting for the right light has made these buildings stand out against the background. Read week 16 to see how you can use different angles of light.

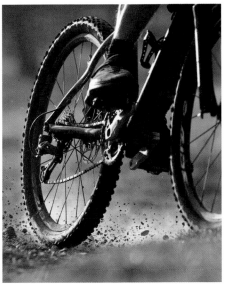

▶ ENHANCE YOUR IMAGES
Using post-production fixes

To get the best from your photos, make a consistent and coherent post-production workflow part of your routine. You can use the automated features of image-processing software, such as Photoshop, for quick results. Here are some basic post-production enhancements.

1 Assess your image

Create a duplicate of your image to work on so you can always return to the original and start again. Study the photo carefully and see which elements could be improved.

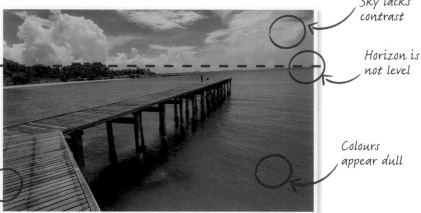

Sky lacks contrast

Horizon is not level

Colours appear dull

Image is poorly cropped

5 Crop the image

Go to the Crop tool in the menu. Select Original Ratio to keep the format of the image the same as you shot it, or Unconstrained if you want to change the ratio of length to height.

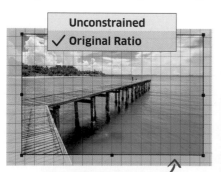

Unconstrained

✓ **Original Ratio**

Unwanted part of image appears grey

6 Save your image

Keep adjusting your image until you are happy. Make sure you save the end result.

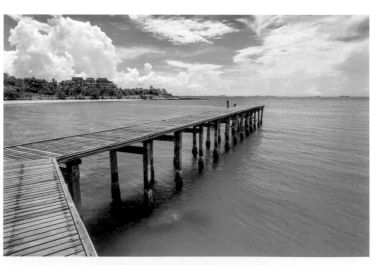

Pro tip: Save images at a variety of settings and resolutions for different uses, such as web design, printing, or at screen resolution.

2 Set Auto exposure

You can alter the brightness and contrast levels in your image quickly and easily using the Auto levels tools to boost the highlights and shadows.

3 Increase saturation

To boost the colours in your image, use one of the image saturation presets – but be careful not to overdo it, as your image may start to appear artificial.

4 Rotate the image

To level the horizon, select the Crop tool, click on one of the corners, and rotate the image until you are satisfied.

Rotate the image by clicking and pulling one of the corners

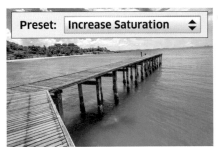

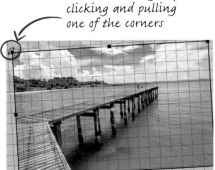

ⓘ DODGE AND BURN

The corrections shown above make changes to the whole image, but you can also alter specific areas. Making part of the image darker is called burning it in, and making it lighter is called dodging.

Zoom in on the area of the image you want to adjust. Set the brush size to match the size of the area you are working on and set the level to about 10–15 per cent – it's better to make a series of small changes rather than one large one. Every now and then, zoom out to make sure the effect looks natural and not overdone. Keep doing this until you are satisfied with the end result.

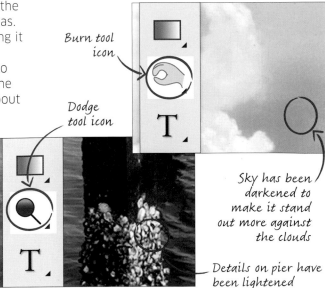

Burn tool icon

Dodge tool icon

Sky has been darkened to make it stand out more against the clouds

Details on pier have been lightened

Select brush size

▶ REVIEW YOUR PROGRESS
What have you learned?

Now that you've taken your first steps towards making perfect photos, have a look through these questions and see if you've grasped the basic issues raised in this module before you move on to the next.

1 **Stopping the action** is useful in what type of photography?

A Close-up B Sport C Portraiture

2 **When should you** decide on the size of your images?

A After you've taken them
B During a shoot
C Before you start

3 **The Crop tool** allows you to do what to a photo?

A Remove any unwanted bits
B Change the colours of the main subject
C Enlarge the whole image

4 **While taking photos** of someone at work, you should do what?

A Try not to disturb them
B Give them instructions about what you want them to do
C Get in the way as much as possible

5 **How many legs** are there on a tripod?

A One B Three C Six

6 **Lines in a photo,** such as the horizon, should do what to the viewer?

A Guide their eyes around the image
B Leave them feeling disorientated
C Stop them from dwelling too long on a single spot

7 **What does** the aperture do?

A It controls how long the shutter stays open
B It selects the shooting mode
C It controls the amount of light that enters the camera

8 **Underexposing** an image does what to subjects that are lit from behind?

A Makes the sky turn dark
B Picks out every detail of their faces
C Turns them into silhouettes

9 **A high ISO setting** lets you shoot in what type of light?

A Low light
B Bright light
C Flashing light

10 **Which shooting mode** allows you to apply the exact settings you want to use?

A Auto B Manual
C Shutter Priority

11 **What can you see** when you look through the viewfinder?

A The image as it appears through the lens
B An upside-down version of the image
C A negative version of the image

12 **Shutter Priority mode** controls what aspect of the camera?

A The size of the aperture
B Whether or not the flash works
C How long the shutter stays open

13 **Which part** of a model should you focus on when taking a portrait shot?

A The hair
B The eyes
C The chin

14 **A slow shutter speed** will produce what effect?

A Freeze a fast-moving subject
B Turn the image black and white
C Create blur for effect

15 **What size of aperture** produces a deep depth of field?

A A small aperture
B A medium-sized aperture
C A large aperture

Answers 1/B, **2**/C, **3**/A, **4**/A, **5**/B, **6**/A, **7**/C, **8**/C, **9**/A, **10**/B, **11**/A, **12**/C, **13**/B, **14**/C, **15**/A.

02 FOCUSING

Deciding what parts of your image you want to be sharp and in focus and what parts you want out of focus is vital to becoming a skilled photographer. Although modern cameras have excellent, fast, and accurate Autofocus, you need to know how to use it to its best advantage, how to select the right mode for the subject you are shooting, when to switch to Manual, and how to use focus creatively.

In this module, you will:

▶ **discover how the focus point** isn't fixed and can be moved;

▶ **compare** Single Autofocus, Continuous Autofocus, and Manual focus, and learn when to use which mode;

▶ **get to grips with the basics** by experimenting with Single point and Multi-area Autofocus;

▶ **familiarize yourself** with how to select the correct focus point through guided assignments;

▶ **analyse your photographs** to understand why it's important to select the correct focus point;

▶ **improve your images** by learning how to sharpen an image in post-production;

▶ **review your understanding** of how to control focus to see if you're ready to move on.

week

Let's begin... ⊙➔

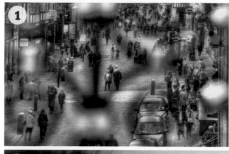

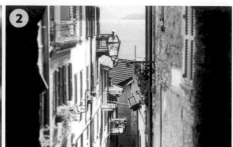

By careful use of the camera's settings, you can control the position of your focus point and decide how much or how little of the scene you want to be sharp and in focus.
See if you can identify which focusing methods have been used in these examples.

A **Telephoto focus:** Often used for nature photography, telephoto lenses offer a shallow depth of field, so focusing must be precise.

B **Moving focus:** Keeps a moving subject in focus.

C **Portrait focus:** Picks out the most important part of the subject, usually the eyes.

D **Landscape focus:** Keeps as much of the image as possible sharp and in focus.

E **Side focus:** Focusing on one side of the image can draw the viewer's eye to important details.

F **Foreground focus:** Creates impact by focusing on what's closest to the lens.

G **Background focus:** Useful when you want to accentuate the context of the scene.

H **Centre focus:** Draws attention to the centre of the frame by making the middle part of your composition sharp.

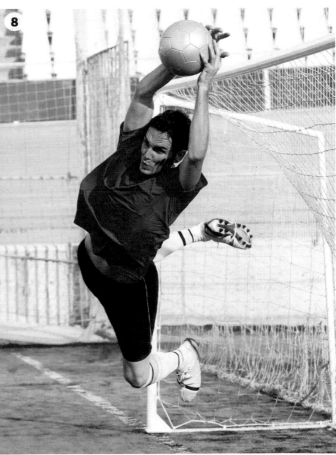

NEED TO KNOW

■ Your camera's Autofocus is fast and accurate, but it can be fooled in certain situations so you need to know how to override it.

■ The focus point is the exact spot you set your focus on. The area around this focus point that also appears sharp is known as the depth of field. How far this extends depends on the type of lens and the size of aperture you are using.

■ A wide aperture will give a small depth of field, which can be used to accentuate part of the image.

■ A small aperture will give a large depth of field so that everything in the frame appears sharp.

■ You don't always have to focus on the centre of your composition. Choosing another focus point can create interest in your images.

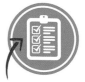

Review these points and see how they relate to the photos shown here

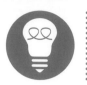
Manual and autofocus

There are two ways a lens can be focused – manually and by using autofocus (AF). When a camera is set to manual focus, the lens focus ring must be physically turned to produce a sharp image. Autofocus puts the camera in control: the camera's AF sensors calculate the distance to your subject and activate motors inside the lens to move the focus ring to the desired point. Once you've mastered a few of its intricacies, autofocus speeds up the shooting process considerably.

AUTOFOCUS POINTS

An AF point is a small box-shaped area of a viewfinder or Live View display that you can select in order to instruct your camera where to focus.
- **In an optical viewfinder,** there are multiple AF points generally arranged in a grid or diamond shape at the centre of the viewfinder.
- **On an LCD screen,** the AF point can usually be moved more freely, including around the edge of the image area.

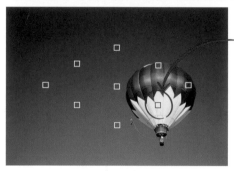

Autofocus point

In AF, your camera will choose which AF point (or points) to use.

FOCUS POINT

The sharpest part of a photo is the focus point. Although this is referred to as a point, it is more accurate to think of it as an invisible plane parallel to the back of the camera. As you move the focus point, this plane of sharp focus shifts either forwards towards the camera or backwards away to infinity (indicated by the infinity symbol on the focus distance scale of the lens). When a lens is manually focused, you can see this plane move as you look at the LCD screen or through the viewfinder.

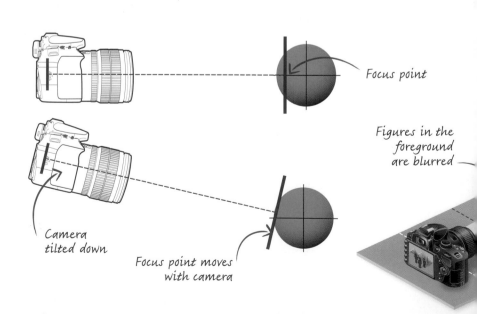

Focus point

Figures in the foreground are blurred

Camera tilted down

Focus point moves with camera

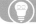 MANUAL VERSUS AUTOFOCUS

MANUAL

Pros
- Lets you select the focus point exactly
- Once a lens if focused, it will stay focused

Cons
- Slow to focus; only suitable for still subjects
- Can be difficult to see the precise focus point through your viewfinder

AUTOFOCUS

Pros
- Easy to use
- Focusing is quick and accurate

Cons
- AF can be confused when the subject is low in contrast or positioned behind another object
- Less accurate when shooting macro subjects
- Limited range of AF indicators when using viewfinder
- Continuous AF uses more battery power

Focusing on infinity
The farthest point to which a camera can focus is called infinity. When focused on infinity, everything at the focus point and beyond is sharp and no adjustment is needed to bring more distant objects into focus. To focus on infinity turn the focus ring until it reaches the infinity symbol.

Mountains in focus

Infinity symbol on a camera lens

Focus point at infinity

The trees and the mountains beyond are in focus, but the people in the foreground are not.

AUTOFOCUS MODES

Once a camera knows where to focus, the next question is for how long. When shooting a still subject, the camera stops focusing once focus has been achieved. If a subject is moving, autofocus must continue to adjust focus until the shot has been taken. Camera AF modes let you choose which of these two situations apply and so adjust AF accordingly.

Single (also known as One-Shot or AF-S)
AF is activated when the shutter button is half-pressed down. Once the lens has focused, AF stops. This means that if your subject then moves, focusing will be inaccurate. It is suitable for still life and landscape subjects.

Continuous (also known as AI-Servo or AF-C)
Once activated, focus is continuously updated to follow a moving subject. This mode is often referred to as predictive focusing, as the camera adjusts focus by predicting how and where the subject is moving within the image frame. It is suitable for sports, action, and wildlife photos.

Selecting autofocus points

Cameras use autofocus (AF) points to focus on a subject. The number of points can vary greatly, depending on the camera. There are two ways to select an AF point: let the camera do it automatically or manually choose it yourself. You'll learn to do both here.

1 Switch shooting mode

Cameras offer a variety of shooting modes, which automate some of the processes of making a photo. Some take focusing out of your hands altogether, so select Program mode, which does allow you some control over AF.

Program mode

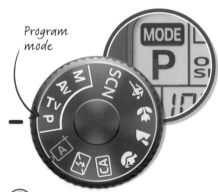

2 Compose your shot

Choose a busy scene with lots of objects at different distances. Set your camera on a tripod to keep your composition consistent as you experiment with focusing. Compose your shot, deciding exactly where you want the camera to focus.

6 Switch to Manual AF point selection

This will vary from camera to camera, but moving the AF point is generally done by pressing the multi-controller (a miniature joystick or set of four buttons on the back of the camera) in the required direction. You may also have to press an AF point selection button.

Multi-controller

7 Move the AF point

With the shutter button pressed halfway, move the AF point to the area of the scene you want to focus on. Press the shutter button fully to take the shot.

Manual AF point selection is useful when there are objects between the camera and the subject

8 Check your shots

Compare both your shots in Playback, looking closely at where the images are sharp and where they aren't. Experiment further with manual selection of AF points, bringing different parts of the scene into focus so as to familiarize yourself with the skill.

3 Select a focus point

Look through the Viewfinder and press halfway down on the shutter button. The camera will automatically select an AF point (or points). This will normally be the element nearest the camera, although this may not be what you want to focus on.

4 Check the options

Keeping your finger on the shutter button, look closely at the AF points the camera has selected, which will be lit up. Compare the points that are lit to where you would actually like the camera to focus, noting how big or small a difference there is.

5 Take your shot

Press down on the shutter button to take the shot.

Part nearest the camera is in focus

AF point is nearest part of the scene

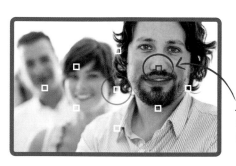

Manual AF point selection has been used to focus on the hands at the side of the image

WHAT HAVE YOU LEARNED?

■ When a camera automatically selects the AF point, it can get fooled by objects that are closer to the camera than your subject.
■ Manually selecting the AF point gives you greater control over exactly what is and what isn't in focus.
■ Manual AF point selection can be slow and is best suited to stationary subjects.

▶ PRACTISE AND EXPERIMENT
Focusing for effect

When looking at a photo we tend to ignore areas that are out of focus in favour of those areas that are sharply in focus. Focusing is thus as much about understanding how focus can be used creatively as it is about the technicalities of focus points. These assignments will help to take some of the mystery out of focusing so you can learn the effect it can have on your photography.

SHOOT AN OFF-CENTRE SUBJECT

- **EASY**
- **1 HOUR**
- **BASIC** + tripod
- **INDOORS OR OUTDOORS**
- **A MODEL**

Where you place a subject within a composition is an aesthetic choice. Placing a subject off-centre is often more pleasing than placing it centrally. However, doing this means thinking carefully about which AF point to use.

- **Ask** your model to find a comfortable pose.
- **Set** your camera up on a tripod and frame your subject so that they are placed to one side in your composition.
- **Select** Manual AF Point Selection mode on your camera. Choose the AF point closest to your subject's face, focus, and take the shot.
- **Experiment** with moving the AF point to different parts of the scene to see how this affects focusing and the sharpness of your subject.

USE MANUAL FOCUS

- **EASY**
- **30 MINUTES**
- **BASIC**
- **INDOORS OR OUTDOORS**
- **A WELL-LIT SCENE**

Autofocus is convenient and quick. However, there will be times when you will need to take control and manually focus a lens. Fortunately, even when doing this, the camera can help you achieve sharp photos by using the AF points as a guide.

- **Switch** your camera to manual focus.
- **Look** through the Viewfinder and point your camera towards an object you want to focus on. Move the AF point to the object.
- **Turn** the focus ring on the lens. If the object looks progressively less sharp, turn the ring in the other direction.

- **Wait** for the AF point to light up, meaning the object is in focus. Some cameras also show a focus confirmation light, generally at the bottom corner of the Viewfinder.
- **Experiment** with different subjects and see how your judgement of when an image is in focus matches that of the camera.

Focusing on the walls or the white furniture in this room would cause problems for an AF system due to lack of detail or contrast

Pro tip: Cameras with electronic viewfinders often offer a focusing aid known as focus peaking. This adds a false colour to edges in a scene that are in sharp focus.

Positioning a subject off-centre helps to place them in context

SHOOT A MOVING SUBJECT

- MEDIUM
- 1 HOUR
- BASIC
- OUTDOORS
- SPORTS EVENT/ MOVING SUBJECT

Find a situation where people will be moving towards you, such as a sports match or running race. Or get a friend or model to run and move around in front of you.

■ **Set** the AF mode to Continuous and the point selection to Automatic. Compose your image, then press the shutter button halfway down to focus.

■ **Follow** your subject's movement as you shoot. Try slower moving subjects first – if using a model, ask them to walk towards you, then jog, then run.

■ **Try** focusing on a fixed point in front of the subject, and then wait for them to pass by it, taking shots as they go.

■ **Switch** off the autofocus and focus manually. Try to anticipate where your subject will move, and focus there.

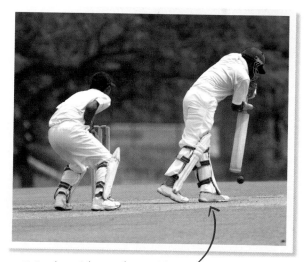

Following this moving subject has kept him in crisp focus

LOCK FOCUS

- **EASY**
- **30 MINUTES**
- **BASIC**
- **INDOORS OR OUTDOORS**
- **A WELL-LIT SCENE**

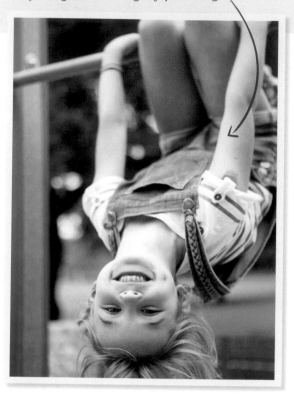

Locking focus allows you to put your subject right at the edge of your image

When using the Single AF mode, you can lock focus by holding down the shutter button. This means that you can focus and recompose if your subject is off-centre and outside the range of a camera's AF points.

- **Identify** an interesting subject and find a composition that would suit placing the subject near the edge of the frame. This means that the background will be prominent in the composition, so consider how this will work with your subject.

- **Set** the AF mode to Single and use manual point selection to move the AF point to the centre.

- **Turn** your camera so that your subject is central in the frame.

- **Press** halfway down on the shutter button to focus. With the shutter button held down, move the camera so that your chosen subject is at the edge of the frame.

- **Press** the shutter button down fully to take the shot.

KIT: UV AND SKYLIGHT FILTERS

UV and skylight filters reduce the effect of ultraviolet light outdoors, which can be seen as haziness on bright sunny days. The difference between the two filters is that the skylight filter is slightly pink in colour and will add a warm tint to a photo, though this effect may be counteracted by the camera's white balance setting (see p.252).

Neither filter affects exposure. In screw-in form they can be left fitted to a lens permanently, and this is often done to protect the front element of the lens from damage. It is far cheaper to replace a damaged filter than a damaged lens.

UV filter

Skylight filter

These types of filter screw in to the front of the camera.

FOCUS FOR CLOSE-UPS

- :::: EASY
- ⏱ 30 MINUTES
- ⊚ BASIC
- ⊚ INDOORS OR OUTDOORS
- ⊕ A WELL-LIT SCENE

Minimum focusing distances differ between cameras and lens types. These can vary quite considerably, from a few centimetres to whole metres. Learning the limitations of your camera's lenses will help you decide whether a close-up shot will work before you begin shooting.

- ■ **Choose** a subject that you can walk around and get close to. If you're using a zoom lens, set the lens to one end of the zoom range first.

- ■ **Stand** approximately 30 cm (12 in) from your subject, look through the Viewfinder of your camera, and press the shutter halfway down to focus. If the camera can't focus, this means that you're too close. Move 10 cm (4 in) farther back and try again.

- ■ **Move** backwards and forwards until you find a distance where the camera focuses reliably.

- ■ **Turn** the zoom ring of your lens to the other extreme and repeat.

- ■ **Do** the same with different lenses if possible.

- ■ **Repeat** with other subjects, but now try to estimate the minimum focusing distance accurately before you focus.

Knowing when you're too close can be the difference between getting a shot or not.

FOCUS ON THE EYES

- :::: MEDIUM
- ⏱ 1 HOUR
- ⊚ BASIC
- ⊚ INDOORS OR OUTDOORS
- ⊕ A MODEL

When we look at someone's face, whether it's in real life or in a photo, we generally look at the eyes first. That's why it is important to ensure that the subject's eyes in a portrait are sharp.

- ■ **Place** your model in reasonably bright light, though not so bright that they squint.

- ■ **Stand** about 1 m (3 ft) or so from your model.

- ■ **Look** through the Viewfinder at your model. Set the AF mode to Single and use manual point-selection to move the AF point to their eyes.

- ■ **Press** halfway down on the shutter button to focus, then press down fully to take the shot.

- ■ **Repeat,** moving different distances from your model between shots.

- ■ **Experiment** with manual focus to achieve sharp focus on your model's eyes.

This shot was taken using Face Recognition, an AF mode available on some cameras when shooting in Live View.

WHAT HAVE YOU LEARNED?

- ■ Your focus point needs to be placed on your subject to ensure that it really is sharp.
- ■ Learn to anticipate action, particularly when using manual focus.
- ■ Cameras will help you judge focus even when using manual focus.
- ■ Continuous AF will track action to keep a moving subject in focus.

Spend time looking through your photos once you've completed this module and experimented with focusing. Select some of the shots you think have either been successful or are interesting even if they're not entirely perfect. Use this checklist to assess what has worked in those photos and what could be refined.

Have you used focus creatively?
Areas that are out of focus can and should still add to a shot. In this photo, the shallow level of sharpness has created a strong sense of depth.

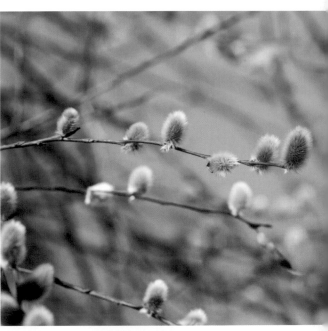

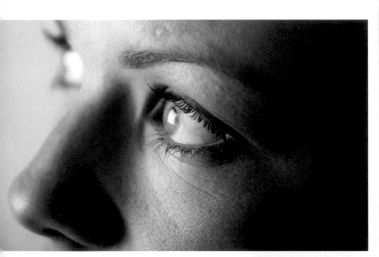

Which eye did you focus on?
When your subject's head is tilted at an angle, it's best to focus on the eye that is closest to the camera, or your image may look a bit odd.

Did you focus on the face?
Placing the focus on an element other than the subject's face can add an extra layer of novelty and interest to your shot.

Is your shot focused correctly?
Place the AF point in the wrong place and your subject may not be in focus. Here the camera has focused on the background rather than on the subject.

Pro tip: Pre-focusing is a useful technique for creating pleasing compositions, as long as you can accurately predict where your moving subject is going to be.

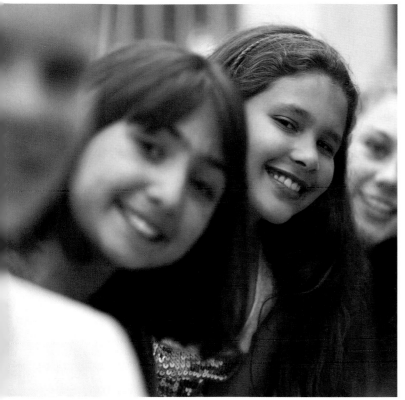

Where did you focus?

Sometimes there is no right or wrong answer as to where you should focus. Here you could have chosen any of these people to be the focus point.

Is your photo suffering from camera shake?

Caused when the camera moves during an exposure, camera shake can soften an image, but not in the same way as a focusing error. This photo is focused correctly but suffers from camera shake.

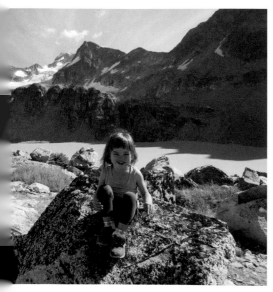

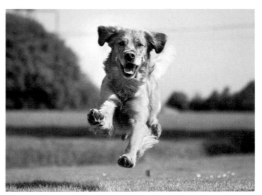

Is everything sharp?

Where you focus is always the sharpest part of a photo. However, the front-to-back sharpness of this photo is controlled by the aperture, an effect known as depth of field (see pp.108–109).

Are your subjects sharp?

The faster a subject moves, the more difficult it is for a camera to keep it in focus. Subjects that move erratically make this more difficult still. Often, switching to manual focus and pre-focusing at infinity, if your subject is more than 10 m (33 ft) from the camera, will lead to better results.

▶ ENHANCE YOUR IMAGES
Sharpening a photo

An out-of-focus photo can't be refocused in post-production, but photos sometimes don't look as sharp as they could. Most sensors are designed to deliberately soften photos slightly so as to reduce the risk of moiré (a false, shimmering pattern, seen in photos that include very fine, repetitive details, such as textiles). These photos often need to be sharpened again post shooting. This can either be set in-camera or tweaked in post-production.

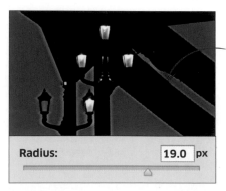

This image is slightly soft-looking.

1 Copy your photo
Sharpening a photo is known as a destructive process. This is because it alters the pixels in a photo dramatically and, once you've saved the results, the process cannot be undone. For this reason, work on a copy of your photo rather than the original.

Bridge_Image.jpg **Bridge_Image copy.jpg**

5 Set a Radius value
The Radius slider controls the number of pixels around an edge pixel that will show an increase in sharpness. The lowest value, 0.0, means that no pixels on an edge will be altered. The highest value, 64, will affect a greater number of pixels and increase the sharpening effect. Move the slider until you get a value that suits your image.

Set too high a radius level and halos will be seen along the edges between the different elements in your photo

6 Reduce noise
An unwanted side-effect of sharpening is the increased visibility of noise, the random fluctuations in brightness that can cause a speckled effect in photos (see p.86). Move the Reduce Noise slider to help combat this. No noise reduction is applied at 0 per cent. At 100 per cent the noise will be fully suppressed, but at the expense of fine detail in the photo.

Set Reduce Noise to a low value if areas such as the sky look smooth and noise-free

> ## Photography has **no rules.**
> ## It is **not a sport.**
> **BILL BRANDT**

2 Assess your photo

Open your copied photo in Photoshop (or similar). Set View to 100 per cent using the Magnify tool and look closely at fine details in the photo to see how sharp they are (only look at areas you know to be in focus). Do not proceed if you feel your image is sharp.

3 Select Smart Sharpen

Photoshop has a number of tools to sharpen photos. The most comprehensive and adjustable tool is Smart Sharpen. To select it, go to Filter in the top menu, then Sharpen, then Smart Sharpen.

4 Choose the amount of sharpening

Move the Amount slider to control the level of sharpening applied to your photo.

View the image at less than 100 per cent and you may not see the effects of sharpening.

The range of adjustment runs from 0 per cent, where no sharpening is applied, to a maximum of 500 per cent

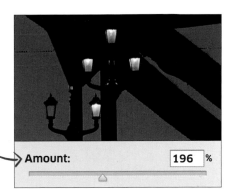

Amount: 196 %

7 Apply sharpening

Once you've achieved a satisfying balance between the three sliders, press OK. As a general rule, less sharpening is better than too much.

The image now looks much sharper.

ⓘ IN-CAMERA FIXES

Digital photos are sharpened by increasing the contrast between edges in the photo. The higher the contrast, the sharper the photo looks. When you shoot JPEGs, the camera applies this type of sharpening automatically, and can be adjusted in-camera using a camera's picture parameters settings (see p.103). RAW files are not sharpened at the time of capture and must be sharpened in post-production.

How much sharpening do I need?
The level of sharpening you apply depends on how you intend to use the photo. Photos to be printed need higher levels of sharpening than those seen only on-screen. But over-sharpening can produce an ugly and unnatural halo-like effect around edges in a photo. Experiment until you find the level that's right for you.

What have you learned?

Focusing isn't a matter of pressing the shutter button and hoping for the best – it's about taking creative control and making a photo, rather than merely taking it. Try these multiple-choice questions to see how much you've learned.

1 Which AF mode constantly updates the focus distance to track a moving subject?

A Single B Continuous C Program

2 The farthest distance a lens can focus on is known as what?

A Infinity B Eternity C Minimal

3 How would you lock focus in Single AF mode?

A Change the shooting mode
B Turn the focus ring
C Hold the shutter button down halfway

4 Which symbol represents infinity on a lens?

A + B ∞ C @

5 Which part of a face should be sharpest?

A The nose B The eyes C The mouth

6 What is the closest distance a lens can focus?

A Its minimum focusing distance
B Infinity
C 30 cm (12 in)

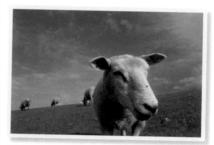

7 In automatic AF point selection, where do cameras usually focus?

A On infinity
B The closest object in the scene
C Exactly 10 m (33 ft) from the camera

8 A skylight filter reduces the effects of what type of light?

A Ultraviolet B X-ray C Visible

9 What is Continuous AF sometimes called?

A Predictive B Single C Constant

10 Which camera control can be used to change the AF point?

A Aperture ring
B Shutter button
C Multi-controller

11 What secondary use do UV filters have?

A They protect the front of the lens
B They look professional
C They speed up focusing

12 What name is Single AF mode sometimes referred to as?

A AF-C
B Aperture Priority
C One-shot

13 At a sporting event, what kind of knowledge helps you to anticipate fast-moving action?

A The rules of the sport
B The names of the players
C The duration of the event

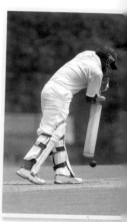

14 If you over-sharpen a photo, what visual effect do you see?

A Lower contrast
B Brighter colours
C Halos around edges

15 Skylight filters are which colour?

A Blue B Pink C Green

Answers 1/B, 2/A, 3/C, 4/B, 5/B, 6/A, 7/B, 8/A, 9/A, 10/C, 11/A, 12/C, 13/A, 14/C, 15/B.

03

USING SHOOTING MODES

DSLRs offer a range of modes which control the technical parameters of a shot. These modes can range from fully automatic to fully manual, and various steps in-between, and are controlled by the Mode dial. On most dSLRs, the Mode dial is split into three sections: fully Automatic; Scene modes; and Program AE, Aperture Priority, Shutter Priority, and Manual modes, which give you varying degrees of control over your shots.

In this module, you will:

▶ **discover what modes are** and how they let you take control of your photography;

▶ **learn which modes are best** for certain shooting scenarios;

▶ **understand how to use** exposure compensation;

▶ **apply your new-found knowledge** by shooting some fun, mode-based assignments;

▶ **review your images** and learn how to spot, and learn from, any mistakes you have made;

▶ **improve your results** using basic image-editing techniques;

▶ **recap and revise** your understanding of shooting modes.

Let's begin... ⊕

✓ TEST YOUR KNOWLEDGE
Which mode is right?

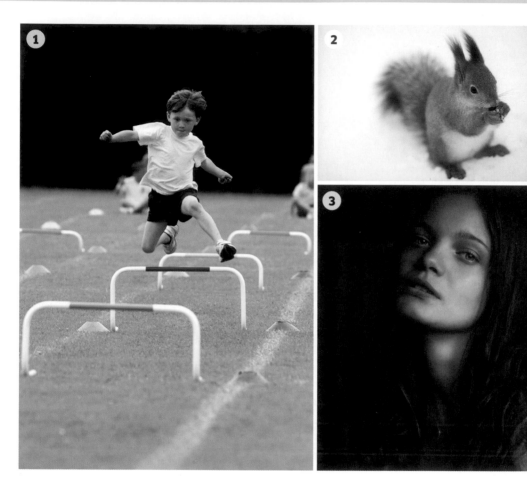

Modes are designed to help photographers capture a variety of scenes and conditions as easily as possible. See if you can match the description of the mode with the right picture.

A **Aperture Priority mode:** Can separate the subject from the background by controlling focus.

B **Sports mode:** Has a fast shutter speed that will freeze the action of the subject.

C **Landscape mode:** Enables the camera to capture the maximum amount of depth.

D **Negative exposure compensation:** Can stop the camera from overexposing flesh tones.

E **Program mode:** Allows you to set the ISO and shutter speed to capture motion blur.

F **Disabled flash:** Lets you preserve the mood and intimacy of a special moment.

G **Portrait mode:** Helps to soften skin tones in portraits.

H **Positive exposure compensation:** Stops the subject being underexposed against a bright background.

NEED TO KNOW

■ Getting to grips with exposure, shutter speeds, and aperture combinations can be quite daunting. Using the preset modes will help you to concentrate on capturing the moments that matter as you learn.

■ The most powerful tool you have when using the various modes is exposure compensation, as this will allow you to override the camera's suggested settings.

■ It is worth studying each mode in turn, as they all have subtle differences and specific uses.

■ If you keep an eye on what settings the camera is suggesting, you will soon start to get an understanding of how exposure works. This will help you to make informed decisions about whether the camera suggestions match your vision.

Review these points and see how they relate to the photos shown here.

Basic camera modes

Understanding what each mode on your camera does, and how and when to use them will take some of the complications and technicality out of your photography without compromising your creativity. Being able to switch between modes as you shoot will give you the confidence to experiment and grow as a photographer. By using the different modes, you will resist the safe option of always shooting in Auto and wondering why your pictures aren't quite as good as you'd hoped.

PROGRAM MODE

Program mode is a step-up from Auto mode. Although the camera sets the aperture and shutter speed, you need to set the ISO or activate the flash. You also have more control over camera functions, such as the file type and picture parameter used. If you want to take more control over your photography but still want some level of automation, then Program is the mode to select.

Program mode will always select the fastest shutter speed possible to reduce the risk of camera shake. However, in low light it may not be possible for Program mode to select a fast enough shutter speed. If camera shake is likely, you should increase the ISO. Only when light levels are bright enough will Program mode select a smaller aperture to increase depth of field, allowing more of the image to appear sharp.

AUTO MODE

Auto mode is completely automatic – it even pops up the flash if it calculates that additional lighting is required. In poor light Auto mode automatically increases the ISO (sensitivity) to cut the risk of camera shake. This mode can be useful if you are in a rush and don't have time to consider the options, or if you hand your camera to a friend for them to take a quick picture.

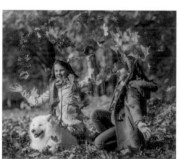

Auto mode is ideal when photographing fast-moving subjects, such as children or pets.

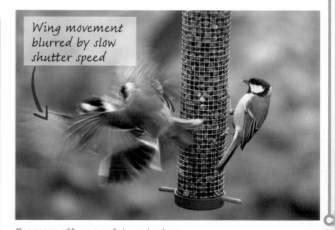

Wing movement blurred by slow shutter speed

Program offers a safety net when shooting, but with far finer control over the exposure setting than Auto.

PROGRAM SHIFT

In Program mode the camera chooses the required shutter speed and aperture. However, you can override this selection by rotating the camera's control dial. This adjusts both the aperture and shutter speed while maintaining the correct exposure. This facility is usually referred to as Program shift or Flexible program.

"Photography is... **visual** and can **transcend language.**"
LISA KRISTINE

SHUTTER PRIORITY MODE

In Shutter Priority (S or Tv) mode, you choose the shutter speed and the camera chooses the lens aperture that will give the correct exposure. This mode is particularly useful when you want to control the amount of movement blur that appears in your shots. To freeze fast-moving action, for example, you should select a fast shutter speed (see pp.188–189).

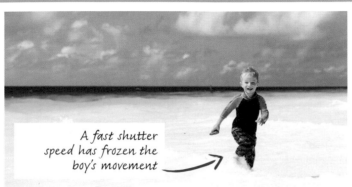

A fast shutter speed has frozen the boy's movement

If the brightness of a scene is too great, the use of Shutter Priority mode can lead to overexposed images. This is because the camera may be unable to select a small enough aperture to match the selected shutter speed.

APERTURE PRIORITY MODE

Aperture Priority (A) mode enables you to choose the aperture, and your camera then automatically sets the shutter speed that will give the correct exposure. Aperture also affects depth of field: a small aperture offers greater depth; a large aperture, shallower depth.

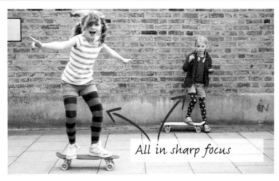

All in sharp focus

Large depth of field means everything is sharp, from nearby objects to the far distance. This is useful when you want precise control over depth of field.

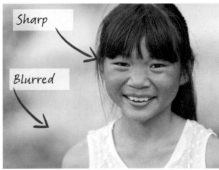

Sharp

Blurred

Shallow depth of field means only subjects close to your camera are sharp, while more distant objects are out of focus.

MANUAL MODE

In Manual (M) mode, you control both the aperture and the shutter speed. The camera will still measure light levels, but will only recommend an exposure – it won't change any of the settings itself (see week 4).

Manual mode lets you be more experimental with exposure settings, which is useful in tricky lighting situations.

Scene modes

As well as the automatic and semi-automatic modes, most cameras have a range of specific scene modes. Each scene mode optimizes the camera's focusing, aperture, and shutter speed for a given set of conditions, and is programmed to minimize common errors. It also changes how the camera processes the image by altering colour saturation and sharpness.

 LANDSCAPE MODE

The purpose of this mode is to boost colours, contrast, and outlines. It selects a small aperture setting to give the greatest depth of field. The smaller aperture will also result in slower shutter speeds.

 PORTRAIT MODE AND BABY MODE

By setting a large aperture, Portrait mode blurs the background and adjusts the image processing for a softer, more flattering result. Some dSLRs also include Baby (or Child) mode, which warms the tones and makes images even softer.

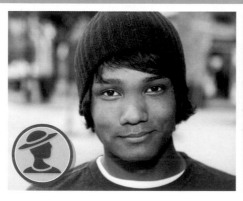

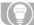 **FLASH OFF MODE**

Useful in low-light conditions, Flash Off mode disables the flash so it won't fire. This can also help you avoid embarrassment in sensitive locations such as theatres, museums, and churches.

> Just **react** to what you see, and take **many, many pictures.**
> ELLIOTT ERWITT

SPORTS MODE

The best mode for action is Sports mode. High shutter speeds freeze action, and focusing is usually switched to Continuous mode or Predictive Autofocus where available (see pp.44–45).

MACRO MODE

This mode, also known as Close-up mode, works by changing the focusing distance on your camera's lens to focus at close quarters. It also tends to pick a wide-open aperture, resulting in a shallower depth of field.

OTHER SCENE MODES

Many dSLRs include additional modes optimized for everyday scenarios. Check your dial and camera manual to see which modes your camera offers.

Fireworks mode
This mode is useful for capturing fireworks or car light trails. It slows the shutter speed, increasing exposure time to around four or five seconds for shooting at night without flash. Avoid camera shake by using a tripod or rest your camera on something solid.

Snow mode
This mode allows for a lot of bright light in a scene and sets for deliberate overexposure. It renders snow as white instead of grey and avoids silhouetting people against the background.

Sunset mode
This mode enhances the red and orange colours of sunsets. Some cameras, when set to Sunset mode, also underexpose the image to intensify the effect still further.

NIGHT PORTRAIT MODE

Another flattering mode for portraits, Night Portrait mode uses flash to illuminate your subject, but this is balanced against the background lighting to produce a natural-looking result.

▶ LEARN THE SKILLS
Exposure compensation

Often, if your subject is standing in front of a bright light or in a very dark room, your camera's light meter will try and even out the exposure. However, this can result in a silhouette or a washed-out subject. Exposure compensation allows you to make a picture lighter or darker than the recommended exposure.

1 Position the subject
Stick a sheet of white tracing paper to a window and place your subject in front of it.

2 Use Aperture Priority
Select Aperture Priority mode (Av or A), and choose an aperture of about f/5.6.

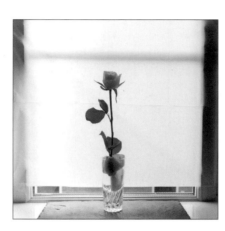

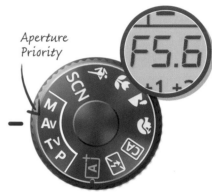

Aperture Priority

6 Engage exposure compensation
Press the exposure compensation button on your camera (this is usually marked with a "+/-" icon). You can now alter the exposure, either positively or negatively. Dial in +1 for increased exposure to lighten the image.

7 Reshoot the picture
Take another shot. The subject should be lighter and the background less grey. If it still looks too dark, dial in a higher number. Exposure compensation is often available in half- or third-stop increments for making fine adjustments.

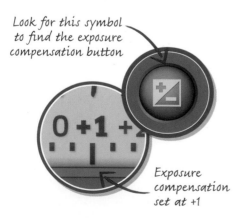

Look for this symbol to find the exposure compensation button

Exposure compensation set at +1

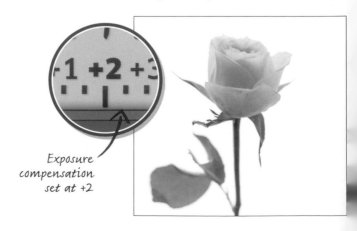

Exposure compensation set at +2

Where to start: Find a brightly lit room with a large window. Gather together a subject to shoot, such as a flower in a vase, a piece of white tracing paper for a background, and some sticky tape to hold it in position.

You will learn: How to use the exposure compensation facility on your camera to turn a high-contrast image into one with a more standard level of contrast.

3 Focus on the subject

Get close to your subject and focus tightly on it so the background is completely made up of tracing paper.

4 Shoot the picture

Once you've got everything lined up, take a shot using the settings provided by your camera's light meter.

5 Review the picture

Look closely at your image. The subject will probably be a bit dark because of the light coming from behind it.

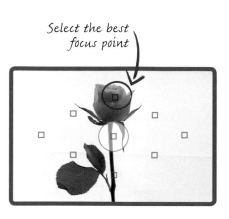

Select the best focus point

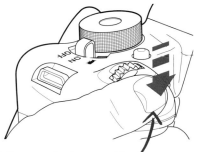

When you're happy with the look of the shot, press the shutter button

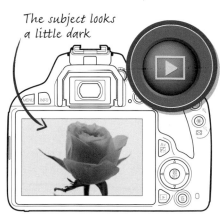

The subject looks a little dark

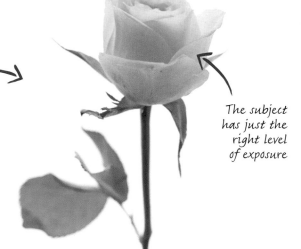

The background is light and even

The subject has just the right level of exposure

WHAT HAVE YOU LEARNED?

- Exposure compensation gives you great leverage as a photographer to fine-tune your exposure, allowing you to take pictures in low-light or high-contrast conditions.
- Exposure compensation can be used in all the automatic and semi-automatic modes on your camera.

Exploring camera modes

Camera modes help take the hassle out of photography. However, by taking control and choosing which mode to use – and learning to understand how each one works – your images will improve dramatically.

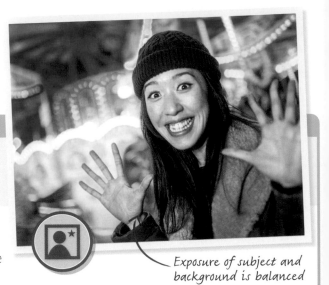

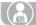 GETTING IT RIGHT AT NIGHT

- 📊 **EASY**
- 🕐 **30 MINUTES**
- 📷 **BASIC +** flash
- 📍 **OUTDOORS**
- ➕ **NIGHT SCENE WITH A BRIGHTLY LIT BACKGROUND**

Using Night Portrait mode is an effective way of illuminating both your subject and their environment. This assignment works best somewhere with night-time lighting, such as a fairground.

- ▪ **Position** your subject so that they're standing directly in front of some lights.
- ▪ **Turn** your camera on. The flash should automatically pop up (if you have to plug your flash in, turn it on).

Exposure of subject and background is balanced

- ▪ **Set** the camera to Night Scene mode. The camera will automatically sort out the setting, and will fire the flash to balance the exposure so that your subject is perfectly exposed.

📷 NOTING DIFFERENCES

- 📊 **EASY**
- 🕐 **15 MINUTES**
- 📷 **BASIC**
- 📍 **INDOORS OR OUTDOORS**
- ➕ **A MODEL**

Program mode is a great setting to learn about modes, as it automatically sets the shutter speed and aperture but lets you alter them to get the effect you want.

- ▪ **Set** your camera to Program (P) mode and position your model about 2.5–3m (8–10ft) from the background.
- ▪ **Focus** on the model's face and then lightly press the shutter button. The camera will set the exposure for the scene. Note the shutter speed and aperture.
- ▪ **Use** the control dial to change the aperture and shutter speed. Take a photo with each change you make and note the effect – for instance, how a wider aperture makes the background more blurry.

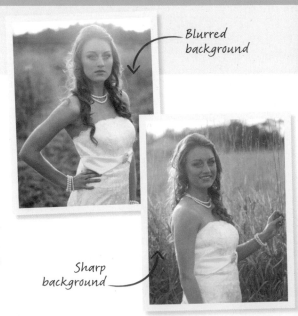

Blurred background

Sharp background

Pro tip: Your photographs will improve the more you take control. Set yourself assignments that take you around the Mode dial, tackling each of the modes in turn until you know exactly what they do, almost instinctively.

PERFECTING THE EXPOSURE

- **MEDIUM**
- **1 HOUR**
- **BASIC +** tripod
- **INDOORS**
- **A MODEL AND A BRIGHT LIGHT SOURCE, SUCH AS A SUNNY SKY**

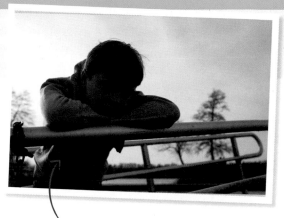

With +1 exposure compensation dialled in, the subject is a bit brighter

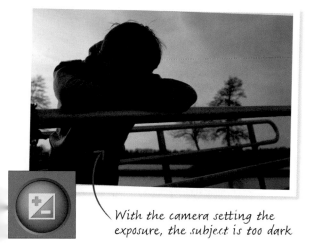

With the camera setting the exposure, the subject is too dark

At +2 exposure compensation, the image is correctly exposed

This simple but challenging exercise will help you to practise controlling your exposure using the exposure compensation dial.

- **Position** your model between your camera and the bright light source, and set the camera so you're shooting slightly upwards.

- **Select** Aperture Priority mode (Av or A), and choose an aperture of about f/5.6.

- **Take** a shot and review your image. It will probably appear slightly dark and the subject may be silhouetted.

- **Set** the exposure compensation to +1. Keep everything else exactly the same and reshoot the picture. Review the image again. This time your subject should be lighter than before.

- **Change** the exposure compensation to +2 if it's still too dark and try again. By now you should be achieving the balance you're looking for.

WHAT HAVE YOU LEARNED?

- You don't have to let the camera do all the work. By using semi-automatic modes you can control the exposure and mood of your images.
- Exposure compensation is a powerful tool and can be used to great effect in automatic and semi-automatic modes.

Reviewing your shots

Once you've got to grips with the basics of using modes and completed the assignments, choose the images you are most pleased with. Now ask yourself these questions to see if any improvements could be made.

Have you used the appropriate mode?
Through practice you'll come to know which modes are best suited to particular conditions. In this image, Night Scene mode has been used to give a long exposure, bringing out the detail as the light begins to fade.

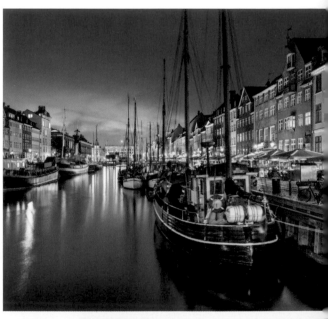

Does the mode match the subject?
This image has been taken using Portrait mode. The shallow depth of field has thrown the background out of focus, helping to draw attention to the subject's features.

Is your image correctly exposed?
The bright background light has underexposed the subject. Exposure compensation would have revealed the detail on the fish's body.

Do you have enough depth in your image?
Landscape mode has been used here to enhance the colour saturation and produce a deep depth of field.

"A good snapshot **keeps a moment** from **running away.**"

EUDORA WELTY

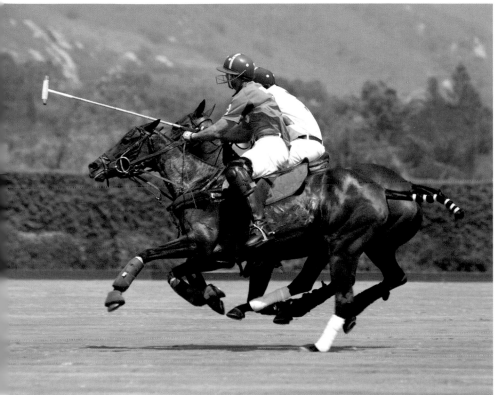

Have you used the right mode to freeze the action?

Taken using Sports mode and a telephoto lens, this image has captured the motion of the riders, filling the frame and creating a dramatic effect.

Have you experimented with the settings?

This image has been shot using Landscape mode to give it depth, but with a fast shutter speed to freeze the cyclist in mid-pedal.

Have you successfully captured the mood of the scene?

Engaging the No-Flash mode and regulating the negative exposure compensation has resulted in an intimate portrait.

Is your image unintentionally blurred?

Using Sports mode would have captured these people in sharp focus. Instead they appear blurred because a mode that doesn't freeze the movement has been used.

► ENHANCE YOUR IMAGES

Adjusting brightness

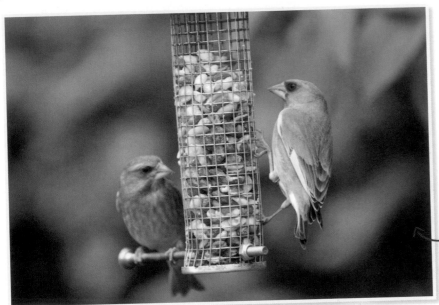

This image looks flat and grey

Despite your best efforts, you may occasionally produce a flat or dull-looking image. This is usually due to your camera incorrectly interpreting difficult lighting or contrast conditions. Don't worry, the image can easily be brightened up on your computer.

4 Brighten the highlights

To brighten the highlights, select the white slider, bringing it to the left. Move it backwards and forwards until you get the exact level of brightness you want, then click OK.

5 Select Vibrance

If you also want to enhance the intensity of the colours, but don't want to end up with an oversaturated image, use the Vibrance tool. Go to the menu bar and choose Image, then Adjustments, then Vibrance.

Image	Layer	Type	Select	Filt
Mode	▶			
Adjustments	▶		**Brightness/Con**	
Auto Tone			Levels...	
Auto Contrast			Curves...	
			Exposure...	
Auto Color			Vibrance...	
Image Size...			Hue/Saturation	
Canvas Size...			Color Balance	
Image Rotation	▶		Black & White	
			Photo Filter	

6 Brighten the colours

Move the Vibrance slider to get the effect you want. This tool subtly increases the saturation so that the tones still look natural.

Vibrance:	20
Saturation:	0

Pro tip: Always try to get your images right in-camera. The less work you have to do on them, the more time you can have taking pictures. If you do opt for some computer fixes, don't overwork your images, as they'll quickly lose their charm.

1 Select Levels

Select the image you want to work on, make a copy, and open it in Photoshop. Go to the top menu bar and choose Image, then Adjustments, and then Levels.

2 Look at the histogram

The histogram that pops up shows the brightness of your image. The left peaks are shadows; the right ones are highlights. A flat image, such as this one, has all the tones squashed in the middle.

3 Darken the shadows

To darken the shadows in your picture, click on the Black slider and move it to the right. As you do, you'll notice the dark areas in your image getting darker.

Image	Layer	Type	Select	Filt
Mode		▶		
Adjustments		▶	Brightness/Con	
Auto Tone			Levels...	
Auto Contrast			Curves...	
			Exposure...	
Auto Color			Vibrance...	
Image Size...			Hue/Saturation	
Canvas Size...			Color Balance	
Image Rotation		▶	Black & White	
			Photo Filter	

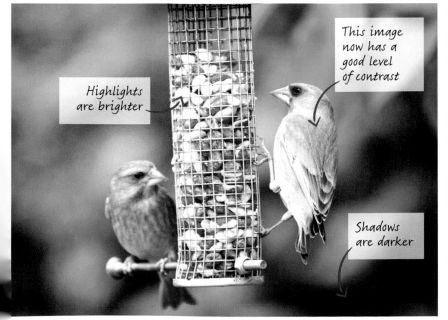

Highlights are brighter

This image now has a good level of contrast

Shadows are darker

ⓘ FIXING CONTRAST

There are other ways to improve the contrast in post-production. One of the most straightforward options is to use the Brightness/Contrast sliders (see pp.102–103). Alternatively, you could try the slightly more complicated Curves tool (see pp.278–279). Remember that a little is often enough to add a little punch to your pictures. If you overdo the adjustment, your pictures may begin to look a bit false.

What have you learned?

Now that you've experimented with the different modes available on your camera, try these multiple-choice questions.

1 What does Av stand for?

A Shutter Priority
B Aperture Priority
C Average metering

2 What does exposure compensation give you?

A Control over depth of field
B More control over exposure in automatic shooting modes
C A sharper picture

3 Can you control the depth of field when using Program mode?

A No
B Yes
C Sometimes

4 If you want to control the depth of field in your pictures, which mode is best?

A Program mode
B Aperture Priority mode
C Sports mode

5 What mode should you use to capture an athlete in action?

A Macro mode
B Fireworks mode
C Sports mode

6 What does the flower symbol mean?

A No-Flash mode
B Close-up or Macro mode
C Colour mode

7 What mode is best to photograph someone at night?

A Night Scene mode
B Fireworks mode
C Program mode

8 What will you gain from using the various modes on your camera?

A A faster shutter speed
B Creative control
C A wider aperture

9 In Sports mode, what will the camera give priority to?

A A greater depth of field
B A higher shutter speed
C A lower ISO

10 Using Shutter Priority will give you control of the:

A Aperture
B Focusing
C Shutter speed

11 Which mode should you select if you want a shallow depth of field for a portrait?

A Program mode
B Shutter Priority
C Aperture Priority

12 How would you stop a subject becoming silhouetted against a brightly lit background?

A Use Sports mode to take the photograph quickly
B Use exposure compensation to brighten the image
C Use Aperture Priority to control the depth of field

13 An exposure setting of 1/1,000 sec with an aperture of f/4 is the equivalent to:

A 1/500 sec at f/11
B 1/125 sec at f/11
C 1/2 sec at f/5.6

14 What sort of shutter speed would you choose if you wanted to freeze the action?

A A fast one
B A long one
C A medium one

15 In the automatic and semi-automatic modes, what is the feature that gives you extra control over your exposure?

A Focusing ring
B Motor Drive settings
C Exposure compensation

Answers 1/B, 2/B, 3/B, 4/B, 5/C, 6/B, 7/A, 8/B, 9/B, 10/C, 11/C, 12/B, 13/B, 14/A, 15/C.

04 GETTING THE RIGHT EXPOSURE

week

A precise amount of light needs to reach the camera's sensor to make a successful photo. This amount is known as the correct exposure. Too much light, and your photograph will be overexposed; too little light, and the photos will be underexposed.

In this module, you will:

▶ **test what you know** about a photo's exposure;

▶ **find out how you can control exposure** and how your camera meter works;

▶ **apply your knowledge** and make the right exposure choices during a step-by-step photoshoot;

▶ **develop your exposure skills** and experiment with different ways to create some dramatic effects;

▶ **review your shots** to see if your exposure settings have been successful;

▶ **improve your photos** by reducing image noise;

▶ **recap what you've learned** about exposure and see if you're ready to move on.

Let's begin... ⊙

Assessing exposure

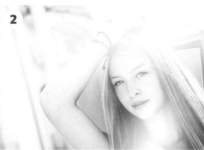

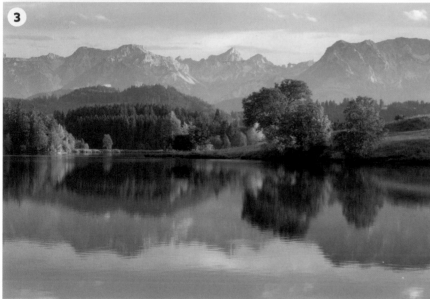

A photo may be correctly exposed, dark due to underexposure, or even light due to overexposure. These photos display different levels of exposure. Can you match the characteristics to the right images?

A Normal subject, correctly exposed: This allows for detail in the brightest and darkest areas.

B Underexposed: There'll be little or no detail in the darkest areas of the photo, and even the highlight areas will look muddy.

C Dark subject, correctly exposed: The exposure of a dark subject should reflect that the subject is dark. Any light areas should be correctly exposed.

D Light subject, correctly exposed: The exposure of a light subject should show that the subject is light.

E Low-key: The scene has mainly dark tones, with few light areas.

F Overexposed: There'll be little or no detail in the lightest areas of the photo, while the shadow areas will look pale and washed out.

G High-key: The scene has mainly light tones, with few dark areas.

ANSWERS

A/3: Mountain reflected in water, southern Germany
B/6: The last rays of the sun
C/4: Close-up photo of a black cat
D/7: Snowy forest scene
E/1: Photo of a man in darkness
F/2: Young woman shopping
G/5: Spring blossom

5

7

6

NEED TO KNOW

■ Exposure is the art of judging how much or how little light is necessary to make a successful image.

■ There are many different ways to expose a photo. Taking control of exposure will expand your creative options when shooting.

■ Experimenting with exposure is highly recommended. Don't be afraid to alter exposure for effect.

■ Shooting under different lighting conditions will help you to see the effect this has on your exposure.

■ Low- and high-key exposure are intentional methods of lighting a scene for effect, and not just the result of under- or overexposure.

Review these points and see how they relate to the photos shown here

Controlling exposure

There are two physical controls on a camera that allow you to determine how much light reaches the sensor. The first control is a variable iris in the lens known as the aperture. By controlling the size of the aperture, you can choose how much light passes through the lens into the camera. The second control is the camera's shutter, which is a light-tight curtain positioned directly in front of the sensor. The shutter can be opened for precise periods of time before closing again, and this period of time is known as the shutter speed.

The exposure triangle

Aperture, shutter speed, and ISO are linked. Adjust one control, and at least one of the other two must also change to maintain the same level of exposure.

Fast shutter speed
Larger aperture

Slow shutter speed
Smaller aperture

Large aperture
Faster shutter speed

Small aperture
Slower shutter speed

Large aperture
Decreased ISO

Small aperture
Increased ISO

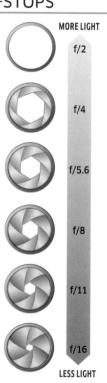

CAMERA APERTURE

ⓘ APERTURE AND f-STOPS

The size of the aperture can be adjusted in a set series of sizes known as f-stops. Lenses vary in the range of available f-stops. A typical range on a lens is f/2.8 – f/4 – f/5.6 – f/8 – f/11 – f/16. Each f-stop in this range represents a halving of the amount of light reaching the camera's sensor compared to the value above – or a doubling of the light compared to the f-stop value below.

MORE LIGHT

f/2

f/4

f/5.6

f/8

f/11

f/16

LESS LIGHT

⚙ APERTURE

The largest
(or maximum) aperture lets in the most light. In low light it allows a faster shutter speed.

A mid-range
aperture is suitable for normal levels of light and allows a standard shutter speed to be used.

The smallest
(or minimum) aperture lets in the least light. In bright light it allows a slower shutter speed.

SHUTTER-SPEED DIAL

Pro tip: Cameras usually allow you to alter the aperture, shutter speed, or ISO by half or even one-third stops. In the sequence of aperture values on the opposite page, f/4.5 and f/5 are the one-third stop values between f/4 and f/5.6.

Fast shutter speed
Increased ISO

Slow shutter speed
Increased ISO

High ISO setting
Faster shutter speed

Low ISO setting
Slower shutter speed

Low ISO setting
Larger aperture

High ISO setting
Smaller aperture

SHUTTER SPEED

Cameras differ in the range of available shutter speeds. A typical range starts at 30 sec and ends at 1/4,000 sec. As with aperture, the difference between adjacent shutter speeds is known as a stop. Each stop represents a halving of the light reaching the sensor as the shutter speed is made faster (the shutter is open for less time), or a doubling of the amount of light as the shutter speed is made slower (the shutter is open longer).

The fastest shutter speed is used to freeze movement or when shooting in light that is very bright.

A mid-range shutter speed is suitable for normal levels of light and for general shooting purposes.

The slowest shutter speed is used to blur movement or when shooting in very low light.

ISO

Changing ISO affects the light sensitivity of a camera's sensor. It stands for International Organization for Standardization, which sets standards for camera sensitivity. ISO determines how much light is needed during an exposure; with a higher ISO, less light is required for a photo. Like aperture and shutter speed, ISO is also adjusted in stops, so an ISO setting of 200 makes the sensor twice as sensitive to light as ISO 100.

Auto ISO dynamically alters the ISO setting automatically according to light levels.

A high ISO is necessary if you want to use a faster shutter speed or smaller aperture in low light.

A low ISO is typically used in normal shooting conditions and allows for a wide range of aperture and shutter speed settings.

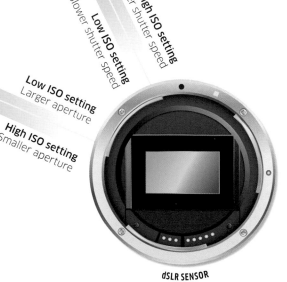

dSLR SENSOR

The exposure meter

Achieving the right exposure would be easy if light levels were constant. However, shooting in low ambient light requires a different mix of shutter speed, aperture, and ISO than shooting in bright light. Fortunately, cameras have a built-in light meter that measures light levels; this helps you to decide what exposure settings are necessary. The meter in your camera is known as a reflective meter as it measures the amount of light reflected by the scene in front of the camera.

 AVERAGE REFLECTIVITY

A scene that reflects 18 per cent of the light that falls on it has an average reflectivity. Mid-greys and colours of a similar brightness are averagely reflective and are known as mid-tones. Camera metering is inaccurate with scenes that aren't averagely reflective: higher-than-average reflectivity causes underexposure; lower-than-average reflectivity causes overexposure. Judge a scene first to avoid errors occurring.

18% GREY

 METERING MODES

Evaluative (or Matrix) metering is the default metering option. It divides the scene into a number of zones, with each zone metered independently and the results combined to produce the final exposure settings. Useful when shooting landscapes with filters.

Good for general shooting purposes

Centre-weighted metering biases the metering to approximately 60–80 per cent of the central area of a scene; the edges are metered too, but this affects exposure less than the central zone. Use for the correct exposure of centrally placed subjects.

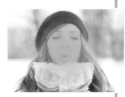
Good for portraits

Spot metering restricts the metering to approximately 1–5 per cent of a scene (a variant is partial metering, which measures 10–15 per cent of a scene). Metering is at the centre of a scene, although some cameras let you lock metering to an autofocus point.

Works for a small part of a scene only

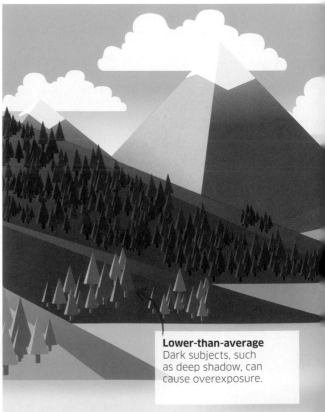

Lower-than-average
Dark subjects, such as deep shadow, can cause overexposure.

> **Pro tip:** A useful highlight warning function during Playback is known as blinkies. This is a flashing indicator that shows areas of overexposure in a photo. If a photo suffers from blinkies, apply negative exposure compensation and reshoot.

HISTOGRAMS

A histogram is a graph showing the brightness range in a photo. Black is at the far left edge, white at the far right edge, and mid-tones are measured at the centre.

SHADOWS MID-TONES HIGHLIGHTS

NUMBER OF PIXELS

DISTRIBUTION OF TONES

Correct exposure There is no ideal shape for a histogram. However, an averagely reflective scene would produce a more centrally placed histogram that isn't lost, or clipped at either end.

Underexposure When a histogram is skewed to the left edge, the photo is potentially underexposed. This shows that the photo is mainly composed of dark tones.

Overexposure If a histogram is skewed to the right, then the photo is potentially overexposed. This shows that the photo is mainly composed of light tones.

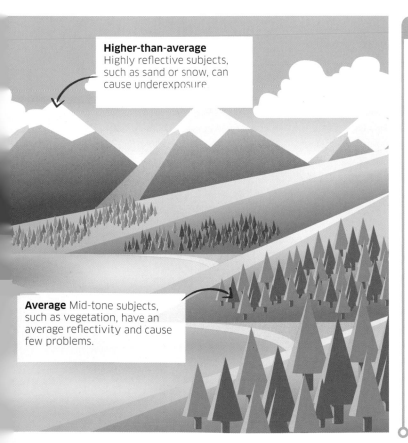

Higher-than-average Highly reflective subjects, such as sand or snow, can cause underexposure

Average Mid-tone subjects, such as vegetation, have an average reflectivity and cause few problems.

EXPOSURE FIXES

As good as modern camera meters are, they are not infallible and can make mistakes. Exposure compensation is a function that allows you to adjust exposure. This can be used when a camera gets the exposure wrong, or for creative effect.

Positive or negative compensation
A typical exposure compensation range is plus or minus 3 stops. Exposure compensation is usually set either by adjusting a dial on the body of the camera or via a menu option. Positive (+) compensation is used to lighten a photo to correct for camera underexposure. Negative (−) compensation is used to darken a photo to correct overexposure.

$$-3 .. 2 .. 1 .. | .. 1 .. 2 .. +3$$

The maximum negative compensation value is -3 stops

The maximum positive compensation value is +3 stops

▶ LEARN THE SKILLS
Fine-tuning exposure

While camera meters are usually accurate, they can get things wrong. Taking control of the exposure will let you correct errors and adjust the exposure for creative effect.

1 Watch the weather
Shooting when the sky is completely cloud-free is less than ideal for outdoor photography. Instead, try shooting when the sky is partially cloudy.

2 Use Program mode
Set your camera to Program (P) mode to fine-tune exposure. The camera will initially select the required shutter speed and aperture; you can alter these by using Program shift or by applying exposure compensation.

Sunny, cloud-free days will create strong, dark shadows.

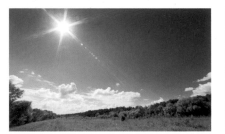

Cloudy days will produce an even light with few strong shadows.

Program mode

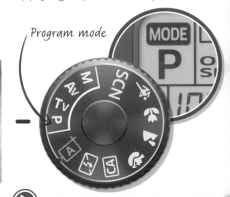

6 Adjust exposure compensation
If the histogram shows the highlights are clipped, apply negative compensation to make the image darker. If the shadows are clipped, apply positive compensation and assess the histogram again.

7 Take a shot
Press halfway down on the shutter button to focus and to make a final exposure reading. Take the shot when you are happy that the focus and exposure are correct for the effect you want.

8 Check your shot
Look at the shot in Playback and check the histogram. If necessary, adjust exposure compensation again and reshoot.

Exposure compensation is set via either a dial or a menu screen

Underexposed histogram

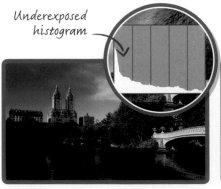

Overexposed histogram

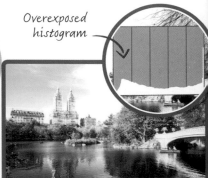

Where to start: Find a location with even lighting and without strong shadows or very bright areas. Shoot a correctly exposed scene using your camera's exposure tools.

You will learn: How to use your camera's histogram to assess exposure, and how to use exposure compensation to adjust it, if necessary.

3 Select Evaluative metering

Program mode will let you select the metering mode. Opt for Evaluative metering – while not 100 per cent accurate every time, it's a good general-purpose choice.

The symbol for Evaluative (Matrix) metering may look like this

4 Use Live View

Switch to the Live View display, which will make it easier to see the effects of adjusting the exposure. You may need to set the Live View display to simulate exposure by using the camera's menu system.

The Live View button may look like this

5 Live View histogram

Check the histogram displayed in Live View, if possible, so that you can assess exposure before shooting. Remember, there is no right or wrong histogram shape. However, check that the histogram is not clipped at either end.

Correct exposure histogram

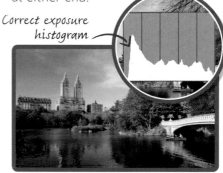

Good range of tones

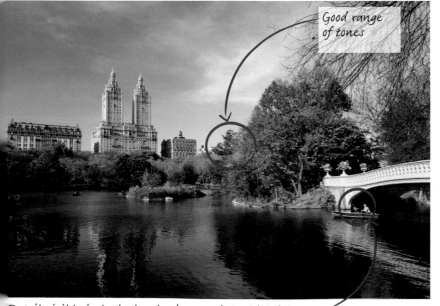

Detail visible in both the shadows and the highlights

WHAT HAVE YOU LEARNED?

■ Selecting Program mode will give you control over the exposure levels, allowing you to adjust the image before you take the photo.

■ Using a histogram – in Live View or after shooting – is a far more accurate way of assessing exposure.

■ Exposure compensation is a simple method of adjusting exposure before you shoot.

Exploring exposure

Digital photography makes it easy to experiment with exposure and see the results instantly. The key is not to worry if things go wrong; making mistakes is often the best way to learn. For these assignments, leave your camera in Program mode so that you can alter functions such as exposure compensation.

If skin highlights burn out, adjust the exposure compensation.

CREATIVE EXPOSURE

- 📊 **EASY**
- 🕐 **1 HOUR**
- 🎥 **BASIC +** tripod
- 📍 **INDOORS OR OUTDOORS**
- ➕ **A MODEL**

You can change your camera's exposure setting to alter the mood of a photo. Underexposing a photo will make it feel more sombre. Overexposing will make a photo look and feel lighter.

- **Mount** your camera on a tripod.
- **Shoot** the scene at the exposure suggested by the camera.
- **Set** exposure compensation to -1 and reshoot.
- **Take** a shot at +1 exposure compensation, and compare the shots.
- **Experiment** using lower negative and higher positive exposure compensation values.

ⓘ KIT: **HANDHELD LIGHT METER**

Handheld light meters work in a different way to the meter in your camera. A handheld meter measures the light that falls onto a scene: this means that a handheld meter is not affected by the reflectivity of a scene. A handheld meter is therefore more accurate than the meter in a camera.

The exposure readings from a handheld meter must be set on your camera using manual exposure, which is a slow process. For this reason, handheld meters are more suited to landscape photography or working in a studio, and not for action shots.

Pro tip: Remember that exposure compensation should be reset to 0 when you finish shooting. Unless it is reset, all your subsequent photos will be incorrectly exposed.

Pro tip: You need to press the shutter button for each shot in a bracketed sequence. Combine bracketing with self-timer and the camera will shoot the entire sequence automatically.

USING SPOT METERING

- 📶 **MEDIUM**
- 🕐 **30 MINUTES**
- 📷 **BASIC +** camera with Spot metering function
- 📍 **INDOORS OR OUTDOORS**
- ➕ **A WELL-LIT SCENE**

Spot metering allows you to precisely meter from specific areas of a scene. It is most useful when you need to meter from a mid-tone area.

- **Set** the metering mode to Spot metering. Not all cameras feature a Spot metering mode; some have Partial metering, which is similar to Spot metering – if necessary, use this instead.

- **Find** an area of mid-tone in the scene and Spot meter from there. Grass and rocks are natural features that exhibit mid-tones.

- **Lock** the exposure and recompose if necessary.

- **Spot meter** from the brightest area of the scene and reshoot. Do the same after metering from the darkest area of the scene. Compare the exposure of all three shots.

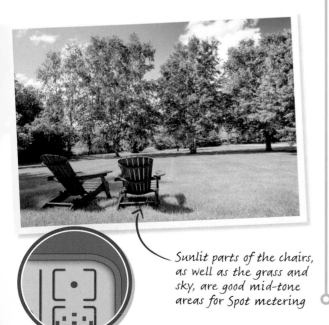

Sunlit parts of the chairs, as well as the grass and sky, are good mid-tone areas for Spot metering

A BRACKETED SEQUENCE

- 📶 **MEDIUM**
- 🕐 **30 MINUTES**
- 📷 **BASIC +** tripod
- 📍 **INDOORS OR OUTDOORS**
- ➕ **A WELL-LIT SCENE**

Bracketing, which is the practice of taking shots that are slightly underexposed and slightly overexposed from the correct exposure, can be a useful safety net, particularly if you're not quite sure what the exposure should be. Many cameras offer auto exposure bracketing, and will typically shoot three photos at different exposure settings: at the correct exposure, underexposed, and overexposed.

- **Mount** your camera on a tripod and select auto exposure bracketing.

- **Adjust** the range of exposures so that there is the maximum difference between the under- and overexposed photos.

Bracketing lets you play with different exposure effects, such as long shutter speeds.

WHAT HAVE YOU LEARNED?

- You don't have to stick to the exposure chosen by your camera. It can be varied for effect.
- Where you Spot meter from will affect the exposure for that specific area.
- Bracketing gives you more options for photo editing – at the expense of memory card space!

▶ ASSESS YOUR RESULTS
Reviewing your shots

After you've spent a week experimenting with exposure, look through the results. Pick out your best shots, showing for example where you used exposure creatively or when you solved a tricky problem. Use this checklist to assess what has worked and where you could improve.

Is your image sharp?
Camera shake is caused by a camera moving during the exposure. You could increase ISO and shutter speed to avoid camera shake or, like this shot, use a long shutter speed to exaggerate movement.

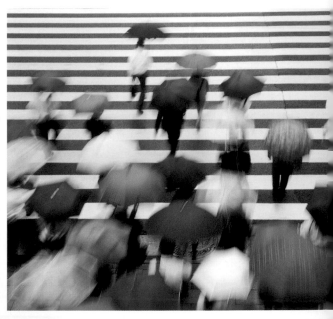

Is your image underexposed?
Underexposure can be corrected in post-production, but this will greatly reduce image quality. It would be difficult to correct this shot without a loss in image quality.

Are your shadows too dark?
You may prefer your shadows to be dark for aesthetic reasons. This shot may look underexposed, but the effect is dramatic.

Is your image overexposed?
There is less image quality loss when correcting an overexposed photo in post-production. This shot is overexposed but, because the highlights have not burnt out, it could be adjusted.

Pro tip: High-key photos are created by adding more light – such as from a flash – into the shadows to even out the exposure. Overexposure can be used to create a similar effect.

Pro tip: Low-key photos are created by restricting the amount of light falling onto a scene – usually by controlling where light does and does not fall. Underexposure can be used to mimic this effect.

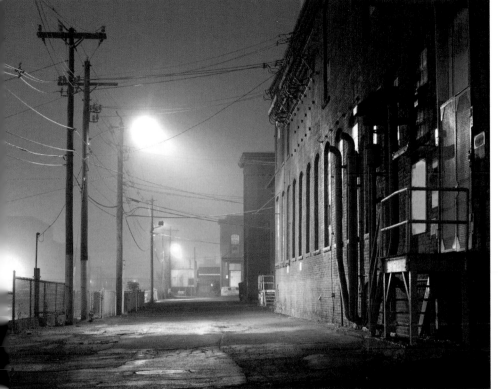

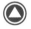 **Are your image highlights burnt out?**
You usually set exposure so that the brightest parts of the image are not burnt out. Certain subjects make this impossible to avoid, but in some cases this can have a positive effect.

 Did you spot meter from the right place?
This stone road is almost all mid-tone and would make a good subject for accurate selective Spot metering.

Is part of your image exposed incorrectly?
A camera can't record the full range of brightness in a high-contrast scene such as this one, so there is a compromise between loss of detail in the shadows or the highlights.

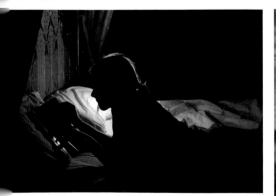

Where are the mid-tones?
In this scene, the ideal mid-tone is the lit headboard. Spot metering from this point would produce ideal exposure.

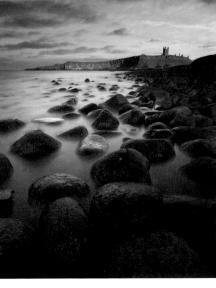

▶ ENHANCE YOUR IMAGES
Reducing noise

Noise is a random pattern of variations of brightness or colour in a photo. The penalty for increasing the ISO setting is a marked increase in the visibility of image noise. Fortunately, this can be reduced in post-production. The key is to not apply too much noise reduction, as this can remove fine detail. It can also cause a photo to look artificially smooth and lacking in texture.

Shot at ISO 6400, this photo suffers from image noise when viewed close up.

1 Assess your photo
Not all photos need noise reduction applied. View your photo at 100 per cent to see whether noise is a problem. Pay particular attention to areas of even tone, such as sky, and to the darkest areas of the photo.

Noise is found in shadows and areas of dark tones

Noise can also be seen in areas of flat tone

4 Set Preserve Details
Drag the Preserve Details slider to recover any fine detail that may have been lost by using the Strength slider. Stop when noise starts to reappear. Preserve Details is adjusted as a percentage.

See texture return as you drag the slider

Preserve Details: 37 %

5 Reduce Color Noise
Colour noise is seen as blotches of random colour, usually only when a very high ISO setting has been used. Slowly drag the slider until the natural colours of your subject show through.

The photo is relatively free of colour, so only a low value is needed

Reduce Color Noise: 12 %

6 Set Sharpen Details
Applying noise reduction can slightly soften an image. Use this third slider to add sharpness back into your photo. Do not sharpen an image if you plan to resize it later.

Sharpen Details: 0 %

> A photograph is the
> **pause button** on **life.**
> TY HOLLAND

2 Use the Reduce Noise filter

Select the Reduce Noise filter and vary the amount of correction applied. Typically, the higher the ISO value you selected at the time of shooting, the more extreme your post-production correction will need to be.

Select Preview to see the changes to your photo

☑ Preview

3 Select the strength of noise reduction

Adjust the Strength slider to tackle the luminance noise. Luminance noise adds a gritty texture to a photo, caused by small, random changes in the photo's brightness. The Strength slider goes from 0 to 10; 10 applies maximum reduction.

Drag the slider until you see the noise disappearing

Strength: 6

Corrected image has less image noise

IN-CAMERA FIXES

Using a low ISO
If you handhold a camera in low light with a low ISO setting, you run the risk of camera shake because a slower shutter speed is usually necessary. Fit your camera onto a tripod.

Setting noise reduction
Cameras have built-in noise reduction to combat high ISO noise. Noise reduction (NR) can often be adjusted to vary the amount of correction, and needs to be set before shooting.

Noise reduction setting

What have you learned?

In this module you've learned about exposure and the variables that can alter how a photo is exposed. Try these multiple-choice questions to see what else you've learned.

1 **What is the fastest** typical shutter speed on a dSLR?

A 1/4,000 sec B 30 sec C 1/500 sec

2 **What type of exposure meter** is built into your camera?

A Incident meter B Reflection meter
C Reflective meter

3 **What metering mode** would you use to meter from a small area of a scene only?

A Evaluative metering B Spot metering C Centre-weighted metering

4 **What visual effect** becomes more pronounced the higher the ISO setting you select?

A Noise B Turbulence C Commotion

5 **What climatic condition** softens shadows in a scene?

A Bright sunshine B Mist C Wind

6 **What ISO setting** results in the least amount of noise?

A The lowest ISO B The highest ISO
C Noise is constant at all ISO settings

7 **A Spot meter** typically measures what percentage of a scene?

A 90–100% B 1–5% C 40–50%

8 **A scene** that has higher-than-average reflectivity can cause what?

A Glare
B Overexposure
C Underexposure

9 **What do you risk** when handholding a camera and using a slow shutter speed?

A Converging verticals
B Camera shake
C Noise

10 **A histogram** that is skewed to the left is an indicator that a photo is...?

A Potentially underexposed
B Potentially overexposed
C Correctly exposed

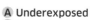

11 **The longest** available shutter speed on a dSLR is what?

A 1 second
B 15 seconds
C 30 seconds

12 **The lowest** ISO setting on a camera is known as...?

A Base ISO B Selective ISO
C Special ISO

13 **Which metering mode** is typically the default option?

A Spot B Evaluative
C Centre-weighted

14 **What would you need to do** to freeze movement?

A Use a fast shutter speed
B Use a slow shutter speed
C Increase the ISO

15 **Increasing the size** of the aperture by one stop has the effect of what?

A Letting twice as much light into the camera
B Making no change
C Halving the amount of light entering the camera

16 **Centre-weighted metering** measures what percentage of a scene?

A 100% B 1–5% C 60–80%

17 **When highlights** are white in a photo, they are what?

A Underexposed
B Burnt out
C Preserved

18 **What aspect of a digital sensor** is controlled by ISO?

A Sensitivity to light B Colour
C Temperature

Answers 1/A, 2/C, 3/B, 4/A, 5/B, 6/A, 7/B, 8/C, 9/B, 10/A, 11/C, 12/A, 13/B, 14/A, 15/A, 16/C, 17/B, 18/A.

05

week

ACHIEVING THE RIGHT CONTRAST

Contrast is the difference in brightness between the shadows and the highlights of an image. Understanding contrast and learning how to achieve different contrast effects will give you greater scope for creating photos that leave a strong visual impression.

In this module, you will:

▶ **discover what contrast is** and how it affects your photos;
▶ **understand how lighting** affects contrast;
▶ **learn what the dynamic range** of your camera is;
▶ **apply your new knowledge** and shoot an HDR photo;
▶ **experiment with** high- and low-contrast light;
▶ **enhance the contrast** in post-production;
▶ **review your understanding** of contrast and see if you're ready to move on.

Let's begin...

The "right" level of contrast is, of course, simply the one that is best for the subject and the image you want to create. These seven photographs demonstrate different levels of contrast. Can you match each characteristic with the relevant image?

A **Normal contrast:** When shadows aren't too deep and highlights aren't too bright.

B **High contrast:** When the difference in the brightness of the shadows and highlights is marked.

C **Low contrast:** When the difference in the brightness of the shadows and highlights is small.

D **Very high contrast:** When the difference between the brightness of the shadows and highlights is extreme.

E **Very low contrast:** When there is virtually no difference in the brightness of the shadows and the highlights.

F **HDR:** An high-dynamic-range photo is a blend of two or more photos to solve a problem with contrast. The results are striking though often unrealistic.

G **Split contrast:** When one area of the scene is in low contrast, while another area is in high contrast.

NEED TO KNOW

■ Creating a successful photo means understanding how contrast will affect that photo, and learning how a camera "sees". This takes practice, but by persevering it is possible to know when contrast is either too high or too low.

■ High contrast generally needs to be corrected at the time of shooting, either by altering the quality of the light or by waiting until the light changes naturally.

■ An extreme level of contrast is rarely seen in nature, although photographs can be adjusted so that they are very high-contrast.

■ Low contrast is more easily adjusted in post-production or by using in-camera fixes during the actual photoshoot (see pp.98–99).

Review these points and see how they relate to the photos shown here

> **UNDERSTAND THE THEORY**
The effects of contrast

It is the quality of the light illuminating a scene that determines the level of contrast. Light is described as hard or soft: hard light causes high contrast; soft light results in lower contrast. What defines a light as hard or soft depends on the size of the light source compared to the scene.

Hard light comes from a point light source – one that is small in comparison to the scene it illuminates. Soft light is created by a relatively large light source.

HARD LIGHT/HIGH CONTRAST
Point light sources cast deep, sharply defined shadows and create small, bright highlights. The sun in a cloudless sky or a single bare light bulb in a room are both point light sources.

HARD LIGHT

Portraits Hard light emphasizes facial features by casting deep shadows. Using hard light/high contrast for portraiture produces dramatic photos but can also lead to unattractive highlights.

Buildings Hard light highlights and accentuates shapes, making it particularly suitable for modern buildings with a geometric design. Bright highlights on glass can create exposure problems.

Landscape Hard light is excellent for defining the shapes of inorganic details, such as rocks, but the contrast is less attractive when shooting organic subjects.

Point light source

Bright, focused highlights

Hard-edged shadows

> **Contrast** is what makes photography **interesting.**
> CONRAD HALL

SOFT LIGHT/LOW CONTRAST

Soft light sources cast very pale, soft-edged shadows – or none at all when a light source is particularly soft – and highlights are muted. Sunlight diffused by cloud is a soft light source.

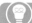

ⓘ SHADE

The ambient light of a shaded area is soft. When shooting details or small items, casting a shadow over the subject will lower the contrast. Ensure the whole of the area "seen" by the camera is in shade: if any part of the shot is in direct sunlight, then the contrast will be higher than the camera can successfully capture. You can use your camera's histogram to check contrast.

High contrast Two peaks separated by a wide gap indicates high contrast.

Low contrast One narrow peak indicates that the scene is very low contrast.

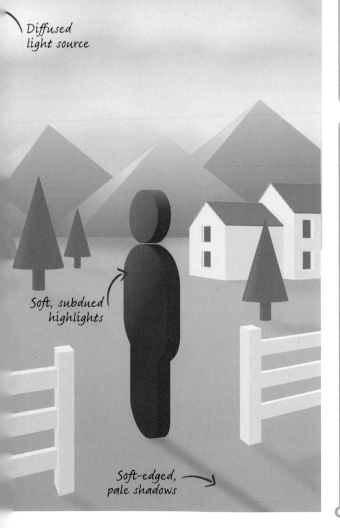

Diffused light source

Soft, subdued highlights

Soft-edged, pale shadows

💡 SOFT LIGHT

Portraits Soft light removes the emphasis from the shape of facial features. It is typically used when shooting female subjects or children.

Buildings With few shadows to define shape, details are often harder to see. Bright highlights on glass are reduced, but the material can look grey and flat.

Landscape Soft light means that there are few shadows to create interesting details in wide-open landscapes. However, soft light is excellent for close-ups of organic subjects such as flowers.

Cameras vary in the range of detail that can be recorded between the darkest part of a scene and the lightest. A camera that can record a wide spread of tones without loss of detail is said to have a high dynamic range, whereas cameras that can only record a narrow band of tones have a low dynamic range. The dynamic range of a camera is important when shooting high-contrast scenes. It determines how well detail can be recorded in both the shadows and highlights without them being lost, or "clipped".

HUMAN EYE

DIGITAL COMPACT

DSLR

ℹ HUMAN EYE VS CAMERA

The human eye can generally see a broad range of tones from black to white. In high-contrast light, a camera with a low dynamic range will capture fewer tones. You should set the camera to expose for the shadows and burn out the brightest highlights (see left), or expose for the highlights and lose detail in the shadow areas (see right).

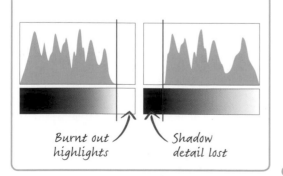

Burnt out highlights

Shadow detail lost

HDR CAPTURE

One technique to get the full tonal range of a scene is to shoot two or more exposure bracketed photos. These images can then be blended in-camera, or in post-production later; such photos are known as High Dynamic Range (HDR) images.

↑ Dynamic range

Shot 1: Exposure captures details in the highlights.

Pro tip: Low-contrast scenes generally benefit from an increase in contrast. You can do this either by setting a picture parameter that boosts image contrast prior to making the shot, or by adjustment in post-production afterwards.

Pro tip: Squint when you look at a scene. A good indication of high contrast is when detail in the shadows is not visible when you're squinting. This is a rough – but useful – way to see whether contrast may be a problem.

Gradation range

The range of brightness the **human eye** can see.

| Pure black | Gradation range | Pure white |

The range of brightness that can be captured by a camera with a **low dynamic range**.

| Pure black | Gradation range | Pure white |

The range of brightness that can be captured by a camera with a **high dynamic range**.

Dynamic range

Shot 2: Detail is retained in the shadows.

Dynamic range

HDR image: Exhibits combined tonal range of both shots.

SENSOR SIZE

The smaller the sensor inside a camera, the lower the dynamic range of the camera. It is generally more difficult to achieve an ideal exposure of shadows and highlights with a compact camera. Cameras with larger sensors – such as dSLRs – can retain detail in both the shadows and highlights more easily.

35mm full frame　　**APS-C**　　**¹/1.8**

CONTRAST

When contrast is high it can be difficult to capture the full tonal range of a scene. One solution is to shoot subjects that benefit from high contrast to help define their shape.

For softer subjects, a better solution is to lower contrast (and reduce the tonal range) by using a fill light such as flash to lighten dark shadows.

When shooting outside, wait until clouds soften the sun's light and contrast is naturally lower.

▶ LEARN THE SKILLS
Shooting an HDR photo

HDR (High Dynamic Range) is a technique for creating photos with a wide range of tone and detail in both the shadows and the highlights. The technique involves shooting a sequence of photos using a wide range of exposures, and then blending them together. Many cameras can now create HDR photos.

1 Assess your location
Look at the scene around you to see if there is a noticeable difference between the brightness of the shadows and the highlights. If so, then HDR will be appropriate.

2 Fit your camera to a tripod
HDR requires the shooting of two or more photos, so use a tripod to avoid the camera moving between exposures.

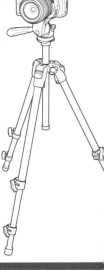

This image has dark shadows in the ruin's corners and bright highlights in the clouds

6 Take a photo
HDR is suited to subjects that don't move. A subject that moves can cause strange visual effects in the final HDR photo. Watch the scene closely for movement, and only shoot when you are confident that the scene is entirely still.

No detail in highlights

7 Review your shot
Look at your shot in Playback to see if there have been any odd effects caused by movement during the HDR process.

Check that there is detail in the shadows and highlights using the histogram

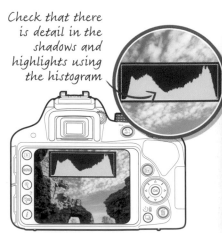

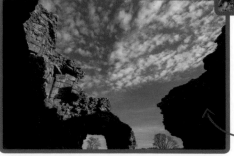

The camera takes a set of photos at different exposures.

No detail in shadows

Where to start: Select a subject suitable for an HDR photo. It should feature contrast that is beyond a camera's normal dynamic range and where there is little movement in the scene.

You will learn: How to shoot a high dynamic range photo in-camera, how to check whether the image is successful, as well as what can go wrong during the shooting process.

3 Choose HDR

Select HDR as shown in your camera manual. HDR is either found as one of a suite of different effects modes or as a separate menu option.

The HDR symbol may look like this

4 Choose the correct settings

Adjust the HDR settings on your camera to suit. If there are no options available, then the camera will shoot a set number of photos and blend them automatically.

DSLRs often let you set how many photos are blended

5 Select self-timer or use a remote release

Use the camera's self-timer or a remote release to reduce the risk of accidentally knocking the camera when pressing the shutter button.

A remote release is the better option if you need to fire the shutter at a specific moment

Detail in shadow

Detail in highlights

WHAT HAVE YOU LEARNED?

■ HDR is suitable when the exposure cannot be set to retain detail in the highlights and the shadows.

■ HDR should not be used when contrast is normal or low and the tonal range is within a camera's dynamic range.

■ Some subjects aren't suitable for in-camera HDR shooting. Windblown subjects, such as trees or flowing water, will cause odd visual effects.

▶ PRACTISE AND EXPERIMENT
Playing with contrast

There is no right or wrong answer as to what level of contrast is right for a photo: the key is to choose the level that is appropriate for the subject. There are several ways to learn about contrast. Looking at the work of other photographers is one very useful method. However, nothing beats practical experimentation. These assignments provide an introduction to the effects of contrast. You'll need to set your camera to Program mode.

SHOOTING IN SUN AND SHADE

- **EASY**
- **2 X 2 HOURS**
- **BASIC +** tripod
- **OUTDOORS**
- **WOODLAND LOCATION**

Although woodland is attractive in bright sunshine, the effects of light and shade can produce very high contrast. It is often easier to produce pleasing woodland photos on overcast days.

- **Spend** two hours photographing scenic and close-up shots in an area of woodland on an overcast day.
- **Mount** your camera on a tripod to avoid camera shake.
- **Return** to the same location on a day with bright sunshine. Repeat your original compositions and note the difference between the two sets of photos.

SHOOTING IN SOFT LIGHT

- **MEDIUM**
- **1 HOUR**
- **BASIC +** tripod
- **INDOORS**
- **MODEL**

Without direct sunlight, light filtered through a window is usually soft and low in contrast. This is ideal for shooting photos with a romantic or innocent feel.

- **Place** your model close to a window so that the light is illuminating your model's face from the side.
- **Mount** your camera on a tripod and shoot five to ten images. Ask your model to move closer to and away from the window.
- **Review** the photos and note how the contrast changes depending on the model's distance from the window.

Adjust the exposure compensation to avoid overexposure.

Pro tip: Even on overcast days, the sky is far brighter than the ambient light of woodland. Sky often burns out when the exposure is set correctly for woodland. Removing sky from the composition will avoid large areas of detail-free white in your photo.

Light levels may be low, so use an ISO of 400 or even 800

ND GRADUATED FILTER

An ND graduated filter can help solve a common problem with landscape photography: the difference in brightness between the sky and the foreground. The filter is split into a clear bottom half and a semi-opaque top half, which reduces the brightness of the sky so that the exposure matches the foreground. ND graduated filters are available in different strengths. The most common are 1-stop, 2-stop, and 3-stop. The strength required will depend on the exposure difference between the foreground and sky, which you can check by using your camera's Spot meter.

POINT LIGHT SOURCE

📊 **MEDIUM** 📍 **INDOORS**

🕐 **1 HOUR** ➕ **MODEL AND DESK LAMP**

📷 **BASIC +** tripod, telephoto lens

Point light sources, such as a desk lamp, don't provide subtle illumination, but they are ideal for adding drama to a portrait.

- **Work** in a room that can be darkened. Ask your model to sit down and illuminate them from one side using a desk lamp.

- **Set** your camera up on a tripod and attach a short telephoto lens.

- **Darken** the room so that the only source of light is the desk lamp.
- **Experiment** by moving the lamp to different positions as you shoot.
- **Review** the photos to see how contrast changes between the shots.

WHAT HAVE YOU LEARNED?

- Soft light is lower in contrast and more subtle than hard light, and, as such, best suits soft, organic subjects.
- Bright sunshine in a woodland setting will create high levels of contrast, which can produce confusing images.
- One small point light source produces high-contrast lighting.

Once you've completed the assignments, pick out your best shots. Use the notes here to help assess what has worked in your photos and what could be improved.

Is your HDR photo successful?
A successful HDR photo should have detail in both the shadows and the highlights, as in this photo. If yours does not, the exposure range needs to be increased.

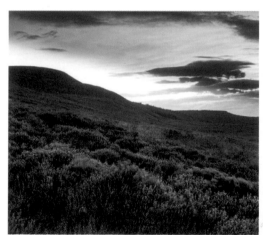

Is there a bright band on your landscape horizon?
When an ND graduated filter is placed too high, it won't cover the entire sky. This can lead to an unnatural bright strip close to the horizon, as shown here.

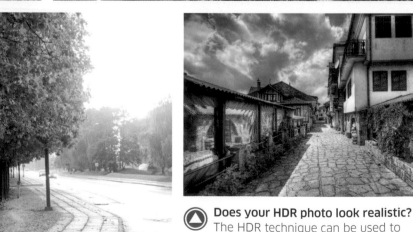

Are large areas of your photo burnt-out?
A burnt-out or pure white area in a photo can be a distraction. Here, the photographer could have prevented a burnt-out sky by shooting when the sun had moved and contrast was lower.

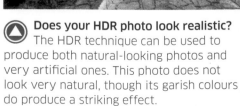

Does your HDR photo look realistic?
The HDR technique can be used to produce both natural-looking photos and very artificial ones. This photo does not look very natural, though its garish colours do produce a striking effect.

Pro tip: We tend to notice brighter areas of a photo more readily than darker areas. Highlights that are brighter than your subject may therefore be more eye-catching. Try to exclude bright areas from a photo if they are not necessary to the composition.

Pro tip: Whether exposure is set to retain highlights or shadows is a choice you often have to make. As a general rule, expose to retain detail in the highlights: dark shadows look more natural than burnt-out highlights.

Is your woodland a mess of shadows and highlights?

Woodland in bright sunshine makes for a high-contrast scene and a confusing image of dark shadows and bright highlights. This photo would arguably work better in softer light when contrast is lower.

Is your photo low-contrast?

Some scenes are naturally low in contrast, which can make for very flat-looking photos. It is for you to decide if contrast should be added in post-production. Would you adjust the contrast in this photo?

Do the shadows lack detail?

High contrast may make it difficult to retain detail in the shadows. Whether this is important will depend on your subject. The shadows in this photo are very dark, but they add to the photo's impact.

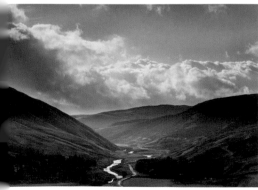

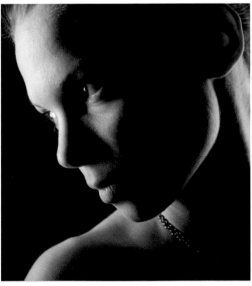

Is the top of your subject dark?

An ND graduated filter will darken any vertical element it covers, and should be used sparingly where there isn't a straight horizon. The ND graduated filter is all too obvious on the hilltops in this photo.

▶ ENHANCE YOUR IMAGES
Adjusting contrast

The aim of adding or reducing contrast in post-production is to produce an image with a pleasing range of tones that enhances your subject. When your photos need added punch, Adobe Photoshop's Brightness/Contrast tonal adjustment tool is very quick and easy to use.

Shot using RAW, this image was flat and lacking in contrast when opened

1 View the histogram
A useful tool that will help you make accurate tonal adjustments is a histogram. This lets you see how the tonal range of your image is affected as you use Brightness/Contrast. To access it, pull down the "Window" menu and select Histogram.

The histogram can be used in conjunction with many other adjustment tools

4 Add contrast
To increase contrast, drag the "Contrast" slider to the right. The shadows in the image will become darker and the highlights brighter. The colour also becomes more intense and vibrant.

Increasing contrast raises the risk that highlights will burn out

Add a value between 0 and 50 to the Contrast box to strengthen contrast, and a value between 0 and -50 to reduce it

Contrast: 27

5 Adjust the brightness
Use the Brightness slider to alter the lightness or darkness of your photo. To darken this photo, the slider has been moved to the left.

Darkening the photo has added detail and impact to the clouds

Brightness can be adjusted numerically between -150 and 150

Brightness: -45

Pro tip: Reducing the contrast of a high-contrast photo can lead to an unwanted loss of image quality. It is better to start with an image where there is little difference between highlights and shadows and then add contrast.

2 Select Brightness/Contrast

Go to the top menu and select Image, then Adjustments, then Brightness/Contrast. Check the Preview box so that you can see how your photo is altered as you adjust the Brightness/Contrast sliders.

Brightness:	0	OK
Contrast:	0	Cancel
		Auto
Use Legacy		✓ Preview

Toggle Preview on and off to see a before and after version of your photo

3 Assess the image

It's a good idea to know how you want the image adjusted before you begin. In this case contrast needs to be increased. However, the photo looks as though it will benefit from a small reduction in Brightness too.

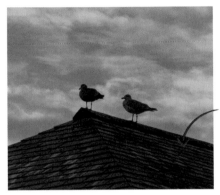

There is little contrast between the grey roof and the clouds in the sky

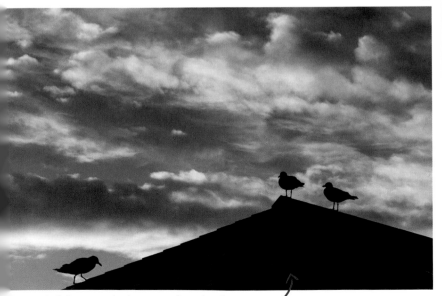

With contrast increased and brightness lowered, the photo has more impact

ⓘ IN-CAMERA FIXES

JPEG images are processed right after shooting according to your camera's picture parameters. These are presets for how sharp the photo is, how vibrant its colours are, and its level of contrast. Picture parameters such as Landscape increase colour and contrast. Others, such as Neutral, affect colour and contrast less, while Low Contrast retains detail in the shadows and highlights. Selecting the right picture parameter before you begin shooting can save valuable time afterwards.

In this module you've learned how the level of contrast depends on your light source and weather conditions, and how contrast can be used to add impact and interest to your photos. Try these multiple-choice questions to see how much you've retained.

1 **What type of light source** causes hard-edged shadows?

A Backlight B Point C Red light

2 **What does HDR** stand for?

A High Density Recording B Horribly Dark Results C High Dynamic Range

3 **Indirect light** through a window produces what sort of contrast?

A Soft and low B Hard and high
C Soft and high

4 **The ambient light** of a shaded area is naturally what?

A Soft B Hard C Bright

5 **What filter can you use** to help retain detail in bright sky?

A Polarizing filter B ND graduated filter
C UV filter

6 **A desk lamp** is what sort of light source?

A Soft B Point C Diffuse

7 **HDR is useful** when a scene is what?

A High contrast
B Badly lit
C Low contrast

8 **The smaller the sensor** the lower the what?

A Contrast
B Shutter speed
C Dynamic range

9 **Overcast light** is very what?

A Red-yellow B Soft C Intense

10 **What type of weather** suits woodland scenes?

A Cloudy B Sunny C Rainy

11 **Retaining detail** in the shadows and the highlights is difficult when light is what?

A High contrast
B Low contrast
C Low

12 **Which parts of a photo** do we tend to notice first?

A The darkest areas
B The brightest areas
C The edges

13 **A histogram** of a low-contrast scene will tend to have what?

A No peaks
B Two separate peaks
C One peak

14 **A point light source** is what compared to the subject?

A Small B Large C Intense

15 **HDR is not suitable** for what?

A Bright subjects
B Moving subjects
C Faraway subjects

16 **An unnatural bright band** on a horizon means that an ND graduated filter was what?

A Not used
B Too slow
C Positioned too high

17 **The light on a cloudless day** can be described as what?

A Soft B Weak C Hard

Answers 1/B, 2/C, 3/A, 4/A, 5/B, 6/B, 7/A, 8/C, 9/B, 10/A, 11/A, 12/B, 13/C, 14/A, 15/B, 16/C, 17/C.

week

06

USING DEPTH OF FIELD

Deciding which areas of the frame should be sharp and which should be out of focus is key to taking a good photo. This zone of sharpness is called depth of field, and it depends on three things: the aperture, the distance between the subject and the camera, and the focal length of the lens.

In this module, you will:

▶ **see how different apertures** affect depth of field;

▶ **examine the theory of depth of field** and the three factors that influence it;

▶ **try it yourself** by following special depth-of-field photoshoots;

▶ **explore how to use** depth of field creatively;

▶ **review your images** to see what's worked, what hasn't, and why;

▶ **improve your photographs** using digital software to alter the depth of field;

▶ **review what you have learned,** and see if you are ready to move on.

Let's begin...

▶ TEST YOUR KNOWLEDGE
What is depth of field?

Using depth of field lets you highlight important elements while downplaying distractions. Use the descriptions here to decide which of these images best displays shallow, medium, or deep depth of field. Some of them could apply to more than one image. Try to choose the closest match.

A **Deep:** Everything in the image is sharp from front to back.

B **Medium:** Objects in the foreground are in focus. Background details are blurry, but still identifiable.

C **Shallow:** A small part of the subject is in focus, the rest blurry.

D **Deep:** Helps reinforce a repeating pattern in an image.

E **Medium:** Background details are recognizable, giving context.

F **Shallow:** Subject focused, background unidentifiable.

G **Deep:** Detail can still be seen in objects farthest from the camera.

H **Medium:** Highlights foreground activity by slightly blurring elements in the background.

I **Shallow:** Viewer's eye is drawn to a small part of the frame.

J **Deep:** All elements are sharp, giving everything almost equal relevance.

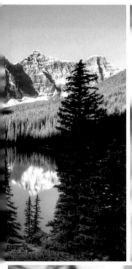

NEED TO KNOW

■ Depth of field can be used to give objects context, blur distracting backgrounds, isolate details, and direct the viewer's eye around the frame.

■ Shallow depth of field can transform a messy background into a wash of colour, letting the main subject take centre stage.

■ When the background is out of focus but still recognizable in a medium depth-of-field image, it tells the viewer that the secondary elements are still relevant.

■ Deep depth of field can emphasize patterns, encouraging the eye to recognize repeating shapes as it travels from the front to the back of the frame.

■ When the picture is entirely sharp, everything has significance, from patches of grass in the foreground to snowy mountain peaks in the distance.

Review these points and see how they relate to the photos shown here

Depth of field

Depth of field refers to the area of acceptable sharpness within an image. In reality, only the element you have chosen to focus on – and anything else located on the same plane – will be perfectly sharp, but a certain area in front of and behind your subject will also appear sharp. This zone of sharpness depends on three factors: the aperture of the lens, the distance between the camera and the subject, and the focal length of the lens. Furthermore, where this zone of sharpness begins and ends depends on where you focus the lens.

APERTURE

The size of the aperture of a lens is indicated by a measurement called an f-number – the smaller the number, the larger the opening. A large aperture (indicated by a small f-number, such as f/2.8) will result in shallow depth of field, whereas a small aperture (indicated by a large f-number, such as f/22) will result in deep depth of field.

f/2.8

f/22

SUBJECT DISTANCE

The closer your lens is to your subject, the less depth of field you will obtain in your image, and vice versa.

Try holding a pencil at arm's length: notice how much of the area around the pencil is acceptably sharp.

Move the pencil towards your face and observe how the background becomes more blurred the nearer it gets to your eyes.

Aperture set at f/2.8 and camera focused on subject 10 m (30 ft) away

Aperture set at f/8 and camera focused on subject 10 m (30 ft) away

Aperture set at f/22 and camera focused on subject 10 m (30 ft) away

> ## "There is nothing worse than a **sharp image** of a **fuzzy concept.**"
> **ANSEL ADAMS**

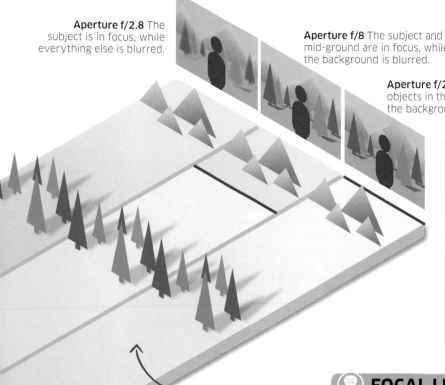

Aperture f/2.8 The subject is in focus, while everything else is blurred.

Aperture f/8 The subject and mid-ground are in focus, while the background is blurred.

Aperture f/22 The subject, objects in the mid-ground, and the background are all in focus.

At f/22, the depth of field is at its maximum

AT A GLANCE

To increase depth of field (or the impression of it), use a small aperture, step back from the subject, or use a lens with a short focal length. Conversely, to decrease depth of field, select a large aperture, step closer to the subject, or use a lens with a long focal length.

FOCAL LENGTH

The focal length of the lens determines how much it can see (known as its angle of view), and how magnified a subject appears in the frame. Shorter focal length lenses (less than 50 mm) have a wide angle of view, so the subject takes up less of the frame than it would if it were shot at the same distance with a telephoto lens. Just as the subject appears magnified with a telephoto lens, so too does any blur. As a result, short focal length lenses appear to offer greater depth of field than long focal lengths.

Short focal length

Subject takes up less of the frame using a short focal length.

Long focal length

Subject appears magnified using a long focal length.

FOCAL POINT

The point at which you focus the lens will affect where the zone of sharpness begins and ends. Depth of field extends from about one-third in front of the point of focus to two-thirds behind it.

One-third in front

Two-thirds behind the point of focus

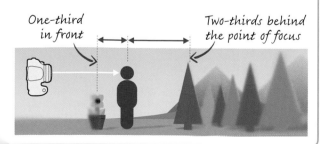

Using shallow depth of field

Keeping a small area of the frame sharp is a great way of directing the viewer's attention to major points of interest. The technique is often used by portrait photographers, who tend to focus on a subject's eyes, allowing messy details to be disguised by blur.

Telephoto lenses have a long focal length and a narrow angle of view.

 1 ## Attach a standard or telephoto lens

For ideal portraiture shooting, attach a lens with a focal length between 50 mm and 105 mm. Shallow depth of field can be achieved with almost any lens, but telephoto lenses give the most dramatic results.

 2 ## Mount the camera on a tripod

Mount the camera on a tripod and then use a remote release to trigger the shutter to minimize any movement.

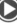 6 ## Use the depth-of-field preview button

Many dSLRs come with a depth-of-field preview button that allows you to see exactly what will appear in focus. Alternatively, you can use a depth-of-field calculation app.

Depth-of-field button

 7 ## Decide on your point of focus

Spend a few moments considering where you would like the viewer's eye to travel to first. With that in mind, select an autofocus point or switch to Manual focus and train the lens on your chosen area.

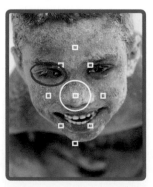

8 ## Shoot and review the results

Take a few shots, play them back, and zoom in to see where the zone of acceptable sharpness begins and ends. If it's not where you hoped it would be, change the settings and try again.

Focusing on your subject's eyes helps the viewer relate to the subject

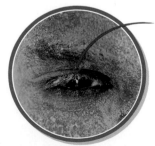

Where to start: Find a willing model and gather together all the necessary equipment, including a telephoto lens, a tripod, and a remote shutter release. You might also consider downloading a depth-of-field calculation app.

You will learn: How to keep a small part of the image sharp while allowing the background to become out of focus and blurred.

 ## 3 Adjust metering, autofocus, and drive modes

Decide on the type of metering you want to use (see pp.78-79) based on your subject. Set your camera to continuous shooting mode.

 ## 4 Use the lowest ISO setting

Select a low ISO speed (such as ISO 100) and decide how much of the subject you would like to appear in focus.

 ## 5 Select Aperture Priority mode

Switch to Aperture Priority and choose a large aperture (such as f/4) to keep shutter speed fast and enable you to freeze any movements made by your subject.

A low ISO speed will produce pictures full of detail and colour

Setting a large aperture will produce a small depth of field

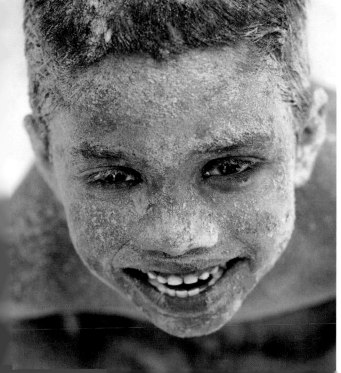

Shooting an engaging portrait requires skill, sensitivity, and confidence.

WHAT HAVE YOU LEARNED?

■ Creating a shallow depth of field is as much a technical exercise as a creative one.

■ To get the best effect, you need to use a lens with a focal length of 50 mm or more, a large aperture, and continuous firing to catch any changes in your subject's expressions.

■ Using Aperture Priority mode allows you to set the size of the aperture, giving you the greatest control over the depth of field.

Using deep depth of field

When everything in the frame is in focus, the viewer knows that all of the elements are important. The deep depth-of-field technique is used by landscape photographers who deploy lead-in lines such as fences and rivers – or, in the case below, rows of flowers – to direct the viewer's gaze around the frame.

Wide-angle lenses give the impression of increased depth of field.

 ## 1 Attach a standard or wide-angle lens

Deep depth of field can be achieved with almost any lens, but for the most effective shots, attach a wide-angle lens. These lenses have a short focal length and a wide angle of view.

 ## 2 Mount the camera on a tripod

When you use small apertures, you often need to use a slow shutter speed. If you try to handhold the camera during a long exposure, the risk of camera shake is significant. To avoid this, mount the camera on a tripod and use a remote shutter release.

You can also use your camera's self-timer

 ## 6 Decide on your point of focus

Chose a specific area of the scene to focus on. As a rough guide, depth of field extends from one-third in front of the point of focus to two-thirds behind it.

Focus point — *Area in focus*

7 Find the hyperfocal distance

To achieve front-to-back sharpness, you need to find the hyperfocal distance. Focus your lens on infinity and train the lens on the horizon. Press the depth-of-field preview button to find the nearest part of the scene that's sharp (the hyperfocal point) and refocus here.

Use the infinity symbol on the lens barrel to find the hyperfocal distance

8 Shoot and review the results

Take a few shots, play them back, and zoom in to see where the zone of acceptable sharpness begins and ends. If it's not where you hoped it would be, change the settings and try again.

Where to start: Choose a landscape where everything from the foreground right through to the background has some relevance and needs to be in focus. Look for lead-in lines that will draw the viewer's eye into and around the picture.

You will learn: How to shoot a landscape with the aim of keeping everything in the frame in focus. You will do this by using a small aperture and by carefully calculating the hyperfocal distance.

3 Adjust metering, autofocus, and drive modes

As always, what type of metering you want to use (see pp.78-79) will depend on the subject. Decide on whether to take a single shot or to keep the shutter firing depending on whether or not your subject is moving and, if so, how quickly.

Continuous shooting mode lets you take multiple images

4 Choose the correct ISO setting

When you're using small apertures, the light reaching the sensor is reduced, forcing the use of slow shutter speeds. If your subject is moving, you may want to consider raising the ISO.

Increase the ISO to keep a fast shutter speed

5 Select Aperture Priority mode

Switch to Aperture Priority and choose a small aperture. Some lenses are less effective at their minimum and maximum apertures, so select an f-stop (see p.76) a few steps away from the extremes.

Aperture Priority

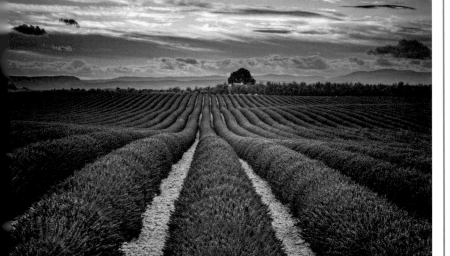

WHAT HAVE YOU LEARNED?

■ In order to achieve deep depth of field, you need to use a standard or wide-angle lens and mount the camera on a tripod to avoid camera shake.

■ Using small apertures will result in slow shutter speeds, so if your subject is moving you may need to boost the ISO speed – try not to go beyond ISO 800 though, as the image quality will suffer.

Be sure to always save your best images

Exploring depth of field

There are no rules insisting that landscapes must be sharp from front-to-back, or portraits shot with shallow depth of field, so experiment with different aperture sizes and varying distances between you and your subject until you get the effect you desire.

MOVING IN CLOSE

- **EASY**
- **45 MINUTES**
- **BASIC +** tripod
- **INDOORS OR OUTDOORS**
- **SMALL AND MEDIUM-SIZED OBJECTS**

If you focus on a subject 10 m (30 ft) away, the zone of sharpness will be greater than if you train your lens on a subject just 1 m (3 ft) away.

- **Set** the aperture to f/11 and take a shot of an object 10 m (30 ft) away.

- **Use** the same focal length and aperture to take a photograph of an object 1 m (3 ft) away. Note how depth of field grows as the distance between camera and subject increases.

- **Find** a small object, and move in close to take a picture. Depth of field is extremely shallow when you are close to your subject.

ISOLATING A SUBJECT

- **EASY**
- **45 MINUTES**
- **BASIC +** tripod
- **INDOORS OR OUTDOORS**
- **A CLEAR SUBJECT AND BACKGROUND**

Shoot an object using a large aperture (such as f/4) and a small aperture (such as f/16) without changing your position.

- **Note** how the foreground and background fall out of focus, and the subject becomes more isolated, as the aperture gets wider.

- **Observe** the effect that changing the aperture has on depth of field, and play around with the idea.

- **Shoot** a row of objects, such as a collection of bottles, trying to keep one, two, or three of the items in focus simply by changing the aperture.

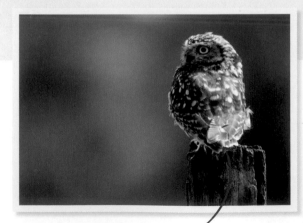

Using a large aperture has isolated the subject against a blurry background

Pro tip: When light is forced through a small aperture, it bends slightly, resulting in softer images – this is known as diffraction. To ease the problem, use an aperture two stops down from the smallest setting when trying to obtain deep depth of field.

CHANGE THE FOCUS

- .ıl **EASY**
- ◐ **45 MINUTES**
- ▣ **BASIC** + tripod
- ⊙ **INDOORS OR OUTDOORS**
- ⊕ **A BUSY SCENE WITH SEVERAL FOCAL POINTS**

As we have seen, the viewer's eye is attracted to the sharpest part of the picture first, so you need to choose your point of focus carefully.

- ■ **Decide** which area you would like to prioritize.
- ■ **Select** an autofocus point that covers this area. If none do, place your subject in the middle of the frame, press the shutter-release button halfway to lock focus, and recompose the picture. Alternatively, switch the lens to Manual focus and rotate the focusing ring until your chosen point appears sharp.
- ■ **Use** the depth-of-field preview button to check how much of the scene will appear in focus before taking a shot.

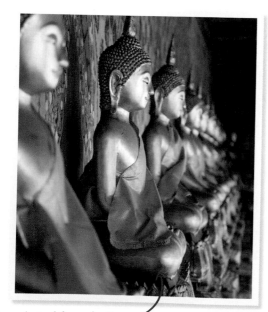

The point of focus is the second Buddha in the row

STANDING OUT

- .ıl **MEDIUM**
- ◐ **1 HOUR**
- ▣ **BASIC** + tripod
- ⊙ **INDOORS OR OUTDOORS**
- ⊕ **SUBJECT IN RELEVANT BACKGROUND**

Sometimes, subjects are so dependent on their environment that it's best to keep the background recognizable, but not completely sharp.

- ■ **Switch** the camera to Aperture Priority, and select an f-number that's roughly halfway between the settings available for the lens you're using.
- ■ **Use** the depth-of-field preview button to check how much of the scene will appear in focus before taking a shot.
- ■ **Switch** to a smaller aperture and try again if the background is not sharp enough.

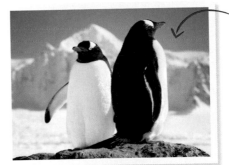

Keeping the background recognizable helps us to place these penguins in the Antarctic

WHAT HAVE YOU LEARNED?

- ■ Large aperture equals shallow depth of field.
- ■ Small aperture equals deep depth of field.
- ■ The closer the subject is to the lens, the less depth of field there is.
- ■ By choosing a mid-range aperture, you can keep the main subject in focus while still keeping the background identifiable.

Reviewing your shots

Having experimented with different apertures, lenses, and focal points, choose your favourite photographs and run through the checklist below. Reviewing your work is an important part of the learning process, so spend some time analysing what has worked and what hasn't.

⚥ Is the aperture appropriate?
Have you selected an aperture that draws attention to the main subject? In this image, the globe holds our gaze without us becoming distracted by the girl's green jumper.

▲ Does any blur look intentional?
When you add blur for artistic effect it needs to look intentional. None of the trees in this orchard are completely sharp, but the blurriness gives a sense of depth to the picture.

▶ How is the viewer's eye directed?
Does the viewer see all of the elements in the order you intended? These flowers at the foot of Mount Rainier in the US are pin-sharp, which attracts our eye first, but our attention is then drawn to the peak at the back.

▲ Is enough of the image in focus?
Is the background also part of the story? This image focuses on the food, but it also wants us to know that a chef has prepared the meal, so the figure has been made recognizable.

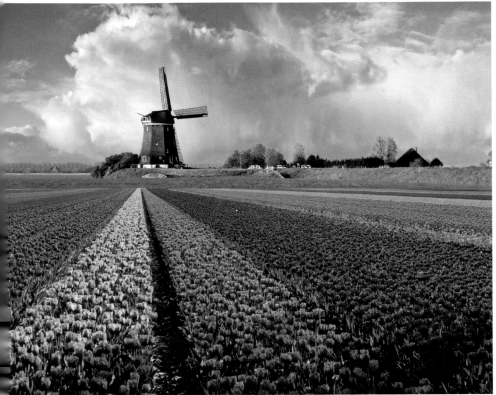

Is the focal point appropriate?

When you want to achieve front-to-back sharpness you need to choose your focal point carefully. To maximize depth of field, this image has focused one-third of the way into the frame.

Have you checked the frame edges?

Scan the frame edges for unwanted elements before releasing the shutter. Cropping out the lower buds here would focus the viewer on the top flower.

Is the background distracting?

It's essential to pay attention to strong colours, even when they are out of focus. The green hedge in this image would have been very distracting it if it was in focus.

Is the shutter speed appropriate?

When using small apertures you're often forced to use slow shutter speeds, but if your subject is moving – such as the bike in this example – you might need to experiment until you get the right combination.

▶ ENHANCE YOUR IMAGES
Adjusting depth of field

There will be occasions when the aperture you've selected isn't quite large enough to throw the background out of focus. Thankfully you can adjust depth of field during post-production. This picture of a boat on the Isle of Barra, Scotland, was taken using an aperture of f/22. As a result, much of the background is sharp and draws the eye to the back of the frame.

The house and boat are both relatively sharp in this image

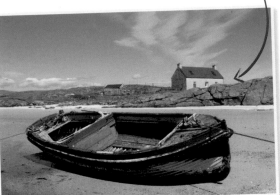

1 Protect your file
In order to protect your original file, duplicate the Background layer first. Select the Lasso tool and, without being too precise, draw around the area you want to keep sharp (in this case, the boat).

Outline created by Lasso tool

4 Alter depth of field
Click on Filter at the top of the screen, and then Blur, Lens Blur. A box will appear with a large preview of your image, and a series of sliders on the right. Under the Depth Map heading, check that the Source reads Alpha 1. Now tick the box that reads Invert.

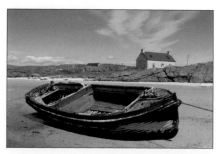

5 Add finishing touches
Staying with the Lens Blur dialog box, under the Iris heading you will find a Radius slider. Move the slider left and right until you achieve the effect you desire. When you're done, click OK and save the file.

Background before blurring

Background after blurring

Pro tip: Save time by using keyboard shortcuts to access common digital tools and settings. For example, in Photoshop you can bring up the Lasso tools by pressing "L", or enter Quick Mask mode by pressing "Q".

2 Quick Mask

Click on the Quick Mask button and the area you want to appear out of focus should now be coloured red.

Areas to be blurred will appear red

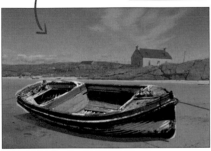

3 Soften the edges

Click on Filter at the top of the screen, and then Blur, Gaussian Blur. A box will appear with a black-and-white graphic in a window. This graphic shows how steeply the edge of your selection will turn from sharp to out of focus. Move the slider left and right until you achieve the effect you desire. Click OK. Now exit the Quick Mask mode by clicking on the Standard Mode icon in the Tools palette.

Decide on the sharpness of the transition

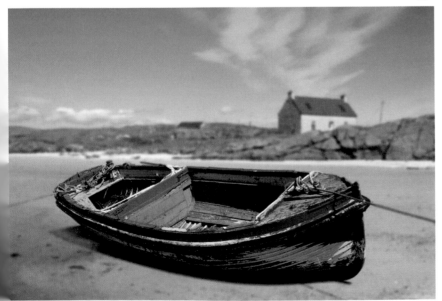

The viewer's attention is no longer distracted by the background.

FOCUS STACKING

To mimic a deep depth of field it's important to note that no software can make an out-of-focus picture sharp – the information just isn't there to begin with. However, by shooting several frames at different focusing distances and combining the results, you can create a file with greater depth of field than any single aperture will allow.

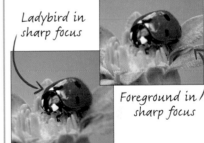

Ladybird in sharp focus

Foreground in sharp focus

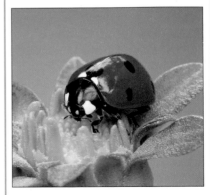

This image of a ladybird displays maximum sharpness due to the combination of multiple frames.

What have you learned?

You should now realize that noticing where sharpness begins and ends in your pictures, and learning how to control this area, is a skill all photographers need to master. See how much you've picked up by answering these questions.

1 If you want front-to-back sharpness, what kind of aperture should you use?

A Wide aperture
B Small aperture
C Medium aperture

2 Depth of field is affected by which three things?

A Lens aperture, subject-to-camera distance, and focal length of lens
B Shutter speed, ISO sensitivity, and size of subject
C Subject movement, shutter speed, and lens type

3 Why should you use the lowest ISO possible?

A So as to use a faster shutter speed
B So as to use a smaller aperture
C To ensure pictures are full of detail and colour

4 What kind of aperture will throw the background completely out of focus?

A Large aperture
B Small aperture
C Medium aperture

5 When viewing an image, where does the eye go first?

A The largest object in the picture
B The centre of the picture
C The sharpest part of the picture

6 What sort of depth of field can be used to emphasize patterns throughout a picture?

A Deep B Medium C Shallow

7 What sort of depth of field can be used to isolate details?

A Deep B Medium C Shallow

8 If the subject in the foreground of an image is in focus, but the background details are blurry, what sort of depth of field has probably been used?

A Deep B Medium C Shallow

9 When shooting shallow depth-of-field images, what sort of lens gives the most dramatic results?

A Standard
B Telephoto
C Wide-angle

10 When shooting deep depth-of-field images, what sort of lens gives the most dramatic results?

A Standard
B Telephoto
C Wide-angle

11 Which mode allows you to select the aperture and control the depth of field?

A Shutter Priority
B Aperture Priority
C Sports mode

12 What do you need to find to achieve front-to-back sharpness in an image?

A The light level
B The precise time of day
C The hyperfocal distance

13 What should you consider doing if the subject is moving when shooting a deep depth-of-field image?

A Add an additional light source
B Mount the camera on a tripod
C Raise the ISO

14 What happens as the subject gets closer to the lens?

A There is less depth of field
B There is more depth of field
C Depth of field stays the same

15 What sort of depth of field should you use to blur a distracting background?

A Deep B Medium C Shallow

Answers 1/B, **2**/A, **3**/C, **4**/A, **5**/C, **6**/A, **7**/C, **8**/C, **9**/B, **10**/C, **11**/B, **12**/C, **13**/B, **14**/A, **15**/C.

07

LENSES

Different lenses can bring radically different perspectives to an image, but they can also dominate a scene if used without care. Before you start, you should consider what you are trying to achieve with your photo. This will help you in deciding what lenses to use in any given situation.

In this module, you will:

▶ **see how the lens you use** affects the visual character of the photographs you make;

▶ **examine what the focal length** of a lens describes and the differences between prime and zoom lenses;

▶ **follow a step-by-step guide** to see how perspective shifts as you change lenses;

▶ **experiment with using lenses** to create different images;

▶ **review your photographs** and learn how to use your lenses to their full advantage;

▶ **correct lens distortions**, such as vignetting, in post-production;

▶ **test your knowledge** of different lenses and how you can use them to get the most from different situations.

week

Let's begin... ⊕

Which lens should you use?

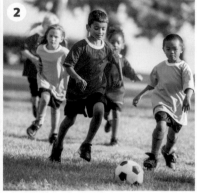

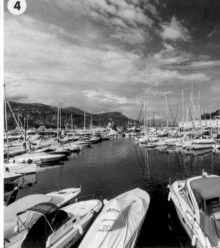

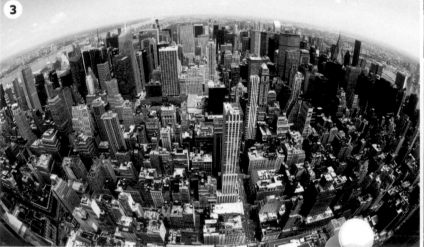

Changing your lens changes your perspective on the world, depending on whether you use a wide-angle, standard, telephoto, or even a specialist lens like a fisheye or a tilt-shift. See if you can work out which lens has been used in these shots.

A **Standard lens:** The field of view of a standard lens is closest to that of the human eye.

B **Wide-angle moderate:** A mid-range wide-angle lens has no distortion, but allows you to work close to the subject.

C **Extreme wide-angle:** Super wide-angle lenses get a lot into the frame but can cause distortion and converging verticals.

D **Fisheye:** A fisheye lens creates a lot of distortion at the edges.

E **Short telephoto:** A short telephoto is great for portraits.

F **Telephoto:** A telephoto zoom is perfect for capturing fast action.

G **Extreme telephoto:** Super telephotos can bring distant objects into close framing.

H **Macro:** A macro lens can make objects larger than life.

I **Tilt-shift lens:** These create special effects, making a scene look like a model.

7

9

6

8

NEED TO KNOW

■ Each lens has a different field of view, from very wide to very narrow.

■ Lenses can either have a fixed focal length (see pp. 124–125), called a prime lens, or one with a range of focal lengths, called a zoom lens.

■ A fixed focal length lens tends to be faster, lighter, and better optical quality than an equivalent zoom lens.

■ Extreme lenses will distort the world in ways that the human eye does not. For example, a fisheye lens will make a subject appear to "bulge" towards the edges, while a tilt-shift lens can make a cityscape look like a toy.

Review these points and see how they relate to other photos in this module

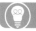

Primes versus zooms

Lenses are available in a range of focal lengths. The focal length determines how much of a scene is captured by the lens. It also determines more subtle factors, such as the depth of field available at each particular aperture. In order to create satisfying photos you want to learn to "see" like a camera, and understanding how lenses work is an important part of this process.

FOCAL LENGTH

The focal length of a lens is the measurement in millimetres of the distance from the optical centre of the lens to the focal plane when the lens is focused on infinity. Prime lenses have a fixed focal length; zoom lenses have a variable focal length.

Zoom lens at telephoto setting

Zoom lens at wide-angle setting

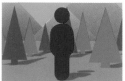

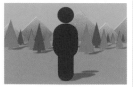

Telephoto A concave element in a zoom lens causes light to diverge. When moved to the front of the lens only the most central rays of light reach the sensor, magnifying the image.

Wide angle A convex front element in a lens causes light to converge, reducing magnification, creating a greater angle of view of the scene to be projected onto the sensor.

ℹ PRIME OR ZOOM?

Prime lenses
■ **A prime lens** is one that has a fixed focal length, such as a 24mm, 50mm, or 135mm. This means that you need several lenses for common shooting situations rather than just one or two.

■ **Prime lenses** are typically lighter, smaller, and have larger maximum apertures than equivalent zoom lenses. Optical quality in terms of sharpness and reduction of chromatic aberration or distortion (see pp.126–127) is often higher.

■ **By using** prime lenses exclusively it gets easier to spot potential compositions.

Zoom lenses
■ **A zoom lens** combines a range of focal lengths all in one. Common combinations are wide-angle zooms in the 17–35mm range, mid-range zooms such as 24–105mm, and telephoto zooms such as 70–200mm.

■ **Zooms** with a very large focal length range – 16–300mm, for example – are known as superzooms. They're convenient as you only need one lens: the downside is a compromise in image quality.

■ **Zooms** sold as kit lenses tend to have small maximum apertures.

Minimum focus distance
The minimum focus distance of a lens is the shortest distance that the lens is able to focus to produce a sharp image. This varies between lens types. Macro lenses have the shortest minimum focus distance (see pp.172–173).

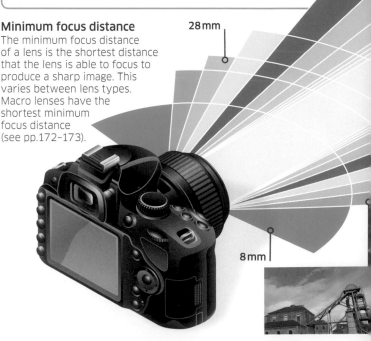

28mm

8mm

18 mm

Pro tip: You'll find that you begin to naturally see composition possibilities that suit the prime lenses you own once you're familiar with their particular angle of view.

Pro tip: A zoom lens can make you a lazy photographer, as composition can be easily altered by turning the zoom ring. Exploring a scene by moving around it will offer more possibilities for creating interesting compositions.

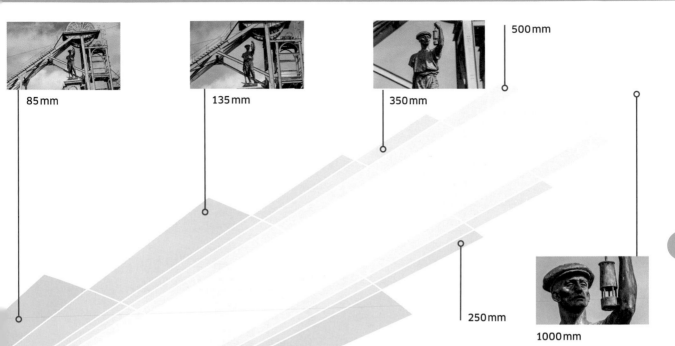

85mm

135mm

350mm

500mm

250mm

1000mm

35mm

ANGLE OF VIEW

The angle of view is the measurement in degrees of the amount of a scene captured by the lens; this can be measured horizontally, vertically, or diagonally. It is affected by the focal length of a lens and sensor size.

Angle of view

A wide-angle lens is so-called because the angle of view is large. A fisheye lens is the most extreme type of wide-angle lens, with an angle of view of 180°.

A standard lens has a focal length that matches the diagonal measurement of the sensor. This produces images that closely match how we see the world.

Super telephoto lenses have extremely narrow angles of view. The longer the focal length of a lens, the narrower this is, so only a small section of a scene can be captured.

50mm

Lens distortions

Almost every type of lens has some minor imperfections or faults that can degrade the image quality. In practical terms, these are normally so small as to be irrelevant, but they can be an issue under certain circumstances and when you're working at large print sizes. Fortunately, these issues can often be fixed either in-camera or in post-production. Knowing the potential problems of your lenses makes you better able to anticipate and fix them.

 ## PERSPECTIVE

Perspective is the visual effect that makes objects appear smaller as their distance from the viewer increases. You can exaggerate or reduce the effect by changing your position and by altering the focal length of the lens.

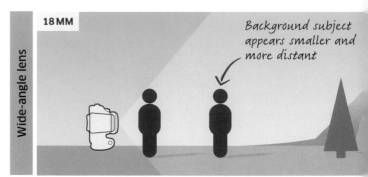

Wide-angle lens — 18 MM

Background subject appears smaller and more distant

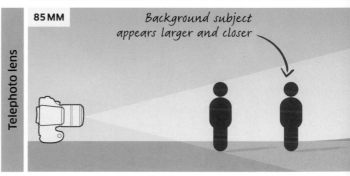

Telephoto lens — 85 MM

Background subject appears larger and closer

 ## VIGNETTING

Vignetting describes the effect seen when the corners of a photo are darker than the centre. The most common type of vignetting is caused when a lens is used at maximum aperture. Making the aperture smaller reduces this type of vignetting.

Mechanical vignetting is caused when the edges of filters or lens hoods protrude into a shot. Mechanical vignetting is most common when using wide-angle lenses.

We tend to look at brighter areas of a photo more readily than darker areas. Deliberate vignetting can help to emphasize a central subject.

 ## CHROMATIC ABERRATION

Chromatic aberration (CA) appears as visible colour fringes around sharp edges in a photo. CA is caused by the inability of a lens to bring all the wavelengths of colour into precise focus on the sensor. More expensive lenses often have special glass elements to reduce CA.

Axial (or transverse) CA is seen as a coloured halo around high-contrast detail. It occurs most often when using a lens at maximum aperture; it disappears when smaller apertures are used

Wide-angle lenses

have wide angles of view, increasing the difference in the apparent sizes of objects that are at different distances from the camera. Nearby objects will appear to be larger and distant objects smaller (see pp.140–141).

Telephoto lenses

have small angles of view, decreasing the difference in the apparent sizes of objects that are at different distances from the camera (see pp.156–157).

DISTORTION

Pincushion distortion is when straight lines curve inward. This distortion is commonly seen in telephoto lenses (see week 9).

Barrel distortion is when straight lines curve outwards. It is typically caused by wide-angle lenses (see week 8).

IMAGE SENSOR SIZE

The image formed by a lens is circular. The size of the sensor determines how much of this circle is used to create a photo. This is why a lens's angle of view is determined by both its focal length and the sensor size. The standard sensor size used for comparison is the full-frame (36 x 24mm) sensor. Lenses fitted to cameras that have a smaller sensor will capture a smaller angle of view. Two other common sensor sizes are 4/3s (17 x 13mm) and APS-C (24 x 16mm).

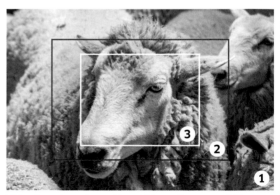

This photo was shot with a 180mm lens on a full-frame camera **(1)**. On an APS-C camera the angle of view would be reduced **(2)**, and for a 4/3s camera the angle of view would be smaller still **(3)**.

ateral CA is seen as colour ringing – often cyan and magenta – usually in the corners f an image. Not affected by the perture size, you can correct it -camera or in post-production.

Sensor blooming occurs when a highlight blows out (for example, tree branches against a light sky), and is usually uncorrectable. This problem is caused by the sensor.

Changing perspective

Perspective is the visual effect that makes objects look smaller as their distance from the viewer increases. This effect can be controlled by changing the lens's focal length: a wide-angle setting exaggerates distance by increasing the apparent space between the elements in a scene; a telephoto setting has the opposite effect, appearing to compress space.

A woodland setting gives you lots of options for background and mid-ground objects.

1 Find the right scene

Look for a location where you have some objects in the background and the middle distance. You will need plenty of space behind you to move away from your model.

2 Attach a mid-range zoom lens

Set up your camera on a tripod with a mid-range zoom lens. The tripod will allow you to be more accurate and consistent.

Attach a mid-range zoom lens

6 Repeat the process

Now repeat the process over a series of focal lengths. Each time check that you have kept the framing of the model constant.

At a mid-setting, apparent background distance relative to the model is reduced

7 Change the focal length from one spot

Move back through the range of focal lengths you have used so far, taking a photo at each one, this time without moving your position.

Use the same focal lengths as Steps 3–6

8 Assess the results

Scan through the images in sequence to see how the relationship between foreground, mid-ground, and background changes with the focal length.

Wide-angle view

Telephoto view

Where to start: You will need a model and a mid-range zoom lens, such as a 28–70mm or 24–105mm, and a tripod.

You will learn: How the relationship between foreground and background elements changes with different focal lengths on a zoom lens.

3 Compose your image

Set the lens to the widest setting. Position your model so that they are framed from the waist up, with the top of their head just below the top of the frame. Take a photograph at that setting.

At a wide setting, background looks far away

4 Move to the next focal length

Now reset the lens to the next focal length you want to use. Move backwards from your subject until you have them framed in the same way as in the first image.

Focal length markings on the lens can act as guides

5 Check your composition

Take a photo at the new setting. Toggle back and forth from the new image to the first image and make sure that the model appears to be the same size in the frame.

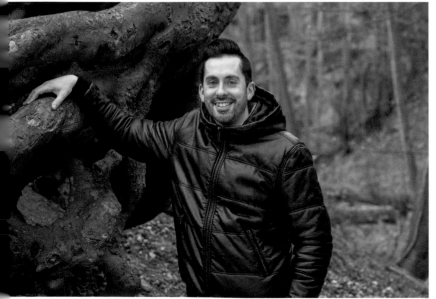

a telephoto setting, foreground and background appear closer together.

WHAT HAVE YOU LEARNED?

■ Using a tripod will help you to be more consistent with your framing and composition.

■ Wide-angle lenses – and settings – have short focal lengths. The shorter the focal length you use, the more distant the background will seem relative to anything in the foreground.

■ Telephoto's longer focal lengths appear to compress distance, so that the elements in a scene appear far closer together spatially.

▶ **PRACTISE AND EXPERIMENT**
Testing out lenses

These three assignments will help you to explore the extremes of individual lenses and their effects on an image. They can be completed using the widest angle and telephoto extremes on a standard zoom lens. However, try getting hold of specialist wide-angle and telephoto lenses and seeing the effects they have on a photo.

TAKE A ZOOM BURST IMAGE

- **EASY**
- **OUTDOORS**
- **2–4 HOURS**
- **POINT LIGHT SOURCES**
- **BASIC +** tripod, wide-angle or standard zoom lens

Using a long exposure has created this zoom burst effect.

This technique works well in situations where you have lower light levels and point light sources, such as in a cityscape.

■ **Position** your camera on a tripod and compose your image at the widest setting of the lens you are using.

■ **Set** your shutter speed to 1/4 sec at the corresponding aperture, using either Manual or Aperture Priority modes.

■ **Press** the shutter and, as you do so, quickly turn the zoom ring towards the longest focal length.

■ **Try** zooming in the opposite direction, from the longest setting to the widest.

SHOOT AT EXTREMES

- **MEDIUM**
- **OUTDOORS**
- **2–4 HOURS**
- **LANDSCAPE SUBJECT**
- **BASIC +** tripod, wide-angle or standard zoom lens

Choose a scene that has objects near to the camera and far in the distance; a landscape is ideal.

■ **Set** up your camera on a tripod and compose your photograph with a wide-angle lens. Take the picture.

■ **Attach** a telephoto lens and shoot the same scene, picking out a detail from the far distance.

■ **Look** at the two images on your computer afterwards. Find the same area on the wide-angle photograph that you shot with the telephoto, and zoom in until it covers the same view. How do they differ?

Shooting with different lenses from the same position is a great way to learn about their different properties.

Pro tip: A piece of gaffer tape will hold a zoom lens at a set focal length once you have set it up.

SINGLE FOCAL LENGTH

📶 **MEDIUM**

🕐 **2–4 HOURS**

📷 **BASIC +** prime lens (or zoom lens set to one focal length)

📍 **INDOORS OR OUTDOORS**

➕ **AS MANY SUBJECTS AS POSSIBLE**

This is a great way to learn the specific characteristics of a certain lens.

■ **Choose** a prime lens in the 28–50 mm range, or set your zoom lens to 28, 35, or 50 mm.

■ **Go out** and shoot using only that lens. Hold the lens up to your eye and scan the scene, and try to memorize the angle of view it gives you. Then look at a new scene, try to estimate the coverage of the lens, and then bring the camera up to your eye and see how close you are to being correct.

■ **Bracket** your photographs using a range of apertures to see how the depth of field changes.

■ **Try** this exercise for a range of different lenses until you are confident you know what each one will do.

You can also try taking a sequence of images of the same object using the same focal length but from different positions.

WHAT HAVE YOU LEARNED?

■ As you change lenses, the perspective stays the same, but the field of view changes.

■ Zoom effects can give dynamism and energy to a shot, especially at night.

Reviewing your shots

Once you've completed the assignments, review your images and choose the ones you are happiest with. Then go through the checklist here to see if any of them could be improved.

Are your verticals true?

When you tilt a camera up or down while using a wide-angle lens, it can create a lot of distortion and converging verticals. Do you think that the converging verticals in this image work or not?

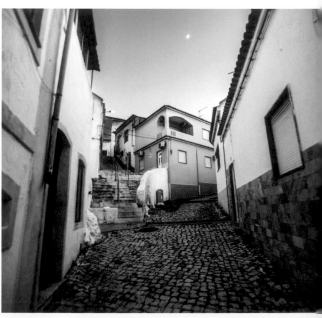

Is there distortion near the corners of your image?

When taking shots of buildings using wide-angle lenses, take care to keep the verticals straight to avoid distortion, especially at the edges of the frame.

Is lens flare visible?

Lens flare is caused by light from a point light source, such as the sun, reflecting inside the lens and recreating the shape of the aperture, as shown here. You can avoid this by using a lens hood or by shading the light source, using your hand or a piece of card.

Have you avoided camera shake?

You need to make sure you set a shutter speed high enough to avoid camera shake. To keep these birds sharp, you would need to set a higher shutter speed than the focal length of the lens.

> The **heart and mind** are the true lens of the **camera.**
>
> YOUSUF KARSH

▼ Has your image got the right focus?

With long lenses you need to be very careful with your focusing, as depth of field will be minimal. In this case, you should focus on the dancers' feet.

◀ Have you got too close to your subject?

If you use a standard lens to shoot a portrait, try not to get too close to the subject or you will distort their features, especially the nose.

▲ Does your image have vignetting?

Vignetting, as shown in this image, can be a problem with fast lenses used wide open, or when an accessory mounted in front of the lens is too small.

▶ **ENHANCE YOUR IMAGES**

Correcting lens problems

No matter how much care you take in setting up a great shot, distortions can still creep in. Fortunately, there are software correction tools that will handle the unwanted variables and distortions created by your lenses.

Image edges show signs of vignetting

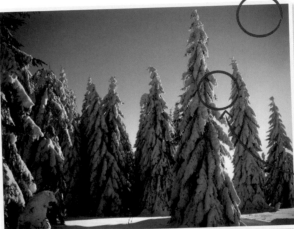

Coloured fringes to trees are chromatic aberrations

1 Study your image

Open your photo in image-editing software and look closely for any signs of distortions caused by the lens. These include distortions to perspective, vignetting, and chromatic aberrations. In this wide-angle shot of a forest, the verticals of the trees look natural, so perspective distortion is not an issue.

4 Check for aberrations

Look closely at the edges of objects in your image, especially where there is a high level of contrast between the object and the background, and look for signs of chromatic aberrations. These may take the form of hazy lines of colour.

5 Use the sliders

Enlarge the area you want to correct by up to 400 per cent so that you can gauge how effective your adjustments will be. In the Lens Correction box, three sliders deal with coloured fringes: each slider adds or reduces a particular colour to reduce lateral chromatic aberration (see pp.126–127).

6 Perform one final check

View the whole image on-screen by selecting Fit on Screen from the magnification menu. Click on OK if you're happy with the corrections you've made.

Colour fringing caused by chromatic aberration

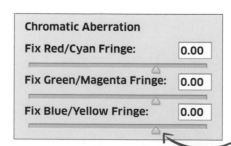

Chromatic Aberration	
Fix Red/Cyan Fringe:	0.00
Fix Green/Magenta Fringe:	0.00
Fix Blue/Yellow Fringe:	0.00

Chromatic aberration has now been reduced

Three sliders control the colours of chromatic aberration

Pro tip: Before you start correcting a set of problems, think about the best order in which to do them. Noise reduction is generally more effective prior to working on chromatic aberrations, while sharpening should be performed afterwards.

2 Open the Lens Correction box

Click on Filter and then on Lens Correction. Click on the Custom tab once the Lens Correction dialog box is displayed. The Vignette slider allows you to lighten or darken the edges of the image. Remember, you can add or increase an image's vignetting effect to draw attention to the central subject if you want to.

3 Adjust the vignette

Move the Vignette slider back and forth to take away vignetting or add it for effect. Note that correction will increase image noise towards the corners, because digitally brightening an image amplifies both image detail and noise equally.

Correcting the vignette has lightened the edges of the image

Vignette slider

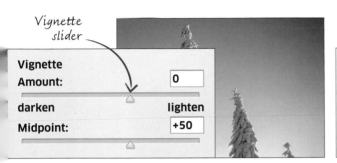

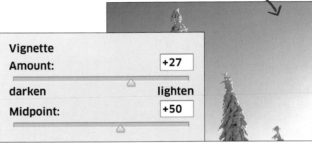

Corrected image with vignetting lightened and chromatic aberrations reduced.

ⓘ LENS PROFILES

Many image-editing software programs now have automated lens correction. This is based on preset parameters for most common lenses. You can load these presets and the software will use a pre-calibrated profile to remove distortions and aberrations typical to that particular lens.

Auto Correction	Custom
Correction	
☐ **Geometric Distortion**	
☑ **Chromatic Aberration**	
☐ **Vignette**	

What have you learned?

In this module you've learned that the type of lens you use can have a huge effect on the images you produce, and how important it is to choose the one that is most suitable for the subject and situation. Try this short quiz to see how well you know your lenses.

1 What is the minimum focus distance of a lens?

A The farthest point a lens can focus on
B The closest point a lens can focus on
C The point where the image is sharp

2 Perspective is the effect that makes objects appear what?

A Larger as their distance from the viewer increases
B Smaller as their distance from the viewer increases
C The same size as their distance from the viewer increases

3 What is a macro lens useful for?

A Shooting distant subjects
B Shooting action
C Shooting extreme close-ups

4 What is the typical range of a superzoom lens?

A 16–300mm B 24–50mm
C 80–200mm

5 What is barrel distortion?

A When straight lines curve outwards
B When straight lines curve inwards
C When straight lines remain straight

6 Compared to a wide-angle lens, a telephoto lens at any given aperture will have?

A Less depth of field
B More depth of field
C The same depth of field

7 How do you avoid camera shake?

A Use a shutter speed that is slower than the focal length of the lens
B Use a shutter speed that is less than 1/30 sec
C Use a shutter speed that is higher than the focal length of the lens

8 What is the viewpoint of a standard lens?

A Wider than the human eye
B Narrower than the human eye
C Similar to the human eye

9 A prime lens is usually what?

A Faster, lighter, and with a better optical quality
B Slower, heavier, and with a poorer optical quality
C The first lens you buy

10 What field of view does a fisheye have?

A A very narrow field of view
B A very high field of view
C An extreme wide-angle field of view

11 What typically enhances the effect of mechanical vignetting?

A When the lens is at its minimum aperture
B When the lens is at its maximum aperture
C When the lens is in the middle of the range of apertures

12 What do chromatic aberrations appear as?

A Colour changes in the midtones in a photo
B Scratches on the surface of the image
C Visible colour fringes around sharp edges in a photo

13 How do you make a zoom burst image?

A Move the zoom ring during the exposure
B Move the focus ring during the exposure
C Move the camera towards the subject during the exposure

Answers 1/B, 2/B, 3/C, 4/A, 5/A, 6/A, 7/C, 8/C, 9/A, 10/C, 11/A, 12/C, 13/A.

WIDE-ANGLE LENSES

week

A wide-angle lens helps you to capture a broader view than a standard or telephoto lens, making it ideal for landscapes and interiors. Wide-angle lenses also open up a range of creative and dynamic possibilities.

In this module, you will:

▶ **identify the characteristics of wide-angle photography** and learn when it is best to use a wide-angle lens;

▶ **see how wide-angle lenses** appear to distort perspective;

▶ **learn the basics** on a step-by-step landscape photoshoot;

▶ **practise your technique** with some guided assignments;

▶ **troubleshoot** some of the most common problems;

▶ **improve your images** in post-production by correcting perspective problems;

▶ **go back over** the tips to see if you are ready to move on.

Let's begin... ⟶

Assessing wide-angle shots

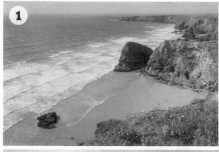

You can use a wide-angle lens to produce highly distinctive images. These seven photos show some of the key attributes of wide-angle lenses. Can you match each characteristic with the appropriate image?

A **A sense of space:** A wide-angle lens lets you capture an expanded view of a scene.

B **Depth of field:** It's easy to keep both foreground and background objects in crisp focus in one shot.

C **Expanded perspective:** Objects close to the camera appear larger, and distant objects seem smaller.

D **Foregrounds:** A wide angle can create dynamic foregrounds, with lines converging into the distance.

E **Distortion:** The closer you get to your subject, the more the subject will appear distorted.

F **Tilted verticals:** If the camera is tilted upwards, vertical elements can appear to tip backwards, creating greater visual impact.

G **Vignetting:** Wide-angle lenses can cause the edges of the shot to darken, which can help draw the eye to the centre.

NEED TO KNOW

- You don't need a special wide-angle lens to experiment with wide-angle shots.
- If your camera has a kit zoom lens, the widest setting on the zoom will be enough to produce wide-angle images. You can then use your kit lens to learn the properties of wide-angle lenses.
- However, if you do buy a wide-angle zoom, it will greatly expand the range of images you can capture.
- A wide-angle lens isn't just useful for landscape shots. It can be used almost anywhere, to photograph almost anything.
- It is ideal for capturing landscapes or cityscapes, and for fitting tall buildings or compact interiors into a shot.
- It can also be used to produce creative and unusual portraits and interiors, as well as eye-catching atmospheric shots.

Review these points and see how they relate to the photos shown here

Wide-angle lenses allow you to photograph more of a scene than a standard lens. The wider a wide-angle lens, the more of a scene is captured. The main visual characteristic of wide-angle lenses is that objects in the background appear smaller and more distant from objects in the foreground. Knowing how to exploit this quirk is an important part of learning about wide-angle lenses.

Standard lens

Wide-angle lens

More or less
Because it has a wider angle of view, a wide-angle lens will capture more of a scene than a standard lens when shooting at the same distance from a subject.

Standard lens

Wide-angle lens

Near and far

It is a common belief that wide-angle lenses exaggerate perspective. However, perspective is only affected by where you stand in relation to your subject (see pp.124–125). As images are smaller on wide-angle lenses, you must stand close to a subject to ensure it is a reasonable size within the frame. This exaggerates the apparent distances between objects.

Standard lens angle of view

Standard lens camera to subject distance

Camera fitted with standard lens

🔆 STANDARD LENS

When using a standard lens you will need to stand back from your subject to make it fit into the camera's viewfinder. In this narrow field of view, the objects in the background will seem proportionally larger and closer.

Pro tip: If you shoot with a wide-angle lens at maximum aperture, the corners of a photo are often darker than the centre. Known as vignetting (see p.126), this can either be reduced by using a smaller aperture or corrected in post-production.

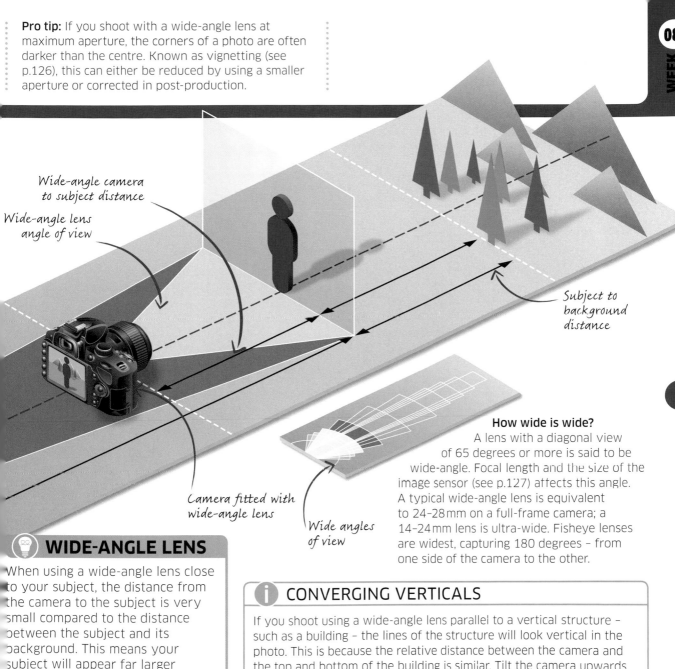

Wide-angle camera to subject distance

Wide-angle lens angle of view

Subject to background distance

Camera fitted with wide-angle lens

Wide angles of view

How wide is wide?

A lens with a diagonal view of 65 degrees or more is said to be wide-angle. Focal length and the size of the image sensor (see p.127) affects this angle. A typical wide-angle lens is equivalent to 24–28mm on a full-frame camera; a 14–24mm lens is ultra-wide. Fisheye lenses are widest, capturing 180 degrees – from one side of the camera to the other.

🔅 WIDE-ANGLE LENS

When using a wide-angle lens close to your subject, the distance from the camera to the subject is very small compared to the distance between the subject and its background. This means your subject will appear far larger in the photo compared to the objects in the background.

ⓘ CONVERGING VERTICALS

If you shoot using a wide-angle lens parallel to a vertical structure – such as a building – the lines of the structure will look vertical in the photo. This is because the relative distance between the camera and the top and bottom of the building is similar. Tilt the camera upwards to take in the full height of the building and the bottom of the image will be magnified as the distance between the camera and the bottom of the building is decreased relative to the distance between the camera and the top. Tilting causes the lines of the structure to converge, making it seem as if the structure is falling backwards (see p.215).

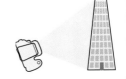

Shooting landscapes

Wide-angle lenses are most closely associated with landscape photography. The wide angle of view lets you create a sense of open space. Try to have a strong foreground so that your composition doesn't look empty.

1 Choose your subject and time of day

Light is often the key to landscapes; when the sun is low to the horizon, shadows add interest. Known as the "Golden Hour", this is when light is at its warmest in colour. Avoid shooting at midday, when the light is cooler.

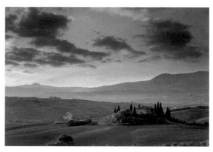

The Golden Hour occurs around sunrise and sunset when the sun is low in the sky.

2 Maximize image quality

Start by setting your camera to its finest JPEG quality setting, or use RAW, which will give you greater scope for post-production adjustments. Use the lowest (or base) ISO setting available.

A low ISO risks camera shake, but a tripod cuts out that risk

6 Set the exposure

Select an aperture between f/8 and f/16. The closer to your camera you focus, the smaller the aperture needs to be. If your camera has a depth-of-field button, use this to check whether the image is sharp. If it isn't, use a smaller aperture.

A smaller aperture gives a greater depth of field

7 Take a shot

Use a remote shutter release or your camera's self-timer to fire the shutter. If using a cable release, make sure the cable is loose so that you don't pull the camera over by accident.

Using a remote shutter release will mean your hand won't knock the camera

8 Check your shot

Zoom in to check whether your image is sharp all over. Check the histogram too: if the highlights have burned out, apply negative exposure compensation (see p.79) and reshoot.

Look to see if shadows or highlights are clipped

Where to start: Find a landscape location with both an interesting foreground and background. Shoot at either end of the day when the sun is low to the horizon and its light is at its most attractive.

You will learn: The best time to shoot landscape images and the importance of foreground detail when using wide-angle lenses.

3 Position the camera

Consider shooting low to the ground to emphasize the foreground. Set the camera on a tripod and make sure it is horizontal using a spirit level.

4 Set your camera to Aperture Priority

Select Aperture Priority. This will let you set the aperture. Aperture controls depth of field, which is the degree of sharpness in the image from front to back.

5 Focus on your subject

Depth of field extends farther back from the focus point than it does forwards. For landscape photos, focus on the foreground. Move the camera's autofocus point to the foreground.

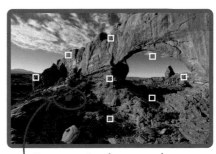

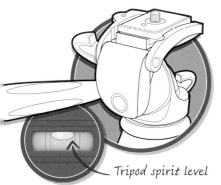

Tripod spirit level

Aperture Priority

Focus on the foreground
(depth of field will ensure
the background is sharp)

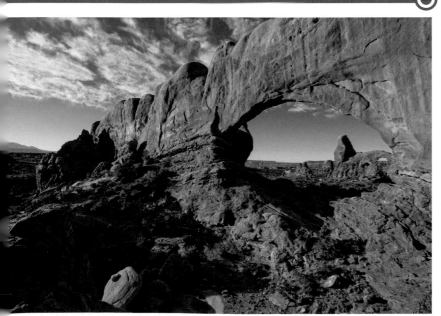

se of a small aperture has ensured front-to-back sharpness.

WHAT HAVE YOU LEARNED?

- Landscape photography can take a while, so get to your location in good time – particularly for a time-critical event, such as sunset.
- Plan your shoot carefully: you want to spend as much time as possible outdoors shooting, not adjusting images in post-production.
- Using a smaller aperture increases depth of field, which will make a tripod all the more necessary.

Wide-angle lenses can be used on all kinds of subjects. To find out how versatile they can be, use only your wide-angle lens (or your kit zoom at its widest setting) to photograph everything for one week. You'll get some amazing images by following a few rules – and by breaking them.

Note the relative sizes of the objects

TABLETOP SHOOT

📊 **EASY**	📍 **INDOORS**
🕐 **15 MINUTES**	➕ **TWO HOUSEHOLD OBJECTS**
📷 **BASIC + tripod**	**ON A LARGE TABLETOP**

This simple shoot shows how a wide-angle lens renders perspective and depth of field. Use Aperture Priority mode so that you can control the lens's aperture.

■ **Fit** a wide-angle lens to your camera (or set your kit lens to its widest setting). Mount your camera on a tripod and position it in front of a table. Select the largest possible aperture.

■ **Choose** two simple objects and position them on a table.

■ **Position** the first object about 50 cm (20 in) from the lens and focus on it. Position your second object behind the first and take a shot.

■ **Move** the second object approximately 5 cm (2 in) farther back and take another shot. Repeat till you run out of table.

■ **Look** at your images. What happens to the relationship between the two objects as you move them apart?

■ **Try** the exercise using a variety of aperture settings. What aperture do you need to use to keep both objects in focus?

Focus on the foreground object

Pro tip: With wide-angle lenses, you need to get close to your subject – maybe closer than feels comfortable when shooting portraits. The effect isn't always flattering, but your images will have impact.

OUT ON THE STREET

.il **EASY** ⊙ **OUTDOORS**
◔ **1 HOUR** ⊕ **CITY STREET OR MARKET**
◎ **BASIC +** 28mm lens (full-frame equivalent)

Wide-angle lenses are great for shooting street scenes. Their wide view lets you show your chosen subject in context.

▪ **Choose** an interesting location with lots of activity.

▪ **Use** Aperture Priority and set the aperture to f/8 or f/11. You may need to increase the ISO if the required shutter speed causes camera shake.

▪ **Frame** your shots tightly by getting close to your subject – a relatively small aperture should give you enough depth of field for their surroundings.

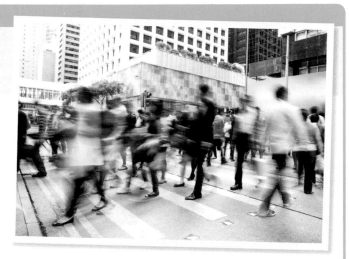

Fit your camera to a tripod and use a slow shutter speed to capture a sense of movement.

INTERIORS

.il **MEDIUM** ⊙ **INDOORS**
◔ **1 HOUR** ⊕ **ANY INTERIOR**
◎ **BASIC +** wide-angle lens, tripod

Wide-angle lenses can produce some great effects when shooting interiors.

▪ **Find** an interior space where a camera and tripod can be set up.

▪ **Mount** your camera on the tripod and compose a shot. Use your tripod's spirit level (or your camera's electronic level) to ensure the camera isn't tilted.

▪ **Repeat,** moving the camera around the room. Try different viewpoints, such as higher or lower than eye level, to see what difference this makes.

CITYSCAPES

EASY	**OUTDOORS**
1 HOUR	**CITY OR LARGE TOWN**
BASIC + tripod	

Photographing a city can be tricky: the buildings may tower over you, but the space to take your shot can be limited. Viewing a cityscape through a wide-angle lens can unlock its potential.

- **Take** time to find pleasing compositions. Look at street level and (if possible) from higher up.

- **Look** for interesting juxtapositions of buildings, reflections, and man-made and natural features.

- **Vary** your approach to composition. Keep the camera level for some shots and then try pointing the camera up to create converging verticals.

Tree helps to fill what would otherwise be an empty sky

Shooting upwards has helped to emphasize the height of the buildings

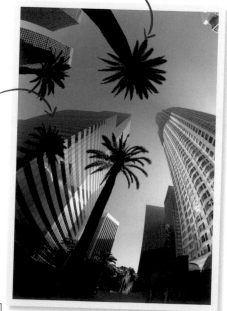

This image has been shot with an extremely wide-angle lens known as a fisheye lens. This has caused extreme, but visually appealing, distortion.

DEEP FOCUS

MEDIUM	**INDOORS OR OUTDOORS**
1 HOUR	**SCENE WITH INTEREST**
BASIC + tripod	**CLOSE AND FAR AWAY**

Wide-angle lenses let you create images with infinite depth of field. This technique is known as deep focus.

- **Mount** your camera on a tripod and position it so your subject fills half of the frame.

- **Move** the camera's autofocus across the subject to focus, or focus manually.

- **Select** Aperture Priority mode, and set the lens to its smallest aperture (typically f/22).

- **Take** one shot and then set the lens to its largest aperture and compare the results.

The closer your subject, the harder it is to keep everything in focus, unless you use an extremely wide-angle lens

BREAKING THE RULES

- **EASY**
- **1 HOUR**
- **BASIC**
- **INDOORS OR OUTDOORS**
- **SCENE WITH CLOSE-UP INTEREST**

Focus on the part of your subject that is closest to the camera

Once you understand the way your wide-angle lens appears to change perspective, you can play with it to create some striking, vibrant, and surreal compositions.

■ **Get** as close to your chosen subject as focusing will allow, so your subject dominates the frame. The wider the lens, the more distorted your subject – that's all part of the fun!

■ **Try** shooting your subject from a variety of different angles. Tilt your camera upwards to force vertical lines to converge dramatically.

ⓘ KIT: **HOT SHOE SPIRIT LEVEL**

The electronic level display on a camera helps you achieve level images, but there is always a small margin of error, and not all cameras have electronic level displays. The solution is to fit a spirit level to your camera's hot shoe. This has several bubbles that show how aligned your camera is, both horizontally and vertically.

Generally you would only use a hot shoe-mounted spirit level when your camera is fitted to a tripod. It is particularly useful when shooting seascapes or when a straight horizon line needs to be kept perfectly level – or when you want to avoid the visual effect of converging verticals.

Hot shoe spirit levels record the angle in three different planes

WHAT HAVE YOU LEARNED?

■ Set a wide-angle lens to any aperture and it will have more depth of field than a telephoto lens set to the same aperture.

■ The distortion caused by wide-angle lenses increases the closer your subject is to the camera.

■ Wide-angle lens distortion can be used to creative effect to add interest to a photo.

Reviewing your shots

After a week of shooting with a wide-angle lens, pick out some of your best shots. Look critically at each image: what's good about each one, and what could be improved? Here's a checklist to help you troubleshoot some common problems.

Are the edges of the image messy?
It's easy to concentrate on the centre of the frame, leading to unwanted elements – such as branches, people, or shadows – creeping into the edges of your composition without your realizing it. This busy image works because your eye is drawn to the bright central area.

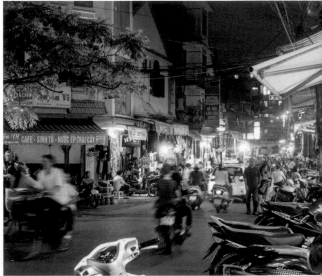

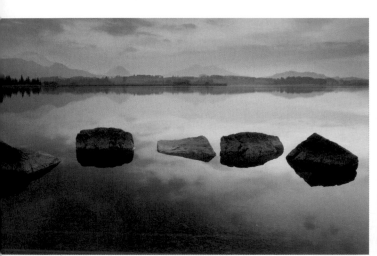

Does your image have a clear subject?
Wide-angle lenses record a huge amount, including details you may not want, so try to get as close as possible to your subject. In this photo, most details have been excluded apart from the foreground rocks, horizon, and sky.

Have you made use of lines?
Lines help to draw your eye through an image. Diagonal lines have more dynamism and energy than horizontal and even vertical lines, particularly if they come in from the sides of the shot. Shooting close to the ground can make these lines recede dramatically.

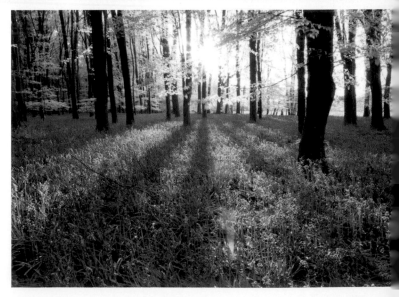

" Be **purposeful** when you're out shooting. "

WILLIAM KLEIN

The positioning of the camera has placed the horizon in the middle of this photo

Do your compositions work?

This photo would have been less balanced if the camera had been higher or lower. Even a small movement of a wide-angle lens, relative to the subject, will have a big effect on the image's balance, so take time composing in your Viewfinder before taking a shot.

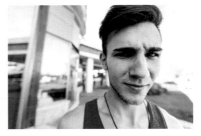

Are the edges of your images distorted?

The optical design of wide-angle lenses – especially less expensive ones – means that photos are heavily distorted around the edge of the frame. This subject's face would be less distorted if he had been placed more centrally.

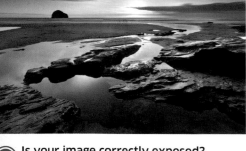

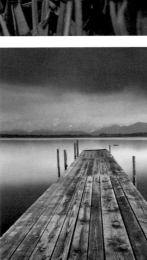

Is your image correctly exposed?

Shooting landscapes with a wide-angle lens often means dealing with a bright sky and a darker foreground. If the contrast is too great, it is impossible to set an exposure that is ideal for both. Here, an ND graduated filter was used to balance the sky and foreground.

Are your images sharp?

With a relatively small aperture and careful focusing, wide-angle lenses can keep near and distant objects in a scene in sharp focus. Depth of field extends farther back from the focus point than towards the camera. This image is pin-sharp from front to back because focusing was precise.

WIDE-ANGLE LENSES / **149**

▶ ENHANCE YOUR IMAGES
Fixing perspective

The scale of many buildings means that only a wide-angle lens can capture them in their entirety. But when you point a wide-angle lens upwards, buildings seem to converge and lean backwards. You can use the effect – called perspective distortion or converging verticals – creatively, but usually you will want the building to look straight and naturalistic. There are several in-camera ways to avoid perspective distortion (see box opposite), or you can correct it with a little post-production work.

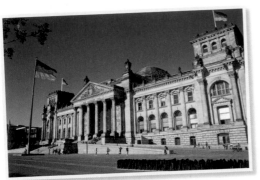

1 Open and activate grid
Go to Filter, choose Lens Correction, and your image will open in a new window. Click on the Custom tab and then the Show Grid box at the bottom of the window. The grid is a useful guide to whether your subject is straight.

4 Toggle preview
Click the Preview box on and off to see how the photo will be adjusted once the changes have been made.

Before

After

5 Save the new perspective
Once you're satisfied with the new perspective, press the OK button at the top of the window to save the changes.

Any adjustment is copied to a new layer.

6 Crop out the blank areas
Use the crop tool to remove any blank areas around the side of the image. You should now have a squared-up image in which vertical elements appear both straight and parallel.

Pro tip: Most cameras have an option to display a grid on the LCD in Live View. Aligning vertical (or horizontal) features of your subject to the grid is an excellent way of ensuring your camera is straight.

Pro tip: Tripods are almost essential when trying to keep architectural subjects straight. It's nearly impossible to do this by hand – particularly when using Live View with the camera held at arm's length.

2 Adjust Vertical Perspective

Move the Vertical Perspective slider so that the sides of the buildings are parallel to both the grid lines and one another.

3 Adjust Scale slider

As you alter the Vertical Perspective, you'll lose some of the photo. Move the Scale slider to recover any missing areas.

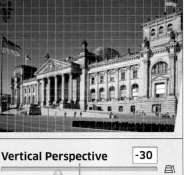

Vertical Perspective **-30**

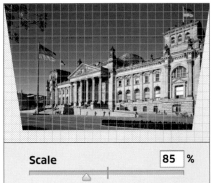

Scale **85** %

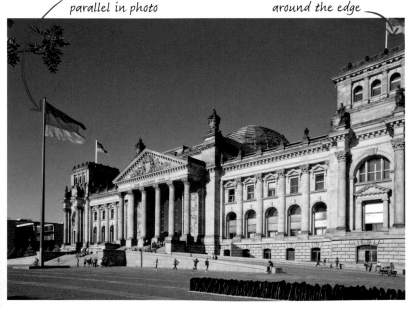

Verticals now parallel in photo

Detail has been lost around the edge

ⓘ IN-CAMERA FIXES

Stand back

Fixing perspective in post-production inevitably reduces the resolution of the image. The better option is to minimize perspective distortion in the first place. Simply move back from your subject and shoot from farther away. This will allow you to fit more into the frame without needing to point the lens upwards.

Tilt-shift lens

If you can't physically move back, a tilt-shift lens lets you move (or shift) the lens up or down relative to the plane of the camera sensor. When the image of a building is parallel to the sensor, verticals appear straight. Tilt-shift lenses are expensive, but they can capture shots that are impossible to achieve with standard lenses.

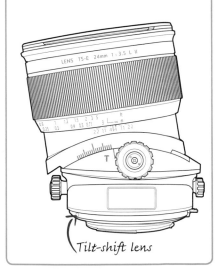

Tilt-shift lens

You've learned that wide-angle lenses let you see and capture the world in a completely different way to human vision, with objects appearing smaller and farther away than they do in real life. Test yourself with the following questions.

1 Where would you see lens vignetting occur?

A In the corners of photos
B At the centre of photos
C Across the entire photo

2 What type of lens can capture a 180° view?

A A telephoto lens
B A tilt-shift lens
C A fisheye lens

3 What type of distortion causes straight lines to bend out towards the edge of a photo?

A Barrel B Pincushion C Perspective

4 What accessory can be used to help set your camera up perfectly straight?

A Remote release
B Hotshoe spirit level
C Polarizing filter

5 What is the visual effect when buildings appear to fall backwards or forwards in a photo?

A Horrible horizontals
B Converging verticals
C Dizzy diagonals

6 Wide-angle lenses are associated with what type of photography?

A Nature B Landscape C Sports

7 The colour of sunlight in the "Golden Hour" is at its what?

A Coolest B Warmest
C Most neutral

8 What button can be pressed to check the extent of sharpness in a photo?

A Depth of field preview
B Shutter release C ISO

9 What type of line has most dynamism in a photo?

A Horizontal B Vertical C Diagonal

10 When using a wide-angle lens, objects in the distance appear more what than when seen with the naked eye?

A Small B Tilted C Large

11 Perspective is mostly affected by what?

A Subject-to-background distance
B Camera-to-subject distance
C The lens you use

12 Light at midday is more what than during the "Golden Hour"?

A Warm B Soft C Cool

13 What do you usually want to maximize when shooting a landscape?

A Front-to-back sharpness
B The aperture size
C Shutter speed

14 A small aperture means using a longer shutter, which risks what?

A Underexposure
B Inaccurate white balance
C Camera shake

15 What Live View function is a useful aid to keeping architectural subjects straight?

A Exposure simulation
B The grid C Image magnification

16 What sort of filter should be used with caution on a wide-angle lens?

A ND graduated filter
B UV filter C Polarizing filter

17 The technique of shooting so that depth of field is infinite is known as what?

A Deep focus B Deep exposure
C Deep imaging

Answers 1/A, 2/C, 3/A, 4/B, 5/B, 6/B, 7/B, 8/A, 9/C, 10/A, 11/B, 12/C, 13/A, 14/C, 15/B, 16/C, 17/A.

09 TELEPHOTO LENSES

week

Telephoto lenses have many uses. They allow you to photograph distant subjects and they can also be used to fill the frame with your subject or compose tightly on a small detail. Telephoto lenses also appear to restrict depth of field; with careful focusing you can use this creatively to isolate your subject from the background or even its immediate foreground. Finally, telephoto lenses compress distance, appearing to bring the elements in a shot closer together.

In this module, you will:

▶ **see how a telephoto lens** can be used in a surprising number of situations, from capturing close-ups to far-off details;

▶ **learn how** telephoto lenses work and how their particular characteristics can be used creatively;

▶ **apply your new knowledge** by following a step-by-step photoshoot of a wildlife subject;

▶ **experiment with using telephoto lenses** for portraits and distant subjects;

▶ **review your photos** to see if you've used your telephoto lens to its full effect;

▶ **enhance a landscape shot** by shooting and stitching together an impressive panorama;

▶ **test how much you've learned** about telephoto lenses and see if you're ready to move on.

Let's begin...

Assessing telephoto shots

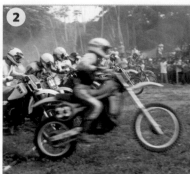

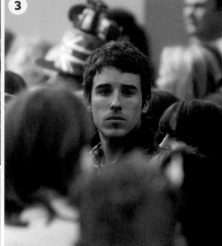

A telephoto lens is a lens with a long focal length resulting in a very narrow angle of view. Telephoto lenses also magnify the image captured by the sensor. This means that distant objects appear larger in the frame compared to a wide-angle or standard lens.

A **Wildlife:** A telephoto lens is ideal for photographing animals without disturbing them.

B **Sports:** A telephoto zoom is perfect for fast-moving sports.

C **Stage shots:** You can capture the energy of a concert by taking close-up shots of the musicians.

D **Portraits:** A short focal length telephoto minimizes distortion and gives a flattering perspective.

E **Candid shots:** Telephoto zooms can pick out faces in a crowd.

F **Close-ups:** Restricting depth of field means that you can make your subject the only sharp part of the photo.

G **Landscapes:** The compression of space offered by a telephoto lens can be used to flatten the various layers in a landscape, highlighting visual contrast rather than depth.

H **Patterns:** Abstract images of your chosen subject can be made by isolating interesting details.

ANSWERS

A / 4: Close-up of a giraffe
B / 2: A motorcycle race
C / 7: Close-up of a lead guitarist
D / 6: Portrait of a young man

E / 3: A face in the crowd, London
F / 1: A used match
G / 8: Svartisen glacier, Norway
H / 5: Detail of a door and rusty hinge

6

7

8

NEED TO KNOW

■ A telephoto is generally used to describe any lens with focal length of more than 85 mm, which is called a short telephoto; anything over 300 mm is called a long telephoto.

■ Telephoto optics require a lot of glass in their construction, which can make these lenses noticeably heavier than wide-angle or standard lenses, and more expensive.

■ The depth of field is more restricted than in standard or wide-angle shots, which means that focusing needs to be very precise when using a telephoto lens.

■ "Fast" telephotos – those with very large maximum apertures – are typically used for sports or wildlife photography. The large maximum aperture allows the use of fast shutter speeds.

Review these points and see how they relate to the photos in this module

▶ UNDERSTAND THE THEORY
Telephoto perspectives

Telephoto lenses have two important characteristics. The first is that they have a narrow field of view. This means that only a very restricted area of a scene is captured. The second is that the image projected on to the camera's sensor is magnified. Practically, this means that distant objects are larger in a photo than they would appear to the eye; the longer the focal length of the lens, the greater this magnification.

PERSPECTIVE

Telephoto lenses appear to flatten perspective. This is due not to the lens itself, but to where it forces you to stand in relation to your subject: using a telephoto lens means being relatively distant from your subject. This increases the camera's relative distance to the subject compared to the distance between the subject and other elements in a scene (see also pp.140–141).

70 MM 135 MM 200 MM

TELEPHOTO LENS

When using a telephoto lens far from your subject, the distance from the camera to the subject is much greater than the distance between the subject and its background. This means your subject will appear far smaller in the photo compared to the objects in the background.

Telephoto lens angle of view

Near and far

Telephoto lenses come in a range of sizes: short, moderate, and super. The best size will depend on your intended use.

- **Short telephoto:** 60–130 mm (full-frame equivalent). Good for portraiture and architectural and landscape details.
- **Moderate telephoto:** 135–300 mm (full-frame equivalent). Ideal for sports/action, wildlife, and street photography.
- **Super telephoto:** +300 mm (full-frame equivalent). Useful for distant wildlife and astronomical photography.

Camera fitted with telephoto lens

Pro tip: Lens-based image stabilization should only be used when handholding a camera. When using a tripod, turn image stabilization off. For increased stability, support a telephoto lens with your left hand closer to the end of the lens than the camera body.

Pro tip: Telephoto lenses give a restricted depth of field. The longer the focal length of the lens, the harder it is to keep everything sharp. This can be used creatively to selectively blur the background behind, or a foreground in front of, a subject in focus.

STANDARD LENS

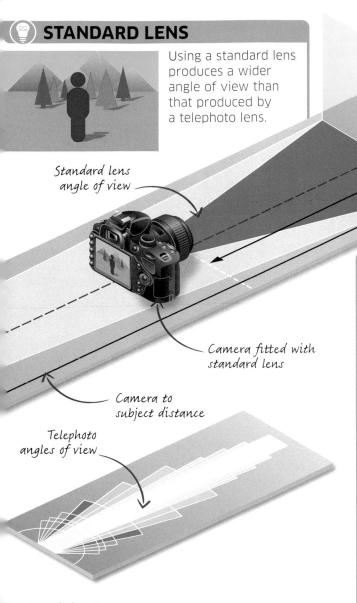

Using a standard lens produces a wider angle of view than that produced by a telephoto lens.

Standard lens angle of view

Subject to background distance

Camera fitted with standard lens

Camera to subject distance

Telephoto angles of view

(i) AVOIDING CAMERA SHAKE

Telephoto lenses are heavy and often cumbersome, and, as they magnify an image, the effects of any movement are also exaggerated. Using a shutter speed that is faster than the focal length of the lens will help – set 1/500 sec for a 400 mm lens, for example – or use one of the accessories or systems below.

■ **Monopods,** although less stable than tripods, they are a good compromise between keeping a camera mobile and keeping it steady.

■ **Lens-based image stabilization systems** compensate for slight movements during exposure. The system takes a second or so to begin working effectively so cannot be used instantly.

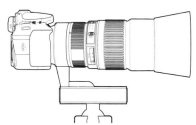

Tripod collar
The weight of a telephoto can tip a camera forwards. A tripod collar helps to make the camera more stable.

How long is long?
Telephoto lenses are often referred to as long lenses due to their physical size. A lens is considered to be a "long" lens when its focal length is greater than the diagonal measurement of the sensor. On a full-frame camera (see p.127) this makes any lens with a focal length greater than 0mm a "long", or telephoto, lens.

Photographing wild animals

Wild animals are generally difficult to get close to. This means that telephoto lenses are often necessary to ensure that an animal is a reasonable size in the image frame. Even in a controlled environment, such as a zoo, a telephoto lens is invaluable and will allow you to crop out clutter and simplify backgrounds with the use of large apertures.

Ring-tailed lemurs are sociable animals that are found in many zoos.

1 Assess your location

Creating a satisfying portrait of wild animals means taking care not to include artificial elements in the shot. Take time to wander around to find the most eye-catching but natural-looking backdrop for your shot.

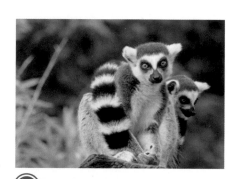

2 Use Aperture Priority and set aperture

Set the camera to Aperture Priority so that you can use the aperture settings to control depth of field. Use maximum aperture initially, but experiment with smaller apertures too.

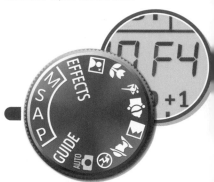

6 Be patient

Knowledge of animal behaviour is useful for predicting what an animal will do over the course of a day. However, photographing animals often involves lengthy periods of waiting, even for experts. Watch and wait, so you can learn to spot and predict your subject's traits.

7 Photograph the animal

Shoot when the animal displays intriguing behaviour, such as looking directly at the camera. Avoid rushing your shots; stay calm and gently press down on the shutter button to reduce the risk of camera shake.

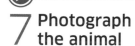
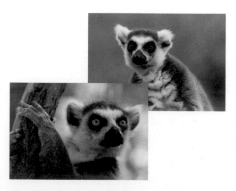

8 Check your photos

Review your photos for sharpness and exposure. Continue to shoot if you feel that your technique hasn't been quite right. Keep your "failures": sometimes shots that don't seem right at the time display interesting qualities that aren't immediately apparent.

Where to start: Photograph an animal in a park or zoo and create an authentic-looking photo.

What you will learn: How to shoot successful animal portraits using a telephoto lens by preparing to shoot and waiting for natural behaviour.

09

WEEK

3 Select Continuous Drive mode

An animal can't be directed in the way that a person can. Selecting Continuous Drive mode means that you can fire off several shots in rapid succession and capture the animal's behaviour.

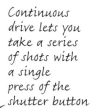

Continuous drive lets you take a series of shots with a single press of the shutter button

4 Check exposure

Press halfway down on the shutter button to activate the camera metering. Check that the shutter speed is fast enough to avoid camera shake – telephoto lenses require the use of faster shutter speeds when the camera is handheld than wide-angle lenses. Increase ISO if necessary.

Start off with a low ISO, such as ISO 100

5 Focus on the subject

The longer the focal length of a telephoto lens, the more restricted depth of field will be at a given aperture. Focusing therefore needs to be precise. Focus on the animal's eye by using Manual AF point selection to select the AF point closest to the eye.

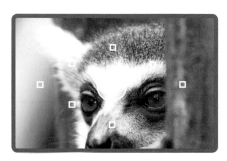

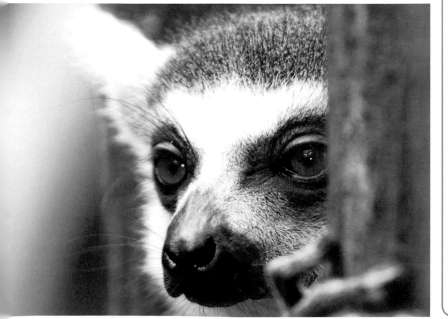

WHAT HAVE YOU LEARNED?

■ Learning to anticipate is the key to photographing animals successfully.

■ Another factor necessary for success is preparation. As such, it's important to set the required camera functions before shooting.

■ It also requires familiarity with your camera equipment. This means that you can change camera functions instinctively so that great opportunities aren't missed.

Using a telephoto lens

The ability to visualize the options that telephoto lenses provide may not come easily at first. However, when you begin to understand their unique characteristics – particularly perspective compression and restricted depth of field – a new way of seeing the world photographically will be revealed. One way to practise is to form a rectangular frame with your thumbs and forefingers. Look through this frame, held at arms' length, to see how a telephoto can be used to frame shots.

TELEPHOTO PORTRAITS

- **EASY**
- **1 HOUR**
- **BASIC + telephoto lens**
- **INDOORS**
- **A MODEL**

A short focal length telephoto is a great lens for shooting head-and-shoulder portraits. As you need to work at some distance from your subject, the resulting perspective is more natural and flattering.

- **Ask** your model to find a comfortable pose. Orient your camera horizontally and position it so that you frame the model at the left side of the composition.

- **Set** the exposure mode to Aperture Priority and select the lens's largest aperture.

- **Focus** on your model's eyes. Shoot several frames, and ask your model to change the direction of their gaze and the angle of their head between shots.

- **Repeat** with your model on the right side of the Viewfinder.

- **Review** your photos to see which of your model's poses are the most attractive.

Try experimenting with different aperture settings and other poses.

Pro tip: A tripod is invariably needed when using a telephoto to shoot landscapes. The need for a small aperture to increase depth of field means that shutter speeds may be lengthy.

TELEPHOTO LANDSCAPES

- **EASY**
- **2 HOURS**
- **BASIC +** telephoto lens, tripod
- **OUTDOORS**
- **SCENIC VENUE**

...ery cool blue aerial perspective ...seen 10 to 20 minutes before ...e sun rises or after it has set.

...elephoto lenses aren't traditionally seen as lenses ...seful for landscape photography. However, they ...e perfect for picking out distant details. They are ...so excellent for emphasizing aerial perspective ...the way that tones in a landscape soften and ...rn more blue the farther away they are.

Shoot from high vantage points across a ...ndscape of rolling hills to make the most of the ...onditions. Aerial perspective is seen most readily ...n hazy or misty days.

Work at either end of the day when shadows ...e at their longest. This helps to define the shape ...landscape details.

Vary how you orient the camera. As well as ...pturing wide panoramas, shoot vertically to ...mphasize the height of subjects such as trees.

TAKING CANDID SHOTS

- **EASY**
- **2 HOURS**
- **BASIC +** telephoto lens
- **OUTDOORS**
- **BUSY SCENE WITH PEOPLE**

Candid photography means photographing people when they are unaware of you and are acting naturally.

- **Spend** time watching people before shooting.
- **Look** for people who are more extroverted in how they react or move. Photos of people showing extreme or exaggerated reactions are always more arresting.
- **Try** using different focal lengths if you're using a telephoto zoom to frame groups of people as well as individuals.

Zoom back to fit in extravagant gestures such as a crowd of people throwing their hands in the air

WHAT HAVE YOU LEARNED?

- The eyes of a subject should be the sharpest part of the photo.
- Candid photography will produce more natural-looking shots of people.
- Telephotos are ideal for picking out details in a landscape.

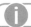 SHOOT THE MOON

📶 **DIFFICULT** 📍 **OUTDOORS**

⏱ **1 HOUR** ✚ **CLOUD-FREE MOONLIT NIGHT**

📷 **BASIC +** telephoto lens, tripod

The moon is a challenging subject to shoot, but with a telephoto lens it's possible to produce striking photos. Popular moon phases include a full moon or a crescent, when shadows make details of craters and mountains easier to see.

■ **Consult** a lunar calendar to check the phase of the moon and when it will rise. These can be found either online or using dedicated smartphone apps.

■ **Work** away from street light if possible and set your camera on a tripod.

■ **Use** Manual mode, set the aperture to f/11, the shutter speed to 1/125 sec, and the ISO to 100.

■ **Switch** the lens to Manual focus and focus on infinity.

■ **Compose** a shot with the moon in the frame.

■ **Shoot** a test shot and review it in Playback. If the moon is too bright, use a smaller aperture – or, if it is too dark, use a larger aperture.

The brightest moon is a full moon.

ℹ KIT: **TELECONVERTERS**

A teleconverter fits between a camera and a lens. An optical system within the teleconverter increases the focal length of a lens by a set factor (typically 1.4x, 1.7x, or 2x). Teleconverters extend the reach of your telephoto lenses with relatively little financial outlay. That said, not all lenses are suitable for use with a teleconverter; some lenses may even be damaged if used with one, so check the manufacturer's guidelines.

Adding a teleconverter reduces the amount of light reaching the sensor. This requires the use of either a slower shutter speed or higher ISO when shooting. One stop of light is lost when using a 1.4x converter or two stops with a 2x converter. Finally, the image quality when you use a teleconverter is lower than when using a telephoto lens on its own.

These pins carry instructions from the camera, through the teleconverter, and to the lens

USE DIFFERENTIAL FOCUS

- **MEDIUM**
- **1 HOUR**
- **BASIC +** telephoto lens
- **INDOORS OR OUTDOORS**
- **SCENE WITH OBJECTS SPACED APART**

Photos don't need to be sharp from front-to-back. Differential focus is the technique of deliberately choosing which areas of a photo are sharp and which are out-of-focus. Out-of-focus areas contribute to the photo aesthetically as much as the in-focus areas.

- **Set** your camera to Aperture Priority and then select your telephoto lens's maximum aperture.

- **Walk** around your chosen scene. Focus on and then shoot the different objects within the scene. Look carefully at how the out-of-focus areas around the object either add to or detract from the photo's appeal. Focusing beyond objects, too, can increase the feeling of depth.

The pose of the out-of-focus figure can still be recognized

CREATIVE BLUR

- **MEDIUM**
- **1 HOUR**
- **BASIC +** telephoto lens
- **INDOORS OR OUTDOORS**
- **A STATIC DIMLY-LIT SCENE**

A soft-focus effect can be created by slowly defocusing a lens during a long exposure. This technique is particularly suited to telephoto lenses. Their restricted depth of field means that the lens can be defocused easily.

- **Set** your camera to Aperture Priority and the aperture to f/8. Select the lowest ISO possible.

- **Ideally** a shutter speed of one second or longer is required. Wait for the ambient light to be low enough – shoot at dusk or use an ND graduated filter (see p.99) to achieve this.

- **Set** the lens to Manual focus and focus on infinity (or your intended subject).

- **Press** the shutter button to start the exposure. Smoothly turn the focus ring away from infinity. Try to time the turn so that you reach the minimum focus distance before the exposure ends.

Lights and sharp detail are softened considerably when defocusing during exposure

WHAT HAVE YOU LEARNED?

- Shooting photos of the moon requires planning, such as finding out the phase of the moon and when and where it will rise or set.
- Out-of-focus areas can contribute to the success or otherwise of a photo.
- Lenses can be defocused during long exposures to produce a soft-focus effect.

▶ ASSESS YOUR RESULTS
Reviewing your shots

Once you've completed this module, look critically at the photos you've made. Select 10 of your more successful shots – images that work well or that you feel are almost, but not quite right. Use the six pointers below to help you assess what you've done right and what you need to work on further.

 Did you try panning to follow the action?
Longer lenses are excellent for taking action shots. Using a slow shutter speed and panning the camera to follow the action creates a sense of speed due to motion blur.

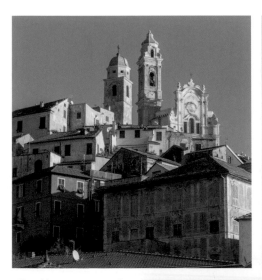

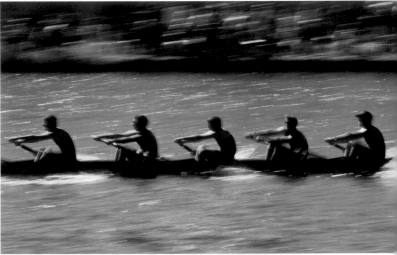

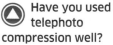 **Have you used telephoto compression well?**
Long lenses appear to reduce the distance between elements in a scene. This photo uses compression to make the buildings in the town look as if they are intimately nestled together.

Have you got camera shake?
Using a shutter speed that is at least the equivalent of the focal length of the lens will help you to reduce the risk of camera shake. Even so, how steadily you hold a camera varies from person to person – to be sure, try doubling the shutter speed relative to the focal length.

> # "Look and think before opening the shutter."
>
> **YOUSUF KARSH**

▼ Have you isolated important details?

Telephoto lenses are great for isolating dramatic details in a scene. This dynamic close-up of the muscles in a runner's leg shows the strain and effort simply but effectively.

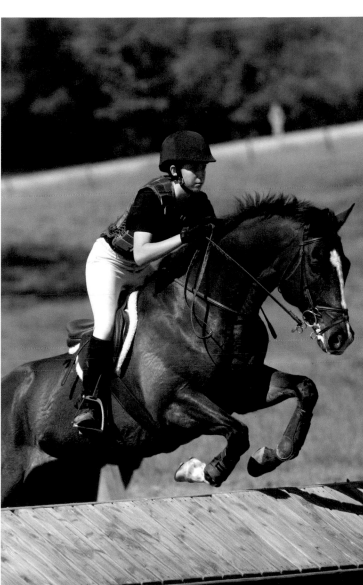

◀ Have you thought about depth of field?

Use the inherent shallow depth of field of longer focal length lenses to simplify shots. Here, the out-of-focus background helps to direct the viewer's eye to the spider.

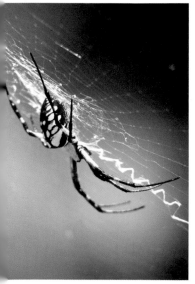

▲ Is your focusing accurate?

Depth of field is very restricted when you use telephoto lenses at large apertures. Focusing therefore has to be very precise and accurate. This shot benefited from using Continuous focus to track the subject as it moved.

Creating a panoramic photo

Sometimes a photo doesn't convey the epic sweep of a landscape: a panoramic photo is more effective. Cropping a standard photo to create a panoramic one will drastically reduce the resolution of the image. A better solution is to shoot a sequence of overlapping photos – moving the camera from left to right as you do so – and then stitch the sequence together.

1 Shoot your sequence

Keep your camera as level as possible as you shoot the sequence. Overlap your photos by about one-third of the frame as you shoot. Look for distinctive landmarks as reference points to help you judge the overlap.

2 Line up your photos

Open the sequence in your image-editing software. Align them roughly across the screen to ensure that the sequence covers the entire scene.

Line up the photos in the correct order

6 Create your panoramic photo

Click on OK to begin the stitching process. This can take time, particularly if you're stitching a number of high-resolution files.

7 Flatten and crop

The panoramic stitch will need a few refinements before it's finished. Flatten the layers and then crop the photo to a rectangle, removing any white border from around the photo.

8 Make your final adjustments

Check around the photo at 100 per cent magnification to see if there are any stitching errors and use the Clone tool to remove them.

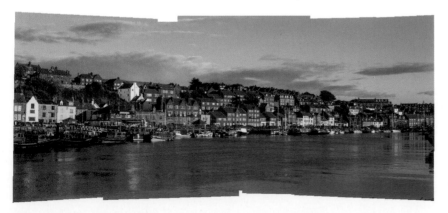

Stitching errors are a particular problem when shooting moving subjects such as water

Pro tip: Shoot your photos vertically to produce a sequence suitable for a horizontal panoramic image, or vice versa. This gives you more room to crop in during post-production.

Pro tip: Keep shooting functions such as exposure, focus distance, and white balance the same for each shot in the sequence.

3 Open Photomerge

Photoshop's photo stitching tool is called Photomerge. To use the tool, go to File, Automate, and then Photomerge. Initially no photos are available for stitching. Click on Add Open Files to add your photos to Photomerge.

4 Choose a stitching method

Layout selects the method used to stitch the panorama. The simplest option is Auto: this uses the most suitable Layout option according to the content of your sequence.

5 Click on Blend

Check Blend Images Together. This ensures that Photoshop will attempt to produce as seamless a panoramic stitch as possible. Leave it unchecked and you may need to adjust stitching errors by using other correction tools.

You can also add photos saved previously by clicking on Browse

Full panorama created by stitching together five different images

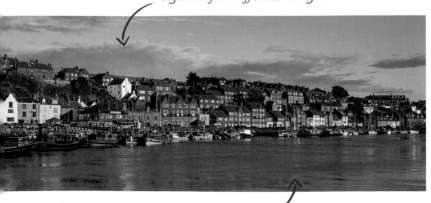

Image joins have been blended together to create a seamless view of the water

ⓘ IN-CAMERA

Many cameras now offer "sweep panoramic" modes. This allows you to shoot a panoramic photo in-camera by moving the camera in a smooth arc across a scene. During the "sweep", the camera shoots multiple photos that are then stitched to produce the final panoramic image. Although "sweep panoramic" modes automate the process of creating a panoramic photo, there are drawbacks. Generally, panoramic photos are limited to certain pixel resolutions and JPEG images.

▶ REVIEW YOUR PROGRESS
What have you learned?

Telephoto lenses can be a challenge – their size makes them a little harder to support, and their restricted depth of field requires more care with focusing. Don't be put off, though – they will add a new dimension to how you see and photograph the world. Work through these multiple-choice questions to test how much you've learned about telephoto lenses.

1 What helps to avoid camera shake when using a telephoto?

A Using minimum aperture
B Setting the lowest ISO
C Working with a fast shutter speed

2 What property does a fast telephoto have?

A It has a large maximum aperture
B It is camouflaged
C It has a tripod collar

3 What effect do telephoto lenses have on perspective?

A Increases the apparent distance between objects in a scene
B Has no effect
C Decreases the apparent distance between objects in a scene

4 What name is given to Photoshop's panoramic photo stitching tool?

A Photoblend
B Photomerge
C Photostitch

5 What focal lengths would a short telephoto be?

A 85–135 mm
B 200–300 mm
C 400–600 mm

6 Can you name the technique used to select which areas of a photo are sharp and which are out-of-focus?

A Differential focusing
B One-shot focus
C Continuous focus

7 When handholding a 400 mm lens, what is a good shutter speed to use to reduce the risk of camera shake?

A 1 sec B 1/125 sec C 1/500 sec

8 What effect does a teleconverter have on a telephoto lens?

A Turns it into a wide-angle lens
B Increases the focal length
C Makes the maximum aperture larger

9 Defocusing a lens during a long exposure creates what effect?

A Soft focus
B Overexposure
C Increases colour vividness

10 What should you try to do when shooting a sequence of images for creating a panorama in post-production?

A Keep shooting settings consistent
B Refocus between shots
C Change focal length as you shoot

11 What quality do telephoto lenses have compared to shorter focal length lenses?

A Increased angle of view
B Lighter weight
C Narrower angle of view

12 How many stops of light are lost when using a 1.4x teleconverter?

A 1 B 2 C None

13 What effect does aerial perspective have on tones in a distant part of a landscape?

A Makes them more blue
B Makes them more intense
C Makes them warmer in colour

14 How will a telephoto lens's depth of field compare with that of a wide-angle lens?

A Increased depth of field
B Less depth of field
C Same depth of field

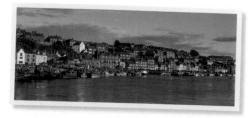

Answers: 1/C, 2/A, 3/C, 4/B, 5/A, 6/A, 7/C, 8/B, 9/A, 10/A, 11/C, 12/A, 13/A, 14/B.

10

TAKING CLOSE-UP PHOTOS

When we view an object up-close, we become more aware of its texture, structure, and detail. Photographing this hidden world requires patience, technical know-how, and a fair amount of curiosity – but once you've mastered the basics, you'll soon be viewing everyday objects with renewed fascination.

In this module, you will:

▶ **judge how close-ups** differ from macro photography;

▶ **understand the theory** and master the main technical challenges facing close-up photographers;

▶ **try it yourself** by taking close-ups during a photoshoot;

▶ **experiment** with shooting close-up subjects;

▶ **review your close-up shots,** looking at what's worked, what hasn't, and why;

▶ **enhance and fine-tune your photographs** by making local adjustments to colour and tone;

▶ **recap what you've learned** about magnification, manual focus, and depth of field, and see if you are ready to move on.

Let's begin... \circledrightarrow

How close is close-up?

In a macro image, the subject is recorded life-size (or greater) on the sensor. In a close-up, the subject appears less than life-size. Use the information here to decide which of the pictures are close-up or macro.

A **Macro:** Reveals minute details in illustration and text.

B **Close-up:** Highlights design details without turning objects into unrecognizable abstracts.

C **Macro:** Makes tiny mechanical parts seem larger than life.

D **Close-up:** Allows a little distance between the camera and a nervous or dangerous subject.

E **Macro:** Draws attention to a very specific part of the frame, while the rest falls out of focus.

F **Close-up:** Turns background blurry, but depth of field places nearby objects in focus.

G **Close-up:** Can be used to reveal the different ingredients of a meal.

H **Close-up:** Emphasizes pattern and repetition of objects without making them hard to recognize.

I **Macro:** Requires creative use of light – subjects may be backlit.

J **Close-up:** Retains some background information, placing a subject in context.

ANSWERS

A / 1: Detail from a US dollar bill
B / 8: A headlight on a red car
C / 9: A watch mechanism
D / 6: Male lion
E / 10: Flower stamens
F / 5: Hands touching
G / 7: A pizza on a wooden table
H / 2: Ripe plums
I / 3: Translucent leaf skeleton
J / 4: Jogger in autumn

NEED TO KNOW

■ When a subject appears life-size (or greater) on the sensor, the image should be classed as macro. Magnification that is less than life-sized should be described as close-up.

■ To achieve the best results, macro photographers need to use lots of specialist equipment, such as tripods with removable central columns, and dedicated macro lenses that allow them to shoot just a few centimetres from a subject.

■ By way of contrast, close-up photographers are capable of creating eye-catching images with just a few screw-on accessories, such as close-up attachment lenses and reversing rings.

Review these points and see how they relate to the photos shown here

Close-ups versus macros

For an image to be considered macro, the subject needs to appear life-size or larger on the sensor – anything smaller than this is simply classed as close-up. To obtain life-size magnifications or greater, you need a macro lens or screw-on accessory, but close-up pictures can be achieved using standard or telephoto lenses. Understanding the difference between the two will help you to appreciate what can be achieved with your camera equipment and what, if anything, you need to buy to take things further.

MAGNIFICATION RATIOS

The relationship between the size of an object and the size it appears on the sensor is shown as a ratio: a fifth of life-size is 1:5, half life-size is 1:2, life-size is 1:1, and five times life-size is 5:1. As a magnification, a fifth is 0.2x, half life-size is 0.5x, life-size is 1x, five times life-size is 5x, and so on.

DISTANCES

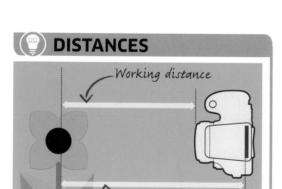

Working distance

Focusing distance

It's a common misconception that focusing distance is measured from the front of the lens to the subject, but this is actually the working distance. The focusing distance is measured from the focal plane (sensor) to the subject. Macro lenses with long focal lengths achieve large magnifications, allowing you to fill the frame with your subject while enjoying the benefits of greater working distances – perfect for insect photography.

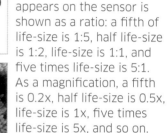

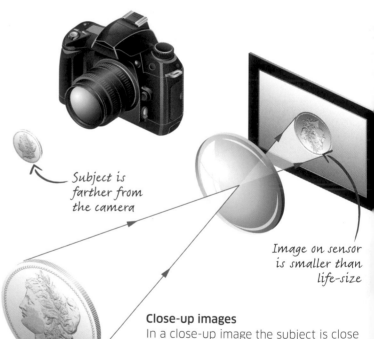

Subject is farther from the camera

Image on sensor is smaller than life-size

Close-up images

In a close-up image the subject is close enough to the camera to fill the frame, but is not magnified to life-size or greater. Some zoom lenses do offer a macro setting but images taken with these lenses are not truly macro and lack much of the detail captured by a true macro lens.

Pro tip: The terms close-up and macro refer to the object's size in real life compared to its size on the sensor.

Pro tip: It's tempting to think that the closer you get to your subject the better the results will be, but a short working distance is not always a good thing: subjects that are easily spooked will be disturbed by your presence.

10

WEEK

ⓘ KIT: MACRO LENSES

Many zoom lenses feature "macro" settings, but most are incapable of life-size magnifications. To achieve 1:1 reproductions without close-up accessories you need a macro lens. Macro lenses have focal lengths ranging from 50 to 200 mm. Short minimum focusing distances let you get extremely close to your subject.

Macro images

True macro lenses can focus on a subject that s very close to the lens. As such, the image roduced will have a magnification ratio of :1 or even higher.

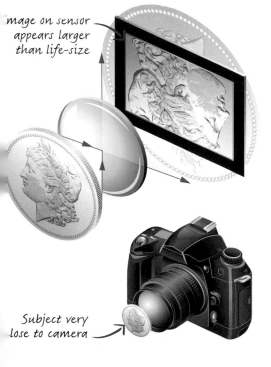

Image on sensor appears larger than life-size

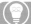

Subject very lose to camera

💡 CAMERA SHAKE

If you're using lenses or accessories that magnify a subject, any movement, from either the subject or the camera, will also be magnified. Many lenses feature Image Stabilization (IS) systems that compensate for camera shake, but to ensure everything is as still as possible you need to use a reliable tripod. Another trick is to keep your subject steady by using props (see p.177).

Shift camera shake

Angle camera shake

💡 SHALLOW DEPTH OF FIELD

The closer you are to a subject, the less depth of field there is. Further, when a subject is magnified, background blur is magnified too, giving the appearance of reduced depth of field. This means that the high magnifications and short focusing distances commonly used for macro and close-up photography result in an extremely shallow depth of field.

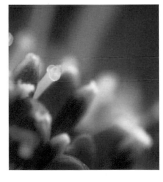

💡 SENSOR SIZE

Cropped or smaller sensors (see p.127), appear to increase the focal length, making objects loom larger in the frame. This is useful for close-up photography because it allows you to keep your distance from a subject while still obtaining frame-filling shots. In reality, what's happened is that the lens has experienced a reduction in its angle of view, allowing it to "see" less of the scene.

Sensor formats
1. Full-frame
2. 4/3s
3. APS-C

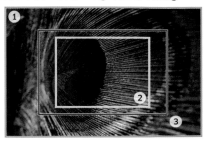

Shooting a close-up

When you fill the frame with your subject, it creates a number of challenges. Before you release the shutter, you need to be sure that the area is well lit, the point of focus is pin-sharp, and the camera remains rock-steady. Follow these steps to achieve a compelling close-up using minimal equipment.

1 Attach a standard or telephoto lens

Make your choice based on how far from the subject you need to be. Without specialist accessories, most standard and telephoto lenses aren't capable of true macro reproduction. For close-ups, however, even cheap kit lenses will do a good job.

Telephoto lenses allows you to take close-up images without getting too close and disturbing your subjects

2 Reduce camera shake

Mount the camera on a tripod and use a remote release or a self-timer function. The camera's mirror, which directs light to the Viewfinder, flips up just before the shutter release, and can cause the camera to vibrate slightly, potentially blurring a close-up image. Some dSLRs let you lock the mirror up to reduce vibration.

The Mirror lock-up function flips the mirror up several seconds before the shutter is opened

6 Choose your mode

If you select Aperture Priority, the camera sets the shutter speed but still lets you control the other aspects. If you use Close-up mode, however, the camera sets the ISO, aperture, white balance, AF mode, Metering mode, and Drive mode.

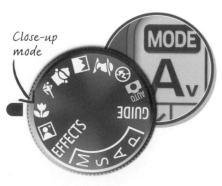

Close-up mode

7 Switch the lens to Manual focus

Activate Live View. Slide the switch on the lens barrel to M and use the focusing ring to obtain rough focus. Position the magnifying frame exactly where you want it, and then enlarge the area. Turn the focusing ring again to refine your focus. Finally, return the display to its normal size.

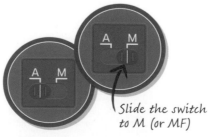

Slide the switch to M (or MF)

8 Shoot and review the results

Take a few shots and look at them in Playback. Scan around the edges of the frame to make sure that nothing unwanted has crept into the shot.

Zoom into your images to check that the point of focus is sharp

Where to start: Head outside on a calm day. Select a suitable subject, and consider it from every angle. Make sure you can keep the subject steady and check that it is free of any flaws or blemishes.

You will learn: The pros and cons of using Close-up mode, when to use a reflector, the benefits of using Manual focus, and when to use the Mirror lock-up function.

WEEK 10

3 Check that the subject is well lit

Light levels can be extremely low when an object fills the entire frame, so use a reflector to bounce sunlight into shady areas. The camera's built-in flash can be useful, but if the subject is less than a metre away, check whether the lens is casting a shadow.

Reflectors

4 Adjust metering and drive modes

Decide whether to use spot, partial, or centre-weighted metering based on the subject. Similarly, whether you take a single shot or keep the shutter firing will depend on whether your subject is moving or not and, if so, how quickly.

Select the most appropriate metering mode for the subject

5 Choose a higher ISO setting

When you're using small apertures to maximize depth of field, the shutter speed may not be fast enough to freeze any movement. As a result, you may need to use a higher ISO speed – anything up to ISO 800 is usually okay.

A higher ISO setting than 800 may result in a loss of detail

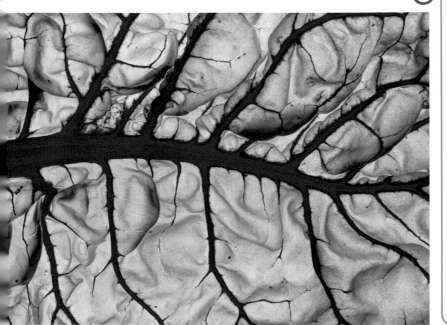

WHAT HAVE YOU LEARNED?

- Camera shake and subject movement are more noticeable in close-up shots.

- Light levels can be very low when an object fills the frame. You might need to use a flash or reflector.

- If you select Close-up mode, the camera makes most of the decisions for you. For more control, select Aperture Priority and Manual focus.

Exploring close-ups

Close-up photography can reveal a secret world where everyday objects become abstract forms and tiny details gain new significance. Now that you understand the basics, it's time to tackle a few assignments, and relax the rules a little.

 A BIT OF A BLUR

⬛ **EASY**　　　　⊙ **INDOORS OR OUTDOORS**

◔ **45 MINUTES**　　⊕ **FLOWERS**

◎ **BASIC +** lens capable of Manual focus, skylight filter, petroleum jelly, tripod

You can introduce a soft-focus effect by shooting through objects close to the camera. Flowers lend themselves well to this technique.

■ **Position** your lens very close to any foreground flowers, switch to Manual focus, and train your lens on a distant bloom.

■ **Practise** this technique, then try another soft-focus effect: screw a cheap skylight filter to the front of your lens, and compose your shot.

■ **Dab** a small amount of petroleum jelly on the filter over any areas you want out of focus, and shoot. Make sure you clean the filter afterwards.

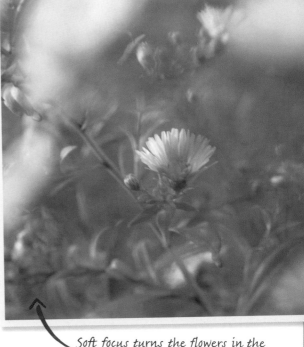

Soft focus turns the flowers in the foreground into a blurred frame

 KIT: **CLOSE-UP ACCESSORIES**

Extension tubes fit between the lens and the camera and increase the distance between the focal plane (sensor) and the rear of the lens, reducing the minimum focusing distance. This allows you to get closer to your subject, making it larger in the frame, while still keeping it nice and sharp. Bellows are fitted between the lens and the camera and they perform the same function as extension tubes. Unlike extension tubes, though, bellows are flexible and allow precise control.

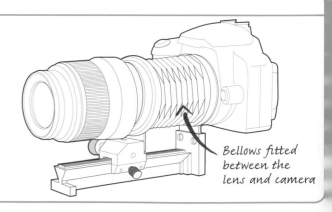

Bellows fitted between the lens and camera

Pro tip: When you're shooting flowers or foliage, head out early, as there'll be less wind. Bright but overcast days are ideal for capturing rich, saturated colours. If it starts to rain, don't pack up – head for woodland where you will be more sheltered.

GETTING ABSTRACT

- **EASY**
- **45 MINUTES**
- **BASIC +** tripod
- **INDOORS**
- **HOUSEHOLD OBJECTS**

Everyday items take on a totally different appearance when viewed up close: the prongs of a fork turn into huge metal sculptures, the leaves of a cabbage look like wrinkled skin, and scissor blades resemble a bird's beak.

- **Select** three household objects and study them up close.
- **Handle** each item, viewing them from every angle, before settling on a small section to isolate and shoot.

With clever lighting, a simple fork can be turned into an interesting abstract image.

KEEP IT STEADY

- **MEDIUM**
- **1 HOUR**
- **BASIC +** clips, wire, windbreak, tripod
- **OUTDOORS**
- **FOLIAGE**

When working with minimal depth of field, it's vital to keep your subject still. There are several handy tools: crocodile clips can be used to hold plant stems steady; floristry wire can keep distracting foliage out of the way; specially designed cubes can be placed around your subject to reduce wind.

- **Wait** for an overcast day when the wind speed is 8 km/h (5 mph) or less, and then head outside.
- **Choose** a sprig of foliage and use any of the tools listed above to hold it steady. When there is a lull in the wind, take your shot.
- **Remove** the props, take a second picture, and compare the results.

Plant stems and small branches can be held steady using your various props.

WHAT HAVE YOU LEARNED?

- You can create a soft-focus effect by shooting through foreground objects.
- There are various tools available to hold your subject steady.
- Everyday objects can be viewed with fresh enthusiasm when you move in close.

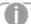 SHIFTING THE FOCUS

📶 **EASY** 📍 **INDOORS OR OUTDOORS**

🕐 **45 MINUTES** ➕ **PARTLY OBSCURED SUBJECT**

📷 **BASIC +** lens capable of Manual focus, tripod

If you use autofocus to shoot through an object – such as a fence, petals, fabric, or a window – the camera will often lock on to the foreground obstruction, rather than the intended subject. Here's how to avoid that happening.

■ **Switch** to Manual focus.

■ **Mount** your camera on a tripod, activate Live View, and then enlarge the area you would like sharp.

■ **Use** the focusing ring to fine-tune your focus. This method lets you control exactly which areas of the frame will be sharp.

■ **Try** focusing on different parts of the subject. See how a quick twist of the ring changes the feel of the composition, and where your eye is taken to first.

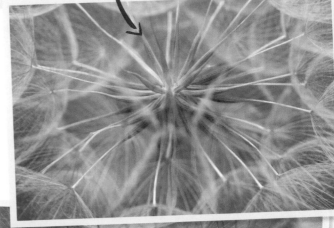

MF has focused through the foreground elements to the flower's centre

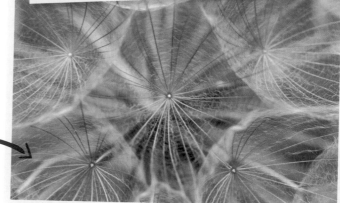

MF has been used to focus on the foreground elements

ℹ️ KIT: **MORE CLOSE-UP ACCESSORIES**

Close-up attachment lenses screw to the front of your lens and reduce the minimum focusing distance. They come in different powers – the higher the number, the greater the "magnification". Reversing rings allow you to mount a lens on your dSLR back-to-front, effectively turning it into a high-quality magnifying glass.

Close-up attachment lens

Reversing ring

BACKGROUND CONTEXT

- **EASY**
- **45 MINUTES**
- **OUTDOORS**
- **SUBJECT OUT IN THE OPEN**
- **BASIC +** wide-angle lens, tripod

You don't need a macro lens to create striking close-up images. Wide-angle lenses have a short minimum focusing distance and a wide angle of view, making objects nearest the lens seem very large, and those farthest away seem very small. This is perfect for getting close to non-sensitive subjects, such as fungi and flowers, while still including much of the surrounding landscape.

- **Find** a static subject in a fairly open environment, such as a shell on the beach or a fungus in a field.
- **Get** as close to the subject as you can with a wide-angle lens.
- **See** how much of the landscape you can include in the picture.

The wide-angle lens has captured the shell close up, but also retained a good deal of the background.

GET DOWN LOW

- **HARD**
- **1 HOUR**
- **OUTDOORS**
- **SUBJECT ON GROUND**
- **BASIC +** tripod, groundsheet, beanbag

There are countless close-up subjects beneath our feet – from plants and pebbles to ripples in the sand – but getting low enough and staying there long enough to shoot them can be challenging. Lying on damp ground is never nice, so invest in a groundsheet.

- **Spread** the groundsheet on the ground, taking care not to crush any plants or insects.
- **Use** a beanbag to support your camera. If it's still awkward, see if your camera has an articulated LCD screen – it will let you compose your shot without your chin being planted in the dirt.
- **Experiment** with these accessories to see just how low you can go.

Shooting subjects on the ground can be tricky, but can produce some stunning results.

WHAT HAVE YOU LEARNED?

- Switching to Manual focus can give you greater control over your compositions.
- You can use a variety of inexpensive tools to enable ground-level shooting.
- Wide-angle lenses can also be used to create striking "close-ups" that distort a sense of scale.

Reviewing your shots

Having turned an everyday object into abstract art and sunk to your knees in search of a ground-level subject, choose your favourite photographs and run through the checklist below. If you find it hard to edit your work, enlist the help of someone else.

Did you use a tripod and remote release?
Close-up subjects, such as this leaf, are often found on the ground, but holding yourself at an uncomfortable angle is more likely to cause camera shake. To minimize the risk, attach your camera to a tripod and use a remote release to trigger the shutter.

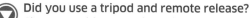

Should you have used MF?
If light levels are low – as in this image of a rose – your camera may struggle to focus. To make sure the focus is where you want it to be, switch to Manual focus, activate Live View, and enlarge the area you want sharp.

Does the background complement the subject?
Check that any colours or shapes at the rear of the image complement the key parts at the front. This pink musk thistle works well against the yellow.

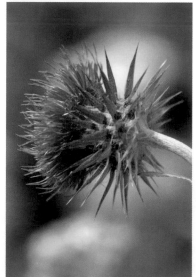

Is the subject in perfect condition?
Torn petals and leaves can ruin close-ups, so select the best specimens you can find – this tulip has no distracting blemishes. Remove any dirt and pollen using a fine paintbrush or tweezers.

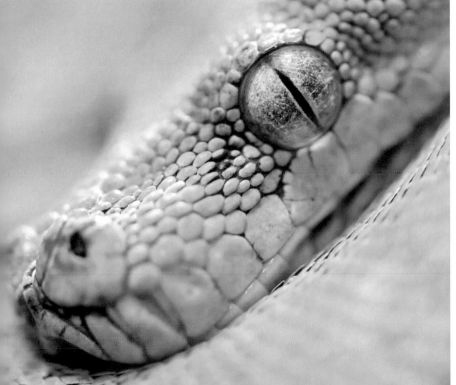

Is the depth of field adequate for the subject?
The closer you are to a subject, the less depth of field there is. As a result, you need to choose your aperture and point of focus carefully. Our attention here is drawn to the python's face, while the rest of its body is thrown out of focus.

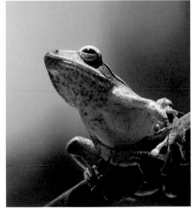

Did you disturb your subject?
When you're trying to get a frame-filling shot of a small animal, such as this frog, it's easy to frighten your subject by moving in too close. Keep a respectful distance and swap your lens for one with a longer focal length rather than risk upsetting your quarry.

Is the subject adequately lit?
Light levels can be limited close up, o use a reflector or off-camera flash to luminate your subject. Here, a wide perture has been used to make the most f the light.

Did the subject move?
Even a slight breeze can lead to out-of-focus pictures, so check the weather forecast. Select a time of day when the air is most likely to be still and delicate subjects, such as these, can be captured with pin-sharp accuracy.

The Adjustment Brush tool

Many of the enhancement tools described in previous modules are known as global adjustment tools; this is because they affect the entire image. However, there are times when only a small area of a photo needs adjusting. When you import a RAW file using Adobe Camera RAW or use Adobe Lightroom, you can make use of the Adjustment Brush to make very localized image alterations.

Dense, dark shadows

1 Using the brush

Select the Adjustment Brush in the tool strip. This lets you adjust any area in your image. The type of adjustment is controlled by sliders, which alter the tonal range, colour saturation, and sharpness.

⊖ **Exposure**	0.00	⊕	
⊖ **Contrast**	0	⊕	
⊖ **Highlights**	0	⊕	
⊖ **Shadows**	0		⊕

Set values to 0 before you start

5 Vary the flow

The Flow slider controls the rate at which the brush effect builds up as you paint. The range is from 0 to 100. Set to 0, the flow rate is slow, and you'll need to paint repeatedly over an area before an effect is seen. Set to 100, the flow rate is fast and the adjustment effect is instant.

Use a high Flow value to make adjustments more quickly

Flow: 70

6 Set the Auto Mask

Select Auto Mask and the Adjustment Brush will detect edges and boundaries in your photo as you paint. If a boundary is detected, the mask will prevent you from painting over it.

The sky is left unaffected by the Adjustment Brush

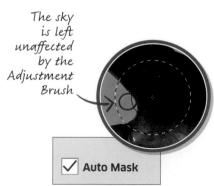

☑ **Auto Mask**

7 Alter the Density

Use the Density slider to control the maximum opacity that an Adjustment Brush applies to a photo. You can paint repeatedly over an area, but the level of adjustment will never exceed the Density value. A value of 0 has no effect, while 100 has the maximum possible effect.

A value of 45 will give the Adjustment Brush a mid-range effect

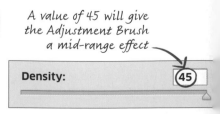

Density: 45

Pro tip: You are not limited to just one adjustment brush per photo: you can apply multiple adjustment brushes by selecting "New". Each adjustment brush you apply is shown as a pin overlay, and can be moved or deleted.

2 Adjust the sliders

Move the sliders according to the type of adjustment you want to make. For example, set the Contrast slider to a minus value and contrast is lowered where you paint. Set a positive value, and the contrast is increased.

Shadows lets you adjust the brightness of shadows

⊖ Shadows	+51 ⊕

3 Alter the brush size

Change the size of the brush according to how fine you want the adjustment to be. Pull the Size slider to the left to make the brush smaller or to the right to make it bigger.

The edge of the Adjustment Brush

The higher the Size value, the larger the brush

Size	16

4 Feather the brush

Use the Feather slider to control how soft the brush is between a range of 0 and 100. At 0 the brush has a very hard edge, while a value of 100 makes the brush very soft.

The feather edge

The amount of feathering

Feather	85

8 Erase

Select the Erase brush to correct a mistake. You can change the Size, Feather, and Flow of the Erase brush to make broad or subtle brushstrokes as required.

The sky here was lightened by an Adjustment Brush – Erase can be used to paint out the error

Shadows more open and detailed

ⓘ OTHER TOOLS

The most similar Photoshop tools to the Adjustment Brush are the Dodge, Burn, and Sponge brushes. Just like the Adjustment Brush, you paint Dodge, Burn, and Sponge onto your photo to make a change. Dodge lightens an area in a photo as you paint, while Burn darkens an area. Sponge can be set to either Desaturate, to reduce the vividness of colour, or Saturate, to increase the colour intensity.

Macro and close-up photography can reveal a world in which insects loom large and flowers fill the frame. It requires a basic understanding of magnification, focusing, and depth of field. See how much you have learned by taking the quiz below.

❶ When a subject is recorded life-size (or greater) on a sensor, it is described as...?

Ⓐ Close-up　Ⓑ Macro　Ⓒ Small

❷ Dedicated macro lenses have which of the following?

Ⓐ Long minimum focusing distances
Ⓑ Short minimum focusing distances
Ⓒ Medium minimum focusing distances

❸ How do photographers maximize depth of field for close-ups?

Ⓐ By using a small aperture (large f-number)
Ⓑ By using a large aperture (small f-number)
Ⓒ By moving closer to the subject

❹ Why is Aperture Priority better than Close-up mode in most instances?

Ⓐ It is easier to find on the mode dial
Ⓑ It instantly blurs the background
Ⓒ It allows you to control aperture, ISO, and metering modes

❺ Where is the focusing distance measured from?

Ⓐ The front of the lens
Ⓑ The focal plane (sensor)
Ⓒ The middle of the lens

❻ What do high magnifications and close focusing distances lead to?

Ⓐ Extremely shallow depth of field
Ⓑ Extremely deep depth of field
Ⓒ Extremely detailed depth of field

❼ What are most standard and telephoto lenses incapable of?

Ⓐ True macro (life-size) reproduction
Ⓑ Accepting specialist macro accessories
Ⓒ Close-up (smaller than life-size) reproduction

❽ In order to minimize mechanical vibrations, what do you need to do?

Ⓐ Turn the in-built flash on
Ⓑ Reduce the ISO sensitivity
Ⓒ Use the Mirror lock-up facility

❾ What can you use to bounce sunlight into shady areas?

Ⓐ A torch
Ⓑ A reflector
Ⓒ The flash

❿ When might a lens struggle to lock focus?

Ⓐ In bright light, or when faced with square objects
Ⓑ In low light, or when faced with low contrast
Ⓒ In ultraviolet light, or when faced with high contrast

⓫ The background in a close-up picture should do what?

Ⓐ Compete with foreground objects for the viewer's attention
Ⓑ Take attention away from foreground objects
Ⓒ Support and enhance foreground objects

⓬ How can you introduce a soft-focus effect to your images?

Ⓐ Shoot through objects in the foreground
Ⓑ Train your lens on foreground objects
Ⓒ Switch off the autofocus

Answers **1**/B, **2**/B, **3**/A, **4**/C, **5**/B, **6**/A, **7**/A, **8**/C, **9**/B, **10**/C, **11**/C, **12**/A.

week 11

CONVEYING MOVEMENT

Using movement in photographs can help to emphasize the energy or emotions of your subject. Movement can also be frozen to convey drama and power or blurred to demonstrate speed.

In this module, you will:

▶ **decide which techniques** will best convey the type of movement you want to show;

▶ **get to grips with the theories** behind capturing and creatively controlling movement;

▶ **learn the practicalities** by following the step-by-step assignments for panning and freezing movement;

▶ **look back over your images** to see what worked and what didn't, and find out how to go about correcting your mistakes;

▶ **improve your images** using computer software to add blur;

▶ **test yourself** on what you've learned to see if you're ready to move on.

Let's begin... ⊕

Looking at movement

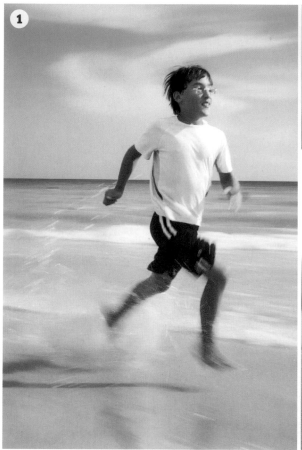

There are many different ways of achieving a sense of movement. Can you tell which techniques have been used to convey motion in these images? Match the descriptions with the relevant picture.

A Long exposure with tripod: Can result in streaking light trails around stationary objects.

B Panning: Following quick-moving action with your camera creates a sense of motion.

C Shooting at too slow a speed: Can result in everything being blurred, including the subject.

D A shutter speed of 1/30 sec: Will keep a stationary subject sharp but will blur the moving background.

E Long exposure while moving: Can create an abstract sense of movement.

F Panning with flash: Used with a slow shutter speed, this can freeze and illuminate the subject against a blurred background.

G Keeping subject central while panning: Focus Tracking will keep your subject sharp as you follow their movement.

H Fast shutter speed: Can capture sudden movements.

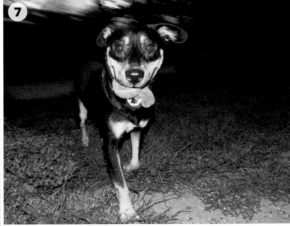

NEED TO KNOW

■ The direction of your subject's movement in relation to the camera can help convey action in your images.
■ The shutter speed can freeze or exaggerate your subject's movement.
■ The timing of your shot can make a huge difference to the final image. Using the flash and moving the camera can capture a moving subject.

■ Switching your camera to Shutter Priority and selecting the appropriate shutter speed for your shot can take the pressure off while you experiment.
■ Use the camera's Focus Tracking setting to help keep your subject sharp. This will emphasize the sense of movement and separate your subject from the blurred background.

Review these points and see how they relate to the photos shown here

► UNDERSTAND THE THEORY
Freeze and blur

To convey the exhilaration of movement, you'll need to think about the type of activity you want to portray. For instance, you can freeze the action at a key moment in a race, blur the background to create the impression of speed, or keep the camera and subject stationary as other elements move around them.

💡 HOW THE SHUTTER WORKS

The shutter uses a pair of blades called the curtains. The first curtain opens to start the exposure, and the second curtain follows to end it. The length of time it takes for this to happen is known as the shutter speed. This determines the amount of movement blur that will appear in your image.

Closed 1st curtain travelling Fully open 2nd curtain travelling Closed

💡 FREEZING OR BLURRING

FREEZE

Freezing your subject while it is moving allows you to show details that would otherwise be missed, such as an extreme sporting pose or the texture of animal fur.

BLUR

Adding blur to an image increases the feeling of movement and speed. Blur can be applied to the subject itself or to the background.

Sports

Fast-moving sports require a shutter speed of at least 1/500 sec. Very fast sports, including motor racing, will need shutter speeds that are even faster than that.

Using shutter speeds of 1/60 sec or slower will produce blur in your photo. Using panning (see p.189) will keep the subject sharp but blur anything in the background.

Wildlife

Pin-sharp wildlife shots will usually highlight textures and markings, or they will focus attention on the animal's behaviour. Shutter speeds of 1/2000 sec or faster may be needed.

Blurring an animal's movement can add a dramatic effect to your photo. A shutter speed of 1/125 sec or slower can also produce some abstract images of the natural world.

Landscape

Even the most serene landscape may have some movement in it, whether it's the waving of long grass in the wind or clouds being blown across the sky. A shutter speed of 1/1000 sec or faster should freeze this.

Slower shutter speeds of 1/8 sec or longer will blur any natural movement, turning fast-moving water into a silky ribbon.

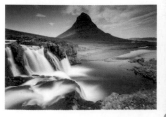

Pro tip: You can further freeze your main subject by using flash (see week 17) while panning. The brief burst of light gives the appearance of freezing the subject nearest the camera and helps to separate them from the background.

Pro tip: By panning with a wide-angle lens, the blurred background in your image may possibly have a curved shape. A telephoto lens will give a flatter, "straighter" appearance to any blur.

 ## PANNING

Panning involves moving the camera to match the movement of your subject. This will keep your subject sharp while blurring the background. Just before your subject reaches where you want to begin shooting, gently press the shutter button and turn at the waist so that you pan smoothly.

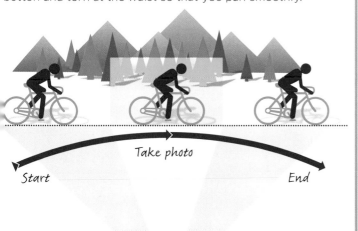

Take photo

Start End

 ## EXPOSURE

You can also vary the other elements that play a key part in exposure to enhance any movement you want to capture.

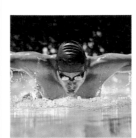

Medium Aperture With Shutter Priority, the camera will adjust the aperture. However, it is worth trying to keep the aperture around f/8. This will keep your subject sharp but limit depth of field, enhancing the background blur.

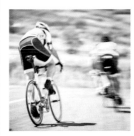

Lower ISO On brighter days outdoors you may have to reduce the ISO, decreasing your camera's sensitivity to light. This will enable you to achieve a slightly slower shutter speed with an aperture of f/8.

 ## SHUTTER SPEED

The shutter speed you choose – the amount of time your sensor is open to record what is in front of it – is the key to how much movement your images will show. The longer it is exposed, the more movement it will record. Varying the shutter speed can create a totally sharp image, one that is slightly blurred to convey a sense of movement, or a photo that has been reduced to an abstract smudge of colours.

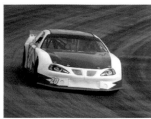

Using a fast shutter speed of 1/3200 sec freezes the action – there's no suggestion of movement and no suggestion of speed. The shutter is open for such a short amount of time that your subject won't have actually travelled any distance.

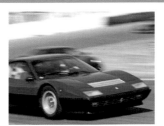

If you slow the shutter speed down to 1/30 sec the subject starts to appear more blurred. The shutter is open for a little longer, during which time your subject will have moved a small distance. You'll notice arms, legs, and wheels start to look blurred.

If you slow the shutter speed right down to 1/15 sec, the subject will appear completely blurred, with very little detail visible as it moves across the image. The level of blur will depend on how fast the subject is moving – more speed equals more blur.

Mastering panning shots

Moving the camera parallel to the movement of your subject can help to express a sense of motion and speed. It can be tricky to get the technique spot-on and will require a little patience to refine. Find an interesting background and position yourself so your subject will move in front of you, either from left to right or from right to left.

1 Set your camera to Shutter Priority

Select Shutter Priority (S or Tv on the control dial) so that you can control the shutter speed – an important consideration when trying to capture motion.

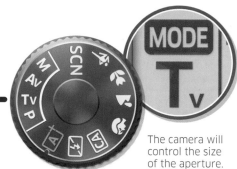

The camera will control the size of the aperture.

2 Set the Motor Drive

Turn your Motor Drive setting to Continuous. This will let you take a sequence of images quickly, rather than you having to keep pressing the shutter button.

The Continuous setting lets you take multiple images

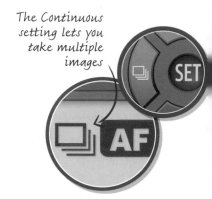

6 Centre your subject

As your subject moves towards you, keep them roughly centred in the frame, allowing the camera's Focus Tracking to keep them sharp.

Focus on your subject's head

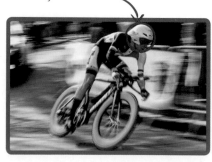

7 Shoot your images

When your subject is parallel to you, press the shutter button and fire a short burst of images. Remember to move the camera to follow your subject's movement.

Hold the camera steady as you pan

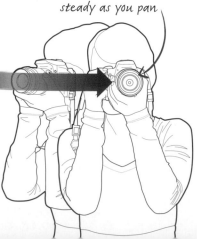

8 Review and repeat

Look at your images. The background should be blurred while the subject should be sharp enough to stand out clearly, but with enough blurring to suggest movement. Repeat the shoot until you have mastered the technique.

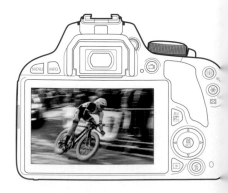

Where to start: You'll need a willing subject who doesn't mind running or cycling in front of you a few times. Find a location with room to move around in and a background that isn't just empty space.

You will learn: How to pan your camera. By the end of this exercise you'll see how camera movement, subject movement, timing, and shutter speed selection can combine to create a feeling of motion in your images.

3 Choose a low ISO

A relatively low ISO of around 200 will help to produce a smooth, noise-free image while using a relatively slow shutter speed.

Select an ISO that's suitable for the conditions and the situation

4 Select your shutter speed

Set your shutter speed to 1/60 sec. This is slow enough to give a sense of motion, but not so slow as to result in a completely blurry photo. The camera will sort out the aperture.

Shutter speed set to 1/60 sec

5 Adjust the focus

Set your camera to active tracking if it has this facility. If not, point your camera at a spot in front of you where your subject will pass by and half-press the shutter button to lock focus.

Keep the button half-pressed until you are ready to take the shot

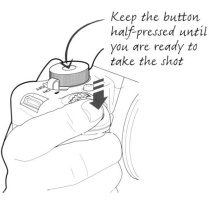

Face is sharp as focus tracking has followed the subject

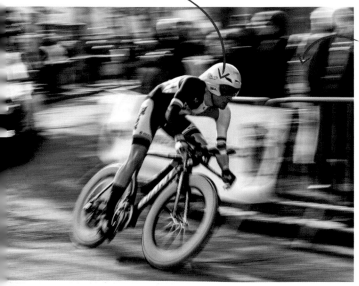

Panning has captured the sense of motion and blurred the background

WHAT HAVE YOU LEARNED?

■ Getting this technique right depends on you finding the right balance between your shutter speed, your position relative to the subject, and the speed at which you follow their movement.

■ Panning is a tricky skill to get right, but the best way to learn is to keep practising.

■ It's important to choose the right shutter speed so as to blur movement just enough without overdoing it.

▶ **LEARN THE SKILLS**
Freezing movement

Using a high shutter speed allows you to freeze the action as it happens, resulting in images that capture the power of an explosive moment. In conjunction with a telephoto lens, you can use a shallow depth of field to isolate your subject from the background and enhance the action.

1 Attach a suitable lens
For the best results, attach a telephoto lens to your camera or set your zoom to its longest setting. A longer lens will highlight the separation of your subject from the background, especially when using a wide-open aperture.

Telephoto lens

2 Turn up your ISO setting
Select an ISO setting of 400–800 if it is a bright day and you are outside, slightly more if it's not or you're indoors. Using a high ISO will increase the camera's sensitivity to light, enabling you to use a higher shutter speed.

Use a higher ISO than you would when shooting a stationary subject

5 Take up your position
Choose a position where your subject will be moving towards you. Consider whether you want a low viewpoint to exaggerate height, or a high viewpoint to get rid of background details. Turn your Motor Drive to Continuous.

6 Take some shots
Shoot a short burst of shots as the subject comes into view. Aim to create the impression that the subject is powering out of the image towards you.

7 Review your images
Look back at your shots. If you're not happy with what you've got, try doing it again.

Review your shots in Playback

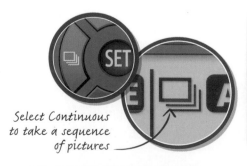

Select Continuous to take a sequence of pictures

Try to fill the frame with your subject

Where to start: You'll need a fast-moving subject that will come directly towards you. To get this technique to work you'll need to use a high shutter speed (over 1/250 sec), which may mean you need to increase your ISO.

You will learn: How to capture the intense power of movement, how to keep the subject completely frozen by using a high shutter speed, and how to set the subject apart from its background through the use of a wide-open aperture setting.

3 Select Aperture Priority

Set the aperture to the widest setting you have: this will give you a shallow depth of field. The camera will set the shutter speed, which will be fast to compensate for the wide-open aperture.

4 Turn on Focus Tracking

Select your camera's Focus Tracking (or Continuous Focus) setting. This will track the subject and keep it in focus as it heads towards the camera, providing you keep the focus point fixed on it.

A small aperture will produce a deep depth of field

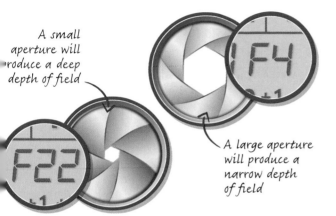

F22

F4

A large aperture will produce a narrow depth of field

Make sure that your focus is set to Continuous

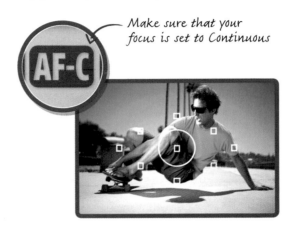

AF-C

WHAT HAVE YOU LEARNED?

■ Using a telephoto lens and a wide aperture will create a shallow depth of field that will set your subject apart from the background.
■ A high-shutter speed freezes the action.
■ Your viewpoint can have as much impact on your shot as your camera settings.

The subject is frozen against the out-of-focus background.

Remember to save your best shots

Freezing and panning

To perfect the different ways of conveying movement, you'll need to practise. That way, when it comes to that all-important sports day or major event, you won't be left with disappointing results. Try each of these exercises several times using faster or slower shutter speeds so that you can see for yourself the difference a few shutter speed changes can make. By working through these assignments, you'll also find that your timing and skill at selecting the right moment to shoot will improve.

FREEZING ACTION

- **EASY**
- **30 MINUTES**
- **BASIC + tripod**
- **OUTDOORS**
- **A SPORTING EVENT OR COMPETITION**

This project is all about judging the right moment to freeze the action.

- **Switch** your camera to Sports mode (or Aperture Priority at the widest setting), use Continuous AF, and set the drive mode to Continuous.

- **Follow** your subject as they move and look for the "peak of the action".

- **Anticipate** when this is likely to occur and shoot through the moment.

- **Try** to fill the frame with your subject. It doesn't matter too much if parts of your subject are bursting out of the frame.

A fast shutter speed will freeze any action

Perfect timing has caught this girl at the peak of her jump

Pro tip: Once you've taken some panning shots that you're happy with, write down the shutter speed setting that worked best for you. This way, you'll be able to use it as a baseline starting point for your next set of images.

SLOW SYNC FLASH

- **HARD**
- **1 HOUR**
- **BASIC +** flash
- **INDOORS OR OUTDOORS**
- **EVENT WHERE PEOPLE ARE MOVING, SUCH AS A PARTY**

This technique results in an image with a sharp, well-lit subject against a blurred background, which magnifies the effect of movement.

- **Turn** on the flash or attach it to the camera and fit a wide-angle lens.
- **Set** your ISO to 200 or slower if the scene is quite bright.
- **Select** Shutter Priority and set your shutter speed to 1/15 sec. The camera will set the aperture.
- **Focus** on your subject and move the camera as they move. The flash freezes them while the slow shutter speed will blur the background.
- **Try** using very slow shutter speeds and moving the camera around to exaggerate the results.

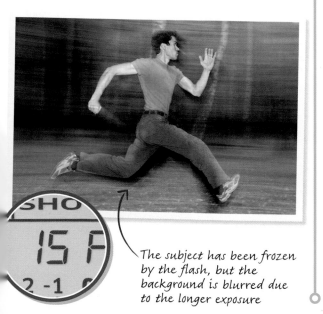

The subject has been frozen by the flash, but the background is blurred due to the longer exposure

PANNING

- **MEDIUM**
- **1 HOUR**
- **BASIC**
- **OUTDOORS**
- **A BUSY ROAD OR STREET**

For this assignment, you'll need to position yourself parallel to a moving subject.

- **Select** Shutter Priority and start with a shutter speed of 1/60 sec – then you can try faster or slower settings. Don't use Sports mode.
- **Pre-focus** on the spot where your subject should move through, or use Continuous AF mode.
- **Set** your Motor Drive to Continuous, and when your subject is directly opposite, fire off a few shots. Remember to keep following the action as it goes past you, as this is what will create the blur in the background.

Moving the camera to follow the snow truck has given the impression of speed.

WHAT HAVE YOU LEARNED?

- Timing is important in order to make sure you capture your subject at "the peak of the action".
- Experimenting with shutter speeds can lead to some interesting results.
- Using Continuous AF and Continuous shooting will give you a better chance of capturing the moment you want.

Reviewing your shots

Once you've completed the assignments in this module and got to grips with the technicalities of capturing movement, pick out some of your best shots. Use the questions here as a checklist to see if anything could be improved.

Are you in the right position to pan?
To pan properly, you need to be in a position to move the camera at the same speed as your subject. If there are a lot of subjects, or they are moving too quickly, the image may end up blurred, as has happened here.

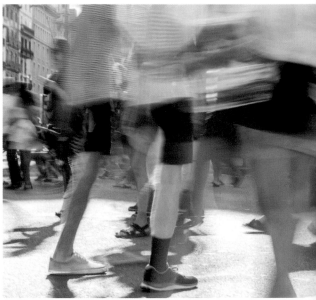

Is your shutter speed too slow?
Getting the right shutter speed is often a matter of trial and error. Here, the shutter speed was too slow to capture the bicycle rider properly, making them appear rather indistinct.

Did you move the camera with the subject?
If you didn't move the camera at the same speed as your subject, your image will be a bit unfocused. Here, the camera hasn't quite kept up with the horse, blurring its outline, but also conveying a sense of speed.

Is your shutter speed slow enough?
This image has been taken from the window of a moving car using a very slow shutter speed, which has convincingly conveyed a sense of movement.

> ## "Photography takes an **instant out of time**, altering life by **holding it still**. "
> **DOROTHEA LANGE**

Is your shutter speed fast enough?

A fast shutter speed has frozen the water droplets kicked up by this runner as he splashes through a puddle.

Have you considered the background?

Shooting against the sun has captured this tennis player almost as a silhouette and has also emphasized the pattern in the fence behind her.

Did you pan at the right speed?

This excellent panning image was achieved by using a fast shutter speed and carefully following the direction and speed of the car with the camera.

Have you got the best viewpoint?

This image works well because of the high vantage point which helps both to convey movement and place the subject in its wider context.

Adding blur

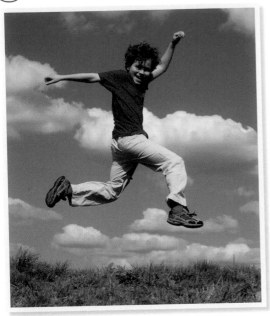

Sometimes you may wish to add the impression of motion after taking your picture. Modern software makes this very simple. Choose an image with a strong foreground subject that looks like it is moving but where the background is sharp. Open it in your image-editing software.

1 Draw around your subject

Using the Lasso tool, draw around the outline of your subject. Try to keep as close to the edge as you can.

A steady hand is needed to draw around the subject

5 Blur your image

A new window will appear with a slider at the bottom. Move it towards the right to blur the background – everything you didn't draw around at the start.

Distance: **10** Pixels

Move the slider or type in a value

6 Aim for subtlety

The farther to the right you move the slider, the more blurred your image becomes. If you go too far, the whole image will look smudged – remember, less is more.

Distance: **55** Pixels

Play with the amount of blur until you're happy

Pro tip: When adding blur to a subject to imply that it is moving, try experimenting with different types of blur; the Motion Blur setting may not give the desired effect.

2 Add a feather effect

Go to the Feather box in Options bar and adjust the value to soften the outline of your subject. This avoids an abrupt transition between blurred and sharp. A value between 10 and 20 should be enough, but you may need to change this later.

Feather: 10 Pixels

The greater the value, the stronger the blur

3 Select the background

Go to the Select drop-down menu and choose Inverse. This will select the background for blurring. If you want to blur your subject instead, ignore this step.

Inverse

4 Choose Motion Blur

Select the Filter drop-down menu, then Blur. This will bring up another drop-down menu. Select Motion Blur.

Motion Blur...

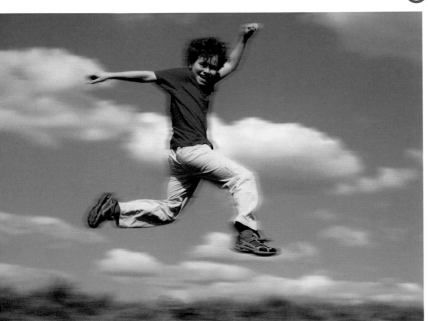

TRY RADIAL BLUR

Experiment with different types of blur. For example, choose Radial Blur in Step 4 instead. A setting of 20–35 is normally sufficient to suggest movement.

Now that you've completed the assignments and reviewed your work, you should have a better appreciation of how to convey movement. Try answering these questions to check your understanding of the various techniques.

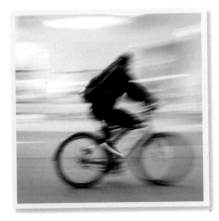

1 **If you have taken a shot** of a subject moving towards you that has ended up blurred, what mistake might you have made?

A Incorrectly focussed
B Shutter speed not fast enough
C Aperture Priority not selected

2 **What is the best** shooting mode to use when panning?

A Aperture Priority mode
B Sports mode
C Shutter Priority mode

3 **What effect does** using a slow shutter speed have on moving lights?

A It makes them out of focus
B It records them as streaks or trails
C It makes them look like blobs

4 **How can you exaggerate** the height of a jump in a photograph?

A Jump with the subject
B Position yourself above the subject
C Position yourself lower than the subject, looking up

5 **How can a telephoto lens** help enhance the action?

A It gets you closer to your subject
B It has a shallower depth of field, giving greater separation from the background
C It lets in more light

6 **How do you** lock focus?

A By pressing down the shutter button halfway
B By turning the Mode dial to Aperture Priority
C By pressing the exposure compensation button

7 **What is** panning?

A Quickly zooming in and out
B Taking a quick burst of shots
C Moving the camera to follow your subject's movement

8 **What effect does** slow sync flash result in?

A A blurred subject against a sharp background
B A sharp subject and a blurred background
C A completely blurred image

9 **What's the best** shooting mode for freezing the action?

A Aperture Priority
B Night-Scene mode
C Sports mode

10 **What technique should** you use if you want to capture the light trails of cars at night, while leaving buildings looking sharp?

A Panning with flash
B A long exposure with a tripod-mounted camera
C A high ISO and a fast shutter speed

11 **What does** focus tracking do?

A Allows you to quickly switch focus from one subject to another
B Lets you focus on something far away
C Keeps the subject sharp as you follow their movement

12 **If your shutter speed** is slow, your image is likely to be what?

A Sharp B Blurry C Overexposed

Answers 1/B, 2/C, 3/B, 4/C, 5/B, 6/A, 7/C, 8/B, 9/C, 10/B, 11/C, 12/B.

12 HOW TO COMPOSE

week

Over the centuries, a set of compositional "rules" for images has been developed. However, sticking too slavishly to these rules can result in repetitive compositions, so it's important to see them as guidelines rather than commands.

In this module, you will:

▸ **learn about composition** and why it matters;

▸ **get to grips with the "rules" of composition,** including the use of odd numbers, the rule of thirds, and using lead-in lines;

▸ **create your own image** using the rule of thirds;

▸ **turn things upside down** by breaking the rules;

▸ **check over your images,** paying attention to viewpoints, directing the viewer's eye, and aspect ratio;

▸ **refine one of your images** by cropping it;

▸ **re-examine** what you've learned about producing powerful compositions, and see if you're ready to move on.

Let's begin... ⊕

Looking at composition

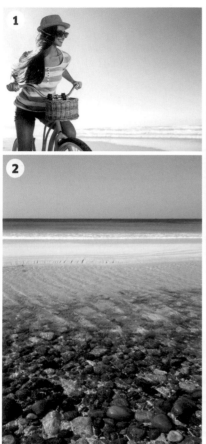

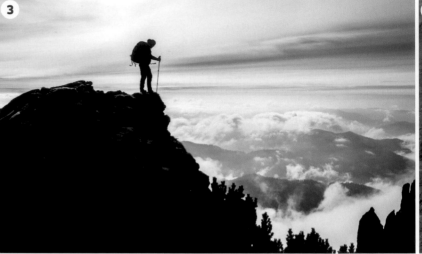

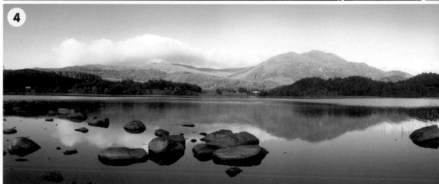

Understanding the "rules" of composition enables you to communicate your message with maximum impact. Look at these photos and match the image with the description.

A **Sense of scale:** Placing a recognizable object next to a large feature helps to indicate scale.

B **Using odd numbers:** Odd-numbered groupings help to hold the viewer's interest in the frame.

C **Positioning the horizon:** Placing the horizon in the upper third of the picture draws attention to the foreground.

D **Frames within frames:** Using natural forms can draw the viewer's attention to key areas.

E **Off-centre subjects:** Placing a subject to one side can create a more dynamic composition.

F **The right aspect ratio:** Pick a format that suits the subject – such as panoramic for landscapes.

G **The rule of thirds:** Dividing the frame into a grid using two horizontal and two vertical lines will help to place key elements.

H **Lead-in lines:** Use lead-in lines to encourage the "reading" of an image from the bottom to the top.

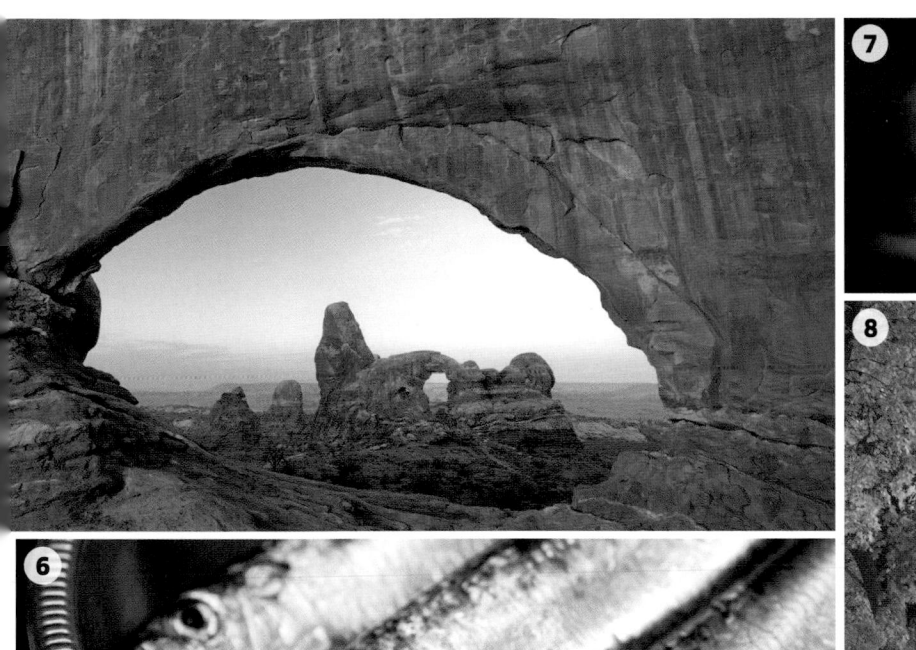

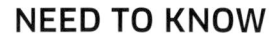

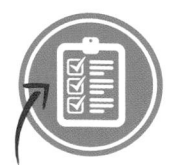

NEED TO KNOW

■ The "rules" of composition are just guidelines, and should not be applied to every picture – following them too closely may lead to dull and predictable work.

■ Remember Leonardo da Vinci's take on composing pictures: "simplicity is the ultimate sophistication".

■ Chaotic and disorganized pictures ask the viewer to work too hard to make sense of them. As a consequence, there's a danger that the viewer will give up and move on.

■ Successful compositions allow the eye to travel around the frame in the intended order, pausing at points of interest along the way.

■ Remember, the quickest way to alter a composition is simply to move your feet.

Review these points and see how they relate to the photos shown here

The "rules" of composition

Creating a well-balanced, aesthetically pleasing photograph can be a challenge. Painters have the luxury of starting with a blank canvas, allowing them to add or subtract components with ease. Photographers, on the other hand, often have to work with what's in front of them. Many artists claim that composition requires a "natural eye": an innate knowledge of where to place objects for maximum impact, but in reality this "eye" can be developed by studying the work of others. If you spend time attending exhibitions, analysing why one arrangement succeeds and another fails, you will begin to see that many successful compositions adhere to certain "rules".

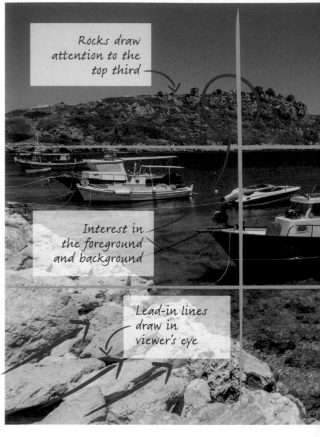

Rocks draw attention to the top third

Interest in the foreground and background

Lead-in lines draw in viewer's eye

USING SHAPES

To create a composition that captures and holds the viewer's attention you need to trap their gaze within the frame. One way of doing this is to organize the elements in a triangular or circular formation so that the viewer's eye absorbs the main components and then returns to the beginning again.

The viewer's eyes move from one subject to the next, eventually returning to where they started.

THE RULE OF THIRDS

This compositional technique involves dividing the frame into a grid using two horizontal and two vertical lines, and then placing major points of interest where these lines intersect. Many cameras come with a grid display to help you achieve this task.

> ## **Photography** is all about light, composition and... **emotion.**
> **LARRY WILDER**

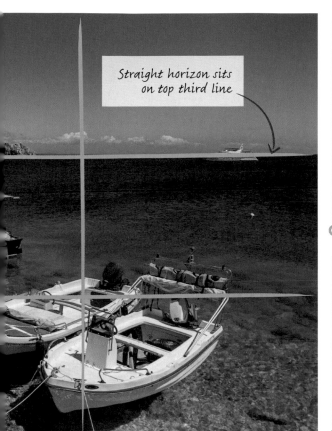

Straight horizon sits
on top third line

POSITIONING THE HORIZON

Placing the horizon high in the frame suggests that the foreground should take precedence, while also giving a sense of depth as the eye travels to reach the sky. In contrast, placing the horizon low in the frame implies that the sky is the most important feature, and conveys a sense of isolation.

USING NATURAL FRAMES

Surrounding your subject with a natural frame created by elements such as branches, rocks, or a bridge is a great way to direct the eye to key areas while concealing any distractions.

THE RULE OF ODDS

When your brain is presented with an even number of objects, it automatically sorts them into pairs and then quickly moves on. If the objects are positioned side by side, the eye falls in the gap between. To persuade the eye to travel to the right place and then stay there awhile, you need to include an odd number of objects in your compositions.

BREAKING THE RULES

Once you've learned the "rules" of composition, it can be liberating to break them. Placing the horizon in the centre of the frame works well if you're trying to capture a symmetrical reflection, while freezing a subject as they are leaving the scene places the emphasis on where they have been rather than where they are going.

HOW TO COMPOSE / **205**

Lines, curves, and diagonals

When lines are used in a composition, they guide the viewer's eye around the frame; they can also elicit strong emotions. Vertical lines, for example, move the eye from the bottom to the top of the picture, conveying a sense of stability and permanence. Lines can be found everywhere, from the curve of a bird's neck to the zigzag of a country road. Some lines are obvious – the diagonal of a boat's sail, for example – and some are implied: loose boulders on a beach, for instance. Lines can be continuous or broken, long or short. When you use them in your composition, it's important to be aware of their aesthetic and emotional impact.

Your eye slowly follows the curve

LEAD-IN LINES

A lead-in line is a clear entry point into a picture. It usually starts at the bottom of the frame and guides the eye into the composition towards the main subject. Lead-in lines can come in the form of roads, walls, flowers, and rivers – anything that directs the eye swiftly and effectively.

HORIZONTAL LINES

When you study an image featuring a horizontal line, you feel calm and at peace (depending on its content). Sunsets over the sea, reflections in still bodies of water, and fallen trees direct our eyes from left to right, leisurely taking in details along the way.

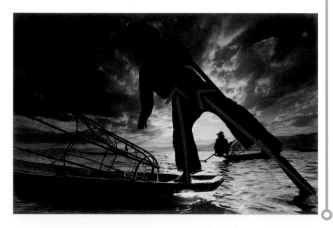

Pro tip: Once you've got to grips with the rule of thirds, take a look at more complicated compositional guidelines, such as those based on the Fibonacci sequence devised by the 12th-century Italian mathematician, Leonardo Pisano.

ZIGZAGS

When the course of a road or a river zigzags through the frame it suggests rapid motion. In these instances the eye darts from side to side, pausing at each turn or bend looking for points of interest. Be aware that jagged or irregular lines can sometimes cause tension.

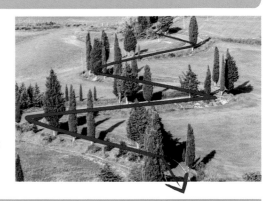

CURVES

Waves lapping at the beach, spiral staircases, and sand dunes all create curves which can add motion and grace to your compositions. These lines suggest slowness and beauty, encouraging the viewer to take their time exploring the image.

VERTICAL LINES

Pylons, skyscrapers, trees, and fence poles can create striking verticals. These lines indicate stability and permanence. When you look at an image with vertical lines, your eye usually travels from the bottom to the top.

DIAGONAL LINES

If you want to stress speed or motion, diagonal lines are ideal. Full of energy, these lines rush the eye to the edge of the frame. Man-made diagonals are common, but you can also create your own by tilting your camera.

BLACK & WHITE

Line, shape, and form can be exaggerated by converting colour images into black and white. Many argue that monochrome requires a different mind-set to colour work, but experimentation can yield excellent results.

▶ **LEARN THE SKILLS**
Using the rule of thirds

The rule of thirds is a popular compositional technique which states that key elements should be positioned where a series of imaginary lines intersect. Camera manufacturers are aware of this rule, and most dSLRs come with grids that can be overlaid on your image in the viewfinder.

1 Attach a suitable lens
As the rule of thirds can be applied to just about any subject, choose a lens based on the effect you're trying to achieve. To show the close relationship between the house and the landscape in the picture below, you should use a telephoto lens, which will flatten the perspective.

2 Mount your camera on a tripod
Use a tripod and a spirit level to make sure everything is straight, allowing you to concentrate on composing your picture.

Telephoto lens

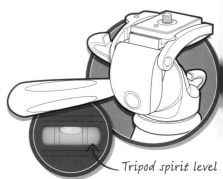

Tripod spirit level

6 Activate the grid
If your camera has a Live View facility, enable it and activate the 3x3 grid display. Use the grid to position key points of interest where the lines intersect. If there is no Live View facility, compose the shot by eye.

7 Select an AF point
Focus on your subject either by manually focusing or using AF (manually select an AF point or place the subject in the centre of the frame, lock focus with a half-press of the shutter button, and recompose).

8 Shoot and review the results
Take a few shots, study them, and consider whether the balance of elements is right. If not, consider cropping the shot in post-production.

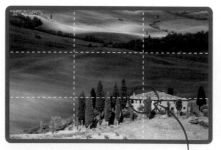

Put the subject where lines meet

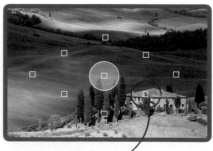

Select an AF point

Examine your shots in Playback

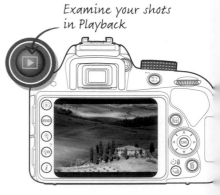

Where to start: The rule of thirds can be applied to almost any subject – even a shaft of light can be positioned where the grid lines intersect. Try using it on solid objects as well as less obvious elements, such as shadows and highlights.

You will learn: How to set up your camera for using the rule of thirds, how to engage and use your camera's grid, and how to focus on an off-centre subject.

3 Adjust the metering mode

Select a metering mode depending on the subject and the light conditions. In this case, there is strong sunlight on the house, but the fields behind are much darker. Such vast contrast may cause the camera to misjudge the exposure and overexpose the picture.

Use Spot or Partial metering to meter from the image's midtones

4 Choose the lowest ISO setting

For smooth, noise-free images, select a low ISO speed (such as ISO 100 or 200). When light levels drop and you're tempted to boost the ISO to compensate, consider using a larger aperture or a slower shutter speed instead.

Keep the ISO as low as possible

5 Select the aperture and shutter speed

Choose the right aperture and shutter speed combination that suits the subject and your desired end result. When you are shooting landscapes, use Aperture Priority mode and select a small aperture to keep the foreground and background sharp.

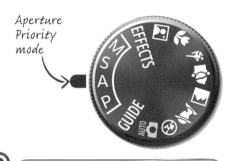

Aperture Priority mode

WHAT HAVE YOU LEARNED?

■ Your camera's grid display will help you to utilize the rule of thirds, although you may need to help the camera decide where to focus when there's an off-centre subject.

■ Using a tripod is not only useful to avoid camera shake and to align your subjects, but it also frees you up to refine your composition.

Be sure to save your best images

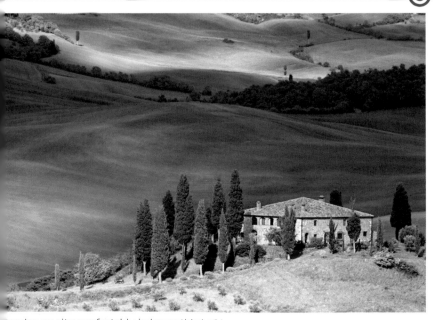

Farmhouse sits comfortably in lower third of image.

▶ PRACTISE AND EXPERIMENT
Using composition

Dramatic compositions are rarely accidental; they are usually the result of an experienced eye and sound technical knowledge. To hone your skills, it's worth setting yourself a few exercises. The following assignments look at positioning your subject in the centre of the frame, grouping objects, and using the camera in horizontal as well as vertical positions.

TAKING CENTRE STAGE

📶 **EASY**
🕐 **30 MINUTES**
📷 **BASIC +** tripod

📍 **INDOORS OR OUTDOORS**
➕ **A SUBJECT THAT WILL FIT INTO THE CENTRE OF YOUR PHOTO**

Placing a subject in the centre of the frame may be breaking the "rules", but for this exercise we will be doing just that.

■ **Choose** your subject wisely: when the point of interest is in the centre of the frame it takes the viewer's eye straight there, but they will need something else to hold their attention. Ideal subjects include the petals of a flower radiating outwards, or a brightly coloured beach ball on the sand.

■ **Use** the grid display on your camera to ensure your subject will be positioned right in the centre of the frame.

■ **Note** how breaking the tried and tested rules has altered your feelings towards the subject.

USE VERTICAL AND HORIZONTAL ORIENTATION

📶 **EASY**
🕐 **30 MINUTES**
📷 **BASIC +** tripod

📍 **INDOORS OR OUTDOORS**
➕ **A HORIZONTAL SUBJECT**

The horizontal format mirrors the way we see the world, so we often frame scenes in this way. But turning the camera on its side can create striking, and often unusual, compositions.

■ **Find** a subject that will fit in the frame both horizontally and vertically.

■ **Mount** the camera horizontally on a tripod.

■ **See** how much space is not taken up by the subject and how any lines or shapes interact.

■ **Turn** the camera to the vertical position, and note how the structure of the photo has altered.

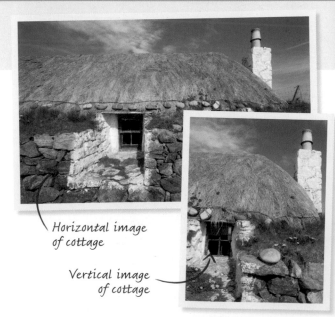

Horizontal image of cottage

Vertical image of cottage

Pro tip: When you are faced with an off-centre subject you have three focusing options: focus lock, selectable AF points, or manual focus. Experiment with all three until you find the one that works best.

Stunt bike in the centre of the image grabs attention

ⓘ ELECTRONIC GRIDS AND LEVELS

If your camera has a Live View facility, you can call up a simple grid to show you when you have achieved (or broken) the rule of thirds. Many cameras also feature an electronic level. This screen-based tool works just like a spirit level, detecting when the camera is misaligned, and turning from green to red accordingly.

The electronic level will tell you when the camera is level

MAKE UP THE NUMBERS

- ⬛ **EASY**
- 🕐 **30 MINUTES**
- 📷 **BASIC + tripod**
- ⦿ **INDOORS OR OUTDOORS**
- ⊕ **AT LEAST THREE OBJECTS OF THE SAME SORT**

Groups containing an odd number of objects tend to be more aesthetically pleasing than those containing even ones.

- ◼ **Place** an even number of bowls on a table: two is a good starting point.
- ◼ **Note** how your eyes jump from one bowl to the other, mentally pairing them up, before you lose interest.
- ◼ **Add** an extra bowl, and observe how the brain spends longer sorting the bowls into satisfying groups. Repeat with other objects.

Objects arranged in odd numbers hold attention.

WHAT HAVE YOU LEARNED?

- ◼ Breaking the rules – for example, placing your subject in the centre of the frame, giving your horizon a tilt, playing with the horizontal and vertical orientation, or freezing a subject walking out of the frame – can lead to striking images.

Reviewing your shots

Now that you have learned the basic "rules" of composition, it's time to assess some of your favourite photographs. Whether your picture succeeds or fails will depend on where you place key points of interest, and how well the viewer's eye is guided towards them.

Have you found the best viewpoint?
Investigate all the possible viewpoints: crouch down low or climb up high. By taking a high viewpoint, this image has made what could be a dull view into something more interesting.

Is the positive and negative space balanced?
Parts of the frame that don't contain content are called negative space. These areas emphasize the subject and provide a place for the eye to rest. This shot of Michelangelo's *David* works well because there is room for the statue to stare in to.

Does the picture have a sense of depth?
A photograph is a two-dimensional object, so conveying a sense of depth can be tricky. You can imply depth by letting objects overlap. For example, in this image of a mountain range, the peaks appear as layers, transporting the eye back towards the clouds.

Have you experimented with both landscape and portrait formats?
You can miss opportunities if you only ever hold the camera vertically for portraits and horizontally for landscapes. Here, the landscape format focuses on the face, drawing attention to the man's expression.

"Learn the rules like a pro, so you can break them like an artist."

PABLO PICASSO

▼ Does the picture adhere to the rule of thirds?

Following the rule of thirds is a great way to give your photos balance. The positioning of this macaque adheres to this "rule", but the photographer has also left space for the animal's line of sight, which draws our attention to the macaque in the background.

▼ Do any lines direct the viewer's eye?

Lead-in lines usually start at the bottom of the frame and guide your eye into the picture to its key focal points. But in this shot the curve of the river guides the eye from left to right, and then back again. Rules are made to be broken.

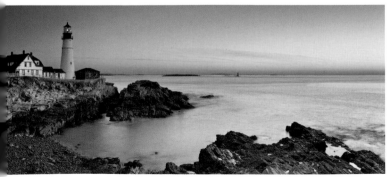

▲ Does your aspect ratio suit the subject?

Before committing to an aspect ratio for square or panoramic photographs, consider how much negative space you need to show. This panoramic picture works because it includes a vast sweep of sea and coastline, placing the lighthouse in context. Would you have used this much negative space?

▲ Is your main focal point obvious?

If the point of focus in a picture is unclear, then the viewer will struggle to make sense of the scene. Everything in this image suggests that the strawberries take priority, with the hands playing a supporting role.

HOW TO COMPOSE / **213**

▶ ENHANCE YOUR IMAGES
Cropping photos

Cropping is a great way to remove unwanted elements from the edges of the frame, but it can also be used to alter the emphasis of a picture, reduce negative space, and apply the rule of thirds. While the best solution is always to create the best image you can in-camera, cropping the image afterwards allows you to address many problems. This image of a stork's nest is well composed, but the large area of negative space is a little distracting and it would be nice to focus on the chicks.

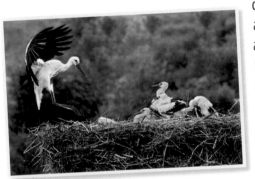

1 Select the Crop tool
Click on the Crop tool. Move your cursor to the Options bar at the top of the screen. Select the drop-down menu on the left side of the Options bar that lists presets of common photo sizes and shapes

Select the Crop tool from the Tools palette

5 Alter the shield
To view other options, click on the Crop Options icon on the Options bar (represented by a cog icon). Check Enable Crop Shield and manipulate the colour picker and the opacity slider to make the shaded area outside the crop frame as clear as possible. To see the cropped area only uncheck Enable Crop Shield.

6 Consider the options
To discard the area outside the crop frame after cropping, check Delete Cropped Pixels on the Options bar. Unchecked, Photoshop will preserve your image outside the crop frame (your image will need to be saved as a Photoshop PSD file). The cropped area can be restored by selecting the Crop tool once more.

7 Save or dismiss the crop
To accept the current crop, press Enter/Return or click on the Commit icon (represented by a tick in the Options bar). To cancel the crop press Esc, or click on the Cancel icon (represented by a circle with a line through it in the Options bar).

Shield controls the colour and opacity of the area to be cropped

Press Enter Return to c your image

Crop

Pro tip: To correct a wonky horizon, rotate the image by moving your cursor outside the frame. Some software packages also allow you to overlay the image with a rule-of-thirds grid, enabling you to crop your image for greater impact.

2 Add your own preset

You can choose a preset or add your own by entering your preferred values in the Options bar, such as "8 inch x 10 inch". Open the drop-down menu again, click on the small arrow at the side, select New Tool preset, and click OK.

3 Create a clipping border

Click on the image and drag your mouse over the area you want to keep. Anything outside this frame will appear darker, which helps you to visualize the end result.

The area to be removed will appear greyed out

4 Fine-tune your crop

Drag one of the corners to resize the crop border. You can rotate the frame by positioning your cursor outside of the border (it turns into a curved arrow) and moving it.

Rotating the frame allows for a different crop

Type in the size you want to use

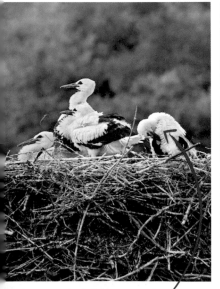

A tighter portrait focuses on the chicks

CORRECTING PERSPECTIVE

The Crop tool can be used as a basic way of correcting converging verticals. To perform this task, draw a crop selection as usual and then check the Perspective box in the Options bar. Take the top corner handles and drag them inwards until the edges of the frame line up with the leaning edges of the building.

Here, the church steeple appears to be leaning backwards.

The tilt has been corrected using the Crop tool.

What have you learned?

Successful compositions are the result of a keen eye and basic technical knowledge. By experimenting, and studying the work of other artists, you'll soon find you're perfecting both. See how much you have learned by taking the quick quiz below.

1 What does composition refer to?

A The way in which you arrange the camera, lens, and subject
B The way in which you arrange yourself before releasing the shutter
C The way in which elements are arranged in the frame

2 Where possible, how should objects be arranged?

A In odd numbers
B In even numbers
C In natural numbers

3 In most instances, where should the horizon be placed?

A As low as possible in the frame
B Directly in the centre of the frame
C In the upper or lower third of the frame

4 Trees, rocks, and arches can all be used to do what?

A Block sunlight
B Create a natural frame
C Support your tripod

5 What does a successful composition do?

A Direct the viewer's eye around the frame in the way you intended
B Confuse the viewer so that they spend longer looking at the picture
C Direct the viewer into and out of the frame as quickly as possible

6 What is the quickest (and best) way to alter a composition?

A Move your feet
B Move your subject
C Move your lens

7 On what occasion would you use a small spirit level?

A When you want to check the position of the sun
B When you want to mend the legs on your tripod
C When you want to keep the horizon straight

8 How do compositions with horizontal lines make us feel?

A Agitated and restless
B Calm and at peace
C Energized and inspired

9 What is the main purpose of a lead-in line?

A To improve a picture that is poorly composed
B To hide some potentially distracting elements
C To guide the eye into the frame

10 When using the rule of thirds, where should you place points of interest in a 3x3 grid?

A Where the lines intersect
B Right in the centre
C In the top squares

11 Why might you place a small object next to a much larger one?

A To give a sense of scale
B To ensure the frame is full
C To adhere to the rule of thirds

12 Curves in a composition encourage the eye to do what?

A Race around the frame quickly
B Take its time exploring the frame
C Leave the frame as soon as possible

13 Most people shoot landscapes with the camera held in which position?

A Upside down
B Vertical
C Horizontal

14 Manually selecting an AF point helps the camera to do what?

A Focus on an off-centre subject
B Judge which aperture to use
C Decide on a shutter speed

Answers 1/C, 2/A, 3/C, 4/B, 5/A, 6/A, 7/C, 8/B, 9/C, 10/A, 11/A, 12/B, 13/C, 14/A.

13 COMPOSE LIKE AN EXPERT

week

Deciding what to include in the frame requires thought. If you allow unnecessary details to creep in, your message may be diluted; but if the picture contains too little information, the viewer may struggle to make sense of it.

In this module, you will:

▸ **judge what should be included and excluded** from the frame;

▸ **study how the theory of visual contrast** works in composition;

▸ **try to apply the theory** by using reflections to create symmetrical pictures;

▸ **experiment and explore** using unusual viewpoints, shadows, and patterns;

▸ **review your photos** and see how you can remove distracting highlights, allow extra space for moving subjects, and fill the frame;

▸ **improve your photographs** using the Targeted Adjustment tool as an intelligent shortcut;

▸ **go over your understanding** of composition to see if you're ready to move on.

Let's begin...

▶ TEST YOUR KNOWLEDGE
Assessing composition

To produce pictures with long-lasting appeal, you need to consider what exactly should be included in the frame. Look at these photos and see if you can match the image number with the right description.

Ⓐ **Fill the frame:** Get close to exclude all unnecessary elements.

Ⓑ **Allow "travelling" space:** Give fast-moving objects negative space to move into.

Ⓒ **Use shade effectively:** Let shadows play a starring role.

Ⓓ **Play with texture:** Position rough and smooth objects together for striking contrast.

Ⓔ **Explore symmetry:** If one side of a picture mirrors the other, the result can be very satisfying.

Ⓕ **Exploit size differences:** Small objects placed next to large ones can have comedic consequences.

Ⓖ **Convey emotion:** Cropping the top of a subject's head draws attention to their emotional state.

Ⓗ **Keep it simple:** Sometimes just one or two elements are needed.

Ⓘ **Consider colour:** Bear in mind the aesthetic and emotional impact of bright hues.

Ⓙ **Try a fresh angle:** Adopt a bird's- or worm's-eye view.

NEED TO KNOW

■ In order to "see" pictures, carry two L-shaped pieces of card with you. Put them together to create a frame around any potential subjects and move them closer together or farther apart to adjust the size of the frame.

■ Deciding when to release the shutter becomes instinctive, but to hone your skills, shoot a sequence and analyse why certain pictures succeed and others fail.

■ Developing a photographic style comes with time, and requires you to think about your past, your cultural preferences, and how your style might develop in the future.

■ You can find inspiration from artists working in a variety of mediums, from music and dance to painting and poetry.

Review these points and see how they relate to the photos in this module

▶ UNDERSTAND THE THEORY
Contrast and composition

When two objects with opposing qualities – such as rough/smooth, dark/light, or large/small – are placed next to each other, the resulting disparities create visual appeal. Such differences can be used to direct the viewer's eye, provide a sense of height, size, or value, or simply add interest to a composition. Generally speaking, contrast can be provided by two main elements: visual contrast (such as colour, shape, size, position, and space), and subject matter contrast (such as day and night).

CONTRAST AND FINE ART

Painters have long understood the effect of using visual contrast in their work. In his painting *Still Life with Apples and Peaches*, c.1905, French artist Paul Cézanne arranged props and objects in his studio until a great number of opposing elements sat happily together. In this one work we see plain fabric resting against patterned, the hard edges of plates and bowls set against soft fruit, and cool colours clashing with warm ones.

SIZE

When objects of the same size are placed side by side, the eye looks for points of difference – if none can be found, we quickly lose interest. Yet, if one object is larger than the other, the brain busies itself making constant comparisons. If you can position large objects next to small ones, the viewer will invest time attempting to interpret the relationship.

SHAPE

Shapes can be described as either geometric or organic. Geometric shapes have clear, well-defined edges, while organic shapes have softer, more natural boundaries. Geometric shapes are regular and precise, and can often be seen in man-made objects; examples include circles, triangles, squares, and rectangles. Organic shapes can be seen in nature, and are irregular and imprecise. When the two are combined, the contrast can be powerful.

> In my photography, **colour** and **composition** are **inseparable.**
>
> WILLIAM ALBERT ALLARD

COLOUR

Colours that sit opposite each other on the colour wheel (see pp.236–237) are known as complementary. For strong, vibrant images that convey energy and stability, make use of the contrasts between red and green, orange and blue, or purple and yellow.

SPACE

The part of the frame containing your subject is called positive space; the unoccupied part is negative space. Negative space helps to define your subject, offers the eye a place to rest, and provides moving subjects with a place to travel to. Shifting the balance between these areas can dramatically change the meaning of your image.

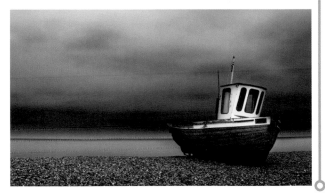

POSITION

Placing a single, stand-alone object next to a group of objects causes great tension. More often than not, the isolated object becomes the main focal point – humans are social animals, so to be set apart from the rest can be seen as punishment. When we understand what the viewer may feel when we position a solo object against a group, we can plan our compositions accordingly.

Capturing reflections

Reflections can be found in puddles, lakes, paintwork, mirrors, windows, and many other places, but capturing them takes patience and perseverance. Water, for example, is easily disturbed. In this instance, you will aim to shoot a perfectly still, symmetrical reflection of a stunning landscape.

1 Do your research

Wait for a still day and use a sunrise/sunset app to work out when the sun will hit your chosen subject. You don't want direct sun on the water as it can cause glare, although it is nice to have the subject bathed in light.

A sunrise/sunset app will tell you the sun's exact position.

2 Attach a wide-angle lens

Fit your camera to a tripod and attach a wide-angle lens, which will allow you to include plenty of the surrounding landscape.

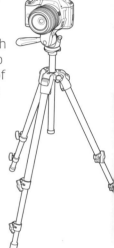

The tripod will let you frame the subject while you set the exposure.

6 Attach an ND graduated filter

Neutral density (ND) graduated filters are used to balance exposure between two halves of a scene. They're available in different strengths: 0.3 (1 stop), 0.6 (2 stops), and 0.9 (3 stops). Use one that matches the difference between the two readings at Step 5. Set the exposure reading for the reflection.

Filter attached to the front of the lens

7 Shoot and review the results

Take a few pictures and play them back. If the reflection looks slightly darker than the subject, don't worry – your eyes naturally perceive reflections as darker.

Where to start: Check the weather forecast and wait for a still day. If planning to shoot a body of water, choose one that is protected from the wind by natural or artificial features.

You will learn: How to balance the exposure of a subject and its reflection using an ND graduated filter, how to break the rules by placing the horizon in the middle, and how cameras struggle to focus in low light and low contrast conditions.

3 Break the rules

Forget everything you've learned about placing the horizon off-centre, and put it directly in the middle of the frame.

Place the horizon in the centre of the frame

4 Select small aperture, focus on reflection

To ensure the subject and its reflection are sharp, select a small aperture such as f/11 or f/16. Your camera may struggle to focus on the reflection, so switch to manual focus.

Small aperture will create a large depth of field

5 Take meter readings

Record one exposure reading from a midtone area of the subject and another from the reflection. The latter will be darker with a difference of around 1.5 to 2 stops. Make a note of the two readings.

Meter here

Meter here

Positioning the horizon in the centre creates perfect symmetry

WHAT HAVE YOU LEARNED?

■ In order to shoot a perfect reflection you need a calm day with no wind. Use a sunrise/sunset app on your smartphone and check the weather forecast to make sure conditions will be perfect.

■ You need to use manual focus, as your camera may have difficulty focusing on a reflection.

■ Reflections are usually darker than the object being reflected, so you'll need an ND graduated filter to balance things out.

▶ PRACTISE AND EXPERIMENT
Mastering composition

Successful compositions have one thing in common: they contain only what's strictly necessary to tell the story. The assignments here cover different topics, but each can be used to practise visual distillation.

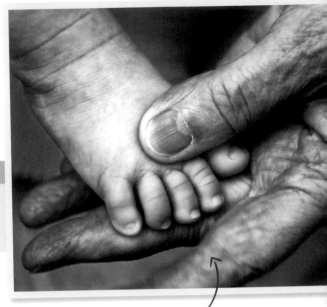

EXPLORING CONTRAST

- 📊 **EASY**
- 📍 **INDOORS OR OUTDOORS**
- 🕐 **45 MINUTES**
- ➕ **CONTRASTING SUBJECTS**
- 📷 **BASIC +** tripod

Shooting subjects with opposite attributes, such as tall/short or rough/smooth, can create emotional, and sometimes even amusing, photographs.

■ **Choose** two of the following themes: small/large, happy/sad, fast/slow, or new/old.

■ **Decide** on the optimum way to show the differences between your subjects – try placing them side by side or one on top of the other.

■ **Keep** your composition simple, and exclude anything that doesn't reinforce your message.

Old hands and young feet show contrasting size and texture

ℹ KIT: **PHOTOGRAPHY DRONES**

Finding unusual viewpoints is pretty much guaranteed when using low-altitude aerial photography.
Depending on the model, specially designed unmanned aircraft (or drones) allow you to shoot up to 120 m (400 ft) above the ground. Before you launch your drone, however, make sure you're familiar with the local laws regarding its use.

Pro tip: Always think about what's behind your subject. Do you want the background to be in focus or should it be blurred? And, if so, by how much?

UNUSUAL ANGLES

- 📶 **MEDIUM**
- 🕐 **1 HOUR**
- 📷 **BASIC +** tripod, stepladder, or groundsheet
- 📍 **OUTDOORS**
- ➕ **A LOCAL LANDMARK**

Unusual viewpoint of the Eiffel Tower, France.

When you spot an attractive subject, it's tempting to just start shooting from where you stand, but in order to find the best viewpoint you need to put your equipment away and move your feet.

Head to a local landmark (note, it doesn't have to be as grand as the Eiffel Tower).

Look at postcards, or carry out some online research, to see how your subject has been photographed in the past.

Try to create a new composition using a fresh viewpoint.

LOOK FOR SHAPES

- 📶 **MEDIUM**
- 🕐 **1 HOUR**
- 📷 **BASIC +** tripod
- 📍 **INDOORS OR OUTDOORS**
- ➕ **SUBJECTS THAT FORM GEOMETRIC SHAPES**

Geometric forms such as circles and squares direct the eye around the frame and strengthen associations between elements. These satisfying shapes can be real or implied.

- ■ **Arrange** the elements in your composition to make the most of any naturally occurring shapes.
- ■ **Create** shapes not just with solid objects, but with shadows, colours, and textures too.

Triangle created using two sides of a cake box and the photo frame

WHAT HAVE YOU LEARNED?

- ■ To make the most of visual contrast, you need to keep compositions simple and find ways to reinforce any differences in the frame.
- ■ More often than not, you can find the best viewpoints by changing your position.

LEAVE SPACE TO TRAVEL

- MEDIUM
- 1 HOUR
- BASIC + tripod
- OUTDOORS
- A MOVING SUBJECT IN PLENTY OF SPACE

When positioning fast-moving objects in a frame, there is one piece of advice you'd be foolish to ignore: leave space for them to travel into.

- **Use** panning to keep the subject sharp while recording the background as a blur. Select a relatively slow shutter speed (such as 1/30 sec), set the autofocus mode to continuous, follow the subject with your camera, and release the shutter gently.

- **Remember** to leave some "travelling" space in front of your subject to avoid it butting into the edge of the frame.

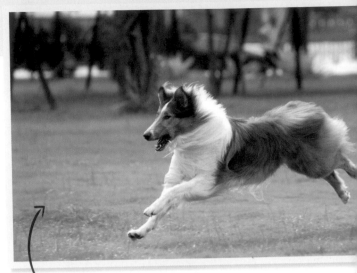

Negative space in front of your subject suggests motion

KIT: TRIPOD HEADS

Investing in a solid, well-engineered head for your tripod will allow you to pan with confidence. There are two types available: pan-and-tilt or ball-and-socket. Pan-and-tilt heads offer movement through two or three axes: tilting forwards and backwards, panning, and moving from left to right. Ball-and-socket heads move in all directions, offering greater versatility.

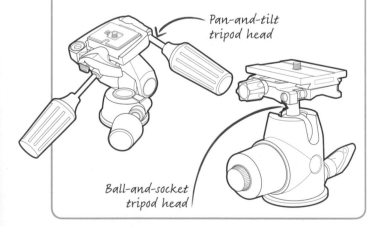

Pan-and-tilt tripod head

Ball-and-socket tripod head

GETTING SHADY

- EASY
- 45 MINUTES
- BASIC + tripod
- INDOORS OR OUTDOORS
- SUBJECTS WITH CLEAR OUTLINES

Deep black shadows are often avoided in photos because they lack detail, but for this assignment, the darker the better.

- **You need** harsh shadows, so wait for a clear, sunny day and locate a subject with a clear outline.

- **Use** Manual mode, as an auto or semi-auto exposure mode will overexpose the image, and check the histogram to ensure most of the peaks are on the left-hand side.

Simple shapes can make powerful images.

🄯 BREAK A PATTERN

📶 **MEDIUM**
🕐 **1 HOUR**
📷 **BASIC +** tripod

📍 **INDOORS OR OUTDOORS**
➕ **A PATTERN THAT CAN BE BROKEN**

Repeating patterns can be observed everywhere, but some of the most beautiful are found in nature. Predictable patterns can be calming, but they can also become monotonous, so for this exercise you will be looking to introduce variation.

■ **Locate** a natural or artificial pattern – this can be anything from a row of fence posts to the markings on a butterfly's wing.

■ **Pick** an angle that will emphasize the pattern, making it appear infinite. Make sure that any unnecessary elements have been excluded.

■ **Find** a way to break the pattern to stop it from being monotonous.

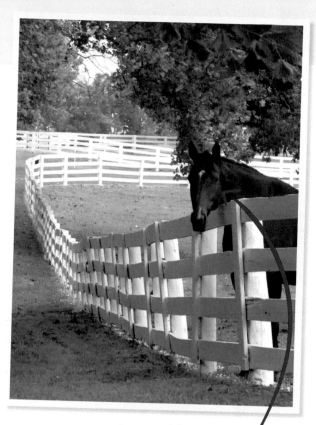

The row of fence posts is broken up by the horse's head

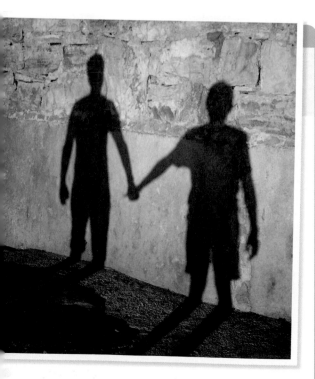

Silhouettes become the focal point of this picture.

WHAT HAVE YOU LEARNED?

■ Shadows don't need to play a supporting role in your photographs; they can become subjects in themselves.
■ Patterns are pleasing to the eye, but they often have more impact if they are broken up in some way.
■ You can use negative space in front of a moving subject to indicate motion and speed.

▶ ASSESS YOUR RESULTS
Reviewing your shots

Having learned how to use colour, shape, position, size, and space to create clear, balanced compositions, it's time to choose some of your favourite pictures and run through this checklist. Look at each composition and ask yourself why you have arranged the elements in a certain way.

⊙ Do all of the elements reinforce your story?
Placing a subject in its natural environment provides extra information about its life. What does this photo tell you about the kingfisher?

⊙ Do highlights and shadows serve a purpose?
Shadows and highlights can be distracting, but don't avoid them altogether. The highlights on this woman's arm suggest a field bathed in sunlight.

⊙ Does your subject fill the frame?
Filling the frame with your subject transports the viewer into the centre of the composition. This image is focused on the centre of a rose, revealing the intricate structure of its petals.

⊙ Could your composition be simplified?
Cluttered, chaotic pictures are unsettling to look at, so reduce your composition to its crucial elements. The colours of this church in Santorini, Greece, are enough to convey the warm sun.

> ## In photography, the **smallest thing** can be a **great subject.**
> HENRI CARTIER-BRESSON

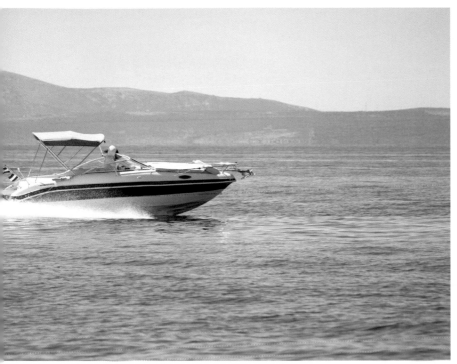

◀ Have you allowed extra space for moving objects?
This reinforces the impression of speed, as the eye moves to where the subject will appear next.

▼ Has colour been used well?
Pure hues tend to dominate the frame, whereas neutral colours are more recessive. Here, the strong blue directs the viewer along the row of sailors.

▲ Have you made the most of any visual contrast?
If your image contains opposites, make the most of any visual contrast they provide. This block of ice has been set against a fiery Icelandic sunrise, creating an ideal contrast between heat and water.

▲ Are there any dominant tones in your image?
The complementary tones here encourage a calm, restful feeling. If one element in a photo, whether it be a shape, a tone, or a shadow, is allowed to overpower the others, it can introduce a sense of tension.

Targeted adjustment

Although it can seem daunting at first, the Adobe Photoshop Curves tool is one of the most useful ways to adjust a photo's tonal range. It features a simple shortcut known as the Targeted Adjustment tool (TAT), which makes these adjustments more intuitive. It allows you to click and drag within an image to make a change. The Targeted Adjustment tool can also be found in Adobe Lightroom and Adobe Camera Raw.

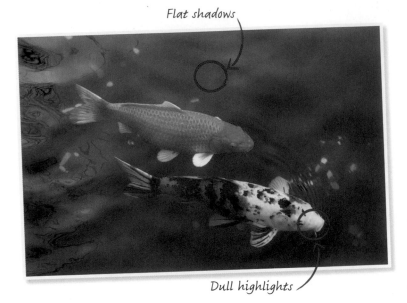

Flat shadows

Dull highlights

4 Darken and lighten

To lighten the pixels under the tool, click and hold down your mouse, then drag upwards. To darken the pixels, drag downwards. All the pixels of a similar tonal value will also be altered.

5 Further changes

If you need to change another range of tones, click in the relevant area of your photo and repeat Step 4. Click OK once you're satisfied with your adjustments.

6 Adding contrast

For a simple way to add contrast, lighten the highlights and darken the shadows. This produces a distinctive "S" shape in the curve.

Dragging the mouse down darkens the chosen area.

Dragging the mouse up lightens the chosen area.

S-shaped curve

Pro tip: With the Targeted Adjustment tool selected, as you move the mouse cursor over the photo a small circle will move up and down the histogram, displaying the tonal value of the pixel currently under the cursor.

1 Adjusting Curves

To start, open Curves by going to the Image menu, then Adjustments, then Curves, which shows a histogram of your photo.

2 Use targeted adjustment

To begin using the Targeted Adjustment tool, click on the hand icon in the Curves dialog box. The cursor should now turn into a colour picker.

3 Select first adjustment area

Move the cursor over your photo to decide what part of the photo's tonal range – the shadows, midtones, or highlights – you want to adjust first. Move the cursor to an area that falls roughly in that tonal range.

The histogram shows the tonal range of the photo.

The hand icon is located in the bottom left-hand corner of the dialog box

Choose a representative patch of pixels, such as the pattern on this fish

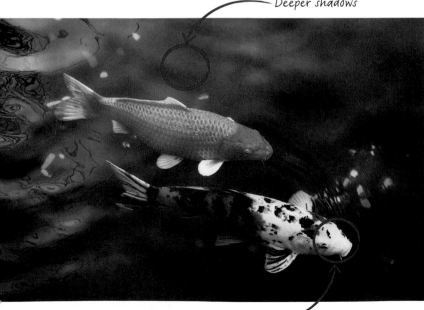

Deeper shadows

Brightened highlights

ℹ MORE PRECISION

Both Adobe Lightroom and Adobe Camera Raw let you use targeted adjustment on the HSL palette to change colours as well as the tonal range. You can precisely alter a colour (changing anything red in a photo to blue, for example), the saturation of a colour, or a colour's luminance.

Saturation		
Red		0
Orange		0
Yellow		0

Move the sliders to alter the saturation

▶ REVIEW YOUR PROGRESS
What have you learned?

Trying to create a picture where everything is relevant to the story takes time, but if you scan the frame carefully you can check that every element earns its place. See how much you have learned by taking the quiz below.

1 **When opposites** are placed together they are said to create visual what?

A Visual harmony
B Visual contrast
C Visual distillation

2 **What do you need** to do to find new viewpoints?

A Move your position
B Hire a plane
C Consult a map

3 **Omitting the top** of a subject's head can do what?

A Make the viewer feel uncomfortable
B Draw attention to the subject's emotional state
C Unbalance the composition

4 **What can you use,** aside from a camera, to perfect your compositions?

A Two black pieces of card
B Two circular pieces of card
C Two L-shaped pieces of card

5 **What kind** of filter is useful for shooting reflections?

A ND graduated
B Polarizer
C Warm-up

6 **What can happen** if objects of the same size are placed side by side?

A The viewer loses interest and quickly moves on
B The objects can look as though they are leaning
C The viewer finds the similarities fascinating

7 **What should you do** when shooting a moving subject?

A Zoom in as close as you can
B Leave space behind it
C Leave space in front of it

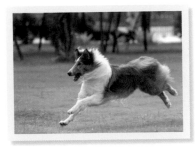

8 **Placing a group** of objects next to a single, stand-alone object creates what?

A Calmness B Tension C Stillness

9 **What role** does negative space play in your composition?

A It helps to define your subject
B Nothing, it has no content
C It helps to fill the frame

10 **Why is direct sun** unsuitable for shooting reflections?

A It can cause asymmetry
B It can cause sunburn
C It can cause glare

11 **Patterns** have more impact if they are what?

A Natural B Broken C Irregular

12 **What type** of tripod head allows movement in all directions?

A Pan-and-tilt
B Ball-and-socket
C Lock-and-load

13 **How do cluttered,** chaotic compositions make the viewer feel?

A Optimistic B Content C Unsettled

14 **Most pictures** are taken from what height?

A Standing B Sitting C Crouching

15 **Specially designed drones** allow you to do what?

A Practice low-altitude aerial photography
B Create a worm's-eye view of your subject
C Fly within 150 metres of a congested area

16 **What kind** of edges do organic shapes have?

A Hard and well-defined
B Soft and irregular
C Imperceptible

Answers 1/B, 2/A, 3/B, 4/C, 5/A, 6/A, 7/C, 8/B, 9/A, 10/C, 11/B, 12/B, 13/C, 14/A, 15/A, 16/B.

week

14 LESSONS IN COLOUR

Understanding how to manage colour in your pictures will allow you to take charge of the relationship between colours and human emotions, and influence how the viewer responds to your subject.

In this module, you will:

▶ **see why colour is important** to your compositions, and how different tones can change the mood of your work;

▶ **study the six main colour harmonies:** complementary, analogous, triadic, split-complementary, tetradic, and monochromatic;

▶ **experiment** by using Picture Styles to adjust contrast, saturation, and tone;

▶ **explore colour** by creating a monochromatic image, shooting at dawn and dusk, and focusing on one key colour;

▶ **review your photos** and learn how to use colours for maximum impact;

▶ **improve** hue and saturation during post-production;

▶ **revise** what you've learned about the aesthetic and emotional power of colour.

Let's begin... ⊛

The importance of colour

Vivid colours, such as red, tend to dominate the frame even when used in small quantities, while neutral colours, such as beige, are restful and recessive. Read these descriptions and match each one to an image.

A **Maximum contrast:** Blue and yellow create a powerful contrast.

B **Vivid colours:** Complementary colours, such as orange and blue, are vibrant and grab attention.

C **Pure hues:** Colours that are not mixed with white, grey, or black can be more exciting to the eye.

D **Small amounts:** Strong colours, such as red, attract attention, even in small quantities.

E **Neutral shades:** Interior designers like neutral colours because they highlight texture.

F **Low contrast:** Low-contrast colours are perfect for revealing architectural details.

G **Gentle tones** Soft, neutral colours can be restful.

H **Pastels:** When soft colours are combined, the result can be soothing.

ANSWERS

A/8: Yellow and blue hot-air balloon
B/2: Bright orange chrysanthemum
C/7: Colourful Indian powders
D/5: Climber on a mountain ridge
E/6: Jug of milk on a piece of cloth
F/1: Stone arches
G/3: Sound-asleep baby
H/4: Close-up of sugared almonds

NEED TO KNOW

■ Black is not strictly a colour (more the absence of colour), while white is composed of all colours.

■ Neutral colours, such as magnolia and stone, are recessive and make ideal blank canvases for interior designers.

■ Complementary colours sit opposite each other on a colour wheel, whereas analogous colours sit next to each other on the colour wheel (see pp.236–237).

■ Colour can have a powerful psychological effect on the viewer. For example, blue is restful, while red is considered energizing.

■ Some colours are perceived as being heavier than others – black, for instance, is often thought of as "weightier" than white.

Review these points and see how they relate to the photos shown here

White light can be split into a rainbow of colours using a prism. The resulting spectrum can be expressed as a wheel divided into primary colours (red, yellow, and blue), secondary colours (orange, green, and violet), and tertiary colours (red-orange, yellow-orange, yellow-green, blue-green, blue-violet, and red-violet). Many of the choices we make about colour are intuitive, but you can improve your images by better understanding colour relationships and their impact.

ℹ COLOUR BASICS

1 PRIMARY
Red, yellow, and blue are the primary colours in the traditional colour wheel.

2 SECONDARY
Made by mixing two or more primary colours, the secondary colours are orange, green, and violet.

3 TERTIARY
Created by mixing a primary and a secondary colour, or two secondary colours, together.

COMPLEMENTARY COLOURS

These colours sit opposite one another on the colour wheel. If complementary colours in a scheme are pure hues (with no grey, white, or black added), they create maximum contrast. When they are put together, each makes the other more intense.

When used in large doses, complementary colours can tire the eyes, so consider using with caution.

ANALOGOUS COLOURS

These colours sit next to each other on the colour wheel. Using small groups of analogous colours can create lovely compositions, but they harmonize so well that you might need to introduce tension.

To strengthen a composition, add a primary colour, or use one colour to dominate, one colour to support, and one to add an accent.

The colour wheel illustrates the relationship between the colours.

YELLOW-GREEN

YELLOW

YELLOW-ORANGE

ORANGE

RED-ORANGE

> **Colours** speak all languages.

JOSEPH ADDISON

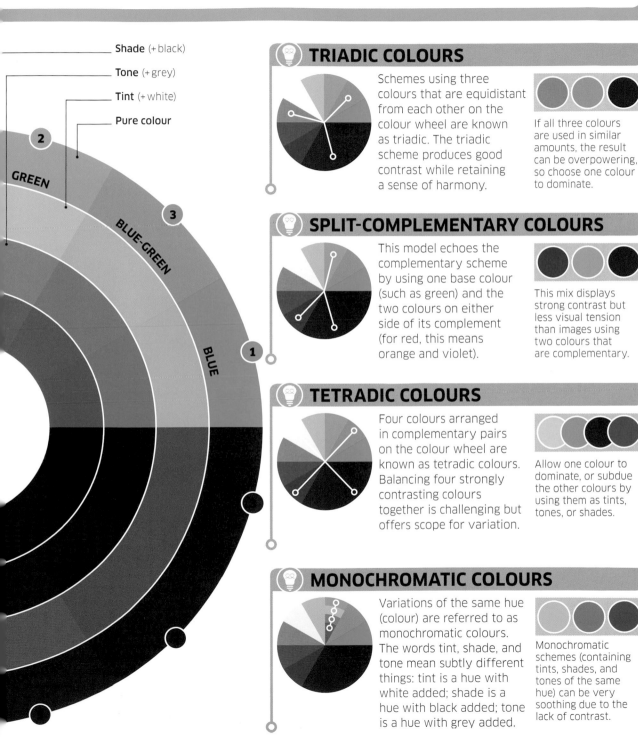

Shade (+black)
Tone (+grey)
Tint (+white)
Pure colour

2

GREEN

3

BLUE-GREEN

BLUE

1

TRIADIC COLOURS

Schemes using three colours that are equidistant from each other on the colour wheel are known as triadic. The triadic scheme produces good contrast while retaining a sense of harmony.

If all three colours are used in similar amounts, the result can be overpowering, so choose one colour to dominate.

SPLIT-COMPLEMENTARY COLOURS

This model echoes the complementary scheme by using one base colour (such as green) and the two colours on either side of its complement (for red, this means orange and violet).

This mix displays strong contrast but less visual tension than images using two colours that are complementary.

TETRADIC COLOURS

Four colours arranged in complementary pairs on the colour wheel are known as tetradic colours. Balancing four strongly contrasting colours together is challenging but offers scope for variation.

Allow one colour to dominate, or subdue the other colours by using them as tints, tones, or shades.

MONOCHROMATIC COLOURS

Variations of the same hue (colour) are referred to as monochromatic colours. The words tint, shade, and tone mean subtly different things: tint is a hue with white added; shade is a hue with black added; tone is a hue with grey added.

Monochromatic schemes (containing tints, shades, and tones of the same hue) can be very soothing due to the lack of contrast.

Optimizing colour

Sometimes, the colours recorded by your camera don't produce the effect you desire. To keep post-production to a minimum, you can apply parameters to your pictures in-camera. For example, if your landscape lacks bright colours, you can boost the saturation before taking your shot.

1 Attach a suitable lens

Choose a lens to suit the result you're after as Picture Styles can be applied to any subject. For example, if you are taking a photo of a landscape, you should use a wide-angle lens to maintain front-to-back sharpness.

2 Select a picture mode

Attach your camera to a tripod and choose a picture mode. Select Aperture Priority and set a small aperture to obtain a deep depth of field.

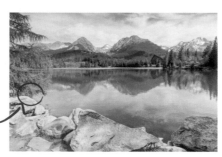

Keep rocks and trees in shot to frame the image

Aperture Priority

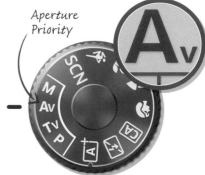

5 Change the parameters

Adjust each of the parameters. Sharpness, saturation, and contrast can all be increased or decreased. Colour tone can be changed from reddish to yellowish.

6 Save the Picture Style

If you've found a combination of settings that you think you might use regularly, you can save the Picture Style in the camera to use later. Some cameras even let you set how a certain Picture Style handles individual colours.

7 Activate Live View

By switching the camera to Live View, you can see how your Picture Style will affect the image. If the result is not what you want, you can make further adjustments before taking more shots.

Alter the settings

Save your settings

Where to start: Find a scene, such as a landscape, that could do with an improvement in sharpness, contrast, saturation, or colour tone.

You will learn: How to choose a Picture Style, how to adjust sharpness, contrast, saturation, and colour tone in-camera, and how to customize and register a Picture Style for fast and easy access.

3 Check the metering mode and the ISO

Choose a metering mode to suit your subject and the light conditions. With this landscape, which has plenty of midtones and low contrast between the sky and foreground, it would be best to set the metering mode to default.

Set the ISO to the lowest sensitivity

4 Choose a Picture Style

With your composition and exposure perfected, select a Picture Style from the Shooting menu. The Landscape option, for instance, offers punchy greens and blues.

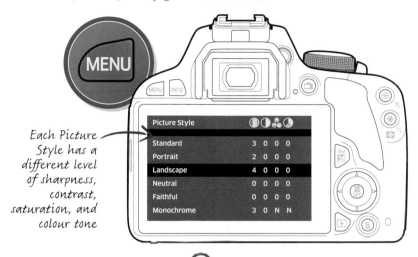

Each Picture Style has a different level of sharpness, contrast, saturation, and colour tone

Picture Style				
Standard	3	0	0	0
Portrait	2	0	0	0
Landscape	4	0	0	0
Neutral	0	0	0	0
Faithful	0	0	0	0
Monochrome	3	0	N	N

WHAT HAVE YOU LEARNED?

■ Common Picture Styles include Standard, Portrait, Landscape, Neutral, Faithful, and Monochrome.
■ Each of these has a different level of sharpness, contrast, saturation, and colour tone preset.
■ All of these parameters can be adjusted before you take a photo.

Save your best images and review them later (see pp. 240–241)

▶ PRACTISE AND EXPERIMENT
Playing with colour

These assignments involve experimenting with colour in a number of ways, including creating contrast using complementary colours, placing a vivid colour against a subdued backdrop, reducing saturation, and using analogous colours.

Analogous colours

USE ANALOGOUS COLOURS

- **.ıl EASY**
- ◔ **45 MINUTES**
- ◎ **BASIC +** tripod
- ◉ **INDOORS OR OUTDOORS**
- ✚ **A SUBJECT DISPLAYING ANALOGOUS COLOURS**

By limiting your colour palette to small groups of adjacent colours, you can create restful images.

■ **Use** the colour wheel to select some analogous colours, such as blue, blue-green, and green.

■ **Look** for examples of analogous colours occurring naturally. For example, if you head outside on an autumn day you are likely to find orange, yellow, and green in woodlands.

■ **Use** image-editing software to desaturate the colours and reduce the contrast between them. Apply any adjustments sensitively though, or your picture could end up looking faded.

MAKING A COMPLEMENT

- **.ıl EASY**
- ◔ **45 MINUTES**
- ◎ **BASIC +** tripod
- ◉ **INDOORS OR OUTDOORS**
- ✚ **A SUBJECT WITH COMPLEMENTARY COLOURS**

Graphic designers and painters are all aware that when a colour is used with its complement, both hues appear brighter. Use a colour wheel to select a pair of complementary colours, such as red and green or yellow and blue, and find subjects with those colours.

■ **Give** the colours a boost by playing with Picture Styles on your camera, or in post-production.

■ **Keep** your composition simple, and exclude anything that doesn't reinforce the contrast between the two colours.

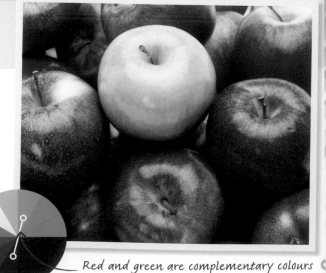

Red and green are complementary colours

Pro tip: You can take inspiration from painters as well as photographers. Vincent van Gogh was highly adept at using complementary colours. If you study his painting *The Starry Night,* you will see a yellow/orange moon and stars set against a blue/purple sky.

STANDING OUT

- **MEDIUM**
- **1 HOUR**
- **BASIC +** tripod
- **INDOORS OR OUTDOORS**
- **A SUBJECT WITH ONE KEY COLOUR AMONG MORE SUBDUED TINTS**

Setting one bold colour against the tints, tones, or shades of another will allow it to take centre stage.

■ **Search** for a subject with pale or neutral tones and introduce one bold colour, such as red.

■ **Make** sure the colour you introduce is relevant and in keeping with the scene. These bright flowers, for example, suggest new life against the ripened wheat stalks.

■ **Select** an AF point or switch to manual focus to ensure the viewer's attention is drawn to the right place if the bold colour is not centrally positioned.

■ **Use** image-editing software to enhance the key colour once you have secured your shot, or desaturate the supporting colours even more.

These bright red poppies stand out against the pale strands of wheat

KIT: **COLOUR CALIBRATING**

Sometimes the colour, brightness, and contrast of the pictures you print bear little relation to the way they look on your computer screen. To solve this problem, you need to calibrate your monitor. A colour calibration device (see p.347) tunes your display to a reference standard, ensuring consistency across multiple devices.

A calibration device fixes to the front of your monitor

WHAT HAVE YOU LEARNED?

■ The use of complementary colours result in vibrant, eye-catching photographs.
■ When a key colour is a pure hue, the effect can be dramatic, but it still needs to be relevant to the subject.
■ Analogous colours lead to calm compositions, but they need to be adjusted sensitively.

PLAYING WITH ONE COLOUR

- 📶 **MEDIUM**
- 🕐 **1 HOUR**
- 📷 **BASIC +** tripod
- 📍 **INDOORS OR OUTDOORS**
- ➕ **A SUBJECT IN VARIOUS TINTS, TONES, OR SHADES**

Images that contain tints, tones, and shades of one colour look balanced and elegant.

- **Try** not to think of monochromatic colour schemes as boring or one-dimensional. Instead, take a paint kit, choose one colour, and add white, black, or grey, and you will get some idea of the number of variations possible.

- **Create** your own monochromatic subjects using everyday objects, such as pencils, vegetables, fabric, or flowers.

- **Prioritize** elements in the frame using depth of field, focus, or compositional aids such as lead-in lines, because using a monochromatic colour scheme can make it hard to establish a clear focal point.

Tints, tones, and shades come from the same segment of the colour wheel

ℹ️ KIT: SUNRISE AND SUNSET CALCULATORS

If you're hoping to shoot a sunrise or sunset, it's worth carrying out a little research first. The light changes very quickly at these times of day, so it's important to have a couple of viewpoints in mind beforehand. To help you plan your picture, download a sunrise/sunset calculator to your smartphone – this will tell you at exactly what time the sun is going to rise and set, and, crucially, at what angle.

Compass from a sunrise and sunset app

WARMING UP

📶 HARD 📍 OUTDOORS
🕐 2 HOURS ➕ A LANDSCAPE AT DAWN
📷 BASIC + tripod OR DUSK

Red, orange, and yellow are considered "warm" colours. We often encounter these colours during sunrises and sunsets, when the sun is near the horizon and direct light is less intense.

■ **Alter** the white balance settings to suit the conditions. If you leave white balance set to Auto, the yellow and orange tones will be perceived as colour casts, and the camera will try to neutralize them.

■ **Experiment** with Picture Styles if the colours aren't rich enough, until you see a difference.

■ **Set** your exposure for the sky or foreground depending on your desired effect: to create a silhouette, take a meter reading from the brightest part of the sky (not including the sun).

A splash of orange adds a touch of warmth to this picture

ENCOURAGE NOSTALGIA

📶 EASY 📍 INDOORS OR OUTDOORS
🕐 2-3 HOURS ➕ A SUBJECT WITH A
📷 BASIC + tripod RETRO STYLE

Camera manufacturers spend a lot of time ensuring our images are bursting with vivid colour, but sometimes this doesn't suit the subject.

■ **Create** a nostalgic look by reducing the saturation using in-camera controls.

■ **Change** the Picture Style to Neutral and move the Saturation slider to the left to make the colours much less intense.

■ **Desaturate** the image using image-editing software – this will enable you to adjust saturation, tone, and contrast sensitively.

Original image.

The same image after -50 saturation has been applied.

WHAT HAVE YOU LEARNED?

■ You can create balanced and elegant images using tints, tones, and shades of one colour.
■ To prevent the camera from neutralizing "warm" colours, you need to make sure white balance is not set to Auto.
■ Reducing colour saturation can add a sense of nostalgia to a photograph.

Reviewing your shots

Having learned how colour can be used to influence emotion, produce contrast, or create harmony, it's time to choose some of your best images and run through this checklist. Look at each shot and ask yourself how colour affects your feelings towards the subject.

Have you achieved contrast between two colours?
Colours that sit opposite (or nearly opposite) one another on the colour wheel produce striking contrast. In this image, the blue of the butterfly looks vibrant set against the orange of the leaves. What other complementary colours work well with each other?

Can you combine vivid colours and neutrals?
Neutral colours create the ideal backdrop for vibrant colours. Here, the grey jumper in the background makes the lollipop look even more bright and colourful.

Does one colour dominate?
Colours of pure hue dominate the frame, and should be used with caution. The car here occupies a small part of the picture, but our eye is naturally drawn to it.

Are you aware of any colour psychology
Green is a colour we associate with natu and tranquillity, so when it features heavily ir the frame, such as here, the result can be wonderfully serene.

> " The chief function of **colour** should be to serve **expression**. "
>
> **HENRI MATISSE**

◄ Have you achieved colour harmony?
Colours that sit next to each other on the colour wheel are extremely harmonious. The purple and blue in this scene work well together.

▲ Can you limit the colour palette?
This image uses different shades and tones of brown, giving it a simple, streamlined look.

▲ Do you find any colours distracting?
In this picture, the red takes our eye first, before shifting to the blue. If you had used two recessive colours, it would be hard to know where to look first.

◄ Is the image warm or cool?
We often think of colours as being either warm or cool. Morning light often appears much cooler than evening light when glorious sunsets, such as this one, can be captured.

▶ ENHANCE YOUR IMAGES
Adjusting colour

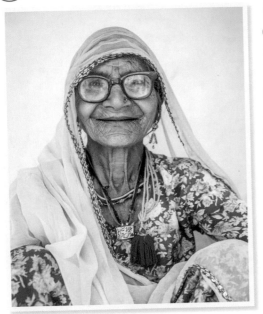

Hue is another word for colour, saturation refers to the intensity of a hue, and lightness describes the amount of black or white mixed with a hue. Many pictures benefit from a quick tweak to one or all of these settings, but it's important not to be too heavy-handed – push the saturation too far in a portrait and skin will look unnatural and blotchy.

1 Create a New Adjustment Layer

Click on the New Adjustment Layer button in the Layers panel to create a new layer. This will protect your original file while you alter the Hue and Saturation. The Hue/Saturation dialog box has sliders for Hue, Saturation, and Lightness, and you will see two coloured bars at the bottom.

The top bar shows the colour before adjustment, and the bottom bar shows how any change will alter the colour

5 Adjust the Lightness

Click on the Lightness slider and enter a value, or drag it to the left to make colours darker or to the right to make the colours lighter.

6 Specify the range of colours to be adjusted

Create a New Adjustment Layer to adjust a specific colour range and select your chosen colour from the drop-down menu. Between the two colour bars at the bottom are two sliders with four adjustment points. The centre points define the range to be adjusted. The outer points define the extent to which similar colours are affected.

7 Confirm your adjustments

When you're happy with your Hue/Saturation adjustments, flatten the adjustment layer. If you feel you may want to come back and make further alteration, keep the adjustment layer; you will need to save your file as a Photoshop PSD or Tiff file.

Click OK to save any changes

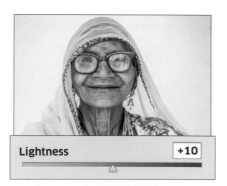

Click on Preview so you can see the effects of your changes

246 / LESSONS IN COLOUR

Pro tip: You can save any Hue/Saturation settings you have made, reload them later, and apply them to other images that feature the same subjects.

2 Choose all colours or a Preset range

Open the drop-down menu at the top of the Hue/Saturation dialog box. This allows you to adjust all the colours at once or target a particular range, such as reds.

3 Change the Hue

Click on the Hue slider and enter a value, or drag it to the left or right. Major adjustments can change colours completely.

4 Alter the Saturation

Click on the Saturation slider and drag it to the left to decrease intensity or to the right to increase it. Excessive boosting can raise noise levels in the photo.

Master

Reds

Yellows

Greens

Cyans

Blues

Hue +6

Saturation +10

The colours in the image have been enhanced, while the lightness has been slightly decreased.

ⓘ COLOUR SPLASH

Keeping one colour intact while the others are converted to black and white can be fun. In post-production, the red umbrella was isolated from the others, all of which were then turned to black.

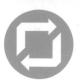

▶ REVIEW YOUR PROGRESS
What have you learned?

Understanding how colour affects emotions will help you to use it to your advantage. Certain colours may encourage feelings of peace and serenity, while others could bring energy and dynamism. See how much you have learned by taking this quiz.

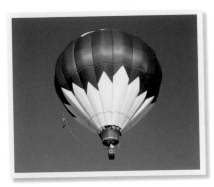

1 Colours opposite one another on the colour wheel are described as what?

A Triadic **B** Complementary **C** Tetradic

2 Which of the following describes a hue with added white?

A Tint **B** Tone **C** Shade

3 Which of the following colours carries more visual weight?

A Blue **B** Black **C** White

4 Orange and yellow are what sort of colours?

A Complementary colours
B Analogous colours
C Tetradic colours

5 Which of the following describes a hue with added black?

A Shade **B** Tone **C** Tint

6 Neutral colours tend to do what in a composition?

A Reflect **B** Recede **C** Refract

7 Picture Styles can be used to adjust sharpness, contrast, colour tone, and what else?

A Depth of field
B Composition
C Saturation

8 Which colour, even when used in small qualities, will dominate the frame?

A Yellow **B** Red **C** Green

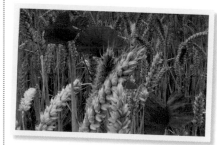

9 Where do analogous colours sit on the colour wheel?

A Behind each other
B Opposite each other
C Next to each other

10 Tetradic colours form which shape on the colour wheel?

A Rectangle **B** Triangle **C** Hexagon

11 Schemes containing tints, tones and shades of the same colour are described as what?

A Monochromatic
B Split-complementary
C Secondary

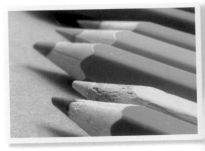

12 How do you make sure the colours you print match those on your computer?

A Hold the print up to the screen
B Calibrate your monitor
C Refresh the ink in your printer

13 Reducing saturation can create pictures with what kind of look?

A Nostalgic **B** Modern **C** Harmonious

14 The period just before sunset and after sunrise is described as what?

A The Late Hour
B The Witching Hour
C The Golden Hour

15 What colour is produced when red and yellow are mixed?

A Orange
B Blue
C Magenta

Answers 1/B, 2/A, 3/B, 4/B, 5/A, 6/B, 7/C, 8/B, 9/C, 10/A, 11/A, 12/B, 13/A, 14/C, 15/A.

15

week

THE COLOUR OF LIGHT

As a photographer, you need to be attuned to how different light sources and their colours will affect your photos. Although this may sound slightly daunting, it is a remarkably easy skill to learn. By the end of this module, you should be well on the way to understanding and appreciating the colour of light.

In this module, you will:

▸ **take a look** at different light sources;
▸ **understand what is meant** by the colour of light;
▸ **apply your new knowledge** and experiment with white balance settings;
▸ **practise** with different light sources and white balance;
▸ **review your photos** to see how you've used light;
▸ **enhance an image** by altering white balance and colour tone;
▸ **go over your understanding of light,** and see if you're ready to move on.

Let's begin...

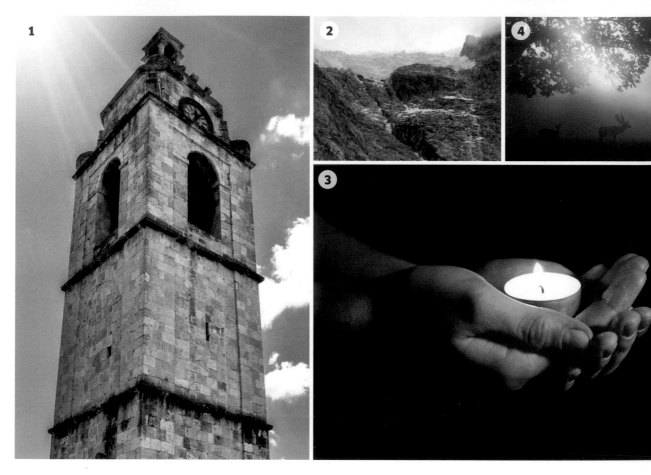

Thinking about light is a crucial part of preparing to shoot a photo. It's important to recognize what type of light is illuminating a scene. Can you match the light sources listed here with the relevant image?

A **Candlelight:** The light from a flame has a very orange tint.

B **Incandescent lighting:** Most domestic light bulbs are biased towards orange.

C **Fluorescent lighting:** Light from a fluorescent tube or bulb can have a subtle green tint.

D **Daylight:** In photography, this refers to the neutrally coloured light of the sun at midday.

E **Sunrise/sunset:** The sun is close to the horizon and the light is heavily biased towards red.

F **Overcast:** Sunlight is softened when it is cloudy. Overcast sunlight is biased towards blue.

G **Open shade:** Scene is lit by ambient light only, which produces soft shadows ideal for portraits.

H **Twilight:** The ambient natural light at this time of day is extremely blue.

NEED TO KNOW

■ We often don't notice that light has a colour tint because our brain corrects the way light is perceived, so it appears neutral in colour. It is only when a colour tint is strong, or when there are two lights with different tints, that we take notice.

■ The colour of light can be broadly split into three groups: "warm" has a red-orange bias, "cool" has a blue bias, and neutral light has no bias. Neutral light is also known as pure white light.

■ The colour of sunlight changes over the course of the day. The term "Golden Hour" refers to the hour after sunrise and before sunset when the sun's light is red-orange in colour. This is because the sun is low in the sky and the Earth's atmosphere scatters its light, giving it a red-orange colour. Once the sun has set, natural light becomes very blue during twilight.

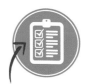

Review these points and see how they relate to the photos shown here

Colour and white balance

Light is rarely neutral in colour. It often has a colour bias that affects how your subject is recorded in a photo. Colour bias is not necessarily a bad thing, as it can be used creatively, to add ambience. The key is knowing when to compensate for the colour bias of light and when to leave well alone.

Colour temperature

The two most common colour biases are red and blue. The degree of bias between red and blue is measured on the Kelvin scale, which indicates the colour temperature of light in degrees.

 WAVELENGTH

Visible light is a small section of the electromagnetic spectrum. It comprises a range of relatively long wavelengths starting at 750 nanometres (nm): this corresponds to the colour we see as red. The wavelengths then shorten as they run through the spectrum of colours to 380 nm, the shortest visible wavelength which corresponds to violet. When light is made up of an equal mix of the wavelengths, it is known as neutral or white light. If one of the wavelengths dominates, the light will be heavily biased to the corresponding colour.

Candlelight, which is a very red light, has a Kelvin value of approximately 1,850 K. The Kelvin scale starts at zero. A low value indicates that the light is very biased towards red.

CANDLELIGHT
1,850 K

SUNRISE/SUNSET
2,000 K

INCANDESCENT LIGHT
3,000 K

FLUORESCENT LIGHT
4,000 K

White balance

A camera function known as white balance (WB) corrects for the colour bias of light. For instance, a white surface in a scene will not appear as a neutral white when illuminated by light that has a colour bias. White balance is the correction that a camera makes to an image in order to remove the colour bias.

Auto White Balance (AWB) is the simplest preset, as the camera automatically calculates which corrections to make.

White balance presets are a step up from Auto White Balance, but less sophisticated than Custom White Balance. These are settings designed for colour accuracy when shooting under specific types of light.

Tungsten

Fluorescent

Pro tip: You would normally set the right white balance for a particular light source. However, there are some types of light – such as candlelight or a sunset – where you would normally want to retain the attractive colour of the light.

Pro tip: If you don't want to adjust for the colour of the light, set the white balance preset to Daylight. As this is a neutral setting, it will not apply any correction to the light.

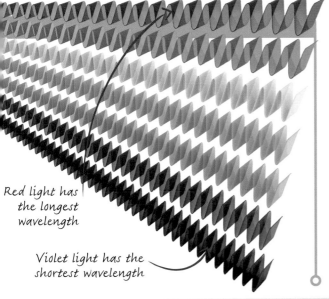

Red light has the longest wavelength

Violet light has the shortest wavelength

ⓘ CORRECTING COLOUR BIAS

To correct for a particular colour bias, another colour must be added. Blue must be added to a photo to correct for an orange/red bias, as shown in the image below. A green bias (such as when shooting under fluorescent lighting) requires the addition of magenta. The same effect as white balance can be achieved using colour filters.

Red is the colour bias

A red bias requires the addition of blue to make the photo more neutral

SUNLIGHT

FLASH

OVERCAST SKY

OPEN SHADE

The shady setting corrects for the blue bias of open shade, which has a value of around 7,000 K. At 10,000 K, light is as blue as the colour of blue sky and has no red component.

BLUE SKY

| 5,000 K | 5,500 K | 6,000 K | 7,000 K | 10,000 K |

Flash provides a neutral light, with neither a red nor blue bias and a Kelvin value of 5,500 K. As the Kelvin value climbs to 5,000 K and beyond, light is progressively less red and more neutral in colour.

ⓘ CUSTOM SETTINGS

More accurate than Auto White Balance is Custom White Balance. This is a setting that allows you to create a white balance setting specifically for the light you are shooting under. Some cameras also allow you to set Kelvin values, which can be selected to match a specific light source.

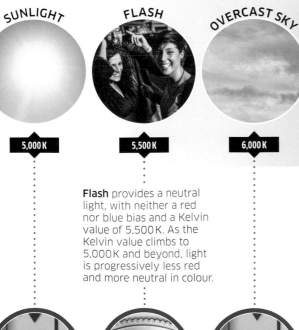

Daylight

Flash

Cloudy

Shady

► **LEARN THE SKILLS**
Setting white balance

The selection of the correct white balance setting for a scene will make a big difference to your photos. Colour can appear more accurate and pleasing, which is particularly important when people are your subject. A cool skin tone is not flattering and can even make your subject look slightly unhealthy.

1 Assess your location
Look at how your location is illuminated. Is it lit by natural or artificial light? And, if it's natural, where is the sun and what type of light is there?

Snow

Sea and sand

Sunset

Midday

2 Use a tripod
Attach your camera to a tripod. This will keep the camera in the same place as you shoot, and allow you to compare photos more easily.

6 Select a white balance preset
Choose the white balance preset that you think most closely matches the light that is illuminating the scene.

This image is lit by sunlight and would benefit from using the daylight setting.

7 Shoot again
When you're happy with your preset, shoot the scene again. Altering white balance does not affect exposure. The exposure should be exactly the same as the first image, unless the light level has changed between the two shots.

Compare your images in Playback

8 Compare photos
Look at the two photos in Playback. Look to see how similar they are in terms of colour. The closer they are, the more likely that both you and your camera guessed the best white balance.

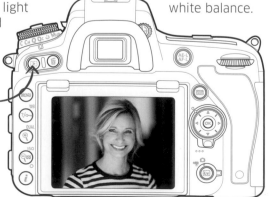

Where to start: Shoot a portrait in an interior and an exterior setting and experiment with white balance presets to adjust the colour temperature of the final image.

You will learn: The difference between using Auto White Balance and a white balance preset, and the effects different settings will have on your photo.

3 Set the mode

Adjust your camera mode to something other than fully automatic. Use Program, Aperture, or Shutter Priority instead.

If you use a fully automatic camera mode, you will not be able to alter white balance

4 Select Auto White Balance

Set the Auto White Balance (AWB) preset. AWB is a useful time-saver as it is often able to choose the right white balance correction.

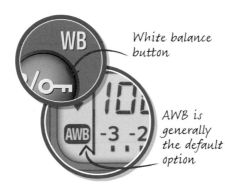

White balance button

AWB is generally the default option

5 Take a shot

Set the exposure: select the required aperture if you're shooting using Aperture Priority or an appropriate shutter speed if you're using Shutter Priority. Focus on your subject and take a photo.

Image with effects of white balance presets applied.

WHAT HAVE YOU LEARNED?

■ It is important to assess the type of light that is illuminating your subject.

■ Your camera needs to be set to a program other than fully automatic in order to alter the white balance.

■ You can alter the white balance without adjusting the exposure settings, unless the light conditions change between shots.

▶ PRACTISE AND EXPERIMENT
Using white balance

We respond emotionally to colour in images. Taking control over white balance is a great way to influence how your photos appear. By the end of these assignments, you will have a better understanding of light and colour, and how they can be used creatively.

USING PRESETS

- **EASY**
- **2 HOURS**
- **BASIC** + tripod
- **INDOORS AND OUTDOORS**
- **SCENES WITH DIFFERENT LIGHT SOURCES**

The white balance presets offer a simple way to adjust white balance.

- **Start** in an interior that uses artificial lighting. Compose a shot with your camera set up on a tripod.
- **Set** white balance to the first preset after Auto on your camera. Focus and shoot a photo. Retake the same shot multiple times using all of the presets.

Overcast light is blue-biased and the Cloudy preset would warm this image up.

- **Move** to an exterior scene lit by sunlight. Work your way through the presets as before.
- **Review** your photos and note how the colour changes through the sequences.

WARM OR COOL?

- **MEDIUM**
- **1 HOUR**
- **BASIC** + tripod
- **INDOORS**
- **AN INTERIOR LIT BY ARTIFICIAL LIGHT**

Generally, the white balance presets are accurate for most types of shooting. However, using a Kelvin value will allow you to be even more accurate.

- **Attach** your camera to a tripod in an interior setting with artificial lighting.
- **Set** white balance to Colour Temperature (or K). If the interior is lit by incandescent bulbs, set the Kelvin value to 2,800 K. If it has fluorescent lighting, set the Kelvin value to 4,000 K.
- **Shoot** and review the shot. Assess whether the white balance looks accurate. Increase the Kelvin

Getting the right white balance is important if you want your colours to be accurate, especially where the lighting varies as in this interior setting.

value by 500 K and reshoot. Decrease the value by 1,000 K and shoot again. See which setting you think best reflects the scene itself.

Pro tip: The white balance setting used for a shot will be displayed on the camera's LCD when you select the camera's detailed Playback mode.

GETTING IT WRONG

- **EASY**
- **30 MINUTES**
- **BASIC +** tripod
- **INDOORS OR OUTDOORS**
- **A WELL-LIT SCENE**

Selecting the right white balance for a light source will make colours more accurate in the final photo. However, you can often have more fun by deliberately choosing an incorrect white balance.

■ **Compose** a shot with your camera on a tripod. Study the lighting that illuminates your chosen scene and then set the white balance preset that you think is correct.

■ **Set** the exposure, focus, and shoot. If you're shooting under artificial light, select the Shade preset. If you're shooting outside, select the Tungsten preset.

■ **Take** another shot using a different white balance preset. Compare the shots.

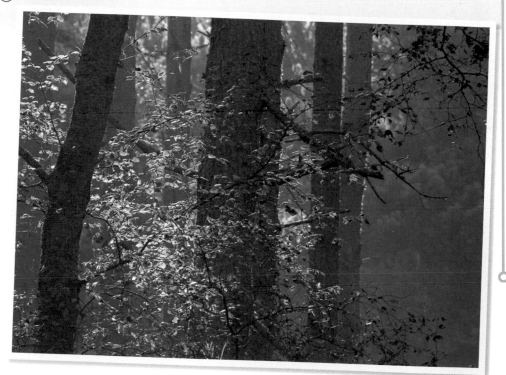

Using the Tungsten preset has rendered the woodland scene blue

WHAT HAVE YOU LEARNED?

■ The white balance presets offer a wide range of ways to alter the overall colour tint of a photo.
■ There is often no right or wrong choice for white balance. Often the white balance can be "wrong", but it will produce a result that is striking or aesthetically pleasing.
■ The Kelvin values offer a greater range of adjustment than the white balance presets.

CUSTOM WHITE BALANCE

- **DIFFICULT**
- **30 MINUTES**
- **BASIC**
- **INDOORS OR OUTDOORS**
- **A WELL-LIT SCENE**

Creating a custom white balance will give you the most accurate setting for a particular light source.

- **Shoot** a photo of a white balance target (see opposite), which should be illuminated by the same light as the scene you intend to shoot afterwards.

- **Hold** the white balance target in front of your camera lens so that it fills the frame.

- **Set** exposure so that the white balance target is close to white. You may need to set +1 to 2 stops positive exposure compensation.

- **Shoot** so that your camera records and analyses the white balance and then set the Custom White Balance preset on your camera.

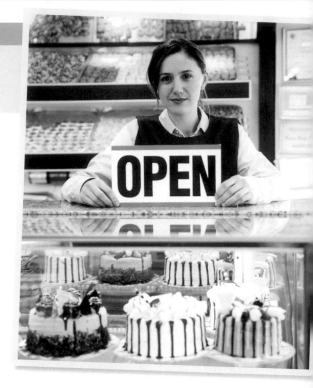

The lights in the bottom display have a different colour temperature from those behind the woman and will require a Custom White Balance setting.

CONTROLLING THE MOOD

- **EASY**
- **1 HOUR**
- **BASIC + tripod**
- **INDOORS OR OUTDOORS**
- **A MODEL**

We associate warm colours, such as red, with happiness and energy. Cooler colours, such as blue, have more negative associations, such as sadness. White balance can be used to affect a photo's mood.

- **Sit** your model on a chair. Set your camera on a tripod and ask your model to pose so that they appear sad.

- **Set** white balance to a low Kelvin value so that the image on Live View is a very cool blue. Set the exposure, focus, and shoot.

- **Repeat** the shot, this time increasing the Kelvin value so that the image on Live View is a very warm yellow-orange.

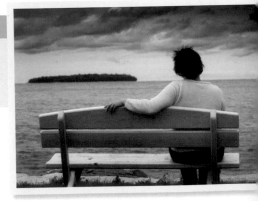

Cool blue tones of water and sky imply negative emotions.

- **Repeat** the shots, but ask your model to pose so that they look happy.

- **Compare** the four shots and decide which is the most effective.

👤📷 SHOOT IN MIXED LIGHTING

📊 **MEDIUM**　　　📍 **OUTDOORS**

🕐 **30 MINUTES**　　➕ **CITY SCENE AT DUSK**

📷 **BASIC + tripod**

Mixed lighting occurs when you have two or more light sources with different colour temperatures illuminating a scene. This happens at dusk in cities when the cold blue ambient light of the sky is mixed with the oranges and yellows of street lighting.

■ **Set** up your camera on a well-lit street approximately 25–35 minutes after sunset. Use a tripod and a low ISO setting to maintain image quality.

■ **Move** the white balance to the Tungsten preset. Set the exposure, focus, and shoot.

■ **Set** the white balance to Daylight. Set the exposure, focus, and take another shot. Compare the two shots.

■ **Experiment** with other white balance presets to see the effects these have on your dusk photos.

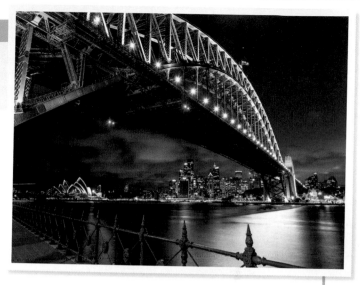

City lighting is far more orange than standard domestic lighting.

Take photos using both the Tungsten (left) and the Daylight (right) white balance presets.

WHAT HAVE YOU LEARNED?

■ Colour accuracy is dependent on setting a precise white balance at the time of shooting.
■ There is no right or wrong white balance setting when shooting in mixed lighting.
■ Colour helps to reinforce any body language signals in a portrait photo.

ℹ️ KIT: **WHITE BALANCE TARGET**

To create a custom white balance you need to shoot a photo of a neutral-white (or grey) surface. This is known as a white balance target. Your camera will analyse this photo to calculate how much white balance correction is needed. The target has to be completely neutral: any colour in the surface will make the custom white balance inaccurate. You should use a white balance target when colour accuracy in the final photo is very important.

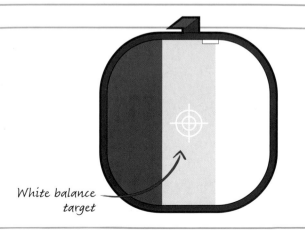

White balance target

Reviewing your shots

Once you've completed the assignments, spend some time looking carefully through your best photos. Pick out the shots that you feel are the most interesting and review them in light of the points raised on these pages.

⊙ Are your shadows too blue?
On cloudless days, ambient light adds some light back into shadows. Because the sky is blue this means that shadows often take on a blue tint, as in this image. Correct this by using a slightly warmer white balance.

⊙ Was your WB preset correct?
There are two ways to set white balance – it can either be technically correct or it can be aesthetically pleasing. This photo has a blue bias, which although not "correct", is still pleasing.

⊙ Did AWB get it right?
AWB is a useful white balance setting, although it is not infallible. Strong, dominant colours in a scene can fool AWB. Overcast light is another situation that can trick AWB. This photo features both and required a custom white balance.

⊙ Is your photo too "cold"?
There is nothing incorrect with a photo that has a blue tint: it is only wrong if this doe[s] not suit your subject. This photo of candy is tinted blue. Cool-toned photos of food are unappetizing, so the WB is arguably wrong.

> ## Wherever there is **light,** one can **photograph.**
> ### ALFRED STIEGLITZ

◀ Was your custom WB correct?
If you create a custom white balance, it is only applicable for the light source it was created for. A custom white balance created for this scene would need to be updated if the weather changed.

▼ Does your WB help to convey emotion?
You need to think carefully about how you want your photo to be perceived and then pick a suitable white balance. This photo has a warm colour bias that helps to emphasize the couple's close bond.

▲ Is your photo too "warm"?
There is also nothing wrong with a picture that has a warm, orange tint. However, it can make a photo look too sickly sweet if the tint is too strong. Do you think this photo is too warm?

The Colour Balance tool

The Colour Balance tool lets you adjust the colour tint of photos. You can increase the intensity of a colour tint – by adding yellow to make an image warmer, for example. You can also remove a colour tint by adding the tint's complementary colour to the photo.

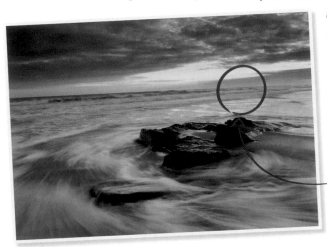

This photo has a strong magenta tint

1 Alter Colour Balance
The Colour Balance tool in Adjustments shows three sliders: cyan/red, magenta/green, and yellow/blue.

Color Balance			
Color Levels:	0	0	0

Cyan	Red
Magenta	Green
Yellow	Blue

Tone Balance

○ Shadows ⦿ Midtones ○ Highlights

☑ Preserve Luminosity

Leave Preserve Luminosity checked so that the tonal range of the photo doesn't change

5 Modify the shadows
Click on the Shadow button to adjust the colour tint of the darkest tones.

Color Balance			
Color Levels:	-5	0	-16

Cyan	Red
Magenta	Green
Yellow	Blue

Tone Balance

⦿ Shadows ○ Midtones ○ Highlights

☑ Preserve Luminosity

Shadows are often too blue – add red or yellow (or both) to warm them up

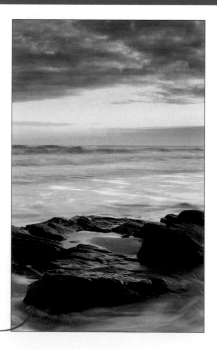

6 Change the Highlights
Select the Highlights button to adjust the colour tint of the lightest tones in your photo. Click OK to apply Colour Balance.

Increasing the amount of red and yellow in the highlights will increase their warmth

Color Balance			
Color Levels:	+3	0	-19

Cyan	Red
Magenta	Green
Yellow	Blue

Tone Balance

○ Shadows ○ Midtones ⦿ Highlights

☑ Preserve Luminosity

Pro tip: An easy way to see the overall colour tint of a photo is to set the Gaussian Blur filter to a very high pixel value (400 or above). Press Cancel to exit Gaussian Blur so that you don't blur your photo.

2 Move the sliders

If you want to remove a colour tint from your photo, click on the slider control for that colour and drag it towards the complementary colour opposite.

Pull the slider towards green to remove magenta

Color Levels: 0 +14 0
Cyan ——————— Red
Magenta ——————— Green
Yellow ——————— Blue

3 Type in a number

You can also move the sliders by adding numerical values into their respective boxes above the sliders – a negative value up to -100 or a positive value up to +100.

The higher the positive green value, the more green is added to a photo

Color Levels: 0 +57 0
Cyan ——————— Red
Magenta ——————— Green
Yellow ——————— Blue

4 Shadows, Midtones, and Highlights

The Shadows, Midtones, and Highlights buttons control which part of a photo's tonal range is adjusted by the sliders.

Selecting Midtones will allow you to adjust the mid-range parts of your photo

Tone Balance
○ Shadows ● Midtones ○ Highlights
☑ **Preserve Luminosity**

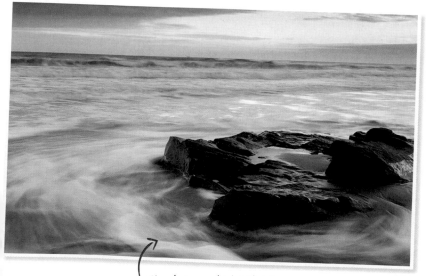

Shadows and highlights in the water appear warmer

ⓘ WHITE BALANCE

If you import a RAW file into Adobe Camera RAW or Adobe Lightroom, you can very finely adjust the white balance to suit. You can either use a white balance preset (including Auto), or you can adjust the colour temperature using a Kelvin scale slider.

The Kelvin scale slider can be adjusted between 2,000 K, which adds a lot of blue, and 50,000 K, which adds a lot of red. Typically, however, you would use values between 2,800 K and 7,000 K, which is the Kelvin range of most light you encounter normally.

▶ REVIEW YOUR PROGRESS
What have you learned?

In this module you've learned about the effects that the colour of different light sources can have on a photo. Try these multiple choice questions to see what else you've learned. Can you get them all correct before you move on?

1 Colour temperature is measured using what scale?

A Mohr B Beaufort C Kelvin

2 What colour is complementary to red?

A Green B Purple C Blue

3 What type of light helps to convey a feeling of happiness?

A Cool light
B Warm light
C Neutral-white light

4 What white balance preset would you use for incandescent lighting?

A Daylight B Shady C Tungsten

5 What Kelvin value is candlelight?

A 1,850K B 4,000K C 5,500K

6 What would you add to a photo to remove a magenta colour tint?

A Green
B Blue
C Yellow

7 What white balance preset would you use on an overcast day?

A Shady
B Cloudy
C Flash

8 What colour is complementary to blue?

A Yellow B Orange C Red

9 Which of these light sources is warmest in colour?

A Flash
B Midday sun
C Candlelight

10 What wavelength corresponds to red?

A 750 nanometres
B 500 nanometres
C 380 nanometres

11 What colour is associated with sadness?

A Red B Yellow C Blue

12 Which is the coolest of these Kelvin values?

A 1,850K
B 7,500K
C 5,000K

13 Open shade light is heavily biased towards which colour?

A Blue B Orange-yellow C Red

14 Which of these light sources is most neutral in colour?

A Candlelight
B Midday sun
C Open shade

15 Fluorescent lighting often has what colour tint?

A Green B Yellow C Red

16 The "Golden Hour" is when?

A At midday
B Early afternoon
C After sunrise/before sunset

17 What colour tint would you see if you used a Tungsten preset when shooting in daylight?

A Red B Green C Blue

Answers 1/C, 2/A, 3/B, 4/C, 5/A, 6/A, 7/B, 8/B, 9/C, 10/A, 11/C, 12/B, 13/A, 14/B, 15/A, 16/C, 17/C.

16 USING NATURAL LIGHT

week

Light from the sun varies over the course of a day. Understanding how this variation in natural light affects the subjects you want to shoot is one of the key skills necessary to becoming a well-rounded photographer.

In this module, you will:

▶ **assess the effect of different light positions** on photographs;

▶ **examine the theory of light and shade** and see how different angles of light can affect your image;

▶ **try it yourself** by playing with the effects of light and shade during a step-by-step photoshoot;

▶ **explore** the potential for light and shade in your photographs with six guided assignments;

▶ **review your photos** and see how you can avoid or correct some common light problems;

▶ **adjust your photographs** using Levels;

▶ **review** your understanding of light and shadow and see if you are ready to move on.

Let's begin...

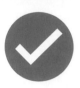

Can you read light?

1

2

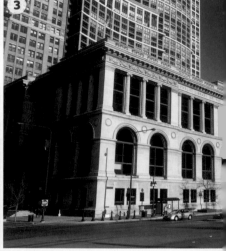
3

4

5

The position of your light source makes a big difference to your photograph. The five choices are: front light, backlight, low-angle light, top light, and side light. Study these images and match them with the right description.

A **Front light:** Casts short shadows and brings out tone and colour.

B **Backlight:** Silhouettes are a common result of backlighting.

C **Low-angle light:** Characterized by elongated shadows.

D **Side light:** Often used to accentuate texture.

E **Top light:** Creates few obvious shadows with grounded objects.

F **Low-angle light:** Is warm in colour and, when shining from the side, casts shadows across a scene

G **Backlight:** A bright halo often appears around soft-edged objects backlit to one side.

H **Top light:** Raised objects can cast strong downward shadows.

I **Side light:** Readable shadows provide good contrast.

J **Backlight:** Translucent objects come alive with colour.

ANSWERS

A / 1: Temple in Thanjavur, India
B / 5: Silhouette of friends jumping
C / 4: Gate to subway, US
D / 3: Chicago Cultural Center, US
E / 8: Relaxing by the pool at midday
F / 6: Road in Tuscany, Italy
G / 2: Teenage girl at sunset
H / 7: Fire escape, US
I / 10: Cuban bass player
J / 9: Sunlit leaves

NEED TO KNOW

■ Shadows are at their sharpest and darkest on cloud-free days.

■ Shadows create contrast, which helps to define the shape and form of a subject. For this reason, overcast days aren't ideal for wide-open landscapes or large architectural subjects.

■ Overcast days are generally shadow-free. This is because light from the sun is diffused by the clouds, which makes the light softer.

■ Overcast days are good, however, for shooting close-ups and organic subjects such as flowers.

■ The direction and time that the sun rises and sets varies through the year.

■ The maximum height of the sun in the sky is greater in summer than in winter.

Review these points and see how they relate to the photos shown here

▶ UNDERSTAND THE THEORY
Light and shadow

As the sun moves around the sky, shadows lengthen, shorten, and change direction. Understanding how shadows impact on your subjects is crucial to creating eye-catching images. Here we take a look at three common subjects – portraits, landscapes, and buildings – and assess the impact of different lighting angles. Remember that this information is only a guide. You will need to photograph and observe your own favourite subjects under different lighting angles to see for yourself how the direction of light strengthens or weakens your imagery.

ⓘ ANATOMY OF A SHADOW

When the sun illuminates an object, the shadows it casts reveal outline, form, and texture in varying degrees depending on the direction of light. The way that light and shade affect your subject can make or break a photo.

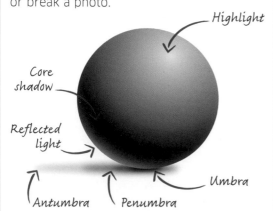

Highlight

Core shadow

Reflected light

Umbra

Antumbra *Penumbra*

TOP LIGHT

Portraits: Top light creates shadows down the length of your subject's face; the eyes are rarely clearly visible.

Buildings: Strong downward shadows can be used to good creative effect in certain cityscapes.

Landscapes: A lack of elongated shadows will make most landscapes look flat. Colours can appear vibrant.

FRONT LIGHT

Portraits: Provided the glare doesn't make your subject squint, front lighting creates attractive, shadow-free portraits.

Buildings: Strong frontal lighting enhances the façades of colourful buildings and shows majestic outlines at their best.

Landscapes: With few shadows to define undulations, landscapes will look flat and dull. But large objects, such as mountains, will stand out well against a blue sky.

> In the **right light,** at the **right time,** everything is **extraordinary.**
> AARON ROSE

BACKLIGHT

Portraits: Backlight is rarely ideal, but dramatic silhouettes are an option; try capturing your subject in profile.

Buildings: Strong backlighting is ideal for powerful skyline silhouettes, but the outlines need to be clearly defined.

Landscapes: Colours will be hard to discern. Look for shadows that run towards the camera for a sense of depth.

SIDE LIGHT

Portraits: Side lighting will result in half the subject's face in shadow – fine if you want to create a little drama.

Buildings: Utilize strong contrast for arresting images, but watch shadows don't make the image hard to read.

Landscapes: Pronounced shadows help to define the shape and texture of landscape features. Well-lit objects will exhibit strong colour.

LOW-ANGLE LIGHT

Portraits: When the sun is low and off to one side behind your subject, look for atmospheric glowing halos of hair.

Buildings: The sun will sparkle off reflective surfaces, while others will be in dark shadow – good for contrast and drama.

Landscapes: Look for aerial perspective (far objects appear fainter than closer ones) to create a sense of depth.

 ▶ **LEARN THE SKILLS**
Using light and shade

Many scenes are at their best when the sun is low in the sky, around an hour after sunrise or an hour before sunset. Shadows at this time of day are at their longest and help to define the shape and texture of objects in a scene. Shadows also add drama that can be used to create images with impact.

1 Assess your location
Take time to walk around your chosen subject and find a position where shadows form an interesting pattern. Use a tripod and a remote shutter release to keep the image sharp.

Check tripod spirit level to straighten camera

2 Use a wide-angle lens
The lens you use will affect your composition. Use a wide-angle lens if you want to exaggerate the spacing of shadows.

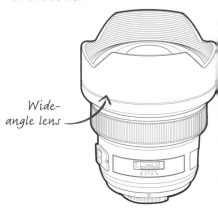
Wide-angle lens

6 Set aperture and metering mode
Use a smaller aperture to maximize depth of field. Select evaluative metering and press halfway down on the shutter button to set exposure.

Small aperture may mean a lengthy shutter speed

7 Shoot a test shot
Focus the camera and take a shot. Check the exposure using your camera's histogram. If the histogram is skewed to the left, the photo may be underexposed. If it is skewed to the right, it may be overexposed.

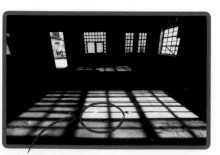
Focus on the foreground to ensure the whole image is sharp

8 Continue shooting
Try different compositions. Wait to see how the light develops and consider more variations of the same scene until the sun is higher in the sky, for example, or has set completely.

Keep your camera switched on between shots, ready for action.

Where to start: Find a location where a low sun creates long, raking shadows that you can exploit for effect. Other elements of the scene will create shadows that add depth to the image.

You will learn: How to accurately expose the scene so that shadows are dark and rich, while at the same time the highlights are not overexposed, and how lens choice affects the spacing of shadows.

3 Use a telephoto lens

Alternatively, use a telephoto lens if you want to compress the spacing of shadows (you may need to position yourself farther from your subject if using a telephoto lens). A zoom lens will let you use both wide-angle and telephoto settings.

4 Use lowest ISO setting

Using the lowest ISO setting will provide optimum image quality. A low setting, such as ISO 100, can result in a slow shutter speed, but with the camera mounted on a tripod you will avoid camera shake.

5 Use Aperture Priority

Select Av (or A) so you can fine-tune aperture to control depth of field. The camera will set the appropriate shutter speed.

ISO 100 is the lowest setting

When you set your zoom lens to its wide-angle setting, you may need to get closer to your subject.

Aperture Priority

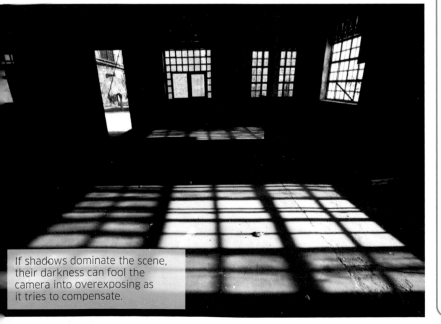

If shadows dominate the scene, their darkness can fool the camera into overexposing as it tries to compensate.

WHAT HAVE YOU LEARNED?

■ The position of the sun relative to your camera and subject changes the shape and visibility of shadows.
■ Where shadows fall affects how three-dimensional your subject looks in a photo.
■ The lens that you use affects the spacing of shadows in your image.

▶ PRACTISE AND EXPERIMENT
Playing with light

The assignments on the following pages will help you develop the way you think about light and shade. The key is to be out shooting at different times of the day to see how light changes. Where you position your camera relative to the sun will play a big part in the success or otherwise of your photos. There's no right or wrong answer, though. Experimentation is often necessary to decide what works and what doesn't.

Shooting a silhouette against a sunset sky will produce a bold, colourful image.

Save your best images and review them later (see pp.276–277)

 SILHOUETTE PORTRAITS

📊 **EASY** 📍 **OUTDOORS**

🕐 **1 HOUR** ➕ **A MODEL**

📷 **BASIC**

Silhouettes are created when shooting backlit subjects. They are caused because cameras typically can't cope with such an extreme contrast range. However, with the right subject and background, silhouettes make interesting photos.

■ **Shoot** at sunrise or sunset. Position your model against the brightest part of the sky.

■ **Compose** different shots so that your model is looking towards the camera and in profile, and see which is more effective.

■ **Keep** your compositions simple. Avoid other elements in the scene overlapping your subject, as this can make the shape of the silhouettes look confusing.

To create a silhouette, the background needs to be far brighter than your foreground subject.

Pro tip: You see the deepest, sharpest shadows when the sun is high in the sky on a cloudless day. Clouds can act like giant reflectors by lightening shadows and reducing contrast.

HALOS

📊 MEDIUM	📍 OUTDOORS
🕐 1 HOUR	➕ A MODEL WITH LONG HAIR
📷 BASIC + reflector (or flash)	

When you use backlighting to shoot a portrait of a person with a full head of hair, you often see a bright outline around their head. This is a halo and it can add an atmospheric feel to a portrait shot.

■ **Shoot** when the sun is relatively close to the horizon, and position your model between you and the sun.

■ **Set** the exposure of your camera so that your model is correctly exposed. You may need to use a reflector (see pp.274–275) or fill-in flash to balance the contrast.

■ **Experiment** with models who have other hair types to see what, if any, difference this makes.

Longer hair makes for better halos than tightly cropped hair

Use a reflector to push light towards your subject and avoid shooting a silhouette.

ISOLATING SHADOWS

📊 EASY	📍 OUTDOORS
🕐 1 HOUR	➕ A SUBJECT WITH AN INTERESTING SHAPE
📷 BASIC	

Shadows can be used to make interesting abstract photos when you exclude the subject casting the shadow.

■ **Shoot** on a cloudless day when there are strong shadows either on the ground or cast onto vertical structures, such as a wall.

■ **Look** for subjects that cast interesting shadows, and find positions where their patterns are most eye-catching.

Shadows become softer the farther they are from the original subject

■ **Frame** your shots so that you exclude the subject and shoot only the shadows.

■ **Use** a longer focal-length lens if the sun is behind you, to avoid your own shadow entering the photo – unless it's intentional!

WHAT HAVE YOU LEARNED?

■ It's easier to create a silhouette when the light source is at about the same level as the camera.
■ Tightly-cropped hair is less effective at producing halos than flowing, wispy hair.
■ Plain, flat surfaces make good settings for shadow photos.

LIGHT STARS

.ıl **EASY**	⊙ **OUTDOORS**
⏱ **1 HOUR**	⊕ **A BRIGHT POINT LIGHT**
⊙ **BASIC**	**SOURCE**

The sun is a point light source, which means that it's relatively small compared to the area that it illuminates. Point light sources in photos produce attractive star shapes that can add a point of interest to an image.

■ Shoot 10 different photos that use light stars for extra interest.

■ Shoot with the camera pointing towards your chosen light source. This can be the sun or even street lighting after sunset.

■ Never look at the sun, either directly or through a camera – it can easily damage your eyes.

■ Adjust the aperture for different effects; the smaller the aperture, the more pronounced the star shape produced.

The number of rays in a light star is affected by the number of blades in the lens's aperture

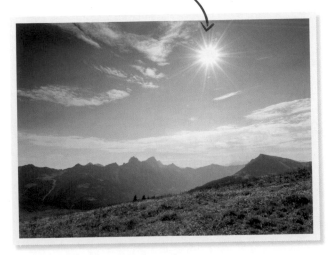

LOW-ANGLE LIGHT

.ıl **EASY**	⊙ **OUTDOORS**
⏱ **1 HOUR**	⊕ **SCENIC LOCATION WITH**
⊙ **BASIC +** tripod	**VERTICAL FEATURES**

The closer the sun is to the horizon, the longer shadows become. Shadows help to define the shape and contours of a landscape or city street.

■ Find an interesting scene with vertical features, such as trees or columns.

■ In the first or last hour of a sunny day, shoot a series of images that include both the vertical features and the shadow they cast.

■ Move around the scene as you shoot, varying the direction of the shadows and the height you shoot at. Compare your shots to see which ones you prefer.

Long geometric shadows create a feeling of depth

ⓘ KIT: **REFLECTORS**

Reflectors are used to redirect light into the shadow areas of a scene so that contrast is reduced. Commercial reflectors come in all shapes, sizes, and finishes such as white or silver. They are typically made of a soft material so they can be folded up to fit in a kitbag pocket. If you want to see the effect before buying a reflector, try using a sheet of white card. Reflectors are most useful when shooting portraits with side or top lighting. Gold reflectors add an appealing warmth that's very effective when shooting portraits.

Shadows often help to add interest to what would otherwise be a nondescript foreground

BACKLIGHT

EASY **INDOORS OR OUTDOORS**
2 HOURS **TRANSLUCENT SUBJECTS**
BASIC

The colours of translucent subjects – such as leaves or stained-glass windows – intensify when backlit.

■ Shoot a series of photos of translucent subjects backlit by the sun.

■ Fill the frame with your subject for greater impact by zooming in.

■ For a more abstract effect, shoot close-up details of your subjects.

■ Experiment with your camera's colour controls to intensify colour even further.

Backlit stained glass throws colour onto its surroundings. These colours can make interesting photos in their own right

Hat causes dense shadow in full sun

Reflectors redirect and soften light to brighten overly dark shadows.

WHAT HAVE YOU LEARNED?

■ Shadows are at their longest just after sunrise and just before sunset.
■ Colour is affected by lighting direction – translucent objects benefit from being backlit.
■ To avoid an unwanted shadow or silhouette, lower the contrast by using a reflector or flash.

Reviewing your shots

Once you've completed your lighting assignments, edit your images and pick out your 10 best shots. Look critically at each image: what's good about each one, and what could be improved? Here's a checklist to help you assess your images and troubleshoot some common problems.

Are your low-angle shadows well-defined?
The light from the sun becomes softer the closer the sun is to the horizon. Mist or haze reduce the sharpness and depth of shadows further, creating what can be a romantic feel to a landscape.

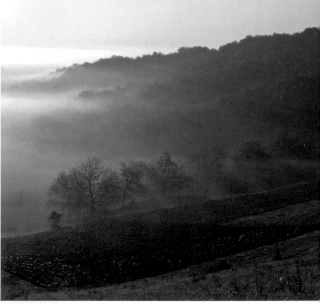

Are your silhouettes confusing?
Simplicity is the key to shooting successful silhouette images. This shot works because the outline of the tree is not confused or obscured by other elements in the scene.

Are your backlit images low in contrast?
Flare from the sun will lower contrast. Placing the lamppost between your camera and the sun has avoided flare in this image.

Is there flare in your photos even though the sun isn't visible?
Fitting a lens hood will reduce flare when the sun is just outside the shot, but using flare can add to an image's emotional appeal.

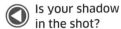
> ## In nature, **light creates the colour.**
> ## In the picture, **colour creates the light.**
> **HANS HOFMANN**

Is your shadow in the shot?
When shooting with front light, it's all too easy to accidentally include your own shadow in the photo. This image makes a virtue of this by turning the shadow into the subject.

Are your portrait subject's eyes hidden by shadows?
With top lighting, the nose, chin, or a wide hat can cast ugly shadows. This shot has used a reflector to bounce light into the shadows.

Is your image correctly exposed?
It's generally better to set exposure to retain highlight detail than shadow detail. In this shot, the balance between the two is successful.

Are your images sharp?
Fitting your camera to a tripod to avoid camera shake is often necessary in low light – particularly when shooting landscapes that require a large depth of field, such as this shot.

▶ ENHANCE YOUR IMAGES
The Levels tool

No matter how carefully you set exposure, occasionally the photo you download onto your computer appears flat and washed out. One of the most common causes is a cloudy atmosphere. This photo of Glen Nevis, Scotland, was taken in hazy light in late afternoon with a telephoto lens. The distance between the camera and the subject exacerbates the poor light quality, resulting in a very low-contrast image. Fortunately, you can fix the contrast by using image-editing software.

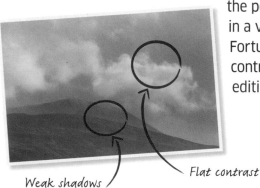

Weak shadows

Flat contrast

1 Working with the Levels tool

To boost the tones of your image, select the Levels command in your editing software. The Levels box shows the image's histogram. Here, we can tell the image lacks contrast because the histogram is very biased towards the midtones.

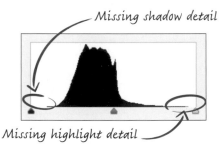

Missing shadow detail

Missing highlight detail

ℹ THE POWER OF CURVES

Another way to adjust the tones in an image is with the Curves command (see pp. 230-231). Curves is only available in more powerful image-editing software, but it offers greater control than the Levels option. The Curves box features the image's information in a histogram. A diagonal line overlaying the histogram represents the tonal distribution of the image, from highlights at top right to shadows at bottom left.

Line showing distribution of tones across the image

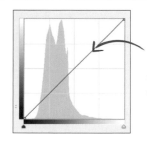

Manipulating the diagonal line to form a simple S-curve will add contrast to a photo

4 Adjust the midtones for more punch

Move the Midtone slider to the left to brighten the midtones and to the right to darken them. With the Midtone slider set to the right, the image looks much punchier. Contrast is improved, and darkening the image has made the colours more intense.

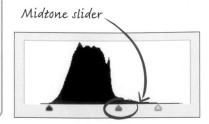

Midtone slider

Pro tip: Don't make numerous Levels adjustments to a JPEG image. Repeatedly altering the tonal range, for example, can cause posterization, visible as abrupt changes in tone across the image.

Pro tip: Another sign of an over-processed photo is when the Levels histogram has a comb-like appearance.

2 Set the black point for richer shadows

To deepen the shadows, move the Black point slider right until it reaches the left edge of the histogram. This is called setting the black point. As you do so, the image will get darker. Having set the black point, shadows now appear much bolder.

3 Set the white point for stronger tones

Set the white point by moving the opposite slider, the white point, to the left. Take more care with this slider: although a few small regions of pure black are acceptable, areas of pure white look unattractive. Avoid pulling the slider so far that the highlights burn out to white.

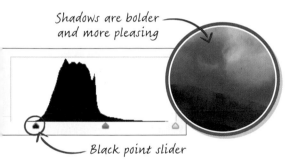

Shadows are bolder and more pleasing

Black point slider

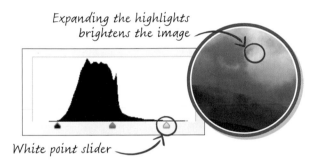

Expanding the highlights brightens the image

White point slider

5 Correct colour casts with Levels

The Levels grey picker tool can be used to remove colour tints in an image. Select the tool and then click anywhere in the image that you think should be a neutral grey.

Greater contrast in the sky

Grey cloud makes good target point

Darker shadows

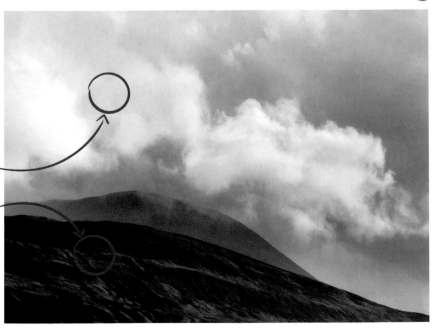

In this module you've learned about how lighting affects shadows, the appearance of texture, and how three-dimensional your subject looks in a photo. Try these multiple-choice questions to see what else you've learned.

1 What type of light do you need to shoot a silhouette?

A Front light
B Backlight
C Side light

2 What accessory would you use to bounce light into an area of shadow?

Ⓐ Reflector Ⓑ Flashgun Ⓒ Tripod

3 What kind of light source do you need to produce light stars?

Ⓐ Bright Ⓑ Warm Ⓒ Point

4 What climatic condition softens shadows in a scene?

Ⓐ Bright sunshine Ⓑ Mist Ⓒ Wind

5 What type of light creates few obvious shadows with grounded objects?

Ⓐ Side light Ⓑ Top light Ⓒ Backlight

6 In low light a tripod helps to avoid the risk of what?

Ⓐ Converging verticals
Ⓑ Depth of field
Ⓒ Camera shake

7 What direction of light helps to accentuate texture?

Ⓐ Side light
Ⓑ Front light
Ⓒ Backlight

8 What is the most brightly lit part of a subject called?

Ⓐ Shadow Ⓑ Highlight Ⓒ Midtone

9 Translucent subjects benefit from what?

Ⓐ Side light Ⓑ Front light Ⓒ Backlight

10 What type of reflector adds warmth to reflected light?

Ⓐ Silver
Ⓑ White
Ⓒ Gold

11 Shadows are at their longest when?

Ⓐ At midday
Ⓑ On overcast days
Ⓒ After sunrise and before sunset

12 To minimize the risk of flare you'd use what accessory?

Ⓐ Reflector Ⓑ Lens hood Ⓒ Tripod

13 When a subject is illuminated by front light, where does its shadow fall?

Ⓐ To the side
Ⓑ Below
Ⓒ Behind

14 Hair illuminated from behind often shows what effect?

Ⓐ Halo Ⓑ Reduced contrast Ⓒ Flare

15 The farther a shadow is from the subject, it becomes what?

Ⓐ Harder Ⓑ Softer Ⓒ Sharper

16 Backlighting has what effect on the colours of a translucent subject?

Ⓐ Intensifies them
Ⓑ Has no effect
Ⓒ Makes them more dull

17 The sun provides top lighting at what time of the day?

Ⓐ At dawn
Ⓑ Midday
Ⓒ Late afternoon

18 Shadows are what on an overcast day?

Ⓐ Stronger Ⓑ Longer Ⓒ More diffuse

19 The shadows on a side-lit subject are?

Ⓐ On the side opposite the light source
Ⓑ Behind the subject
Ⓒ In front of the subject

Answers 1/B, 2/A, 3/C, 4/B, 5/B, 6/C, 7/A, 8/B, 9/C, 10/C, 11/C, 12/B, 13/C, 14/A, 15/B, 16/A, 17/B, 18/C, 19/A.

week 17

WORKING WITH FLASH

Most dSLRs come with a built-in flash. However, its fixed range and position limits its uses. A separate flashgun – or flash unit – offers much more versatility. It can be used on the camera to give a hard light or to fill in details, or off the camera to provide gentler and more directional illumination.

In this module, you will:

▸ **assess your understanding** of how camera flash can be used to creatively light a situation;

▸ **study how flash works** and how to use bounce flash and fill-in flash;

▸ **get to grips with the basics** by following a step-by-step guide for off-camera flash effects;

▸ **learn how to freeze motion** and to create drama in low-light scenes;

▸ **correct mistakes** such as red eye using editing software;

▸ **review your photographs** to make sure you're using your flash as creatively as possible;

▸ **recap what you have learnt** and test your knowledge of flash techniques to see if you're ready to move on.

Let's begin... ⊙➔

What does flash do?

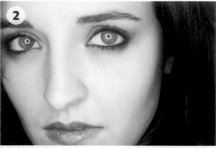

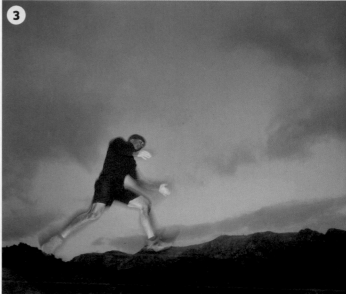

Flash can be used as the main light in a scene, or used more subtly to fill in shadows in bright sunlight. It can be used to freeze the action, or to selectively illuminate part of a subject. See if you can identify how flash has been used in these examples.

A **Overexposed flash:** Produces an image that's very light.

B **Ring flash:** Used to create a shadowless illumination of a close-up subject, and can produce ring-shaped highlights in the eyes.

C **Off-camera flash:** Can be used to create a dramatic sidelight.

D **Softbox or umbrella:** These additional pieces of equipment can be used to simulate natural light from a window.

E **Direct flash:** A flash mounted on the hot shoe can create strong shadows in the background.

F **Freeze flash:** Can freeze the action of a fast-moving subject.

G **Bounce flash off a ceiling:** Used to give a soft overall light.

H **Spotlight flash:** Allows you to use the flash like a torch, illuminating part of your image.

ANSWERS

H/1: Man crouching in alleyway
G/8: Girl sitting in her living room
F/3: Man running along a ridge
E/5: Statue of a cello player

D/4: Cat sitting on the floor
C/6: Golden retriever puppy
B/2: Close-up of a woman's face
A/7: Man with moustache

WEEK

17

5

7
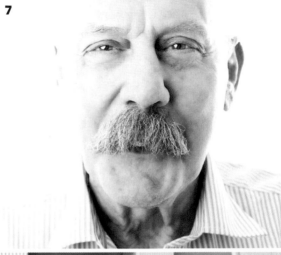

6
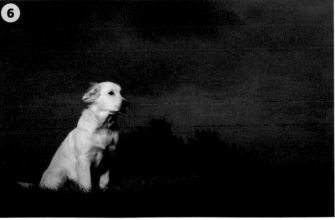

8

NEED TO KNOW

■ A flashgun can be used to give a variety of lighting effects, from natural-looking to highly stylized, depending on its position and how direct or diffuse the light from it is.

■ The smaller and farther away the light source is from the subject, the harder the light it produces. Conversely, the larger the light source and the closer it is to the subject, the softer and more diffuse the light will be.

■ Direct flash, used either on or off the camera, is hard like direct sunlight, while bounced or diffuse flash is soft like the light on a cloudy or overcast day.

■ Photographing the same object over the course of a single day is a good way of observing how the angle of light impacts on a scene.

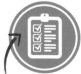

Review these points and see how they relate to the photos shown here

Using a flashgun

By controlling the strength and direction of the light precisely, a flashgun gives you the ability to light your subject the way you want to. Understanding how to use your flashgun and how to balance it with the light in the scene will let you predict how the flash will affect your image.

FLASHGUN

Most flashguns are powered by normal batteries, although some use an external rechargeable power pack for faster recharging and more flashes per charge.

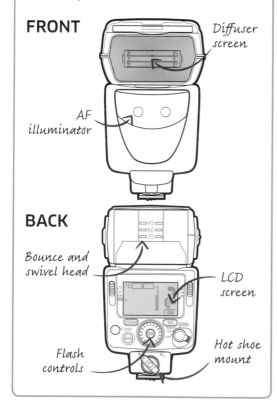

FRONT

Diffuser screen

AF illuminator

BACK

Bounce and swivel head

LCD screen

Flash controls

Hot shoe mount

POWER

Light decreases with distance.

Subject at short range, low GN.

Subject at long range, low GN.

Subject at long range, high GN.

Flashguns vary in power: typically the smaller the flash, the less power it has. Flash output is measured in Guide Numbers (GN): the higher the number, the more powerful the flash.

The light from a flash will decrease the farther away the subject is. GN is therefore usually given in metres at an ISO setting of 100. If the distance between the flash and the subject is doubled, only one-quarter the amount of light will reach the subject.

To work out the aperture for any given distance, divide the GN by the distance. So a GN of 40 would give an aperture of f/8 at 5 metres.

LIGHTING ANGLES

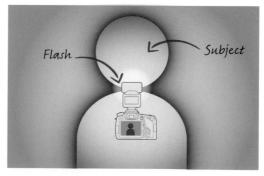

Flash

Subject

On-camera flash gives a direct light with hard edges and high contrast, flattens out the subject, and can cause red eye. It should only be used when there is no alternative, such as in a tight space or when the subject is very far away.

Pro tip: More advanced flashguns have zoom settings that you can use to match the focal length of your lens to the flash head. This allows you to maximize the power of your flashgun when shooting subjects that are farther away.

Pro tip: You can buy a wireless transmitter for the camera that will let you use your flash without it being physically connected to the camera. This is useful to avoid wires or to position the flash far from the camera.

DISTRIBUTING LIGHT

With bounce flash the light is reflected off the ceiling or wall, creating a larger light source that is softer and more even.

Fill flash is used to fill in hard shadows from the sun or backlit subjects so that the contrast between subject and background is evened out.

RATIOS

The flash ratio is the difference between the power of the flash and the main exposure for the subject. For example a ratio of 1:2 would mean that the flash was one stop below the exposure for the scene

Ratio = 0
Only ambient light

Ratio = 1:8–1:2
Fill flash

Ratio = 1:1
Balanced flash

Ratio = 2:1–8:1
Strong flash

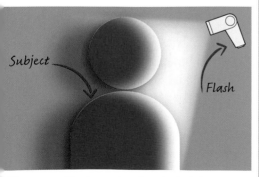

Subject

Flash

Off-camera flash can be directed at the subject from the side and at an angle. This provides directional light and gives the image greater depth. You can use a cable to get the flashgun off the camera.

EXPOSURE

When you use a flash, you effectively have two light sources – the available light in the scene and the light from your flash. Most modern cameras and flashes work with Through The Lens (TTL) metering and this will adjust the power output of the flash. As you press the shutter button, the flash sends out a small pre-flash before the shutter opens. The camera uses this to take a meter reading and then adjusts the power of the flash, which fires while the shutter is open.

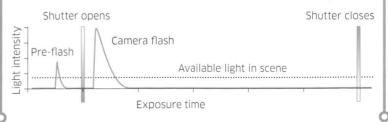

Shutter opens

Shutter closes

Light intensity

Pre-flash

Camera flash

Available light in scene

Exposure time

Using flash off-camera

By getting your flash off the camera, you can use it to create much more interesting light, giving a more three-dimensional feel to your subject. Experiment with the flash in different positions in relation to the subject, and with both hard and soft light to create the effects you want.

1 Set your exposure

Modern dSLRs use TTL (Through the Lens) metering whereby the flash fires a pre-flash and sets the appropriate exposure based on the amount of light that returns through the lens. Attach the TTL cable and set the exposure.

A TTL cable lets you use a flash off camera

2 Set up the flash

Attach the flash to a stand, and position it at a 45-degree angle to the side of the subject and 45 degrees above it. This is the classic 45/45 lighting position for simulating natural light from the sun.

Mount your flash on a stand or tripod

6 Create a beauty light

Place the flash close to the subject and close to the camera axis. Use a softbox or an umbrella to create a very soft, almost shadowless and very flattering light. Known as "beauty light", this is often used in fashion shoots.

An umbrella gives a soft, overall light.

7 Add a second flash

Attach a second flash to the hot shoe of the TTL cable on your camera. Keep the first flash as the main light and set the power output for the second flash at one stop less than the first. To soften the light of the second flash, angle the head to bounce the light off a reflector onto your subject.

Adjust the outputs of the flashes to get the perfect illumination.

8 Review your images

Take a shot and review it. The second flash should fill in light to reduce contrast. If the balance isn' right, decrease or increase the output of the second flash in third stop increments until you're happy

Check your image to make sure you have the right balance

Where to start : Find an indoor location where you can set up a temporary studio. You will need a willing model (or an object for a still life), a stand to hold your flash, a TTL cable, a softbox (or umbrella), and a snoot for changing the light quality.

What you will learn: How to create a simple off-camera lighting set-up for shooting portraits and still lifes; how to use a softbox, a snoot, and an umbrella to change the quality of the light; and how to use a second flash to reduce contrast and fill in shadows.

3 Experiment with flash positions

With the flash aimed directly at your subject, take a shot. Note how direct flash has produced a hard light with high contrast. Move the flash to a position 90 degrees to the side of your subject. From here, the shadows will be even more pronounced.

4 Soften the light

Attach a softbox (a device for diffusing light, see p.289) to your flash, or attach a photographic umbrella to your flash stand. The flash needs to be pointed inside the umbrella to diffuse the light. Take some shots. The light will now be softer with less contrast.

5 Make a spotlight

Attach a snoot (a tube for controlling the direction of flash light) onto your flash, and focus it on a part of your subject. The tube will make the flash operate like a flashlight, illuminating a small area of the subject for dramatic effect. You can make your own snoot from aluminium foil or card.

Flash directly in front.

Flash positioned at 90 degrees.

A softbox attached to the flash will produce a diffuse light.

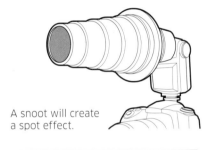

A snoot will create a spot effect.

WHAT HAVE YOU LEARNED?

- With just a few simple accessories you can create lighting set-ups for shooting portraits and still lives.
- A 45/45 set-up simulates the light from the afternoon sun.
- Diffusers, such as softboxes and umbrellas, can be used to soften the light.
- Flashes can be used with each other to reduce contrast, fill in shadows, and make light more flattering.

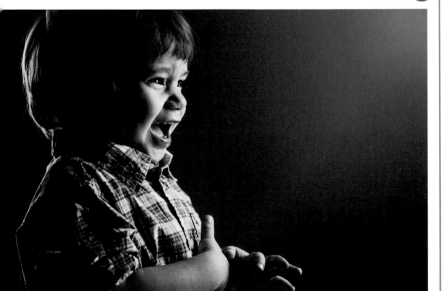

With diffused flashes placed on either side of the subject, the light is soft but with some areas of dark shadow.

Using fill-flash

By learning how to balance the light from your flash with the available light, you will open up a range of creative effects. These assignments will also show you how to use flash to achieve a soft light, freeze the moment, and fill in shadows. Fill-flash is particularly useful for reducing the contrast on a backlit subject. It can also be used more creatively as the main light source to create a dramatic effect or to simulate window light. You can use Aperture Priority or Program modes with fill-flash, but for the most control, use the Manual setting, as described here.

BALANCING THE FLASH

- **MEDIUM**
- **1 HOUR**
- **BASIC +** flash
- **OUTDOORS**
- **MODEL AND A SUNNY DAY**

Shooting on a sunny day can cause a lot of problems with contrast and exposure. If you expose for the sun, people's faces can be very dark, but if you expose for the shadows then the rest of the scene will be overexposed. The answer is to experiment with the ratio of flash to available light to subtly fill in shadows and reduce contrast.

- **Go** out in the morning or afternoon when the sun is at an angle. Place your subject with their back to the sun so that their face is in shadow.
- **Take** a meter reading for the scene and then set the flash power between 1/2 and 2 stops below the ambient light. The lower the power of the flash, the less pronounced the effect will be.

USE FLASH AS THE MAIN LIGHT

- **MEDIUM**
- **1 HOUR**
- **BASIC +** flash
- **OUTDOORS**
- **SUBJECT AND LOW-LIT SCENE**

The flash can be adjusted to be more powerful than the available light, thereby acting as the main light source. This technique can be used to darken the background, turning day into night and creating dramatic night-time scenes.

- **Go** out around sunrise or sunset and frame your subject against the sky.
- **Remove** the flash from the camera, as this will give a better quality of light.
- **Take** an overall exposure reading.
- **Set** the camera exposure so that the background is 2 stops darker than the flash-exposed subject.

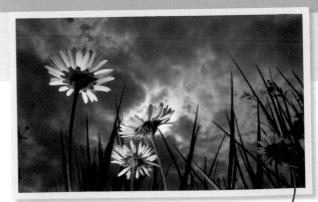

The sky and background are underexposed, picking out the foreground subjects

- **Take** a shot. Your subject should be brightly lit by the flash while the background remains dark.

Pro tip: Use flash exposure compensation to fix meter readings that have been thrown by very light or dark subjects. For light subjects, increase the flash output by around +1/2 to +1½ stops; for dark subjects, reduce it by round -1 to -2 stops.

Pro tip: Many flashes give out a rather cold light, especially when they are new. Soft plastic filters called gels can be placed over the flash head to change the light. A very pale orange one will warm the light up a bit.

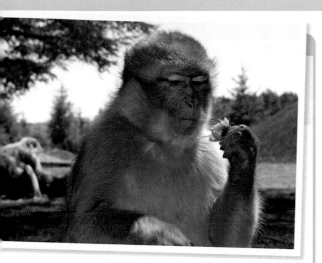

KIT: DIFFUSERS AND SOFTBOXES

There are devices for softening the harsh light from a flash which, if used skilfully, can replicate natural light almost perfectly. A small plastic diffuser, which clips onto the front of the flash, softens the light by increasing the size of the source. Similarly you can use a softbox, which will bounce the light around inside it to give an even more diffuse and soft light.

This small softbox fits over the flash head

▪ **Adjust** the balance further, if necessary. Most modern flashguns let you reduce the power in 1/3 stop increments so you can be very precise.

▪ **Experiment** until you get a ratio between the flash and the daylight that you like. The aim is for the flash to "fill in" any shadows, so the lighting looks as clear and natural as possible.

USING FILL-FLASH IN THE DARK

- MEDIUM
- 1 HOUR
- BASIC + flash
- INDOORS OR OUTDOORS
- MODEL AND A NIGHT-TIME SCENE

Fill-flash can be used in a dimly lit interior or at night to balance the flash to the available light.

▪ **Take** an overall light reading of your scene.

▪ **Use** the flash to fill the foreground and illuminate your subject, while using a long exposure time to fill the background. For example, if your light reading for the available light is 1/15 sec at f/5.6, you would set the flash to f/5.6 and let it light the main subject.

▪ **Experiment** with different shutter speeds to get the exact amount of background detail you want. A slower shutter speed will make the background relatively bright, a faster one will make it darker.

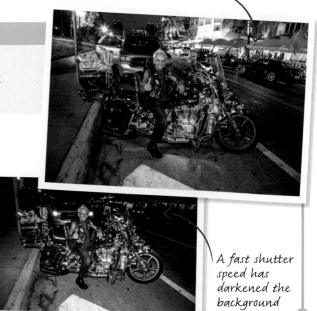

A slow shutter speed has brightened the background

A fast shutter speed has darkened the background

FLASH BLUR

- **MEDIUM**
- **3 HOURS**
- **BASIC +** flash
- **INDOORS OR OUTDOORS**
- **MODEL, POINT LIGHT SOURCE**

The flash has been combined with a slow shutter speed to freeze the subject

You can combine flash with a slow shutter speed to create the illusion of movement in an image. A longer exposure time will give a "flash blur" effect, where the subject is frozen by the flash while the background appears blurry, making for dramatic and interesting pictures.

■ **Set** your flash to f/8 as a starting point, and the shutter to 1/15 sec.

■ **Get** your model to move in front of you, slowly at first, as you take a series of images.

■ **Experiment** with different exposure times from 1 sec to 1/30 sec to get the effect you want. Adjust the aperture if necessary to get the right shutter speed. Once you feel confident, try getting your model to move more quickly and pan with them as they move.

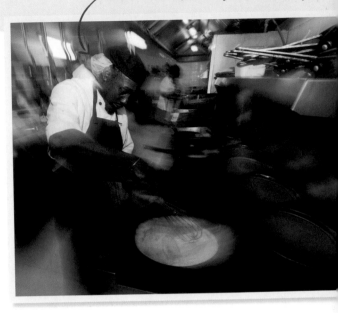

KIT: **RING FLASH**

A ring flash is a circular flash that fits around the lens. As it is located very close to the lens, it provides an even, flattering illumination with almost no shadows and is often used for portraits and fashion shoots. It typically has relatively low power, so it is best used near to the subject. As such, it is well suited to macro photography and close-ups, as it gives enough power for you to be able to use a small aperture, giving a lot of depth of field. One small problem with ring flash is that it can sometimes produce a tell-tale ring-shaped light in the subject's eyes.

Ring flash fits around the lens

FRONT AND REAR CURTAIN

- **MEDIUM**
- **2 HOURS**
- **BASIC +** flash
- **OUTDOORS**
- **MOVING SUBJECT**

Front Curtain Sync mode fires the flash at the beginning of the exposure. This means that when a moving subject is illuminated by flash during a long exposure, the subject's motion blur is recorded in front of the subject. Rear Curtain Sync mode fires the flash at the end of the exposure, producing a motion blur behind the subject, which looks more natural. The curtain sync modes can be altered on your camera's flash settings menu.

■ **Go** out at night and place your subject in front of some point light sources such as spotlights or street lamps. Experiment with different long exposures from 1/30 sec to 1 sec or more.

■ **Balance** the aperture to the available light and match the flash to that. Take a few test shots.

USING BOUNCE FLASH

- 📶 EASY
- 🕐 1 HOUR
- 📷 BASIC + flash
- 📍 INDOORS
- ➕ ROOM WITH PEOPLE

Flash can be bounced off interior ceilings or walls to give a soft, flattering light that fills the whole space.

- **Set** up your subject in the centre of a small room with, ideally, white walls and ceiling.

- **Attach** the flash to your camera, and tilt it so it's facing away from the subject.

- **Set** the flash to f/8 and the shutter to 1/60 sec as a starting point and take a series of shots bouncing the light off the ceiling and walls.

- **Make** a note of how you positioned the flash for each shot, so you can work out how the light changes as you move the flash around. If your flash has a zoom head, experiment with different settings.

- **Remember,** the higher the ceiling, the higher the power of the flash will need to be.

- **Note** that the flash will take on the colour of the surface it bounces off. Beware of green walls.

Bounced flash light is much softer than direct flash

- **Try** the front and rear curtain settings. Ask your subject to move across the frame and see what happens with each mode. Shooting moving cars is also a good way to learn how this effect works.

Rear-curtain flash has blurred the lights behind the subject.

WHAT HAVE YOU LEARNED?

- By controlling the ratio of light from the flash with the available light, you can creatively control contrast and shadows to get precisely the effect you want.
- The flash can be used to dramatically isolate the subject and make it stand out from the background.
- Bounce flash is very useful indoors to give a soft, directionless, overall light that will gently illuminate the whole scene.

After using your flash creatively for a period, choose your best shots and assess the results. See where the flash worked well, and what might have gone wrong. Look at how hard or soft the light was, and how the shadows fell. Here are some pointers on how to assess your images and improve your results next time.

▼ Are there dark shadows in a close-up image?
Using a ring flash has resulted in an almost shadow-free close-up image of a flower.

▲ Is the light from the flash too hard?
If you want to soften the light coming from the flash, use a softbox or diffuser. Alternatively, you may want to use a hard shadow for creative results, as here.

▶ Have you checked for possible reflections?
Subjects with shiny surfaces can reflect the flash light back at the camera, potentially spoiling the composition, or, as here, this can be used to emphasize the polished texture of the subject.

▲ Is the light too harsh?
The light and shadows in this image have been softened by using a softbox fitted over the head of the flash and by positioning the flash to one side of the subject.

> **Wherever there is light,
> one can photograph.**
> **ALFRED STIEGLITZ**

**Should you use
Rear Curtain Sync?**
In this image, Rear Curtain
Sync has been used to
simulate forward movement,
thereby emphasizing the real
movement of the subject.

**Have you got the ratio
of flash and ambient
light right?**
Flash has been used so
carefully and subtly in this
sunny scene that it is barely
noticeable and looks
completely natural.

Have you got the right shutter speed?
In this panned shot, the shutter speed
was just right – too slow and it would have
been blurred; too fast and it would not have
given the appearance of motion.

**Is your subject
overexposed
compared to the
background?**
To avoid this, reduce the
flash in relation to the main
exposure so that the ratio
of flash to available light is
more balanced.

Reducing red eye

Red eye is caused when light from a flash is reflected by the retina at the rear of the subject's eye back into the lens. The light is red because it reflects the colour of the blood vessels in the eye. This is more of a problem with point-and-shoot cameras than

cameras with a moveable hot shoe mounted flash, as the flash is mounted close to the camera lens, so the light is reflected straight back. Most post-production software programs have a simple red-eye reduction feature. This is how to remove red eye in Photoshop.

1 Find the eyes
Open the file you want to alter and zoom into the eyes so you can work on them in detail.

The pupil is bright red

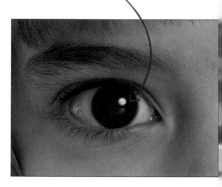

5 Click on an eye
Place the cursor over the eye you'd like to reduce red eye for and click once. This should automatically fix the problem.

6 Click on the other eye
The tool only fixes one eye at a time, so you will need to click on the other eye too.

7 Adjust until you are satisfied
If the Pupil Size isn't big enough, a small amount of red may remain. If this happens, or you're not happy with the results, adjust the settings and try again until you are.

Click in the centre of the pupil

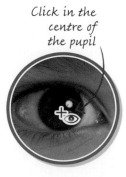

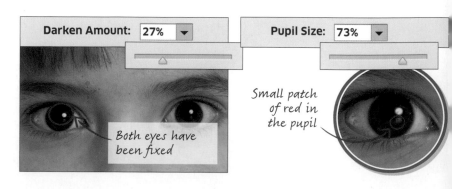

Darken Amount: 27%

Both eyes have been fixed

Pupil Size: 73%

Small patch of red in the pupil

Pro tip: If you don't like the effect created by the Red Eye Tool, or don't think it's working properly, you can also remove red eye manually by using the Colour Replacement tool.

Pro tip: The higher the power on the flash, the longer it will take to recycle after each exposure. If you plan on shooting a lot of images in quick succession, think about buying an external battery pack that will allow you to shoot for longer.

2 Select the Red Eye Tool

Go to Tools and select the Red Eye Tool under the Healing Brush Tool menu. It's the last tool on the list.

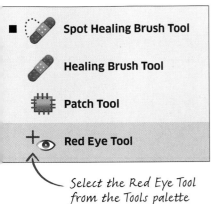

Spot Healing Brush Tool

Healing Brush Tool

Patch Tool

Red Eye Tool

Select the Red Eye Tool from the Tools palette

3 Adjust the pupil size

Use the Pupil Size slider on the Options bar to set how much of the eye the tool should regard as the pupil. A low setting will not cover the pupil; a high one will cover too much. Start with 50 per cent and see which works best.

Pupil Size: 50%

Move the slider to change how much of the pupil will be affected

4 Adjust the darkness

Use the Darken Amount slider to darken the pupil. A low figure will only partially remove the red eye, while a higher one will make the pupil very dark and will look rather obvious.

Darken Amount: 50%

Start with a setting of 50 per cent and experiment to get the most natural effect

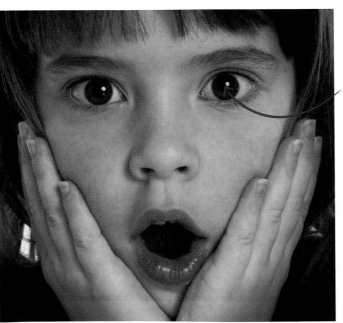

The pupils are now dark and natural-looking

ⓘ RED-EYE FIXES

Some point-and-shoot cameras have a red-eye reduction setting whereby a brief burst (or bursts) of flash is fired before the main flash, causing the subject's pupils to contract, lessening the red-eye effect. You can avoid the problem of red eye completely by taking the flash off the camera, so that the path of the light is not reflected directly back into the lens.

Learning how to use flash is an essential addition to your armoury of creative techniques. Test how confident you are of getting the lighting effects you want in any situation by answering the following questions.

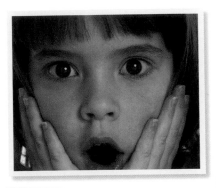

1 Which effect causes red eye?

A Red light from the flash
B The flash reflecting off the blood vessels at the back of the eye
C The subject blinking

2 What piece of equipment could you use with a flash to mimic the natural light from a window?

A Softbox B Snoot C Tripod

3 What is 45/45 lighting?

A The light source is positioned at an angle of 45 degrees to the side and 45 degrees above the subject
B The light is positioned 45 cm (18 in) from the subject
C White light

4 What is the guide number (GN) of the flash?

A A measurement of the flash power
B Sunset colours
C Advancing colours

5 In Rear Curtain Sync flash, when does the flash fire?

A At the start of the exposure
B At the end of the exposure
C In the middle of the exposure

6 What device can you use to turn a flash into a spotlight?

A Softbox
B Snoot
C Umbrella

7 A distinctive circular light in a subject's eye is produced by what type of flash?

A Freeze flash
B Bounce flash
C Ring flash

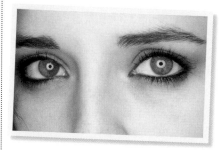

8 What sort of flash technique produces a very light image?

A Overexposed flash
B Underexposed flash
C Freeze flash

9 What sort of flash is hard, like direct sunlight?

A Bounce flash
B Spotlight flash
C Direct flash

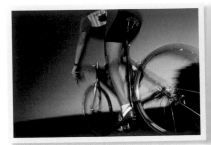

10 A fast-moving subject can be captured using which of these flash techniques?

A Freeze flash B Direct flash
C Ring flash

11 You can connect a flashgun to your camera using which type of cable?

A USB
B TTL
C SCART

12 What does TTL stand for?

A Through The Lens
B To The Limit
C Transistor Technology Logic

13 What flash technique would you use to lighten shadows on a backlit subject?

A Freeze Flash
B Overexposed flash
C Fill Flash

Answers 1/B, 2/A, 3/A, 4/A, 5/B, 6/B, 7/C, 8/A, 9/C, 10/A, 11/B, 12/A, 13/C.

week

18 WORKING IN LOW LIGHT

At some point, all photographers have to work in low-light conditions. Whether you're snapping friends on an evening out, shooting a wedding party in a dimly lit hall, or capturing a landscape at dusk, it's important to understand the basics of shooting when light conditions are not at their best, without having to rely on your flash.

In this module, you will:

▶ **discover the ways** your camera can be adjusted to cope with low light;

▶ **get to grips with the basics** of low-light photography, and find out how it can lead to a whole new world of creativity;

▶ **learn how to crank up the ISO,** use a larger aperture, and slow down the shutter speed;

▶ **practise how to get the best results** in low-light conditions.

▶ **identify some of the most common** low-light problems, and find out how to correct them;

▶ **reassess what you have learned** to see if you're ready to progress to the next chapter.

Let's begin...

When does low light work?

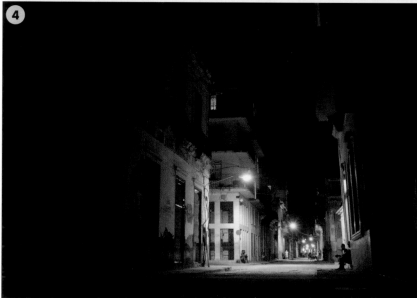

Taking shots when light is limited may pose difficulties, but it also offers opportunities for creativity using various light-enhancing techniques. Can you match the descriptions here with the correct images? Try to pick the best match.

A **High ISO, widest aperture:** Can capture subjects that are lit only by candlelight.

B **Wide aperture:** Gathers whatever available light there is in a shadowy street scene.

C **High ISO:** Allows you to shoot a moving subject without the need for flash.

D **High ISO, wide aperture:** Captures the feel of an event dominated by stage lighting.

E **High ISO:** Allows you to take photos using a single low light source, such as a TV.

F **Tripod, slow shutter speed:** Shows the details in an outdoor scene where there's little light.

G **Long exposure, narrow aperture, and tripod:** Can render a deep depth of field, even when shooting in low light.

H **High ISO:** Helps to convey a low-lit, flickering interior without the need for flash.

NEED TO KNOW

■ Don't put your camera away just because the light is fading. Modern cameras have the sensitivity to work under low-light conditions, but there are techniques you can employ to improve your camera's performance.
■ Change the aperture to let more light in through the lens and onto the sensor.
■ Slow down your shutter speed, but remember that exposing the sensor for longer will require a steady hand.

■ You can use a tripod if your shutter speed becomes too slow for you to keep the camera stable by hand.
■ Push up your ISO to adjust the camera's sensitivity to light.
■ As the light fades, it's worth exploring how the colour of light changes too.

Review these points and see how they relate to the photos shown here

▶ UNDERSTAND THE THEORY
Ambient light

When you are shooting with only limited illumination, your images will take on the colours of the ambient light. This can elevate your photographs from mere pictures to dramatic recorded moments that convey the mood and emotion of a place or event.

Capturing light

Photographers use a variety of techniques to get the most from low-light conditions. However, these methods can also reduce depth of field, blur movement, or add noise to images. This wheel shows which settings let in more light, and their negative side effects.

💡 SLOWER SHUTTER SPEED

■ **The longer the shutter** remains open, the more light is captured.

■ **Blurred movement** caused by camera shake can occur at low shutter speeds. The longer the focal length of a lens, the greater the risk of camera shake.

■ **Using a tripod** or modern lenses with image stabilization can counteract camera shake at slower shutter speeds.

💡 INCREASED ISO

■ **At higher ISO numbers,** your camera's sensor is much more sensitive to light. The ideal ISO range for low light is 800–6400.

■ **Some cameras** reach far higher numbers, but, as the wheel shows, at this point digital background noise can start to become a serious issue.

■ **Post-production** methods allow you to filter out excess digital noise generated by a high ISO (see pp.86–87). Shooting in RAW allows for the most flexibility when improving images.

■ **Extra noise** can improve the shot. The appearance of grain can add a softness to portraits, or a grittiness that can be effective in black-and-white images.

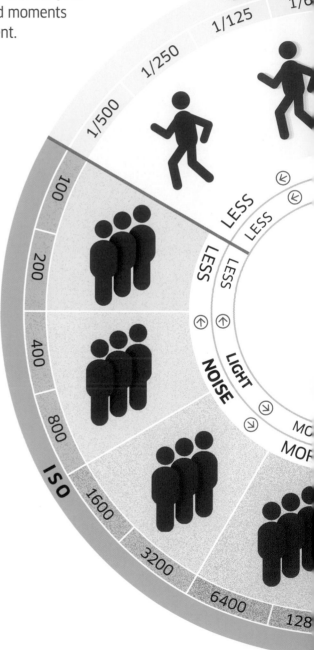

> Photographers deal with things
> which are **continually vanishing.**
> HENRI CARTIER-BRESSON

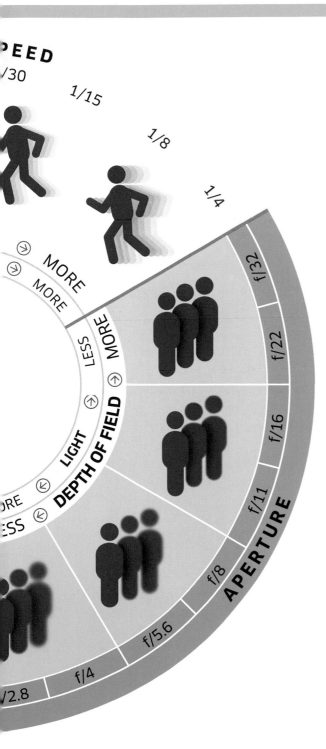

PEED
1/30
1/15
1/8
1/4

MORE

MORE

LESS

MORE

DEPTH OF FIELD

LIGHT

ORE

ESS

APERTURE

f/32
f/22
f/16
f/11
f/8
f/5.6
f/4
2.8

ⓘ AVOID DIRECT FLASH

Direct flash can flatten out digital images or distract your subject, ruining the moment. But there are plenty of other ways to take advantage of low-light conditions to create striking images.

■ **Slow-synch mode** enables you to fire the flash at a lower shutter speed. This enables you to fully illuminate your subject, while the slow shutter speed records more background detail.

■ **Use flash off-camera** and angle light so that it is not directly in front of the subject. Use reflective surfaces and diffusers to soften the light and avoid startling people.

■ **Supplement ambient light** with strategically placed constant light (such as tungsten lamps with soft white bulbs). These provide additional illumination without sacrificing the atmosphere.

💡 LARGER APERTURES

■ **At larger apertures,** more light can enter the lens. Shooting at f/5.6 lets in far more light than shooting at f/18 (remember, the lower the number, the larger the aperture).

■ **When shooting** with a wider aperture, however, you will have less depth of field and your focusing therefore needs to be very accurate.

Using a wider aperture

Choosing a wider aperture will allow you to keep shooting as the light begins to fade. But remember, the larger the aperture, the more your depth of field is reduced, so you will have to be more accurate with your focusing.

1 Set the mode

Choose Aperture Priority mode, which will allow you to control the depth of field of your shot. The camera will take care of the shutter speed, freeing you up to concentrate on getting the focusing and composition right.

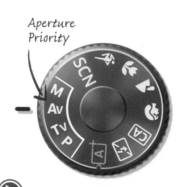

Aperture Priority

2 Consider using a tripod

Use a tripod to ensure the camera is steady and the image isn't affected by camera shake. You can handhold the camera if you're shooting in a crowded place, as this will give you greater freedom of movement.

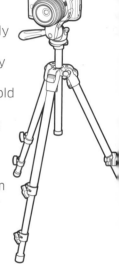

6 Compose and shoot

Arrange your composition carefully, and then, if using a tripod, use a remote shutter release (or cable release) to take a shot.

Using a remote shutter release will minimize camera shake

7 Hold the camera steady

If you're handholding your camera, be sure to hold it steady, or rest it on something, when taking a shot, as using a wide aperture means you'll be shooting with a slow shutter speed.

8 Review your image

With a wide aperture, it's important to get the point of focus right. If it's a little bit off, refocus, recompose your shot, and try again

Check Playback for accuracy of focusing and any unwanted camera movement

Where to start: Choose a location with low, moving, or scattered lighting and a subject that will stand out from the background. Taking a portrait of someone in a moodily lit bar would be a good choice.

You will learn: How to alter the camera's aperture to take advantage of shooting in low-light conditions, and how important it is to focus and meter correctly in order to get the best results.

3 Adjust the aperture setting of your lens

Pick your smallest f-stop number, which will give you the widest possible aperture.

An f-stop of f/2 will allow more light in but will reduce the depth of field

4 Focus on your subject

With a wide aperture, the depth of field is reduced, so accurate focusing becomes critical. If photographing a person, manually focus, or select an AF point, on the eye closest to you.

Select an AF point

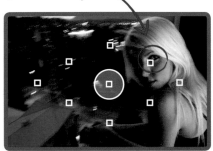

5 Take a meter reading of the subject

Select a metering mode, and meter the area that is most critical to your image – in other words, the main point of focus. For this image, it would be the subject's skin tone.

Spot metering will allow you to accurately expose your subject

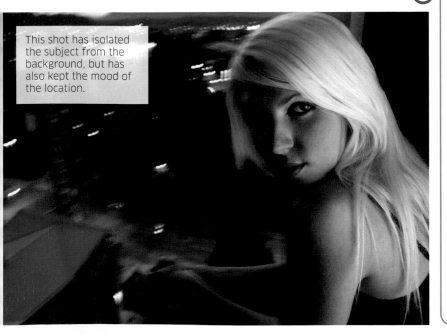

This shot has isolated the subject from the background, but has also kept the mood of the location.

WHAT HAVE YOU LEARNED?

- It's possible to take good photos even in low light.
- By using a wide aperture, you can continue shooting without using flash.
- However, the wider the aperture, the more the other factors, such as focusing and metering, become important.
- Working in low light will help to improve your camera handling and focusing skills.

Using constant light

A single strategically placed constant light source (such as a lamp fitted with a soft white incandescent, or tungsten, bulb) is excellent for providing additional ambient light in a low-lit scene without sacrificing the atmosphere of the setting.

1 Choose your shooting mode

As you're going to be shooting in a relatively dark setting, select Aperture Priority. This will allow you to choose the aperture while the camera controls the shutter speed. Pick your camera's widest aperture.

2 Set your ISO

Owing to the low-light conditions, you need to increase the camera's sensitivity to light. Try turning the ISO up to 1600 for this exercise. Once the camera is set up, get your model into position.

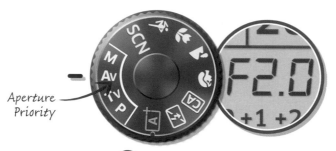

Aperture Priority

Use a high ISO

6 Recompose your shot

You will probably have had to move your camera to check your focus and exposure, so take some time to recompose your image so it is balanced.

You can use a piece of paper or card to reflect light back onto your subject

7 Shoot the picture

Although you can shoot handheld, in some circumstances it may be necessary to use a tripod or to brace the camera against something solid to keep it steady. The high ISO setting can lead to blurry images, particularly if there's any camera shake.

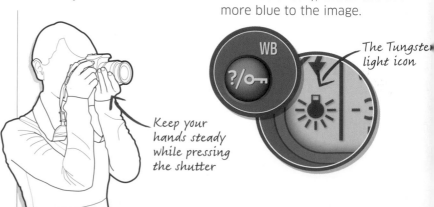

Keep your hands steady while pressing the shutter

8 Review and reshoot

When your light source is a desk lamp, you may find that the colour of your pictures becomes quite red or orange. To combat this, you may need to adjust the white balance setting from AWB or Daylight to Tungsten (the little white bulb icon), which will add more blue to the image.

The Tungsten light icon

Where to start: This is a good technique to try around the home or in an office where computers, lamps, and televisions offer a wide choice of light sources. By carefully metering your subject's face, you can get some wonderfully atmospheric results.

You will learn: How experimenting with aperture, ISO, and constant light sources can result in some effective low-light shots, and how altering the position of the light source can greatly affect the mood of your image.

3 Position your lights

Move a desk lamp (or other gentle light source, such as a tablet computer) so that its light falls on your subject in a flattering way. Experiment by moving the light side to side and up and down.

Tablet computers offer a nice, soft light

4 Focus on your subject

Because you are using a wide aperture, the depth of field in your image will be very small. Accurate focusing is therefore essential. Make sure the features of your subject are sharp.

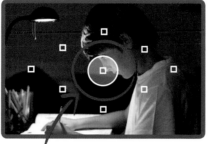

Focus on the most important feature, such as the face

5 Check the exposure

Use Spot metering, as this will allow you to precisely meter the area you have focused on while ignoring the dark shadowy areas. Centre-weighted or Evaluative (Matrix) metering will be fooled by the darkness around your subject.

Spot meter for the highlights on your subject's face

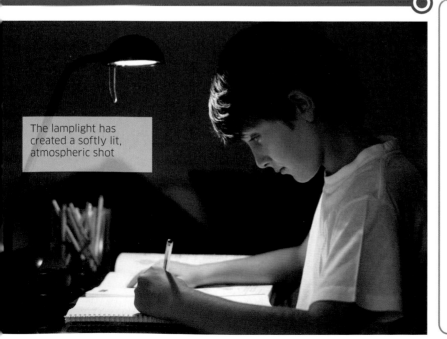

The lamplight has created a softly lit, atmospheric shot

WHAT HAVE YOU LEARNED?

- You don't need fancy equipment for high-end results – you can use everyday items as light sources.
- Getting your subject to interact with the light sources, such as by holding a tablet computer, can result in interesting compositions.
- Achieving the best shots requires careful control of the aperture and ISO settings.
- You can use your camera's white balance setting to add more blue to an image.

▶ PRACTISE AND EXPERIMENT
Shooting in low light

These three assignments will help you to hone your skills in low light. They are simple in theory but will take a little time and patience to get the best results. As with anything in life, the only way to learn is by practising and making mistakes.

CREATE LIGHT TRAILS

- **EASY**
- **1 HOUR**
- **BASIC** + tripod
- **OUTDOORS**
- **AN URBAN LOCATION WITH MOVING LIGHTS**

Using a tripod to keep your camera still, slow your shutter speed down to capture streaming light trails in your town or city at night.

- **Find** a position with a good view down a busy street, or perhaps on a bridge over a motorway, once the sun has set.
- **Attach** your camera to a tripod.
- **Pick** a low ISO – around 200 – and set your camera to Shutter Priority. Dial in the slowest shutter speed your camera can achieve. On most models, this is around 30 seconds.
- **Press** the shutter button to take a shot, then bring the shutter speed up and take another. Repeat. Note how the light trails get longer, and the slower your shutter speed, the less detail is recorded.

TAKE A DIM VIEW

- **EASY**
- **30 MINUTES**
- **BASIC** + tripod
- **INDOORS**
- **A LOW-LIT BUILDING**

Increasing your ISO makes your camera more sensitive to light, allowing you to take images inside a dimly lit building without using a flash.

- **Take** a series of pictures from the same position, turning the ISO up each time until you reach the maximum setting.
- **Observe** that, as the ISO increases, so does the amount of noise, making the picture appear grainy.
- **Experiment** until you find the perfect ISO setting. This will be a bit lower if shooting with a tripod than without one.

A church is a perfect location for this exercise.

Pro tip: Although these assignments are primarily about experimenting with capturing light, don't forget the composition of your shots. Learning to see and compose images in any conditions – especially in low light – is one of the keys to great photography.

In this image you can see the lights but not the vehicles that created them.

LIGHT SOURCES

EASY	**INDOORS**
1 HOUR	**MODEL AND A CONSTANT**
BASIC	**LIGHT SOURCE**

Gather together as many different light sources as you can, including angle lights, desk lamps, and tablet computers, to illuminate your subject.

■ **Open** your aperture to its widest setting

■ **Take** a series of shots using each of the light sources in turn and compare the results.

■ **Note** how a desk lamp creates harsh shadows while a computer screen gives a gentle glow. Also check differences in colours. For instance, a candle gives a warm-looking light while light from a tablet computer will seem white in comparison.

Soft, even lighting from the computer has enhanced this portrait

KIT: GORILLA POD

Sometimes it's not possible to use a tripod to steady your camera when shooting in low light. The scene may be too crowded or your vantage point too precarious. This is where a gorilla pod could come in handy: these are small tripods with flexible, bendable legs that can be balanced on uneven surfaces or used to grab objects to hold the camera steady.

The pod's legs can grab hold of trees, poles, and railings

WHAT HAVE YOU LEARNED?

■ Shooting in low light without flash offers a range of new photographic challenges.
■ It's possible to use readily available light sources, such as desk lamps, computer screens, or car lights, creatively.
■ You can turn the ISO up to increase your camera's sensitivity to light.

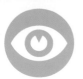
Once you've spent some time exploring the possibilities of low-light shooting, gather together some of your best shots. Look at them again with a critical eye and consult the following checklist to see if there are any skills or techniques you need to work on.

Is the exposure long enough?
To get a shot of long, streaking car lights, you need to use a long exposure. The idea behind this image was good, but the exposure wasn't long enough to make it work properly.

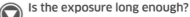

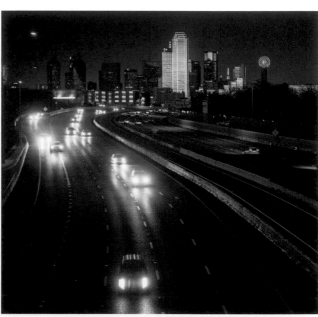

Have you positioned your light source correctly?
Here, the constant light source has been placed in the optimum position, creating an image with a lot of atmosphere. The small aperture has kept everything in the scene in focus.

Is the exposure too long?
This shot of a Ferris wheel was taken using a slow shutter speed. It has created a striking image, but a higher shutter speed might have brought out more detail.

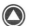

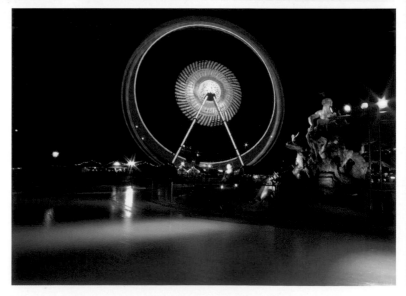

> ## Photography's primary **raw materials** are **light and time.**
> **JOHN BERGER**

Is the ISO high enough?
A flash can kill the mood of a scene. This image was made using a high ISO to make full use of the available light and create a natural-looking portrait.

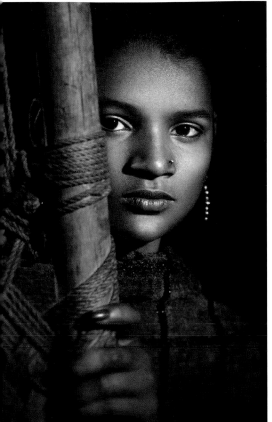

Is your image correctly exposed?
The combination of a small aperture and a high shutter speed has resulted in this dark image of a cat. Would the image work as well with a brighter exposure?

Was the camera shaking when you took the shot?
Here, the combination of low light, a slow shutter speed, and excessive camera shake have resulted in an abstract-looking image where it's difficult to tell exactly what's going on.

Did you use a tripod?
Taken by a camera mounted on a tripod, this image has captured the intertwining light patterns created by the traffic while keeping the buildings in focus.

▶ ENHANCE YOUR IMAGES
Lightening key areas

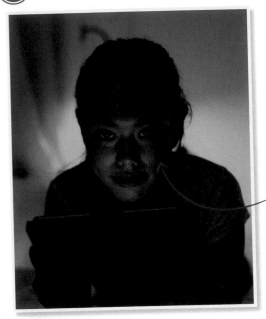

If parts of your image are too dark, it's a straightforward task to lighten them on the computer so as to draw attention to key features, while leaving the other areas as they are.

The girl's face needs lightening to bring out the illumination from the tablet computer

1 Select the Lasso tool
Open the image you want to work on in Photoshop, assess which areas you think need to be lightened, and then select the Lasso tool in the tool bar.

Select the standard Lasso tool, not the Polygonal or Magnetic Lasso tools

5 Adjust Curves
Click and hold the diagonal line and drag it slowly upwards. As you do, the selected part of your image should begin to lighten subtly. Click OK when you are happy with the effect.

6 Invert the selection
If you need to balance the lighting of the background with your subject, choose Select in the menu bar, then Inverse. Then choose Image, Adjustments, and Exposure. Use the slider to bring the exposure of the background up or down until you get the desired balance.

7 Check the image
Use Cmd D or Cntrl D to de-select the lassoed area. Carefully look over the image. If it's still not quite right, redo the steps, adding more or less exposure until your image has the right level of contrast.

Select	Filter	View	Window
All			
Deselect			
Reselect			
Inverse			

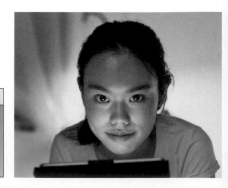

Pro tip: You can add emphasis to an image by adding a vignette to the edges to subtly darken the corners. This will draw the viewer's attention to your main subject, although don't be too heavy-handed or the image will no longer look natural.

2 Draw around the area
Use the Lasso tool to draw a rough line around the area you want to lighten.

The line doesn't have to be that accurate

3 Select the Feather tolerance
Use the Feather box at the top of the screen in order to soften the edges of your selection, so it doesn't look like the effect has been added in afterwards.

A feather tolerance of about 80 will make the light appear soft

Feather: | 80 px |

4 Open Curves
In the menu bar, choose Image, then Adjustments, then Curves. A window will appear with a mountain-like histogram showing the brightness of your image.

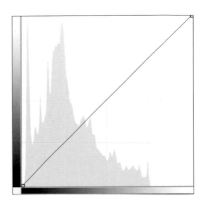

The image is now much more balanced, with a more subtle transition from the light on the girl's face to the background.

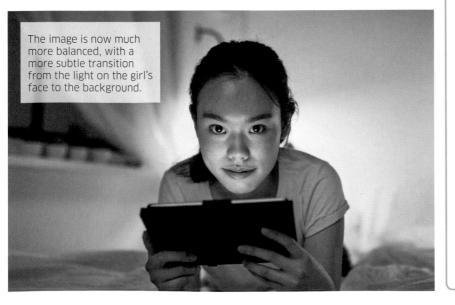

ⓘ WARMING UP

You could go even further than the changes described here and exaggerate the lighting by warming up areas of the image. To experiment, go to the top menu, then Adjustments, then Colour Balance, and play around with the sliders.

Remember that you can also alter the exposure in-camera when taking a photo – thus foregoing the need for post-production fixes – by carefully adjusting the exposure compensation.

This module has explored the various challenges and possibilities thrown up by working in low-light conditions. Test yourself with the following questions to see how much information you have retained.

1 **What would you expect to see** in an image if you increased the ISO number on your camera?

A Movement
B Noise
C A shallow depth of field

2 **What becomes critical** in low light?

A Exposure
B Focusing
C A flash unit

3 **What happens when** you open up the aperture?

A Depth of field decreases
B Depth of field increases
C More noise can be seen

4 **What do you need to be aware** of when you slow your shutter speed down?

A How heavy your camera is
B Camera shake
C Focusing

5 **If your pictures** are coming out too orange or red when you're shooting indoors, what can you change to correct this?

A The aperture
B The shutter speed
C The white balance setting

6 **What can you use** to reflect light onto your subject?

A A flash unit
B A piece of white card or paper
C A bright desk lamp

7 **What key piece of equipment** might be used when shooting at slow shutter speeds?

A A tripod
B A flash
C A softbox

8 **What happens** to your shutter speed when you open up your aperture?

A It gets slower
B It stays the same
C It gets faster

9 **Can you use** a slow shutter speed, a high ISO, and a wide aperture at the same time?

A Yes
B No
C Sometimes

10 **If you are** taking shots inside a dimly lit building and have your aperture wide open, what else can you do to increase your exposure?

A Increase your ISO
B Slow down your shutter speed
C Use a tripod
D All of the above

11 **Focus, exposure,** and what else make a pleasing image?

A Depth of field
B Composition
C A long lens

12 **What metering mode** would you use if you were taking a portrait of someone's face lit only by their tablet computer?

A Spot metering
B Average metering
C Program mode

13 **What sort of ISO setting** should you use to capture light trails?

A High
B Low
C It doesn't matter

14 **What two things combine** to make a perfect exposure?

A Shutter speed and aperture
B Digital noise and depth of field
C Aperture and depth of field

Answers 1/B, **2/**B, **3/**A, **4/**B, **5/**C, **6/**B, **7/**A, **8/**C, **9/**A, **10/**D, **11/**B, **12/**A, **13/**B, **14/**A.

week 19

BLACK AND WHITE

Once there was no choice but to shoot in black and white. Although black-and-white photography has since been overshadowed by colour, it is still popular and has a timeless quality that colour struggles to match.

In this module, you will:

▶ **assess what type of photo** is suitable for this treatment;

▶ **understand how different colours** are converted to black and white;

▶ **see for yourself** by taking black-and-white photos on a step-by-step photoshoot;

▶ **practise with shooting** different subjects in black-and-white;

▶ **review your black-and-white photos** to see how successful they are, and troubleshoot some common problems;

▶ **enhance a colour photo** by converting it to black and white using post-production software;

▶ **go over** your understanding of black-and-white photography and see if you're ready to move on.

Let's begin...

Will black and white work?

Any colour photo can be changed to black and white, but some subjects suit this treatment better than others. Can you work out which of these seven images have the potential for black-and-white conversion and which do not?

A **Vibrant colour:** If a photo relies purely on colour for impact, it's unlikely to work in black and white.

B **High contrast:** Deep shadows and bright highlights will work well in black and white.

C **Drama:** Black and white suits moody weather conditions.

D **Similar colours:** A limited range of colours isn't usually suitable for the monochrome approach.

E **Pattern and texture:** A subject with a distinctive shape, pattern, or texture that is revealed by light and shade is often a good candidate for black and white.

F **Flat light:** Low contrast and subdued colour are not ideal for changing to black and white.

G **Complementary colours:** Colours that are opposite each other on a colour wheel are ideal for setting as black and white.

NEED TO KNOW

■ Not all photos suit black and white. With practice, you'll soon appreciate which shots will work and which won't.

■ There are two ways to shoot black-and-white photos. You can shoot them in-camera; most cameras have a black-and-white (or monochrome) setting. Or you can shoot a photo in colour and convert it to black and white in post-production.

■ If you shoot JPEG with a black-and-white picture parameter, there is no going back once you've pressed the shutter button: the resulting photo will be black and white. It will be too late if you then decide that colour was the better option.

■ However, if you shoot RAW, you can undo the picture parameter in post-production and revert to colour.

Review these points and see how they relate to the photos shown here

▶ UNDERSTAND THE THEORY
Colour to black and white

There is more to taking black-and-white photos than simply removing the colour. In fact, it is essential to be aware of the different ways colours are converted into the shades of grey that make up black-and-white photos. Which colours you emphasize will determine the tone and quality of your pictures.

Filtration and channels

Before digital, coloured filters were the sole way to alter a range of tones in a black-and-white image. The filter lightened its own colour, while darkening complementary tones (see pp.236–237) by blocking wavelengths of light that correspond to the complementaries (see right).

Digital cameras with a Monochrome mode often let you simulate the use of coloured filters. However, converting colour to black and white in post-production will give you a greater range of options to adjust the tones in your photos.

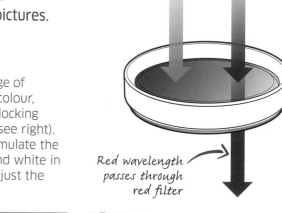

Red wavelength passes through red filter

ⓘ REFLECTIVITY

Lighter objects reflect more light, which affects the way they look when converted to black and white. This is useful to know when setting up and editing your shots.

■ **Black** A smooth black object absorbs most of the light shone on it and appears very dark as a result.

■ **Grey** Objects with a mid-grey tone reflect around 18% of the light falling onto them.

■ **White** A white object reflects most, though not all, of the light that falls onto it to create a bright, shiny effect.

💡 COLOUR

When shooting in colour, the red, green, and blue spheres are easy to differentiate. However, they all have the same level of brightness.

RED GREEN BLUE

In a colour photo it is easy to distinguish one object from another.

💡 MONOCHROME

A simple conversion to black and white makes each of the colours into a uniform mid-grey with no tonal separation. The sense of three different spheres is lost.

RED GREEN BLUE

In a black-and-white photo differently coloured objects may have the same grey value. This would make them difficult to tell apart and result in a flat, uninteresting photo.

Pro tip: Alongside red, green, and blue, yellow and orange filters are also commonly used when shooting in black and white. They have a similar effect as the green and red filters, although they are far weaker.

Pro tip: Blue filters are rarely used for either landscape or portrait photos because they can make blue skies very pale and skin tones very dark. They can be used to lower contrast for a hazy effect.

ℹ COLOUR AND TONE

An object's reflectivity is important because it defines the tone it will have when converted to black and white. More reflective surfaces will be brighter than duller, less reflective ones.

This means that although two objects may be differently coloured, if they are equally reflective they could still take on the same tone once converted to black and white.

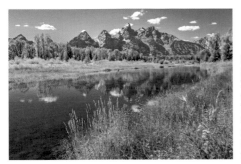

In a colour photo it is easy to distinguish one blue object from another, such as the sky, mountains, and river in this scene.

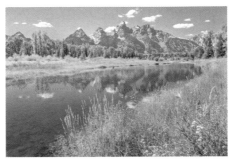

In a black-and-white photo the sky and sea would have the same grey value, creating a flat photo. Use filters to compensate.

💡 RED FILTER

The red sphere is lightened considerably. The green sphere remains a mid-grey and the blue sphere is now much darker.

RED · GREEN · BLUE

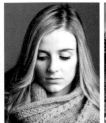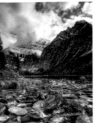

Very pale skin tones. Red hair lightened.

Blue sky darkened. Clouds more prominent. Effects of mist reduced.

💡 GREEN FILTER

The green sphere is now lightest, while the red sphere stays mid-grey. The blue sphere is dark, but not as dark as when the red filter is used.

RED · GREEN · BLUE

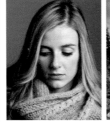

Darker skin tones.

Green foliage made lighter. Blue sky slightly darkened.

💡 BLUE FILTER

The blue details are the lightest. Both the green and red spheres are darker than a mid-grey, with the red sphere the darker of the two.

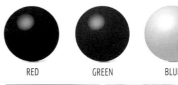

RED · GREEN · BLUE

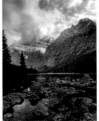

Unnaturally dark skin tones. Red hair darkened.

Very pale sky. Cloud detail lost. Effects of mist increased.

Shooting in black and white

When you can't rely on colour for impact, you have to think about tones instead. In black-and-white photography, tonal range is partially achieved by the quality of the light and level of contrast. How colours are converted to black and white will also affect the tonal range, and whether they lighten, darken, or stay the same relative brightness.

The bold colours on this steam engine make it a good subject for a black-and-white photo

1 Assess your location

Look carefully at the scene in front of the camera and note how light falls in the image. Are there shadows that add contrast? Look also at the colour range. Are there too many colours that are similar or is there a wide diversity of colour?

2 Choose a mode

Set your camera to an exposure mode suitable for the type of scene you are shooting. Do not use a fully automatic mode, as you may not be able to switch to black and white.

Use Aperture Priority if you need to control the depth of field

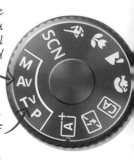

Use Shutter Priority if movement is more important

6 Switch to black and white

Go to your camera's picture parameter menu and select Black and White (or Monochrome). If you are using a tripod and your camera has an optical Viewfinder, switch to Live View. This will let you preview your shot on the LCD.

Look for the monochrome symbol in your shooting menu

7 Reshoot the scene

Shooting in black and white does not alter how photos are exposed. Leave the exposure settings as they were and reshoot the photo.

8 Check your photo

Review both the colour and the black-and-white version on your camera's screen. In particular, look at how colours have been rendered as shades of grey in the black-and-white photo.

Check the colours in your image

Where to start: Select a scene which you think is suitable for the black-and-white approach; the scene can be indoors or outdoors, but you need to make sure that the colours and lighting will produce a good black-and-white image.

You will learn: How to assess a scene for its suitability as a black-and-white photo; and where to find your camera's black-and-white picture parameter.

3 White balance

Select the correct white balance even though you're not shooting in colour. The more inaccurate it is, the fewer true colours the camera can use when converting to black and white.

4 Compose your shot

Position your camera and select a lens focal length that produces the most pleasing composition. See where shadows fall and help define certain details.

5 Select exposure and shoot

If you're not using a tripod, check that the ISO is sufficiently high to avoid camera shake. Focus the camera and shoot. Check the histogram to make sure that exposure is correct.

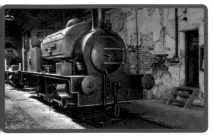

The blue cast of a Tungsten White Balance preset would not be suitable for this scene.

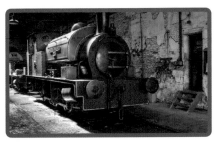

Make sure your composition is tight to exclude any distracting elements.

Check the histogram isn't displaying clipped shadows or highlights.

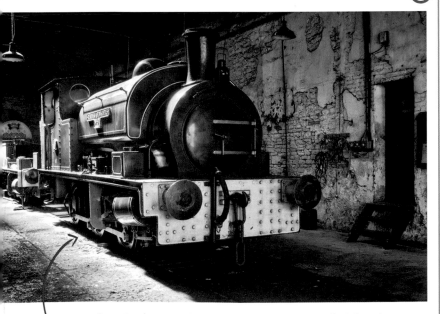

Interesting shadows can help to improve black-and-white photos

WHAT HAVE YOU LEARNED?

- It's generally easier to shoot in black and white during one photoshoot and in colour on a different shoot than switch back and forth.
- Your camera's Live View mode will give you instant feedback on a monochrome display, and help you see if a scene will work as a black-and-white photo.
- Don't be afraid to stick to colour if you think a scene isn't suitable.

Save both versions and review them later

Removing colour

To develop a sense of what subjects are still effective in a photo without the aid of colour, try the black-and-white assignments on the following pages. Remember to set your camera's picture parameter to Monochrome, and shoot both RAW and JPEG images.

USING COLOURED FILTERS

📶 **MEDIUM**　　📍 **INDOORS**
🕐 **1 HOUR**　　➕ **A VARIETY OF COLOURED OBJECTS**
◎ **BASIC +** tripod, coloured filters (optional)

Coloured filters can help you control how dark or light a colour is once it has been converted to grey.

■ **Arrange** your coloured objects on a tabletop.

■ **Set** your camera up on a tripod and compose a shot so that all of the objects are in the frame.

■ **Focus** and set the exposure – use a small aperture so that all of your objects are sharp. Shoot one photo.

■ **Select** the Yellow Filter effect from the picture parameter menu, if the option is available, and shoot again using this setting.

■ **Repeat** using the other available filter effects and review your photos.

TEXTURE AND DETAIL

📶 **MEDIUM**　　📍 **INDOORS OR OUTDOORS**
🕐 **1 HOUR**　　➕ **TEXTURAL SUBJECTS**
◎ **BASIC +** close-focus lens

Images look more abstract in black and white. Close-ups of texture and detail work well.

■ **Set** the appropriate filter effect to alter the tonal range of your subject if necessary.

■ **Compose** the shots so that you fill the frame with your subject.

■ **Use** a small aperture to keep the whole subject in focus. If the resulting shutter speed is too long, you may need to use a tripod or increase the ISO.

■ **Experiment** with lighting, too. Shoot with side, top, and front lighting to see how these affect the contrast in your photos.

Side lighting will accentuate texture, such as the veins on this leaf.

Pro tip: Don't use coloured filters if you shoot in RAW: the aim when shooting in RAW is to retain all the colour information for conversion later on.

Pro tip: Use a long focal length lens when shooting details. This will help you crop out unwanted elements that could be distracting.

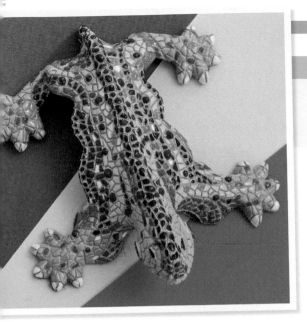

Complementary colours make it easy to separate tones in black and white.

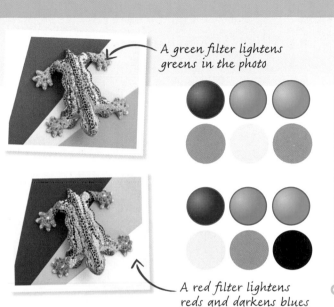

A green filter lightens greens in the photo

A red filter lightens reds and darkens blues

MONOCHROME PORTRAIT

(ii) **MEDIUM**

(>) **2 HOURS**

(o) **BASIC + tripod**

(o) **INDOORS AND OUTDOORS**

(+) **A MODEL**

Older, weathered faces are often appealing subjects for black-and-white portraits

Portraiture is particularly suited to black and white, but is more heavily dependant on the quality of the light.

■ **Shoot** ten shots with your model, both indoors and outdoors.

■ **Vary** the lighting. Shoot outside on overcast days, and, on sunny days, shoot indoors with artificial and window lighting.

■ **Compose** each shot in a similar way so that your subject occupies roughly the same area of the frame.

■ **Experiment** with using different filter effects when shooting portraits. Typically green filters are the most flattering, while blue filters are the least flattering.

BLACK-AND-WHITE STILL LIFE

📊 **EASY**　　　📍 **INDOORS**

🕐 **1 HOUR**　　　➕ **COLLECTION OF RELATED OBJECTS**

📷 **BASIC +** tripod

When shooting a still life, it's not just about the objects – setting and lighting will both play a key role in the success of your image.

■ **Arrange** your objects on a tabletop and use a background that is sympathetic to your objects – a busy one may be too distracting.

■ **Use** a reflector to bounce light back into the shadows if low contrast is suitable, or increase contrast with a point light source, such as a desk lamp.

■ **Set** your camera on a tripod and frame your shot.

■ **Focus** on the nearest object and set aperture to achieve front-to-back sharpness.

■ **Shoot** 10 to 12 images. Rearrange your subjects in different ways and experiment with different aperture and colour filter effects settings.

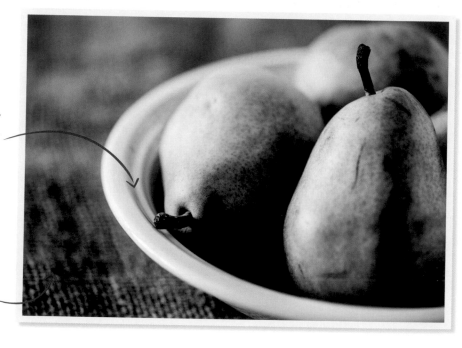

Ensure objects are clean and free of dust or fingerprints

Shoot with a simple background that doesn't detract from your subject

ℹ️ KIT: **COLOURED FILTERS**

Specialist coloured filters for black-and-white photography either attach directly to a lens or fit into a filter holder system. Yellow, orange, red, and green filters are the most useful for everyday shooting; blue filters are often sold separately. Most cameras can now reproduce filter effects. You can also mimic them when converting in post-production. However, coloured filters are still useful if you shoot in JPEG only, and if your camera does not have a filter effect option.

REPORTAGE

MEDIUM	**INDOORS OR OUTDOORS**
2 HOURS	**A SETTING AROUND WHICH YOU CAN TELL A STORY**
BASIC + zoom lens	

Reportage, or documentary photography, is a genre closely associated with black and white. Find a location and tell the story (see pp.332–333).

■ **Look** around your location to work out possible shooting positions.

■ **Set** the exposure mode to Program so you can concentrate on shooting and not worry about exposure.

■ **Use** the full range of your zoom. Use the wide-angle end of the zoom to shoot photos that create context; use the longer focal length end to zoom in on individuals or details.

■ **Take** as many shots as you think necessary. Better too many than too few.

■ **Review** your shots in chronological order. Choose 10 to 15 shots that best tell the story of the event.

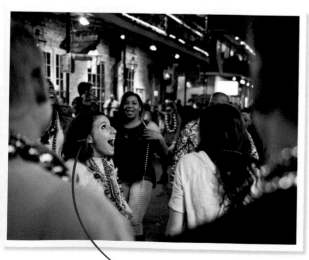

Capturing expressions are an important part of telling a story photographically

LANDSCAPE SHOOTING

MEDIUM	**OUTDOORS**
2 HOURS	**SCENIC LOCATION**
BASIC + tripod	

Black and white is ideal for conveying drama in a landscape. Rain and stormy conditions arguably work better in black and white than in colour.

■ **Shoot** 8–10 shots of a landscape, employing both the vertical and horizontal orientations and a variety of focal lengths.

■ **Use** a tripod. If there is movement in the scene – running water, for example – vary the shutter speed to see how this affects any movement.

■ **Experiment** with the colour filter effects to see how these alter the sky and foliage.

Effects such as long shutter speeds work well in black and white.

WHAT HAVE YOU LEARNED?

■ It can take time to set up a pleasing still life composition as you need to think carefully about how you arrange your subjects.

■ When shooting a documentary, taking more shots than you need will give you plenty of options for creating the perfect narrative.

Once you've completed your assignments, select the ten shots you feel most pleased with. Use the following eight pointers to help you decide what was successful in your photos and what could be refined on future shoots.

Is your black-and-white landscape interesting?
Shadows help to define the shape and form of landscape subjects. If you shoot at midday or on an overcast day, the three-dimensional nature of the landscape can be lost. This photo works well because the side lighting creates shadows that help to define the shapes of the buildings.

Are your highlights burnt out?
Shooting in black and white requires more personal interpretation than when shooting in colour. This photo is overexposed – and would look odd in colour – but this style is very effective in black and white.

Would colour work best?
There are some subjects that just don't suit the black-and-white treatment. This photo – bursting with vibrant colour – would be far less effective in black and white.

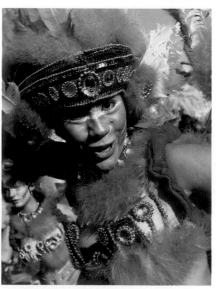

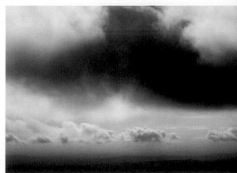

Did you need to use a filter?
You don't need to use (or simulate) a coloured filter for every black-and-white photo. If you shoot directly into light, as here, then the results are often monochromatic even in colour.

" Colour is everything, black and white is more. "

DOMINIC ROUSE

Is your portrait flattering?
Softer light and lower contrast are more flattering than hard light and high contrast. However, this portrait is effective due to the high contrast.

Does your photo look flat?
What level of contrast is suitable depends on the subject. Low contrast works well for soft, organic subjects – such as this orchid – as it helps to convey delicacy. If contrast needs to be higher, use a harder light source or select a different conversion filter.

Is the contrast of your black-and-white photo too high?
Abstract photos – such as this backlit rock formation – work well when shot in a high contrast way. A portrait would not benefit from having such a high level of contrast.

Does your documentary photo tell a story?
Less is often more. Reject any shots with elements that detract from your main subject. In this powerful image, the car fills the frame.

Although you can shoot in black and white, post-production conversion gives you more control. The Adobe Photoshop Black and White adjustment tool lets you very finely adjust how individual colours switch from colour to black and white. First, though, assessing how suitable an image is will save time and reduce frustration.

Complementary and contrasting colours will make it easy to separate the tones

1 Assess the photo
Look carefully and decide which colours should be lightened, which ones should stay at the same brightness, and which should be darkened.

Different colours of similar brightness will be the same tone in black and white unless adjusted

5 Try a preset
Photoshop's built-in set of presets are a useful shortcut for common black-and-white conversions, such as mimicking the effect of a red filter. Create your own preset if you find a particular combination of slider settings works best.

Click here to save or load your own presets

| Preset: | Red Filter | ⬍ | ⚙▾ |

6 Move the sliders
At 0 per cent, a pure colour, such as red, will be completely black. The higher the slider value, the closer to white the colour becomes. Adjust the sliders until a satisfactory black-and-white conversion results.

The tram's blue isn't a pure blue, so it needs a negative value to darken it sufficiently.

| Blues: | ◼ | -23 | % |

7 If you like, add a tint
Click on Tint. Drag the Hue slider to select the overall colour of the tint. Adjust Saturation to alter its vividness: at 0 per cent, the photo stays black and white; at 100 per cent, the tint is set to maximum vividness.

A subtle orange/ yellow tint mimics a sepia effect.

☑ Tint	☐	
Hue		41 °
Saturation		21 %

Pro tip: Start with a photo that has an accurate white balance. If white balance is skewed to either red or blue, it will be harder to separate tones during the conversion process.

Pro tip: After clicking OK on the Black and White tool, you can then use the Fade option on the Edit menu. By varying the Fade amount, you can add subtle colour back into your photo.

2 Set the photo to 100% magnification

On the Tool bar, double-click on the Magnify icon, which sets the magnification of the photo to 100 per cent. This will make it easier to see how fine details in your photo are converted to black and white.

3 Select Black and White

On the Image/Adjustments menu, select Black and White. The main controls are the sliders representing six colours. These sliders control whether each colour is darkened, stays the same brightness, or is lightened when converted to black and white.

4 Select Auto

Click on Auto, then Photoshop will analyse your photo and set the sliders to what it considers are their optimum position. This is a good starting point, but may not achieve the most pleasing black and white conversion.

If your photo doesn't fit on screen at 100 per cent, hold down the Space key and drag the photo to view a particular area

Reds:		40 %
Yellows:		60 %
Greens:		40 %

Various colours have converted to the same tone

With the red lightened and blue darkened, the image has tonal contrast.

ⓘ SPECIAL EFFECTS: **GRAIN**

Old photos were often grainy in nature. Photoshop's Add Noise filter can be used to reproduce this effect, but keep it subtle: set the slider to a low percentage value to keep noise under control. It's also worth switching between the Uniform and Gaussian settings. Gaussian produces a less-regular noise pattern and so is closer to the random nature of film grain. Finally, click on Monochromatic so that the Add Noise filter doesn't add colour back into your photo.

The higher the Add Noise value, the more fine detail is lost.

What have you learned?

Black and white is arguably a more expressive way of working than colour. However, without colour to add impact, you need to think more about light and shade and how these help to define your photographic subjects. See how much you've learned by answering the following questions.

1 What picture parameter would you use to shoot in black and white?

A Landscape B Standard
C Monochrome

2 What accessory is most useful when shooting black and white?

A Flashgun B Set of colour filters
C Hot shoe spirit level

3 What type of colouration do old black-and-white photos often have?

A Blue
B Magenta
C Sepia

4 What colour filter darkens blue the most?

A Blue B Red C Green

5 What colour filter would you use to brighten a red subject in black and white?

A Red B Green C Blue

6 How much light does a smooth, mid-grey object reflect?

A 18% B 25% C 50%

7 What lighting direction helps to reveal surface texture on details?

A Top lighting B Backlighting
C Side lighting

8 Old photos are often...?

A Out-of-focus B Underexposed
C Grainy

9 A blue filter would have what effect on cloudless sky in black and white?

A Make it lighter B Make it darker
C No effect

10 Which of the following would not make a good black-and-white subject?

A Textural scene
B High contrast scene
C Scene with similar colours

11 Where are complementary colours found on a colour wheel?

A Next to each other
B Opposite each other
C On either side of another colour

12 What colour filter could you use to reduce the appearance of freckles?

A Blue B Green C Orange

13 What Photoshop Black & White slider option intensifies the colour of a tint?

A Saturation B Magenta C Hue

14 A green filter would have what effect on skin tones in black and white?

A Make them lighter
B Make them darker
C No effect

15 Which colour filter would you use to lighten foliage in a landscape scene?

A Blue B Red C Green

16 What tone in a scene would reflect the least amount of light?

A White B Midtone C Black

17 What colour filter increases the effects of mist?

A Red B Blue C Green

18 What camera function lets you preview the effects of black and white?

A Live View
B Exposure compensation
C Depth-of-field preview

19 A colour filter does what to objects in a scene that are the same colour as the filter?

A Darkens them
B Has no effect on them
C Lightens them

Answers 1/C, 2/B, 3/C, 4/A, 5/A, 6/A, 7/C, 8/C, 9/A, 10/C, 11/B, 12/C, 13/A, 14/B, 15/C, 16/C, 17/B, 18/A, 19/C.

20

WORKING ON A PROJECT

week

To create a thematically coherent project, you need to have a clear vision and a real understanding of what it takes to communicate a story concisely and with passion.

In this module, you will:

▶ **establish what a photo project is** and how it can benefit your artistic development;

▶ **learn the formula behind a successful photo story** by studying how to research, shoot, and edit a wedding project;

▶ **engage your critical faculties** by editing and ranking a selection of images;

▶ **experiment and explore** by shooting the same subject in all seasons, undertaking a creative self-portrait, and photographing a carnival;

▶ **look back at your work** to evaluate what could be improved upon and to seek an outlet for your completed project;

▶ **improve the organization** of your images by using keywords;

▶ **confirm what you have learned** about planning, executing, and completing a project.

Let's begin... ⊙

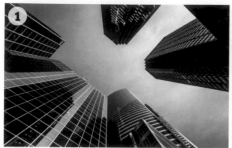

Embarking on a photography project lets you explore a subject in-depth and will help to develop your skills and style as a photographer. See if you can match these concepts with the correct images.

A **Shapes in nature:** Choose a geometric shape and look for naturally occurring examples.

B **Time passing:** Show the effects of weeks, or even years, passing.

C **Learn a new language:** Look for letters in an urban setting, and use them to spell a sentence.

D **Unusual family portraits:** Capture family members in a fresh way by focusing on details.

E **Humour:** Look for mishaps, contrasts, and funny expressions.

F **Low light:** Wait for nightfall and photograph illuminated buildings and objects.

G **A different view:** Shoot architecture from a new angle.

H **Look skywards:** Search high and low for a fresh interpretation of the traditional landscape.

I **Self-portraits:** Express yourself with unconventional self-portraits.

J **Sit and wait:** Catch people in public places for some off-the-cuff picture opportunities.

ANSWERS

F / 3: Night-time skyline, Atlanta, US
G / 1: Skyscrapers in Chicago, US
H / 8: Fluffy clouds in a blue sky
I / 9: Silhouette selfie
J / 5: Man on a park bench

A / 7: Red starfish in blue water
B / 2: Rusting car, California, US
C / 6: Letter "P" painted on a wall
D / 4: Feet sticking out from a duvet
E / 10: Horse pulling a funny face

NEED TO KNOW

■ A project requires discipline, so dedicate 30 minutes to it each day – make the most of time spent commuting or waiting in queues.

■ You need to be flexible: if your project takes a new turn, go with it. The results are sure to be interesting.

■ Before starting a project, you need to consider the amount of time and money you are prepared to spend on it.

■ Set achievable goals and tick each one off as you reach it. Make your goals short, medium, and long term.

■ Sharing your project with friends makes you more likely to complete it – so the more people you tell, the higher the potential success rate.

Review these points and see how they relate to the issues raised in this module

The perfect photo story

If you remember that every good tale has a beginning, a middle, and an end, then communicating your message via a series of images will seem much more manageable. If you take a special occasion as an example, you can see how planning, structure, shot variety, and editing all have a part to play in the success of your project.

SUBJECT RESEARCH

It's important to have a clear idea of what you'd like to achieve with your photo story before you start, whether you're shooting an event, animals, people, or a journey. If you take time beforehand to visualize how a subject will look under different lighting and weather conditions, you'll save time later.

For a wedding, talk to the couple about their expectations and visit the location before the day to plan backdrops and lighting set-ups.

PLANNING

BEGINNING

MIDDLE

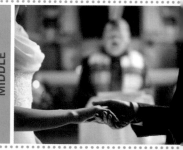

SHOT VARIETY

Movie directors use a variety of camera angles to tell their story, such as the establishing shot (which sets the scene), the medium shot (which features two characters interacting), and the close-up (which draws attention to details). By varying your viewpoint and focal length, you can do the same.

You might like to mix medium shots of the couple with close-ups of the groom's buttonhole and the bride's accessories.

TIGHT EDITING

Take more memory cards than you think you'll need and save the editing for later. Afterwards, when you sit down at your computer, make sure each picture works as a stand-alone image and also adds to the project as a whole.

Don't include too many multiples of the same image, as this could dilute your message.

Pro tip: In photography, the word "series" denotes a set of pictures showing related content (the images are all based around a theme), while "sequence" describes a set of pictures taken in quick succession (the images are all part of the same story).

STORY STRUCTURE

All stories need a structure – whether they be in the form of a fairy tale, a novel, or a photography series. It can help to draw a storyboard, sketching out how the plot will be introduced, developed, and concluded.

A classic wedding story would start with the bride getting ready (the beginning), showcase the ceremony (the middle), and continue right up until the time when the couple leave for their honeymoon (the end).

SKILLS REQUIRED

Storyboarding your project and then realizing you don't have the necessary skills to bring it to fruition can be disheartening, but it can also be a great opportunity

to learn something new. Go online and research different techniques, listen to a podcast, or sign up to a photography webinar.

You may need to practise your panning skills if you want to capture the moment when the newlyweds make their exit.

END

OUTLETS

Now that you've made a captivating body of work, make sure your photos actually get seen. Create a collage, online slideshow, book, exhibition, or album of your work. The end result should communicate your vision and artistic intention, while also showing the passion and dedication you've applied to the job.

PHOTOBOOKS

The presentation of your images is critical when you're creating a photobook or photo album. Consider how one image will impact on another, and vary the pace by juxtaposing long shots with close-ups or by inserting white space after a run of fast-moving action. Remember to include a beginning, a middle, and an end.

► **LEARN THE SKILLS**
Editing a photoshoot

Editing your work is one of the photographer's toughest jobs. When you've made an emotional connection with a subject, or overcome technical challenges to produce a picture, it's hard to look at your files objectively. However, you need to take a step back and use a combination of personal judgment and computer software to edit your work.

1 Distance yourself from your photographs
Copy your photos onto a computer and leave them for a few days before reviewing them. It's never a good idea to go through your images straight after a photoshoot.

2 View your images
Open the images on your computer using image-editing software. This will allow you to adjust your pictures without losing any of the original data.

6 Seek advice from trusted people
Show your images to family, friends, and, if possible, other photographers, and try not to be offended by their comments. Constructive criticism has the potential to make you a better photographer.

7 Make prints
Print out your images to assist you in a final cull. Tape these printouts to the wall and live with them for a while to see if your opinions change.

Where to start: Import your images from a recent photoshoot to an image-editing program of your choice. Make sure your monitor is calibrated and that the room is lit by natural daylight (or a daylight-simulation bulb).

You will learn: How to check your photos for faults, how to rank them according to preference, how to seek the advice of friends and colleagues, and how to order your photos into a satisfying sequence.

3 Look for faults

Use your image-editing program to check for major faults, such as lack of sharpness, poor composition, or excessive noise. Identify any images that could be improved by editing, and put them aside for later.

4 View similar images side by side

If you have pictures with near-identical content, compare them by viewing them side by side. Some editing programs let you zoom in to check the focus on both pictures simultaneously.

5 Mark your images with flags or stars

Rank your pictures with flags or stars so you can organize them quickly.

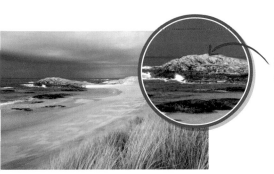

Zoomed-in detail of main image

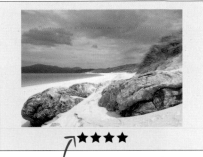

★★★★

Rank your own photos

8 Reorder the prints to get the right sequence

When sequencing your work, bear in mind that most good stories have a beginning, a middle, and an end. Consider the rhythm of your book and judiciously insert white spaces as part of your design. These will give the viewer a chance to pause as they view your images.

WHAT HAVE YOU LEARNED?

- It's hard to look at your own work objectively, so show your images to people you trust.
- Ranking your pictures will allow you to organize and retrieve them easily.
- Printing your pictures can help you to create a sequence.

A sequence of images arranged to show a tour through the Scottish countryside.

▶ PRACTISE AND EXPERIMENT
Taking on a project

Setting yourself an achievable goal will boost your photographic skills, confidence, and creativity. The six assignments here look at shooting the same subject over the course of a year, taking a self-portrait, forming a street alphabet, capturing emotions, joining a street carnival, and picking a colour theme. Try one, or all six.

OBSERVE THE SEASONS

- 📊 **HARD**
- 📍 **OUTDOORS**
- 🕐 **1 YEAR**
- ➕ **OUTDOOR SUBJECT THAT WILL NOT MOVE DURING THE YEAR**
- 📷 **BASIC +** tripod

Shooting the same subject in all four seasons can lead to images that express very different moods.

- ■ **Choose** an object that's unlikely to move throughout the year, such as a tree.

- ■ **Use** a sunrise/sunset app to work out how the path of the sun will affect your subject during the project.

- ■ **Record** the exact spot where you took your shot with the GPS system on your smartphone or mark it on a map. Once the first picture has been taken, note the focal length of the lens you used and the height of the tripod.

Different seasons lead to surprisingly diverse pictures.

ℹ KIT: RAIN COVERS

When you're out in all seasons, you're going to encounter the odd rain shower, so it's worth investing in a protective cover for your photographic equipment. Rain capes, weather shields, and storm jackets are good tools for keeping your camera and lens dry, and they're lightweight and inexpensive too.

Pro tip: You can create an unconventional self-portrait by shooting your own reflection in a mirror or a pond, by focusing on parts of your body rather than your face, or by capturing your face from an unusual angle.

20

WEEK

LEARN A NEW ALPHABET

- **MEDIUM**
- **2 HOURS**
- **BASIC**
- **OUTDOORS**
- **AN URBAN SCENE WITH SIGNS AND LETTERS**

We are surrounded by letters, but few of us notice the "secret" language hidden in architectural details and everyday objects on the street.

- **Leave** the tripod at home, as it might cause an obstruction. Handholding your camera will also allow you to act fast if you see a "letter" you like.
- **Use** a shutter speed roughly equal to the focal length of your lens, such as 1/60th of a second for a 50mm lens.
- **Go further:** try to make letters out of abstract forms, such as the double arch of a bridge for "M" or a crack in the wall for "Z".

TAKE A SELF-PORTRAIT

- **MEDIUM**
- **1 HOUR**
- **BASIC +** tripod, remote release or self-timer
- **INDOORS OR OUTDOORS**
- **A STAND-IN OBJECT**

Creating a meaningful picture of yourself requires patience and planning.

- **Find** an object to "stand in" for you, such as a chair. Switch to manual focus and train your lens on this object – autofocus would focus on the background and record you as a blur.
- **Set** the Drive mode to Self-Timer plus Continuous (or use a remote release). Go to your position and then take a series of shots.
- **Experiment** with poses and props.

Take a range of images in varying light conditions.

WHAT HAVE YOU LEARNED?

- When you want to return to the same location in different seasons, you need to mark the exact spot where you set up your tripod.
- Self-portraits give you the opportunity to tell a story about yourself, so feel free to use props and various poses to get your message across.
- Once you start looking, you'll find letters of the alphabet everywhere.

👤 SHOW SOME EMOTION

- 📊 **MEDIUM**
- 🕐 **1 HOUR**
- 📷 **BASIC +** tripod
- 📍 **INDOORS OR OUTDOORS**
- ➕ **MODEL**

Photographing emotions can be tricky, but you can obtain striking portraits by asking friends to pose for you.

- **Get** everything ready beforehand so you won't be fumbling around during the shoot.

- **Switch** the camera to Aperture Priority and choose an f-stop that will throw the background out of focus while keeping your subject's facial features nice and sharp.

- **Select** an AF point that covers the most important part of the subject's face – usually their eyes. Set the Drive mode to Continuous.

- **Ask** your subject to think of a time when they were particularly angry, frightened, or unhappy, and press the shutter-release button halfway to get the focus, then take the shot. Try using Continuous Drive to capture a sequence of shots as their emotions change.

This model has tried out an extreme emotion.

ℹ️ KIT: CAMERA BAGS FOR STREET PHOTOGRAPHY

Shooting street events calls for a compact, lightweight camera bag that doesn't scream "photographer" to would-be thieves. There's no need to carry more than one dSLR and a couple of lenses for this kind of work, so a messenger bag will do the job. Choose one with plenty of padding, removable internal dividers, and a wide strap to distribute the load on your shoulder. It's also a good idea to make sure it's showerproof too.

JOIN THE PARTY

- MEDIUM
- 2 HOURS
- BASIC
- OUTDOORS
- STREET PARTY OR CARNIVAL

One of the great things about carnivals is that people expect, and often like, to be photographed. This removes some of the fear associated with street photography.

- **Plan** carefully. Get hold of a map of the route, and arrive early to secure the best vantage point.
- **Leave** your tripod at home: it will slow you down and could be a hazard. Instead, make use of any nearby walls or benches to steady the camera.
- **Select** a fast shutter speed if the action is moving quickly, but, if you're shooting portraits, consider using a wide aperture to throw dull backdrops out of focus.

Masked revellers at carnivals make great subjects for portraits.

PICK A COLOUR

- EASY
- 45 MINUTES
- BASIC + tripod
- INDOORS OR OUTDOORS
- OBJECTS LINKED BY COLOUR OR THEME

Shooting a series of images based around one strong colour, such as red, can produce countless images if you're willing to think a little differently.

- **Think** laterally. Shooting red objects is easy enough, but how about capturing someone who is seeing red (very angry), or in the red (in debt)?
- **Try** using the same format, such as panoramic, across the set, or add an effect, such as a vignette, to each image to emphasize the connection.

The edges of this frame have been darkened using vignetting

WHAT HAVE YOU LEARNED?

- When shooting a portrait, get everything ready before the subject arrives.
- Carnivals provide the perfect opportunity for fast, energetic photography, but they are no place for a tripod.
- If you've chosen a project based on a colour, you don't have to be too literal.

Reviewing your project

Having learned how a project can help you develop your technical skills and individual style, it's time to choose some of your favourite images and run through the following checklist.

Have you managed to find enough time?
Working on a personal project can feel self-indulgent, but there are ways to free up time without neglecting friends, family, or work. To get this dawn shot, you'll have to get up while others are still in bed.

Are the parameters too limiting?
Try not to be too blinkered; embrace new chances as they arise. If focused only on leaves and small details, you may miss the opportunity to capture a beautiful mossy trunk.

Do you lack inspiration?
If you're struggling to settle on a project, stay close to home and take a picture of a family member every day for a prescribed length of time.

Have you thought of a suitable outlet?
You could turn your project into a book or an online showcase. Or, if you have a series of food shots, such as this one, you could create a recipe book for friends and family.

◉ Do you have the necessary skills?

Don't worry if you don't quite have the technical skills for a project: use it as an opportunity to learn. For an image like this, you would need to master HDR (High Dynamic Range).

▲ Is the subject worthy of a project...

...or should it be a stand-alone image? If you're shooting cupcakes, for example, you might also like to include images showing the making and eating of the cakes.

◉ Are your files organized effectively?

Use keywords to organize your images. This image is tagged with the terms "beach", "Florida", "umbrella", and "chair". What other terms could you use?

◉ Are you struggling to edit your work?

Sharpen your editing skills by looking at as many pictures as you can until your work is of as high a quality as this shot of an Ethiopian tribeswoman.

When your image archive consists of just a few photographs, it's tempting to ignore adding keywords in the belief that your pictures will always be easy to find. But fast forward a few months and your archive will be teeming with images of a similar content and style. By applying keywords as soon as your files are imported, you will make them easy to locate and save yourself hours of frustration later.

A collection of bird photos taken over just a couple of months.

4 Add more detailed keywords

To add Sub Keywords to the set, right-click (or ctrl-click) on one of the Keyword sets, select New Sub Keyword and add your word. Repeat as necessary. For this exercise we have chosen "Owls", then "Falcons".

▽	**Birds**
	Falcons
	Owls
▽	**Events**
	Birthday
	Wedding

5 Delete irrelevant keywords

Many of the preset keywords will be irrelevant, so you can safely remove them. To delete one, hover over it, right-click (or ctrl-click), select Delete, then "OK".

List of keywords with unwanted entries deleted

▽	**Birds**
	Close-up
	Falcons
	Flight
	Owls
	Portrait

6 Search using keywords

Once you've assigned your keywords, you can use them to locate images by selecting the Edit drop-down menu and then Find. In the dialog box, check that Criteria says Filename, Contains, and the Keyword you wish to search by (in this case "Owl"). Click Find. You can refine your search by pressing the plus sign and adding extra criteria.

Criteria			
Filename ▼	contains ▼	owl	- +

Pro tip: When you're looking for files using the Find dialog box, you can select Keywords in the drop-down menu under Criteria and use the plus sign to add a series of keywords to search by. You can also search by star rating.

1 Locate the Keywords tab

Open Photoshop and then Adobe Bridge. In Bridge, Select a folder of images to add keywords to and click on the Keywords tab.

2 Apply preset keywords

Look down the list of preset keywords, which are arranged in sets. To assign one, simply click on a thumbnail, and check the box next to the word.

3 Create a new Keyword set

To create a new set, click on the New Keyword (+) icon at the bottom of the panel. Rename the folder, keeping your terminology quite general – for this exercise we have simply called it "Birds".

This image would use the keywords "owl", "portrait", and "perch".

ⓘ THE METADATA PALETTE

The Metadata palette in Bridge contains useful information about each image listed under three headings: File Properties, Camera Data (Exif), and IPTC. File Properties describes information relating to the file itself, such as its resolution, file type, and size. The Camera Data (Exif) section covers technical information for the image, such as the exact focal length of the lens used, the shutter speed, and the ISO setting. Finally, the IPTC section contains user-generated information, such as copyright details.

Image metadata showing technical information.

METADATA	KEYWORDS		
f / 5.6	1/ 400	2824 x 4192	
	--	5.80 MB	--
	ISO 800	Adobe RGB	RGB

What have you learned?

In this module you've learned how to research, shoot, and edit a photo project, as well as the importance of keeping an open mind, setting goals, and finding an outlet for your work. See how much you've taken in by answering the questions below.

1 When you're planning a project you should always make sure your goals are what?

A Achievable
B Long term
C Short term

2 Where can you find details of the focal length used for a certain picture?

A In the camera manual
B In the lens box
C In the Exif/Metadata

3 If you're handholding a camera you should use a shutter speed equal to what?

A The aperture you have selected for the lens
B The length of time you can hold your breath
C The focal length of the lens you're using

4 How long should a photo project take to complete?

A Just a couple of minutes
B As long as you like
C As long as your concentration lasts

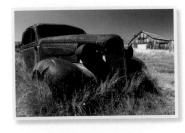

5 Which type of focus should you use for a self-portrait?

A Manual focus
B Autofocus
C It doesn't matter

6 What can be inserted into a sequence of images to help break up the pace a little?

A White space
B Travelling space
C Space for text

7 If you experience a rain shower, what should you do with your camera?

A Take it indoors straight away
B Protect it with a rain cape or storm jacket
C Take out the battery

8 If you're shooting a photo project, it can help to create which of the following?

A Story line
B Storybook
C Storyboard

9 What does the word "series" mean in relation to photography?

A A set of pictures taken in quick succession
B A set of pictures based around a theme
C A set of pictures with a beginning, a middle, and an end

10 If you are taking a portrait, where should the point of focus usually be?

A On the eyes
B On the nose
C On the lips

11 When you're shooting a carnival, what should you do with your tripod?

A Splay the legs fully
B Use it at its full height
C Leave it at home

12 What is the name of a shot that helps you to set the scene in a photo story?

A Close-up shot
B Low shot
C Establishing shot

13 When should you add keywords to your pictures?

A When you have 100 images
B Straight after you have imported them to your computer
C When you have 10,000 images

14 Why should you rate your pictures with stars or flags?

A To help you sort and retrieve them
B To help you delete them in bulk
C Both of the above

Answers 1/A, 2/C, 3/C, 4/B, 5/A, 6/A, 7/B, 8/C, 9/B, 10/A, 11/C, 12/C, 13/B, 14/C.

what next?

Congratulations on completing the 20 modules in this book. The techniques of photography – many of which you will have covered over the past 20 weeks – take time to learn. However, they can be mastered with patience and practice. The key is not to get too downhearted by the odd failure: even professionals make mistakes. What is important is that you learn from your errors, use them to expand your knowledge of photography, and keep progressing.

Get ready to show and tell

We are often wary of putting our photography on view. However, photography should be shared, and criticism – as long as it's fair and balanced – should be welcomed. The two simplest ways to share photos is to make prints or to post the images to media-sharing platforms on the internet. The first involves sharing your work with individuals or small groups. The latter means sharing your work with potentially the entire online world.

In this final chapter, you will:

▶ **learn about printers,** printing, and the types of paper available;

▶ **look at social media** and the ways you can promote your photography online.

Printing your images

As good as it is to see a photo on-screen, it's even better to see it printed. There's a tactile quality to a print that cannot be beaten. Printing was once seen as a dark art with results that were often hit or miss. Sophisticated modern desktop printers have made it far easier to produce pleasing results.

📷 PRINTERS

Inkjet printers are the default choice for photographic printing (colour laser printers don't offer the same image quality). Inkjet printers work by firing tiny droplets of ink from a cartridge at a sheet of paper as it's fed through the printer. The droplets are so small that they're virtually impossible to see with the eye and so they appear to be solid areas of colour.

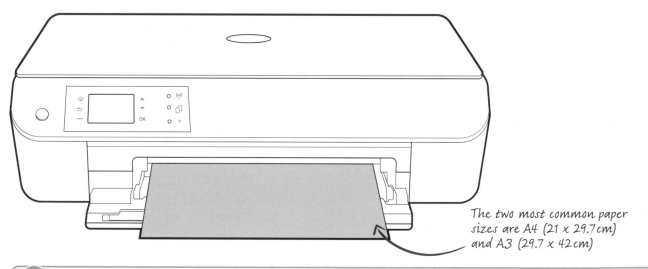

The two most common paper sizes are A4 (21 x 29.7cm) and A3 (29.7 x 42cm)

ℹ CMYK

There are four basic ink colours used by inkjet printers: cyan, magenta, yellow, and black (CMYK). By varying their proportions, an inkjet printer can reproduce a wide range of colours.

■ When a photo is printed, the RGB colours in the photo are converted to CMYK by the printer driver (the software installed on a PC to control the printer). Although it's possible to convert an image to CMYK in Photoshop, always print in RGB mode.

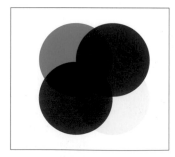

Darker areas of photos require lots of ink. If an area of a photo is pure white, no ink is used.

Pro tip: High-end inkjet printers supplement the basic four ink colours with cartridges containing lighter variants of those colours. This increases the subtlety of colours the printer can reproduce.

Pro tip: Monitors are generally able to display a greater range of colours than a printer can reproduce. Typically printers struggle to reproduce very vivid colours accurately.

INK TYPES

Light is incredibly destructive. Over time light will cause prints to fade. There are currently two types of inkjet printers: pigment and dye. Of the two, prints made with pigment inks are far less prone to fading than one made with dye inks. Pigment inks are therefore considered more suitable for archiving. The downside to using pigment ink printers is that both the printers and ink cartridges tend to be more expensive than dye. However, if you plan to display or even sell your photography, it is worth the expense for peace of mind.

Pigment inks are made of particles of colour pigment suspended in a liquid

PAPER

The choice of paper used to make a print should be based on what best serves a photo.

■ **Gloss paper** is superb for reproducing bold colours and high contrast photos. But some images may benefit from a more subtle approach.

■ **Semi-gloss** or **pearl paper** is less reflective than gloss, making it suitable for showing photos in well-lit areas.

■ **Matte paper** is the most subtle paper type of all. It is far lower in colour saturation and contrast than both gloss and semi-gloss (blacks in particular are never as deep). Matte paper works well for black and white photos.

PROFILES

Every digital device handles colour in a slightly different way to every other device. This can result in the colours of a photo looking different on a monitor compared to a print. The solution is to use a profile for both the monitor and the printer (or rather the particular paper type you plan to use).

■ A profile is a file that describes how a particular device reproduces colour. A computer can then use the relevant profiles to translate colours from one device to another.

■ Profiles are created using hardware known as a colour calibrator. Monitor calibrators are readily available and inexpensive; printer calibrators are more specialist and therefore more expensive.

Monitor calibrators read swatches of colour displayed by the calibration software (see p. 241).

■ A profile must be created for every type of paper you use; different types of paper absorb ink in different ways, which alters the reproduction of colours.

■ Fortunately, paper manufacturers often supply ready-made profiles for their papers for popular printer models. These profiles can usually be downloaded from the paper manufacturer's website and installed by following the instructions.

Sharing your images

Making and showing prints is by its nature an intimate pastime. Posting photos onto social media sites on the internet offers you the chance to show your work to a larger audience. Posting your first photograph can be daunting. However, it's a great way to receive valuable feedback and be inspired by the photography of others.

Picking a social media site

There are scores of social media sites that let you post photos. Some are not photography-specific and you may find your audience limited to family and friends. Currently the most popular photography-specific social media sites include Flickr, Instagram, and 500px.

Building an audience

People who like your work will follow you. Every time you post a photo, your followers will be notified. Gaining followers is therefore key to building your audience and opening up conversations. The clue to how best to go about achieving this is in the word "social". Seek out photographers whose work you admire and follow them. Comment fairly on their work and, if the site allows, add their most appealing photography to your favourites list.

Joining some groups

One useful aspect of photography-specific sites are groups dedicated to particular genres of photography. If there isn't a group that covers your own interests, you could create your own. Joining a relevant group is a good way to build up followers, "meet" like-minded photographers, and show your work to them. Groups tend to have rules. These rules often include the types of photography that can be added to the group and how many photos per day you are allowed to add. Stick to the rules so that you don't alienate anyone or risk being thrown out of the group entirely.

Social media sites automatically scale your photos to suit the screen size of the viewing device.

BEFORE YOU POST

■ **One way to lose followers** and goodwill is to post hundreds of very similar photos. Be selective when you add photos to a site. Only add your best photography, or post work that may not be perfect, but that you'd like to have critiqued – people will generally either be positive or offer constructive advice.

■ **Reduce the resolution** of your photos before adding them to social media sites. There's no need to post a full-resolution file: upload times will be longer and you run the risk of someone using your photo without your permission.

■ **Don't resize your original photo,** however. Save a copy to your computer's desktop and resize that version, then delete the copy once uploaded.

> ## Photography is a **love affair** with **life.**
> **BURK UZZLE**

ℹ COPYRIGHT

You may be perfectly happy for others to use your photos without permission (you could argue that it's a compliment). Even so, your photos are your copyright and should be protected.

■ Adding a watermark to each photo – your name is an obvious choice – makes the photo less attractive for use without permission. Image-editing software often has text entry tools that make this task easier.

■ There's a fine balance to be struck between a watermark that's too obtrusive and one that's too subtle. Experiment until you find a style that suits you.

■ **There's no right size** for a social media photo, but 1,000 pixels along the longest edge is a good compromise between too much detail and too little.

■ **Use JPEG** when saving your photos for posting to a social media site. Save the JPEG at a medium image quality to reduce upload times.

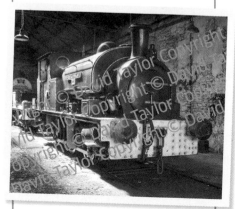

Pale watermarking will still let people look at your photos.

Image Size		
Pixel Dimensions: 1.56M (was 1.56M)		**OK**
Width: 1000	Pixels ⬍	**Cancel**
Height: 545	Pixels ⬍	**Auto...**

1,000 pixels is too low-resolution for printing but perfect for display on a monitor

Glossary

aberration A visual flaw in an image caused by the optics of a lens.

angle of view The angular extent of an image projected by the lens onto a camera's sensor.

aperture The hole through which light passes to the camera's sensor. The size of the hole can be varied using an iris-like diaphragm.

Aperture Priority Semi-automatic shooting mode that allows the photographer to select the aperture, with the camera selecting the required shutter speed.

aspect ratio The shape of an image expressed as a ratio of the horizontal dimensions to the vertical.

Autofocus (AF) Focusing mode in which the camera selects the required focus distance.

black and white Genre of photography in which tones in a photo are rendered as varying shades of grey rather than colour.

bracket To shoot a number of sequential photos with a particular camera setting varied during the sequence. The most common type of bracketing is exposure bracketing.

buffer The camera's built-in memory that acts as a temporary store for photos until they are written to a memory card.

Bulb Exposure mode that allows a photographer to hold open the shutter for an indefinite period, usually activated by holding down the shutter button.

burnt out Term describing the way that highlights are rendered as white and lacking in detail due to overexposure.

camera shake Unsharpness in a photo caused by camera movement during exposure.

Centre-weighted metering Camera exposure metering mode that biases metering to a large central area of the image frame.

chromatic aberration Coloured fringing seen along high-contrast edges in a photo caused by a lens's inability to focus different wavelengths of light to the same point.

clipped Term used when either the shadows or highlights in a photo are pure black or pure white respectively.

colour temperature Measure of the red/blue colour bias of light, measured in degrees Kelvin.

compression A method used to reduce the file size of an image. Compression can either be lossless, in which no image detail is lost, or lossy, which degrades fine detail.

Continuous AF Autofocus mode that continually updates focus distance until the moment of exposure.

Continuous shooting A Drive mode that allows the shooting of multiple photos, activated by holding down the shutter button until the buffer is full.

contrast Term used to describe the difference in brightness between the darkest and brightest areas in a scene or photo. It can also be used to describe visual difference such as that between colours or textures.

converging verticals Visual effect caused by tipping a camera back to shoot a vertical subject which makes the subject appear to fall backwards.

crop To resize a photo by trimming around any or all of the edges.

crop factor Figure used to calculate the difference between the angle of view of a lens when used on cameras with different sensor sizes.

depth of field The extent of sharpness in a photo. It extends out from the focus point and is controlled by adjusting the size of the aperture.

digital sensor Light-sensitive electronic chip able to form a photographic image.

distortion Warping of a photo caused by a lens: makes what should be a straight line in a photo appear to curve.

Drive mode Sets how many photos a camera will shoot when the shutter button is pressed down.

dSLR Contraction of Digital Single Lens Reflex; a camera system that uses a reflex mirror to direct the view through the lens to an optical Viewfinder.

dynamic range Term used to describe the ratio of the intensity of the darkest and brightest tones that can be captured by a digital sensor.

DSLRs have a very wide dynamic range.

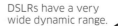

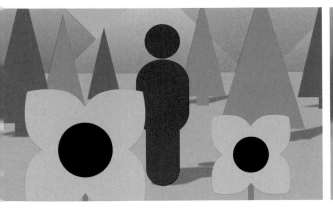

Evaluative metering Also known as Matrix metering, this is an exposure metering mode in which a scene is divided into zones with each zone metered independently. The camera determines the final exposure by analysing and evaluating the readings from each zone.

exposure The act of making a photo; also the aperture, shutter speed, and ISO setting required to make a satisfactory image.

exposure compensation An adjustment of the exposure values set by the camera. Exposure compensation is either negative (when the exposure is darkened) or positive (when the exposure is lightened).

exposure lock Camera control that lets a photographer hold an exposure reading so that it does not change.

fill-in flash The technique of using a flashgun to illuminate a backlit subject and so reduce contrast.

filter (physical) Sheet of glass, plastic, or optical resin that affects light that passes through the filter in a predetermined way.

filter (post-production) An effect that can be applied to a photo, such as noise reduction or sharpening.

flashgun A device able to emit a short but intense burst of light to provide extra illumination. Flashguns can either be built-into a camera, fitted to a camera, or fired remotely.

focal length The optical distance (in mm) of a lens focused on infinity from the point where rays of light begin to converge inside the lens to produce a sharp image at the camera's focal plane.

focal plane Area inside a camera where light is focused. In a digital camera the digital sensor is positioned at the focal plane.

Changing your depth of field can produce dramatic results.

focus To adjust the optics of a lens to produce the correct level of sharpness in an image when it is projected by the lens onto a camera's focal plane.

frame (camera) One individual photo; frame is most commonly used to describe how many frames-per-second are shot when using a Continuous Drive mode.

frame (other) Wooden, metal, or plastic surround used to support prints for display.

frames-per-second (fps) The number of photos that can be shot by a camera over the course of a second when using a Continuous Drive mode.

f-stop Name used to describe a lens aperture value.

Fully Automatic Shooting mode in which the majority of shooting functions are controlled entirely by the camera rather than the photographer.

HDR Short for High Dynamic Range. Technique used to create a photo with a wide dynamic range by blending photos shot using different exposure settings.

high contrast A scene or photo where there is an extreme tonal difference between the darkest and brightest areas.

highlights The brightest parts of an image.

histogram Graph showing the brightness or range of tones in an image.

horizontal Camera orientation in which the camera is held parallel to the horizon. Often referred to as landscape format.

hot shoe Electrical connection and mount that lets a camera fire an external flashgun during an exposure.

incident-light metering Measurement of the level of light falling onto a scene. Typically this is achieved using a handheld exposure meter. *See also* reflective metering.

interpolation Software technique used to increase the number of pixels in a photo when resizing it.

ISO Numerical value that reflects a sensor's sensitivity to light.

JPEG A compressed image file type in which some of the image detail is lost.

kit zoom Basic zoom lens commonly sold with dSLR and mirrorless cameras.

landscape Genre of photography that takes the natural world as its subject. Also used as a synonym for horizontal when describing a camera's orientation.

LCD Short for Liquid Crystal Display. The technology used to create the electronic Viewfinder and rear displays on cameras.

lens An assembly of glass or plastic optical elements used to focus light onto the sensor of a camera.

low contrast A scene or photo where there is a narrow tonal difference between the darkest and brightest areas.

macro Term used to describe the close-up shooting of subjects at a 1:1 reproduction ratio.

Manual exposure An exposure mode that requires a photographer to physically set both the shutter speed and aperture to obtain the desired exposure.

Manual focus Focusing mode in which the photographer turns the focus ring of a lens to achieve focus.

megapixel Term used to denote one million pixels in a digital image.

memory card Storage medium used in digital cameras.

metering The act of measuring the light levels of a scene to determine the required exposure settings.

midtone A tone halfway between black and white with an average reflectivity.

mirrorless Interchangeable lens camera that feeds the image data from the sensor to an LCD screen without the need for an optical Viewfinder.

monochrome A synonym for black and white. It can also be used to describe a photo comprised of a limited range of colours.

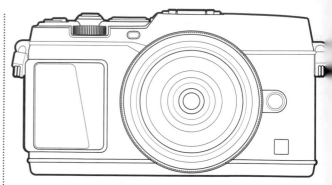

Mirrorless cameras offer near-on dSLR quality in a much smaller size.

ND filter Semi-opaque filter that is neutral in colour and reduces the intensity of light passing through the filter. Usually used to extend the shutter speed.

ND graduated filter Filter with a semi-opaque top half and clear bottom half. Commonly used in landscape photography to balance the exposure between the sky and an unlit foreground.

noise Grainy pattern that reduces fine detail in a photo. It is most commonly seen when either a high ISO setting or very long shutter speed has been used.

orientation The angle at which a camera is held when shooting. The two most common camera orientations are vertical (portrait) and horizontal (landscape).

overexposure The result of letting too much light reach the sensor during an exposure. This is usually accidental, but can be done deliberately.

perspective A term used to describe the apparent distances between the various elements in a photo.

picture parameter Camera setting that adjusts visual aspects of photos such as contrast or colour saturation.

pixel Short for Pixel Element; the smallest block of image information in a photo.

Playback Act of displaying and reviewing a previously-shot photo stored on a camera's memory card on the camera's screen.

polarizing filter Filter that polarizes light that passes through it. Commonly used to reduce reflections from non-metallic surfaces and deepen the blue of skies.

portrait Genre of photography that takes people or animals as its subject. Also used as a synonym for vertical when describing a camera's orientation.

post-production The act of adjusting an image after shooting using either tools built into a camera or specialist software on a computer.

Predictive AF Autofocusing mode that constantly updates focus distance by tracking how and where a subject is moving within the image frame.

RAW A RAW image file containing all the image data captured by the camera at the time of exposure.

red eye Visual effect seen in the pupils of human or animal subjects when direct flash is used. The pupils turn red due to flash light reflecting from the blood vessels at the rear of the eyes.

Red-Eye Reduction Flash mode in which a pre-flash is fired to reduce the risk that a human or animal subject will suffer from red eye.

Reflective metering Measurement of the level of light reflecting from a scene to reach the exposure meter inside a camera.

reflector Sheet of light-coloured material that can be used to redirect light into shadow areas to lower contrast.

remote release Device used to fire a camera's shutter. Communicates with the camera via a cable connection or infrared signal.

resolution A measure of the pixel dimensions of an image that corresponds to how sharp the picture looks.

RGB Short for Red, Green, and Blue – the primary colours used by digital cameras and computer monitors.

shadows The darkest areas of a photo.

shutter Light-tight curtain in front of a sensor. During an exposure the shutter is opened and then closed. The length of time the shutter is open is known as the shutter speed.

Shutter Priority Shooting mode in which the photographer selects the required shutter speed with the camera automatically selecting the correct aperture.

single shooting Drive mode that lets a photographer shoot only one photo per press of the shutter button.

skylight filter Filter with a light pink tint used to reduce the effects of UV light in a photo.

Spot metering An exposure metering mode in which only a small area of a scene is measured.

standard lens Also known as a normal lens. Reproduces an angle of view that closely matches human vision.

telephoto Long focal length lens commonly used in wildlife and portrait photography.

tone A level of brightness. Commonly split into three broad categories: shadows, midtones, and highlights.

tripod Three-legged accessory used to support a camera and prevent camera shake.

TTL Short for Through The Lens. Used to describe a flash metering system where flash exposure is determined by the camera rather than the flash.

underexposure The result of letting too little light reach the sensor during an exposure. This is usually accidental, but can be done deliberately.

USB Short for Universal Serial Bus; a standard connection cable used to connect digital devices.

UV filter Filter that cuts out the effects of ultraviolet light. Commonly used to protect the front glass element of a lens.

vertical Camera orientation in which the camera is held at right angles to the horizon. Also commonly referred to as portrait format.

Viewfinder Optical or electronic device that shows a photographer the scene through the lens that will be captured by the camera during exposure.

vignette Darkening of an image's corners that is either accidental – such as when using a lens at maximum aperture – or applied deliberately in post-production.

white balance Camera function that compensates for any potential colour bias in a light source.

wide-angle lens A lens with a diagonal angle of view greater than 65 degrees.

working distance The distance between the camera and the subject when shooting macro.

zoom A lens with a variable focal length.

Capture subjects from a distance with a telephoto lens.

Index

Page numbers in **bold** refer to main entries.

Acknowledgements

Dorling Kindersley and Tall Tree would like to thank:

Tracy Hallett, Paul Sanders, and David Taylor for allowing the use of their images in this book; Sam Kennedy and Tejaswita Payal for their editorial assistance; Stephen Bere for his design help; and Helen Peters for the index.

Picture credits

The publisher would like to thank the following for their kind permission to reproduce their photographs.

Key: a = above; b = below/bottom; c = centre; f = far; l = left; r = right; t = top.

2 iStockphoto.com: PhotoTalk **3 iStockphoto.com:** Bepsimage (cl); Marcus Lindstrom (fcl); jodiecoston (cr); CaroleGomez (fcr). **18 iStockphoto.com:** GP232 (bl); Ron Thomas (ca); guvendemir (c); TonyFeder (cb); Mac99 (bc). **19 iStockphoto.com:** Onfokus (tr); ozgurdonmaz (crb). **20 iStockphoto.com:** fotolinchen (tr). **21 iStockphoto.com:** antonyspencer (bl); JayKay57 (clb); olliemtdog (clb/sunset); Michael Westhoff (cb); MvH (cb/mountain); YasmineV (bc); ltphoto (crb); macroworld (crb/Winter); TheDman (br, fbr); narloch-liberra (fcrb); OGphoto (fcrb/Lake). **24 iStockphoto.com:** Yuri (br). **26 iStockphoto.com:** JLPhotographix (tr); knape (tl); ltphoto (tc); PhotoTalk (cr). **27 iStockphoto.com:** Guasor (tr); Nikada (tl); KenCanning (cl); isitsharp (tc). **28 iStockphoto.com:** allekk (bc); Maksymowicz (tr); Preslav (cb). **29 iStockphoto.com:** franckreporter (cra); Juanmonino (bc); Chris Schmidt (br). **31 iStockphoto.com:** ltphoto (fcl); Turnervisual (fcla); triloks (cla); Sportstock (cl, tr). **32 iStockphoto.com:** RichLegg (br); sanchezgrande (clb). **33 iStockphoto.com:** baranozdemir (tr); PeopleImages (cb). **34 iStockphoto.com:** gcoles (cra). **35 iStockphoto.com:** PeopleImages (bl); technotr (crb). **36 iStockphoto.com:** CreativeArchetype (cr); gabomadar (cl); Turnervisual (crb); Zhenikeyev (br). **37 iStockphoto.com:** encrier (cr); triloks (tl); sborisov (clb); stefanschurr (bc). **38–39 iStockphoto.com:** Noppasin (all images). **40 iStockphoto.com:** franckreporter (cr). **42 iStockphoto.com:** Alphotographic (tl); EyeEm (tc); YsaL (cl); GibsonPictures (tr); Ryzhkov (cr). **43 iStockphoto.com:** Dhoxax (tl); EyeEm (cl); Oktay Ortakcioglu (cr). **45 iStockphoto.com:** photofxs68 (br); pixhook (cl). **46–47 iStockphoto.com:** webphotographeer (b). **47 iStockphoto.com:** Yuri (cl, cr). **49 iStockphoto.com:** afby71 (br); PamelaJoeMcFarlane (cla); irina88w (bl). **50 iStockphoto.com:** Mark Bowden (tr). **51 iStockphoto.com:** druvo (crb); ictor (bl). **52 iStockphoto.com:** chubbs1 (cl); Evgeny Sergeev (cra); pixelfusion3d (bc, crb). **53 iStockphoto.com:** Bigandt_Photography (cb);

PeopleImages (tl); stockstudioX (bl). **56 iStockphoto.com:** afby71 (cr); ictor (c); YsaL (bl). **58 iStockphoto.com:** bradleym (tl); f4f (tc); JayKay57 (tr); Oleg_Ermak (cr). **59 iStockphoto.com:** Enjoylife2 (cr); mtreasure (tl); grigphoto (tr); stockfotoart (cl). **60 iStockphoto.com:** Andrew_Howe (cr); ArtMarie (clb). **61 iStockphoto.com:** bgfoto (br); Nadezhda1906 (t); Johnny Greig (c); zhaojiankang (cr). **62 iStockphoto.com:** 2630ben (c); Steve Debenport (c); Feverpitched (cr); FrankyDeMeyer (bc). **63 iStockphoto.com:** Christopher Futcher (tl, ca); Anna Omelchenko (cl); ross1248 (tc); tunart (c); RapidEye (br). **66 iStockphoto.com:** franckreporter (tr); RealCreation (cb, br). **68 iStockphoto.com:** jk78 (crb); Juanmonino (cl); Sean Pavone (cr); photographer3431 (bc). **69 iStockphoto.com:** amygdala_imagery (cl); InterestingLight (tl); Alex Potemkin (clb); sergio_kumer (bl). **70–71 iStockphoto.com:** clubfoto (all images). **72 iStockphoto.com:** bradleym (bl); photographer3431 (cra). **74 iStockphoto.com:** johnnyscriv (tl); LaraBelova (tc); MvH (cl). **74–75 iStockphoto.com:** ronypetry (tc). **75 iStockphoto.com:** camacho9999 (c); iluhanos (tc); macroworld (r). **78 iStockphoto.com:** karamysh (c); vestica (cb); tellmemore000 (bc). **80 iStockphoto.com:** Marek Mnich (ca); toxawww (cla). **80–81 iStockphoto.com:** Maxian. **82 iStockphoto.com:** anneleven (tr). **83 iStockphoto.com:** BenDower (cr); Elenathewise (clb). **84 iStockphoto.com:** Eivaisla (crb); jojoo64 (cla); ooyoo (cr); TheDman (bc). **85 iStockphoto.com:** antonyspencer (bc); DenisTangneyJr (cla); entrechat (cr); LyleGregg (clb). **88 iStockphoto.com:** anneleven (cra). **89 iStockphoto.com:** Vesna Andjic (c); Nicolas McComber (tl); Michael Westhoff (tc, cl). **90–91 iStockphoto.com:** MTrebbin (tc). **91 iStockphoto.com:** hept27 (tr); MAYBAYBUTTER (cr). **94–95 iStockphoto.com:** Trout55 (all images). **98 iStockphoto.com:** PeopleImages (crb). **99 iStockphoto.com:** John Gomez (cra); Nikada (tl). **100 iStockphoto.com:** cunfek (bc); goldistocks (cr); DaveLongMedia (crb). **101 iStockphoto.com:** Casarsa (bc); Seadog53 (c); Sara Corso (cr). **104 iStockphoto.com:** Nikada (cb); PeopleImages (cl). **106 iStockphoto.com:** Andrew_Mayovskyy (tl); Marcus Lindstrom (tc); Ladida (cr). **106–107 iStockphoto.com:** OGphoto (tc). **107 iStockphoto.com:** dwowens (cr); Minerva Studio (tc); gemenacom (tr); Sarsmis (cl); PeopleImages (cr). **110 Alamy Images:** Tim Gainey (bc, br).

111 Alamy Images: Tim Gainey (bl). **112 iStockphoto.com:** Xavier Arnau (bl). **113 iStockphoto.com:** Xavier Arnau (bl). **114 iStockphoto.com:** Phil_Scarlett (br). **115 iStockphoto.com:** Volodymyr Goinyk (cr); KoBoZaa (bl). **116 iStockphoto.com:** CrackerClips (bc); konradlew (cl); Steve Debenport (cr); gilaxia (crb). **117 iStockphoto.com:** George Clerk (clb); JacobH (tl); Whiteway (bc). **119 iStockphoto.com:** macroworld (r). **120 iStockphoto.com:** dwowens (c). **122 iStockphoto.com:** FOTOGRAFIA INC. (tl); Christopher Futcher (tc); slobo (cl); ThomasVogel (cr). **122–123 iStockphoto.com:** Flavio Vallenari (tc). **123 iStockphoto.com:** iconogenic (cr); luke_63 (tc); Ricardo Reitmeyer (cl). **126 iStockphoto.com:** lechatnoir (br); Martin Wahlborg (clb); PeopleImages (bl). **127 iStockphoto.com:** claudio.arnese (bc); nojustice (tl); SensorSpot (tc); Manakin (bl); superjoseph (br). **130 iStockphoto.com:** Leonardo Patrizi (tr). **132 iStockphoto.com:** Xavier Arnau (cl); Peeter Viiisimaa (cr); Petrichuk (tc); stanley45 (tr). **133 iStockphoto.com:** Elcurado (r); Rike_ (cl); HadelProductions (bl). **134–135 iStockphoto.com:** zhuzhu (all images). **136 iStockphoto.com:** slobo (cl); ThomasVogel (clb). **138 iStockphoto.com:** diane10981 (tl); gilya (tc); tunart (tr). **138–139 iStockphoto.com:** dynasoar (tc). **139 iStockphoto.com:** EcoPic (tc); Ingenui (c); ParamountPics (tr). **142 iStockphoto.com:** Peter Zelei (c). **143 iStockphoto.com:** Adventure_Photo (bl, cra). **145 iStockphoto.com:** benimage (tr); irina88w (br). **146 iStockphoto.com:** chaoss (br); LPETTET (clb). **147 iStockphoto.com:** IdealPhoto30 (tl). **148 iStockphoto.com:** johnbloor (br); wingmar (cl); Nikada (cr). **149 iStockphoto.com:** antonyspencer (clb); PIET (tl); nullplus (cr); wingmar (bc). **150–151 iStockphoto.com:** WEKWEK (all images). **152 iStockphoto.com:** LPETTET (cl). **154 iStockphoto.com:** Danieloncarevic (cl); Adam Petto (tl); luoman (bl); DavidCallan (tr); Thomas_Zsebok_Images (cr). **155 iStockphoto.com:** halbergman (tc); MichaelSvoboda (tr); rusm (cr). **158 iStockphoto.com:** eskamilho (bc); seewhatmitchsee (c); Rufous52 (cb); jeryltan (br). **159 iStockphoto.com:** jeryltan (cr, bl). **160 iStockphoto.com:** isitsharp (br). **161 iStockphoto.com:** jjwithers (crb); fabio lamanna (cra). **162 iStockphoto.com:** kenhurst (tr). **163 iStockphoto.com:** kaspiic (tr). **164 iStockphoto.com:** fabio lamanna (cl); shayes17 (bc); ogergo (cr). **165 iStockphoto.com:** carlofranco (bl); DaveLongMedia (cl); rhyman007 (r). **168 iStockphoto.com:** jeryltan (br). **170 iStockphoto.com:** claudiodivizia (tc); NikWaller (tl); Franz Wilhelm Franzelin (tr);

Halfpoint (cl); guvendemir (cr). **171 iStockphoto. com:** CaroleGomez (cr); Pieter-Pieter (tl); Yingko (tr); Mouse-ear (c). **173 iStockphoto.com:** Mshake (br); Tom Nulens (cr). **174 Corbis:** Kimberly White (br). **175 Corbis:** Kimberly White (bl). **177 iStockphoto.com:** HAVET (crb); northlightimages (bl). **179 iStockphoto.com:** DusanBartolovic (crb); Borut Trdina (bl). **180 iStockphoto.com:** MariuszBlach (cl); Borut Trdina (cr); metinkiyak (crb). **181 iStockphoto. com:** Kenneth Canning (bc); Sergey Skleznev (tl); Teradat Santivivut (cr); macroworld (clb). **184 iStockphoto.com:** MariuszBlach (cra); Mouse-ear (cla); Sergey Skleznev (c). **186 iStockphoto.com:** Leoba (t); Roberto A Sanchez (tl, cr); Adam Petto (tc). **187 iStockphoto.com:** amygdala_imagery (cra); MOLPIX (ca); technotr (c); nadla (cl). **190–191 iStockphoto.com:** Razvan (all images). **192 iStockphoto.com:** SDAM (br, bc). **193 iStockphoto.com:** SDAM (bl, cr). **194 iStockphoto.com:** bradleym (cr). **195 iStockphoto.com:** kurdigo (cr); Viorika (clb). **196 iStockphoto.com:** baona (crb); Roberto A Sanchez (cl); Eloi_Omella (cr); gunelguldagi (cb). **197 iStockphoto.com:** 33ft (br); DKart (tl); Sjo (clb); Tuna Tirkaz (bc). **198–199 iStockphoto. com:** gbh007 (all images). **200 iStockphoto.com:** Brasil2 (cla); SDAM (cb). **202 iStockphoto.com:** AlexSava (tr); pixdeluxe (tl); fotoVoyager (cr). **203 iStockphoto.com:** 4FR (tl); jpsowin (tr); Lauren King (c); narloch-liberra (cr). **204 iStockphoto.com:** Bartosz Hadyniak (br); Ridofranzv (bc); stockstudioX (bl). **204–205 iStockphoto.com:** to_csa (c). **205 iStockphoto. com:** alaincouillaud (cr); Analisa Hegyesi (tr); Bartosz Hadyniak (cra); AVTG (cb); LaurenJane (bc); pawel.gaul (br); AleksandarNakic (fbr). **206–207 iStockphoto.com:** PhotographerCW (tc). **206 iStockphoto.com:** Bartosz Hadyniak (bl); aNdreas Schindl (br). **207 iStockphoto.com:** CoffeeAndMilk (br); MACIEJ NOSKOWSKI (tr); Mr_Twister (c); Rawpixel Ltd (bl); PeskyMonkey (bc). **208–209 iStockphoto.com:** pitrs (all images). **211 iStockphoto.com:** alistaircotton (tl); PeopleImages (cr). **212 iStockphoto.com:** azndc (cla); EyeEm (cr); ImpaKPro (cb); BDphoto (crb). **213 iStockphoto.com:** jetbug (cl); Dariusz Paciorek (cr); Sara Winter (clb); PeopleImages (crb). **214–215 iStockphoto.com:** eli_asenova. **215 iStockphoto.com:** 4loops (br). **216 iStockphoto.com:** AlexSava (cra); aNdreas Schindl (cb). **218 iStockphoto.com:** ClaudioVentrella (cl); luoman (tl); tipton (tc); meodif (cr). **218–219 iStockphoto.com:** mbbirdy (tc). **219 iStockphoto.com:** AlbinaTiplyashina (tr); EnolaBrain (tc); rvbox (cl); Zoran Kolundzija (c); Sara Winter (cra). **220 Getty Images:** Buyenlarge / Archive Photos (bl). **iStockphoto. com:** RomoloTavani (cr). **220–221 iStockphoto. com:** kinugraphik (bc). **221 iStockphoto.com:** Claudia Lusa (cl); RBOZUK (cr); Marek Mnich (br). **222–223 iStockphoto.com:** igorkov (all images). **224 iStockphoto.com:** LisaValder (tr). **225 iStockphoto.com:** Andrea Carolina Sanchez Gonzalez (tr); WEKWEK (cla). **226 iStockphoto.com:** raywoo (tr). **227 iStockphoto.com:** KimberlyDeprey (tr); robertiez (crb). **228 iStockphoto.com:** charliebishop (c); HaraldBiebel (cr); stevanovicigor (bl); waiheng (crb). **229 iStockphoto.com:** gaspr13 (tl); Litleskare (cr); Sjo (clb); Peter Mukherjee (crb). **230–231 iStockphoto.com:** kharps (all images). **232 iStockphoto.com:** raywoo (cb); WEKWEK (cla). **234 iStockphoto.com:** carterdayne (tl); Jovanna_Novakovic (tc, tr, cl, cr). **235 iStockphoto.com:** YelenaYemchuk (tc, c, tr). **238 iStockphoto.com:** alistaircotton (cb/Sport); Janoka82 (c, br); MTrebbin (cb); kevinruss (bc); MvH (bc/landscape). **239 iStockphoto.com:** Janoka82 (br); standret (tr). **240 iStockphoto.com:** aluxum (br); standret (tr). **241 iStockphoto.com:** allou (cr). **242 iStockphoto.com:** FrankyDeMeyer (tr). **243 iStockphoto.com:** anzeletti (bl); ROMAOSLO (cr). **244 iStockphoto.com:** anandaBGD (cl); jodiecoston (cr); hfng (bc); blackestockphoto (crb); thefinalmiracle (bl). **245 iStockphoto.com:** alekleks (cr); EHStock (tl); titoslack (bc). **246–247 iStockphoto.com:** Mlenny (all images). **247 iStockphoto.com:** Fotovika (br). **248 iStockphoto.com:** allou (cb); FrankyDeMeyer (cra); scampsdesigns (cla). **250 iStockphoto.com:** aimintang (tc); johnnymix (tl); GP232 (tr); Ale-ks (cr). **251 iStockphoto. com:** baona (tl); Sirikunkrittaphuk (tr); dspn (cl); compassandcamera (cr). **252 iStockphoto.com:** bangkokhappiness (cr); DDieschburg (cl); David Sucsy (cr); zarinmedia (fcr). **253 iStockphoto. com:** ChamilleWhite (tr); Marek Mnich (fcl, fcr); franckreporter (cl); IndypendenZ (c); Yobro10 (cra). **254 iStockphoto.com:** GP232 (c); IPGGutenbergUKLtd (ca); sborisov (cra); KellyISP (cr); NADOFOTOS (bl). **255 iStockphoto.com:** NADOFOTOS (bl). **256 iStockphoto.com:** Peter Burnett (tr); harrastaja (crb). **258 iStockphoto. com:** aydinmutlu (tr); YinYang (crb). **259 iStockphoto.com:** Siwawut (tr). **260 iStockphoto.com:** cocoangel82 (cra); imv (cl); JLBarranco (bc); Lauri Patterson (crb). **261 iStockphoto.com:** davidf (br); monkeybusinessimages (tl); Ron Thomas (clb). **264 iStockphoto.com:** Ale-ks (clb); GP232 (crb). **266–267 iStockphoto.com:** stevegeer (tc). **266 iStockphoto.com:** alexemanuel (cr); lore (tl); kevinruss (tc); Chalabala (cl). **267 iStockphoto. com:** Ray Hems (cr); Wolfgang_Steiner (tc); WGCPhotography (tr); najin (cl); RuudMorijn (c). **270 iStockphoto.com:** Marccophoto (bc). **271 iStockphoto.com:** Marccophoto (bc). **272 iStockphoto.com:** Cameron Strathdee (cr). **273 iStockphoto.com:** CPaulussen (clb); pifate (cra). **274 iStockphoto.com:** photohomepage (bl). **275 iStockphoto.com:** archives (tl); wrangel (clb); DegasMM (cr). **276 iStockphoto.com:** EcoPic (cl); YasmineV (cr); EduLeite (bc); M_a_y_a (crb). **277 iStockphoto. com:** AZarubaika (clb); urbancow (tl); CamiloTorres (cr); Voyagerix (bl). **280 iStockphoto.com:** Cameron Strathdee (cla). **282 iStockphoto.com:** amygdala_imagery (cr); Chris Schmidt (tl); Ian McDonnell (cr); CocoZhang (tr). **283 iStockphoto.com:** JoopS (c); knape (cr); LisaAnfisa (cr). **286 iStockphoto.com:** knape (br). **287 iStockphoto.com:** knape (bl). **288 iStockphoto.com:** blende64 (crb). **289 iStockphoto.com:** Gerdzhikov (tl); Meinzahn (crb, br). **290 iStockphoto.com:** isitsharp (tr). **291 iStockphoto.com:** jaredhaller (tr); Meinzahn (clb). **292 iStockphoto.com:** aikbossink (cl); ReformBoehm (cr); NovaBirth (bc); Nikolay Pandev (crb). **293 iStockphoto.com:** mauro grigollo (tl, cr); rolfbodmer (clb); pixelfusion3d (bc). **294–295 iStockphoto.com:** J2R (all images). **296 iStockphoto.com:** J2R (cla); rolfbodmer (cra); Ian McDonnell (cb). **298 iStockphoto.com:** mpilecky (tc); Notorious91 (tl); Chris Schmidt (cl); olliemtdog (tr). **298–299 iStockphoto.com:** PeopleImages (tc). **299 iStockphoto.com:** MichaelSvoboda (cr); Nikolay Pandev (tr); scarlett070 (c). **301 iStockphoto.com:** Imgorthand (crb); knape (c). **Thinkstock:** George Doyle (cra). **302–303 iStockphoto.com:** Casarsa (all images). **304 iStockphoto.com:** Pali Rao (bl). **305 iStockphoto.com:** Mark Bowden (c, bc); vitapix (cl). **306 iStockphoto.com:** ArtEfficient (br). **307 iStockphoto.com:** michellegibson (cr); Nikolay Pandev (cla). **308 iStockphoto.com:** A330Pilot (cl); franckreporter (cr); hsvrs (br). **309 iStockphoto.com:** defun (bl); Gawrav Sinha (tl); HaiMinhDuong (cra); Liufuyu (bl). **310–311 iStockphoto.com:** BONNINSTUDIO (all images). **312 iStockphoto.com:** olliemtdog (tr); Chris Schmidt (cla). **314 iStockphoto.com:** ghornephoto (cl); kevinruss (tl); Yurikr (tc). **314–315 iStockphoto.com:** PolarLights (tc); Tuna Tirkaz (c). **315 iStockphoto.com:** andrej67 (c); marcviln (tr). **316–317 iStockphoto.com:** gcoles (b/landscape); ilbusca (b). **317 iStockphoto.com:** David Sucsy (cla, cra). **320 iStockphoto.com:** annaaged (br). **321 iStockphoto.com:** Casarsa (br). **322 iStockphoto.com:** vkbhat (cr). **323 iStockphoto.com:** Joel Carillet (clb); Vasilis_Liappis (cr). **324 iStockphoto.com:** DeanDrobot (cl); PytyCzech (cr); StockPhotosArt (cr). **325 iStockphoto.com:** Fitzer (tl); Tetiana Ryshchenko (cr); ilbusca (clb). **330 iStockphoto. com:** EHStock (tr); Paul Velgos (tl); GoodLifeStudio (cl); parema (cl). **330–331 iStockphoto.com:** Sean Pavone (tc). **331 iStockphoto.com:** Bepsimage (tc); vencavolrab (cl); polarica (tr); DLeonis (c); treasurephoto (cr). **332 iStockphoto.com:** DigtialStorm (cl); sjharmon (ca); eli77 (c); maximkabb (cr); jezphotos (bl); DorianGray (br, fbr). **333 iStockphoto.com:** mauro grigollo (cra); maximkabb (cla); Rich Legg (cl); omgimages (c); Massimo Merlini (cr); kevinruss (bl). **334 iStockphoto.com:** 4774344sean (bl). **336 iStockphoto.com:** vandervelden (cl). **337 iStockphoto.com:** HelenPI (tr); Brendan Hunter (cl). **338 iStockphoto.com:** yuriyzhuravov (tr). **339 iStockphoto.com:** collazuol (clb); Yuri_Arcurs (cr). **340 iStockphoto.com:** keiichihiki (cl); kevinjmills (cr); SensorSpot (bc); kimikodate (crb). **341 iStockphoto.com:** Bertlmann (cl); Paul Velgos (tl); Anna Pomaville (cr); Bartosz Hadyniak (bc). **342 iStockphoto.com:** Dirk Freder (fcr); iculizard (tr); tattywelshie (ftr); SteveMcsweeny (c); PhilEllard (fcr). **343 iStockphoto.com:** PhilEllard (bl). **344 iStockphoto.com:** collazuol (cra); EHStock (bl). **347 iStockphoto.com:** 4FR (tr); iconogenic (cra); Fitzer (cr).

All other images © Dorling Kindersley
For further information see:
www.dkimages.com